Praise for *The Mirror*

"In this candid book by Jennifer Higgie, an Australian art critic, each painter endures some life-changing trauma. The stark message is that women need to suffer in order to make great paintings, and that trauma is the alchemical ingredient necessary for transforming talent into genius."
—**Celia Paul**, *The New York Times Book Review*

"Higgie's book is a useful primer for those seeking to understand the obstacles and challenges faced by women artists over the centuries, as well as a timely assessment of what it means to look at women artists from history today. It's a subject that's been covered before, but with Higgie's background at *frieze*, she's equally plugged into the contemporary currents of feminist art as she is its historical context, lending the text an important freshness . . . For those wanting to move beyond biography and learn more about the why and how of the struggle of women artists to make their voices heard, *The Mirror and the Palette* is an important and brilliantly accessible resource."
—*Vogue*

"A master storyteller and brilliant translator of sensory experiences, Higgie makes us care about her artists as people. She is able to retrieve personalities from historical obscurity with just a few words. An eye-opening intervention in the memory system of art history, *The Mirror and the Palette* is a major contribution, not least for the author's appealing, accessible writing. She shows that we are still just coming to terms with how biased our institutions have been, and how much bigger the story of art really is."
—*The Times Literary Supplement*

"Higgie has organized the book thematically to bob and weave through the ties that have bound female painters—and blow open the so-called liberties they've taken with their art. Coming exactly fifty years after Linda Nochlin published her famous essay 'Why Have There Been No Great Women Artists?' Higgie wants to lay the question to rest, once and for all."
—**Hillary Kelly**, *Vulture* and *New York Magazine*

"As editor at large of *frieze* magazine and the presenter of *Bow Down*, a podcast about women in art history, Higgie has an extensive knowledge of the works of women artists, most of whom have struggled historically with being accepted as serious artists. An engaging analysis of the resilience of female artists throughout modern history."

—*Kirkus*

"Higgie's inevitably sprawling narrative taking its structure from what is essentially a group biography—though she [titles] her chapters not for the women they portray, but for vague moods and themes ('Solitude', 'Hallucination', 'Naked'). Artemisia Gentileschi, Angelica Kauffman, Alice Neel, Helene Schjerfbeck, Suzanne Valadon and—yes—Frida Kahlo: all of them are here. Among the less-well-known names she includes are those of the Australian artist Nora Heysen, and the New Zealander Rita Angus."

—*The Guardian*

"In this idiosyncratic and fascinating primer, critic and artist Higgie skillfully restores marginalized women self-portraitists to their rightful place in the art pantheon. Full of edgy insights, this engrossing survey will delight art connoisseurs and general readers alike."

—*Publishers Weekly*, (Starred Review)

"Higgie's writing is at its most emotionally evocative, even lyrical, when she imagines multitudes of women in their tiny attics and dimly lit studios, looking at themselves and deciding how they want to be remembered. She reflects the feelings of countless women, known and unknown . . . By skillfully balancing the historical and the imaginative, *The Mirror and the Palette* is not only a delight to read, but inspirational."

—**Arts Fuse**

The Mirror and the Palette

Rebellion, Revolution, and Resilience:
Five Hundred Years of Women's Self Portraits

Jennifer Higgie

PEGASUS BOOKS
NEW YORK LONDON

THE MIRROR AND THE PALETTE

Pegasus Books, Ltd.
148 West 37th Street, 13th Floor
New York, NY 10018

ISBN: 978-1-63936-293-6

10 9 8 7 6 5 4 3 2 1

Printed in the United States of America
Distributed by Simon & Schuster
www.pegasusbooks.com

To my mother, Jean Higgie

Contents

Prologue

Anyone who wanted could cite plentiful examples of exceptional women in the world today: it's simply a matter of looking for them.

Christine de Pizan, *The Book of the City of Ladies*, 1405

She looks at herself, again and again. She's in London or Paris or Helsinki or Sydney. She's in a village by the sea or a hamlet in the mountains, in a room, a studio, a flat, a place, however small, she can call her own. She's a mother, she's childless, she's straight, she's queer, in a relationship or relationships, happily celibate or filled with a longing for something or someone just out of reach. She's finally found some time alone, perhaps even a moment of peace, even though there's a clamour in the streets: modernity is hurtling towards her.

She's in competition with history, which has always been dismissive of her power. Until very recently, museums wouldn't buy her work, art historians wouldn't acknowledge her and commercial galleries would only rarely represent her. She's a miracle, a marvel, a mystic, a seductress, a changeling, a visionary, a man-hater, a freak; she's never considered normal. She knows that no two women are the same. She knows that she has always been here, there and everywhere, but for reasons that baffle her, people still refuse to *see* her. Even now, decades or centuries after she has died, her magnificent achievements remain largely unsung; there are still countless museums, galleries and collectors who do not appreciate her worth, who do not rate her, who are

not interested in the many stories she has to tell. She still has so far to travel.

For centuries, she couldn't enter the academy, even though she and her sisters never stopped pounding on its doors; nor was she allowed to paint anyone naked, not even herself. She couldn't vote and had little or no governance of her own body. She was all too often defined by the men in her life even if they meant nothing to her. She constantly struggled to support herself financially. She was mocked, excluded, ignored. She was laughed at, told what to wear, what to think, how to move through the world. Her appearance was always commented upon. If she was beautiful, her morals, her intellectual depth, her innate skills, all were questioned; if, according to the conventions of the day, she was considered plain, she was pitied and patronised. If she didn't conform, she was assumed to be mad. If she didn't have children, she was frustrated, frigid, grief-stricken, cold. If she did bear children, more often than not she disappeared for a while or forever; it was a rare husband who understood her need to paint. If she juggled art and motherhood, she was super-human. Time and again she had to work early in the morning or late in the evening, as during the day she had to run a household or earn money. She worked so hard it's a wonder she didn't fall asleep on her feet. She scrutinised herself over and over again.

From the moment she was born, she was told who to *be*.

She paints a self-portrait because, as a subject, she is always available. (This is putting it mildly.) She's been barred from so many other places, so many other bodies. Sometimes, she's unclear about why and who she's painting her picture for. (Does anyone really know what a painting is *for*?) All she knows is that something compels her to look at herself for hours on end, for reasons that have nothing to do with vanity - quite the opposite. What draws her back to her reflection again and again is the raw self-scrutiny that stems from unknowing; from the confusion

she's experienced between the reality of living in her body and the lies that she's been told about it that have been drummed into her since the moment she arrived on earth. She looks at herself in order to study what she's made of, to understand herself anew and, from time to time, to rage against the very thing that confines and defines her. She paints herself to develop her skills, to converse with her contemporaries and with art history. In the act of painting herself she makes clear that she is someone worth looking at, someone worth acknowledging. Her paintings assume shapes that she does not always predict. Against all odds, she discovers what she is capable of.

The Deceits of the Past

> When you're an artist, you're searching for freedom. You never find it because there ain't any freedom. But at least you search for it. In fact, art should be, could be called 'the search'.
>
> Alice Neel

The museums of the world are filled with paintings of women - by men. Ask around and you'll find that most people struggle to name even one female artist from before the twentieth century. Yet women have always made art, even though, over the centuries, every discouragement was - and, in many ways, still is - placed in their way.

In the words of the nineteenth-century writer and art critic Vernon Lee: 'There is no end to the deceits of the past.' The story told by traditional art history is that, despite the occasional complication, creativity is a relatively straightforward and progressive affair. According to this tale, since the first cave paintings, one artistic movement has segued neatly into the next and each new artist has in some ways improved upon the one who came before

him. Yes, *him*. Western art history began in sixteenth-century Italy, when the individuals who made paintings and sculptures became famous as artists, not just as craftsmen. It continued to prosper in the following centuries thanks, generally speaking, to the scholarship of privileged white men - men who, despite their often original insights and scholarship, were blinkered: they tended, with few exceptions, to write about the achievements of other white men. Until very recently, the idea that women have always made art was rarely cited as a possibility. Yet they have - and of course continue to do so - often against tremendous odds and restrictions, from laws to religion and convention, the pressures of family and public disapproval. Apart from the occasional mention of these trailblazers by male historians, it is thanks to feminist art historians - such as Renée Ater, Frances Borzello, Janine Burke, Whitney Chadwick, Sheila ffolliott, Frima Fox Hofrichter, Mary Garrard, Germaine Greer, Kellie Jones, Geeta Kapur, Lucy R. Lippard, Linda Nochlin, Rozsika Parker, Griselda Pollock, Arlene Raven, Gayatri Sinha, Eleanor Tufts and others - that the achievements of these artists have at last been given their due.

Feminism has shaken up how art history has been read and written. For the first time, artists who were previously ignored, patronised, marginalised or ostracised due to their gender, race, sexuality or class, are being recognised for their originality and resilience. The infinitely varied work of these artists embodies the fact that there is more than one way to understand our planet, more than one way to live in it and more than one way to make art about it. This new art history celebrates and champions difference - the very lifeblood of art. When I began researching self-portraits, despite being all too aware of the reality of gender exclusion, I was staggered at the sheer depth and variety of paintings made by women over the past five centuries who, it is fair to say, have, until recently, been erased from the story of art. The fact of their existence makes very clear that a segregation of the history of

creativity – or anything else, for that matter – no longer makes any sense.

Given the formidable restrictions placed in their way (more of that later), it's understandable that throughout history women have made fewer works of art than men. But if you took some accounts as gospel, you'd be forgiven for thinking that women only started making art after World War II – and not many of them, at that.

It's important though to stress that the existence of pre-modern women artists was not suddenly and miraculously discovered in the mid-to-late twentieth century. Although scarce, women's creativity has, in fact, been noted since the beginnings of written history. The Roman historian Pliny the Elder – who was to die as a result of the eruption of the volcano Vesuvius that destroyed Pompeii in AD 79 – even asserted that the art of painting *originated* with a woman. In his *Natural History* (AD 77), he recounts how the sculptor Butades of Corinth discovered portraiture around 650 BCE thanks to his daughter Kora of Sicyon, 'who, being deeply in love with a young man about to depart on a long journey, traced the profile of his face, as thrown upon the wall by the light of the lamp'. According to this tale, her father then filled in the outlines with clay and modelled the features of the young suitor – and so created the first portrait as a sculptural relief.

The story endured. In the eighteenth and nineteenth centuries, depictions of Kora tracing the outlines of her lover's shadow – often titled *The Origin of Painting* or *The Art of Painting* – became popular. But Kora is not the only woman Pliny mentions; he cites six other women artists from antiquity: Aristarete, Calypso, Irene, Olympia, Timarete and Iaia of Cyzicus; the last was a Roman painter from the first century BCE, who according to the historian 'remained single all her life' and rendered 'a portrait of herself, executed with the aid of a mirror' – the earliest mention of a self-portrait made

with a mirror.* In the late twelfth or early thirteenth century the German illuminator Claricia depicted herself in a wide-sleeved dress swinging from the letter 'Q' like a trapeze artist. Although she's airborne, any sense of danger is undermined by her very evident sense of humour. Her name, in tiny letters, frames her face. It's a rare, exuberant image of a medieval woman thumbing her nose at decorum. You can almost hear the sound of her distant laughter echoing across nine centuries.

In the fourteenth century, some of the women mentioned by Pliny resurface in the Florentine historian Giovanni Boccaccio's collection of 104 historical and mythical biographies, *De Mulieribus Claris* (Concerning Famous Women, 1361-2), the first book in Western literature devoted to the achievements of women – and it also includes the earliest representations of a woman painting her self-portrait. A French version of the book from 1402 includes a beautiful ink-and-colour parchment illustration, *Marcia Painting her Self-Portrait*.

The unknown artist has depicted Marcia – who Boccaccio possibly based on Iaia of Cyzicus – seated at a desk, a convex mirror held in her left hand; her right hand holds a brush, with which she is painting the lips of her self-portrait, as if to stress that Marcia's powers of articulation resided in paint, not spoken words. A small palette, which at first glance looks like a hand mirror, is placed to her right, next to two brushes. The image is rendered in patterns of warm ochres, reds and yellows. This tiny image is, remarkably,

* For the sake of clarity and consistency, after mentioning their full names, I refer to the women artists I focus on by their first names. In Ancient Greece and Rome and then well into the Middle Ages women were often known by one name; from the late Middle Ages until well into the 20th century, every time she married, a woman would take the name of her husband. While not all of the women I discuss married, most of them did and some of them changed their name numerous times. A woman's first name was often the one constant in her life.

a triple portrait: we see Marcia at the easel, represented in her self-portrait and reflected in her mirror. That it was created in 1404, around thirty years or so before Jan van Eyck painted what is considered to be the first self-portrait in oils, makes it even more original.

However, despite the positive focus of Boccaccio's book - he believes, to a certain extent, that women should be allowed to choose the direction of their lives - the historian was obviously unconvinced about the potential of women artists. With staggering pomposity, he opines that 'the art of painting is mostly alien to the feminine mind and cannot be attained without that great intellectual concentration which women, as a rule, are very slow to acquire'.

The City of Women

We can only imagine how this might have made a female reader feel. One told us. Christine de Pizan, who was born around 1364, was a French poet, scholar, philosopher and writer of what today we might call experimental fiction. After the death of her husband in 1390, she became the first woman in Western letters to support herself, her three children and her mother by writing. Her wildly original defence of women's talents and potential, *The Book of the City of Ladies* (1405),* embodies the medieval literary tradition of the 'dream vision', which was popularised by Dante Alighieri in his *Divine Comedy* (c. 1320). Because of the very nature of dreams - absurd, non-linear, fantastical - writers used them as a springboard to explore ideas free from the constraints of convention and logic. *The Book of the City of Ladies* opens with the narrator wondering 'why on earth it was that so many men, both clerks and others,

* She also wrote a sequel: *The Treasure of the City of Ladies*.

have said, and continue to say and write such damning things about women and their ways'. Pondering the question, she slumbers 'sunk in unhappy thoughts', but is startled awake by a beam of light, which reveals itself as three virtuous women, Reason, Rectitude and Justice. They have come to comfort Christine and tell her that 'those who speak ill of women do more harm to themselves than they do to the actual women they slander'. They explain that she has been chosen to construct a walled city, 'to ensure that, in future, all worthy ladies and valiant women are protected from those who attack them. The female sex has been left defenceless for a long time now, like an orchard without a wall, and bereft of a champion to take up arms in order to protect it.'

They propose that only 'ladies who are of good reputation and worthy of praise' will be allowed through the city's gates. After much discussion, they choose around 200 women from history - ironically, many of them possibly sourced from Boccaccio's *Concerning Famous Women* - who will lead by example. They include warriors, nuns, priestesses, saints, scholars, inventors - and artists: Irene, a painter from Ancient Greece whose skills surpassed all others; her compatriot Thamaris whose 'brilliance has not been forgotten', and the aforementioned Marcia the Roman, whose talent 'outstripped all men'. Christine is also vocal in her praise of her contemporary Anastasia, who she describes as 'so good at painting decorative borders and background landscapes for miniatures that there is no craftsman who can match her in the whole of Paris, even though that's where the finest in the world can be found'.

Reason responds drily to Christine that: 'I can well believe it, my dear Christine. Anyone who wanted could cite plentiful examples of exceptional women in the world today: it's simply a matter of looking for them.'

None of Anastasia's work has survived - or if it has, it is not attributed to her.

Their Little Hands, So Tender and So White

Arguably the originator of art history as we know it was the Tuscan painter, architect and biographer Giorgio Vasari. He was responsible for writing the best-known biography of artists, the *Lives of the Most Excellent Painters, Sculptors and Architects*, in 1550; it was added to and re-issued in 1568. Of the 300 or so artists he discusses, the only woman he mentions in the first edition is the Bolognese sculptor Properzia de' Rossi, who was famously so skilful that she sculpted a Crucifixion from a peach stone and carved a hundred heads onto a cherry stone. In the 1568 edition, Vasari mentions thirteen women, including the prolific self-portraitist Sofonisba Anguissola – more on her later – and her sisters, and the self-taught nun Plautilla Nelli. With an air of astonishment, he writes: 'It is an extraordinary thing that in all those arts and all those exercises wherein at any time women have thought fit to play a part in real earnest, they have always become most excellent and famous in no common way, as one might easily demonstrate by an endless number of examples . . .'

Despite acknowledging that 'in no other age, for certain, has it been possible to see this better than in our own, wherein women have won the highest fame', Vasari observes that:

> Nor have they been too proud to set themselves with their little hands, so tender and so white, as if to wrest from us the palm of supremacy, to manual labours, braving the roughness of marble and the unkindly chisels, in order to attain to their desire and thereby win fame; as did, in our own day, Properzia de' Rossi of Bologna, a young woman excellent not only in household matters, like the rest of them, but also in sciences without number, so that all the men, to say nothing of the women, were envious of her.

Vasari also, however, unwittingly pre-empts twentieth-century feminist theories in his understanding of the structural exclusion of women from art. Writing about Sister Plautilla, he declares that she could have created something even more wonderful if she 'had enjoyed, as men do, advantages for studying, devoting herself to drawing, and copying living and natural objects'.

In the following years, other writers followed Vasari's example by attempting to catalogue the best artists of the day. In northern Europe, Karel van Mander's *Schilder-boeck* (Book of Painters) was published in 1604; he mentions a few female artists. In 1718 a three-volume sequel of sorts by the artist and historian Arnold Houbraken, titled *Groote Schouburgh der Nederlantsche konstschilders en schilderessen* (The Great Theatre of Netherlandish Painters and Paintresses), mentions twenty-three women artists, a reflection of this small country's influence on the global stage: it was a leading economic power that had the highest literacy rate in the world, unequalled religious tolerance and certain freedoms for women.

Women artists were mentioned by art historians well into the nineteenth century, though not nearly as often, of course, as male artists. Many of these books and articles were by women: this did not mean, despite their sisterly intentions, that they were automatically much wiser than their male colleagues. In 1859, Elizabeth Ellet's ambitious, yet very misleadingly titled *Women Artists in All Ages and Countries* was published: her idea of 'all countries' only includes those found in the northern hemisphere and she repeatedly falls into the kind of platitudes that reinforce the fallacy that all women have 'tender natures'.

In their ground-breaking book of 1981, *Old Mistresses: Women, Art and Ideology*, the art historians Rozsika Parker and Griselda Pollock observe that something strange happened in the twentieth century: that a focus on the achievements of women artists dwindled just when women were beginning to practise art in far greater

numbers than they ever had before. Their theory is backed up by two of the most popular art-history textbooks of the twentieth century: E.H. Gombrich's *Story of Art* (1961) and H.W. Janson's *History of Art* (1962). In their first editions neither of them mentions a single woman artist. How to explain this? It's hard not to see it as a sign of how threatened men, even unconsciously, have been – and in many cases continue to be – by women finding their voices and expressing something about their place in the world.

Cabinet of Curiosities

Over the past 500 years or so, there are seemingly countless stories of women struggling to be accepted as serious artists in the face of mass exclusion. When, in 1747, the Kunsthistorisches Museum in Vienna acquired the earliest known self-portrait from 1554 by the great Italian artist Sofonisba Anguissola, it was considered so astonishing that a woman should be an artist, that her painting was hung not in the art galleries but in the *Schatzkammer* or *Kunstkammer* – the Cabinet of Curiosities – and this despite the fact that, alongside her role as a lady-in-waiting, she had worked as a painter in the court of Philip II of Spain. According to *Thieme-Becker*, in the sixteenth century alone there were thirty female artists practising in Italy and in the fifteenth century about ninety. Tragically, much, if not most, of their work is now lost. An extreme example of a woman disappearing from the history books is that of the Venetian writer and artist Irene di Spilimbergo, whose gifts, when she died in 1559 at the age of nineteen, were such that she was praised not only by Vasari but by no fewer than 140 poets in around 300 Italian and Latin poems. None of her work has survived, or if it has, it must be hanging in a gallery or a home, assumed to be by someone else – most likely a man. Likewise, no works by Irene's contemporary Lucrezia Quistelli (1541–94) have survived with watertight

attributions. In Holland, the paintings of Judith Leyster, one of the most prolific portrait artists in seventeenth-century Holland, were, soon after her death and until the late nineteenth-century, mostly attributed to her rival Frans Hals. Also in Holland, where the guilds kept organised records of their members, Sara van Baalbargen is listed in 1631 as an oil painter, but no works survive, or at least none are attributed to her, today. In recent years, New York's Metropolitan Museum discovered that a portrait of a young woman drawing, which had long assumed to be by the eighteenth-century painter Jacques-Louis David, was in fact by Marie-Denise Villers (1774–1821). The list goes on.

History is a story told in words: if women aren't mentioned in books, they may as well have never existed. Although there is far more awareness today about history's blind spots, the erasure persists. Only 27 women out of 318 artists are included in the reissue of H.W. Janson's textbook, *History of Art* – a book that has sold more than four million copies in fifteen languages – which, as mentioned earlier, is up from zero. However, Janson himself, who died in 1982, was fully aware that art history is a story ripe for re-writing. In his introduction to the 1962 edition – the one that included no mention of women – he wrote:

> There are no 'plain facts' in the history of art – or in the history of anything else, for that matter, only degrees of plausibility. Every statement, no matter how fully documented, is subject to doubt and remains a 'fact' only so long as nobody questions it. To doubt what has been taken for granted and to find a more plausible interpretation of the evidence, is every scholar's task [. . .] The history of art is too vast a field for anyone to encompass all of it with equal competence.

Despite Janson's admission of fallibility, it rarely seemed to occur

to the art historians of the past that their views might reflect the conventions of their gender, race, class, country and sexuality or that there might be ways of creatively responding to the world that didn't fit into their narrow remit - by women, for example, who hadn't been taught at an academy or who had worked in isolation or for their own pleasure, or who were mothers who made art while their children were sleeping or who were uninterested in modernity. The way art is made is not neat because the human mind isn't; it's limitless in its variations. Art can reflect religious, spiritual and political beliefs, private mythologies, secret obsessions, a fascination with a body or the bodies of others, sexuality, the past or the future. It can be a site of reverie or rebellion; a form of propaganda or an idiosyncratic way of responding to the world: its openness to what it can be is one of its - if not its greatest - sources of power. It can be a response to anything and made anywhere by anyone: it can give permission to the silenced to speak or create a lexicon for the illiterate; it can lend the world shape and make it graspable to those who feel that it is out of reach.

The Fault in Our Stars?

In 1971 the late art historian Linda Nochlin's ground-breaking essay 'Why Have There Been No Great Women Artists?' was published in the American magazine *ARTnews*. In an interview with Maura Reilly she explained that the essay came about after a conversation she had in 1970 with a famous gallerist, Richard Feigen. He told Nochlin that he would love to show women artists but 'couldn't find any good ones'. He then famously asked her: 'Why are there no great women artists?' Her answer analysing the structural exclusion of women artists from the mainstream is worth quoting at length:

... things as they are and as they have been, in the arts as in a hundred other areas, are stultifying, oppressive, and discouraging to all those, women among them, who did not have the good fortune to be born white, preferably middle class and, above all, male. The fault lies not in our stars, our hormones, our menstrual cycles, or our empty internal spaces, but in our institutions and our education - education understood to include everything that happens to us from the moment we enter this world of meaningful symbols, signs, and signals. The miracle is, in fact, that given the overwhelming odds against women, or blacks, that so many of both have managed to achieve so much sheer excellence, in those bailiwicks of white masculine prerogative like science, politics, or the arts.

Linda Nochlin's words are all the more powerful because her argument is grounded in fact. Women's absence from art history is not a theory and it has nothing to do with innate or gendered talent. If a woman - a person - isn't encouraged or allowed to study, if she has no political or financial independence or day-to-day freedoms, how can she possibly compete with a man, who - if he is talented, white and has enough money - has access to pretty much anything he wants?

The restrictions faced by women meant that, generally speaking, they *did* make less art than men - but who could blame them?* Until well into the twentieth century, unless they joined a convent, women were expected to be wives and mothers, not artists or writers; they had no political agency and, unless their father was a painter, they had very little to no access to any kind of artistic training. As it was in men's financial, cultural and, we can assume,

* It is important to clarify here that I'm focusing on women artists in the European tradition: in many Indigenous cultures around the world, women's creativity has been, and continues to be, central to individual and community self-expression.

emotional interests to discourage women to pursue a career - she's no use in the bedroom, kitchen or nursery if she's busy in the studio - for centuries, women were denied access to materials, to study and to the essential space and time every artist needs to nurture their talent. Although women were active in the Middle Ages in crafts and illumination, apart from superstars such as the polymath Hildegard of Bingen, they tend to be anonymous. In the Renaissance, women were forbidden to work on scaffolds, which meant they couldn't be commissioned to make frescoes; public art schools for female students didn't come into existence until the nineteenth century and even if they studied with a private tutor, in the main they were forbidden to work from life models. The fear abounded that once they were allowed into the art schools, who knew where it would end: their demands for equality were understood to be akin to anarchism, socialism, vegetarianism and atheism. But a lack of access wasn't the only thing stopping women from pursuing a career as a painter or a sculptor. No artist works in a vacuum: they push against what has come before, re-inventing their language time and again. Without the financial and critical support of collectors, curators and art historians, and the encouragement that being part of a group of like-minded artists affords, the work of even a great painter or sculptor can disappear into obscurity. More often than not, this has been the case with the work of female artists. Even today, despite the fact that many more women than men graduate from art schools, commercial galleries, on the whole, represent significantly more male than female artists, and museum collections and displays are heavily weighted towards the achievements of men.

Yet, somehow, over the last five centuries countless women rose, often magnificently, to the challenges they faced and many of them became trailblazers. Their exclusion from certain genres meant that they excelled in the ones that welcomed them: botanical and scientific studies, still life and self-portraiture. They might not

be allowed to study a naked man, but a flower, a table arrangement or their own face was another matter. If she had access to a mirror, a palette, an easel and paint, a woman could endlessly reflect on her face, and, by extension, her place in the world.

A Self-Portrait Is Never One Thing

With very few exceptions, and until relatively recently, historians have focused on masculine achievement - not just in art, but in pretty much everything: from politics, exploration, empire-building and warmongering, to literature, music and philosophy. Women, relegated to the hearth, the nursery or the convent, have long been considered inconsequential. Even now, education tends to highlight the stories of white men who excelled in their fields. Given their invisibility, the act of female self-portraiture - a woman declaring that her existence is something worth recording - is one of radical defiance: 'Look at me,' she is saying, 'I exist. I have something to say.'

As psychoanalysis has made so clear, human beings move through life dictated to by a mess of conscious and unconscious memories, acts and feelings. The language of art is a reflection of this: it's one of slippages, ambiguities and contradictions that are communicated via images, which are, by their very nature, indeterminate. (A rose or a dog, for example, might have very specific meanings for a seventeenth-century artist, and very different ones for the person looking at it 200 years later.) Artists are rarely good at explaining precisely what they are trying to communicate - and why should they be, as they've decided to say what they want to say in images? In the midst of creating a painting, shapes, colours and composition can mutate and regroup as the artist moves between intention, intuition and imagination, the filter of memory and the physical world. As such, the meaning of a picture is rarely

singular: often, it's as multi-layered and as mysterious to the artist as it is to the person looking at it. Despite portraiture's relationship to physical reality - how someone looks - this element of mystery is as applicable to a self-portrait as it is to an abstract painting.

A self-portrait can be both idiosyncratic and yet also say something more generally about the human condition - a reflection not only of what someone looks like but who they are and what they think and feel about the world. It can be used to signify the artist's religiosity or irreverence or it can function as a calling card to show off a painter's skills - someone who can accurately render flowers, cloth, skin, eyes, personality and a landscape in one picture is someone worth hiring - or it can be a coded protest, a riddle or an allegory, a form of propaganda or an intensely private form of self-expression that was never meant to be sold or even to be seen by anyone other than the artist. In our contemporary moment, of course, 'selfies' are ubiquitous, but they take but a moment to make - in the past, a single image of yourself could take months to create.

Unless an artist penned a clear statement about what they intended to do in a painting, it's impossible to know exactly what prompted them - all we have to go on are the richly coded visual messages they have sent to us across the centuries. Pictures are made to be looked at but they can never, ultimately, be fully deciphered; this, to my mind, is why we keep returning to them again and again - their riches are infinite.

Despite the very real social and political restrictions the women in the following pages faced, the paintings they have left behind are proof that the imagination can roam across vast distances in space and time - and that, in many ways, they are as profoundly interesting, and often as moving, today as they were in the very different places and times in which they were made.

The title of this book is a blunt summation of some of the objects a woman needed to make a self-portrait. Whatever the constraints

of her private life, if she was able to find some time alone and had access to paint, something to paint on and a mirror to observe herself in, she was at liberty to examine – and to represent – herself. Interestingly, though, women rarely included mirrors in their self-portraits, perhaps because for centuries the sin of vanity was embodied, again and again, by a woman holding one. It's possibly why so many women chose to portray themselves looking out at us: while the artist may have been looking at a mirror to make the painting, once it's completed, we become the mirror's substitute.

I have selected a smallish group of self-portraits as a sampler, in a sense, of the great diversity – across time and geography – of artists whose stories deserve to be told and whose stories, in particular, fascinate me personally. This book is clearly not encyclopaedic: in many ways, it's meandering and personal and the biographical details of many of the women are sketchy. For every artist I discuss, there are countless more hovering in the wings (and occasionally centre stage) whose lives and works also deserve attention. Of course, especially in the twentieth and twenty-first centuries, women created and continue to create self-portraits with a variety of media, in particular photography, but for the purposes of this book, I'm focusing on paintings before the twenty-first century, as the role of the self-portrait in the age of the selfie requires a book of its own.

The artists I have chosen hailed from Australia, England, Finland, France, Germany, India, Italy, Mexico, the Netherlands, New Zealand, Switzerland, Ukraine and the United States; they lived from the sixteenth to the twentieth centuries and their artistic language evolved from European traditions. How did they become artists and what does their self-representation reveal about the times in which those images were produced? Who were their families and how supportive were they? How, when so many of them weren't allowed to enrol in art schools and were either barred or discouraged from joining academies, did they receive training?

What were the different opportunities available to them? How did marriage and motherhood affect their creativity and ambitions or, conversely, how were they treated if they chose not to marry or bear children? Who bought their work and where is it now? Is it on view? This book is not simply intended as a study of a selection of paintings and artists but the story of the societies that produced them.

These women exemplify the bravery, skill and innovation that was required to become a professional artist when the odds were very much stacked against them. It's hard enough to be an artist - but it's infinitely more difficult if you're a woman. Why then, when it was - and is - so difficult to make a living as an artist, did so many women persist? (We can only imagine their mental robustness.) The words that Hélène Bertaux, the founder of the Union des Femmes Peintres et Sculpteurs (Union of Women Painters and Sculptors), uttered in Paris in 1881 are still, in many ways, as relevant today as they were almost 150 years ago: 'The woman artist is an ignored, little understood force, delayed in its rise! A social prejudice of sorts weighs upon her; and yet, every year, the number of women who dedicate themselves to art is swelling with fearsome speed.'

While most of the artists I discuss are known to readers with a specialist interest in art history, only a few of them - such as Frida Kahlo and, more recently, Artemisia Gentileschi - are familiar to the wider public. But one thing unites all of them: their life force. It is hard to resist their tales of rebellion, adventure, revolution, travel and tragedy. These are stories about women who were born either into enormous wealth or terrible poverty; who started out as circus performers, lace-makers or artist's models before picking up a brush; women who, in their journey to become artists, didn't care for the conventional roles that society ascribed to them. They were employed by kings and queens as propagandists or created their masterpieces as acts of political rebellion in order to stimulate

social change; some were central to artistic movements whereas others worked in isolation, indifferent to modernity. They were communists and socialists, monarchists and conservatives; some were uninterested in politics but for others, it was their lifeblood. Some led lives of monogamous, heterosexual virtue, whereas others had numerous sexual partners, irrespective of gender. As to the sexuality of pre-twentieth-century artists, we can only speculate. Many of them had to deal with illness and injury and died tragically young, while others lived to a great age. Despite the fact that they're all women, the differences between these artists - joyfully, to my mind - renders the idea of a singular feminine sensibility obsolete. The one thing that absolutely links them is their shared desire to try to make sense of the world with a paintbrush.

But for now, our story begins in the early sixteenth century with the tale of an apparently demure young woman who, in the quiet of her studio, was to make a very radical statement.

1

Easel

One day in Antwerp in 1548 a young woman painted a modest self-portrait in oil on a small oak panel.

Like a hall of mirrors, her painting is a depiction of herself in the act of painting: her left thumb is hooked through a small palette covered in smudges of paint and she holds five thin brushes. Her right hand rests on a *mahlstick* - a tool which, for centuries, painters have used in order to steady their brush when they work on details. She is pictured forever frozen in the middle of composing an image of a small head within the panel that is balanced on her easel, but she turns to look directly at us; it's as if we've walked into her studio and interrupted her. She is pale and, although she faces us, the expression in her dark eyes is very far away; she's obviously deep in concentration. (It is possible that she is playing a joke on us, treating us as the mirror she is looking at to paint herself.) She seems tired and is very young. The proportions of her body are awkward; it's as if she's still growing. She's narrow and flat-chested, her arms seem a little too long and her large head has a very small chin. Her clothes are unusual for the studio; the conventions of the time would have demanded she wear a smock, but she has paid convention no heed. She is both modest and magnificent: resplendent in a fine, fitted dark brocade dress with decorated red-ochre sleeves and a lace headdress, her neck adorned with a delicate checked red collar.

A self-portrait is not only a description of concrete reality, it's also an expression of an inner world. Paint gives the artist

permission to express something that might not always be acceptable in words. Here, the young woman depicts herself not only as demure and well off but as someone interrupted in the midst of her creative work. That she is painting at all is, of course, unremarkable by today's standards but, in the mid-sixteenth century, it would have been highly unusual. Women were wives, mothers and daughters, peasants, nuns, queens and abbesses. Only very rarely were they artists or writers. That she has depicted herself with the tools of her trade – her easel, her palette, her brushes – is significant. Each one of these objects is more than the sum of its parts: they are symbols of this young artist's resistance to the conventions of her time.

Most artists worked on commission at that time; painting was, of course, a job, and, as such, self-portraiture wasn't as prevalent as it was to become. Self-expression for its own sake is a very modern idea. However, there are precedents. In 1433 in nearby Bruges, Jan van Eyck had painted his majestic *Portrait of a Man (Self Portrait?)*, which is presumed to be the earliest known self-portrait in oil paint. He was one of the first artists to popularise the medium; its slow drying time allowed details to be reworked and layered and resulted in a surface that displayed a rare gloss and subtlety.* Travelling throughout Germany, by 1500 the twenty-nine-year-old Albrecht Dürer had painted his three great, Christ-like self-portraits. Further south, in Venice, Giorgione had portrayed his dreamy, enigmatic self in 1509-10, and in 1545 Tintoretto had followed suit with a haunting head-and-shoulders self-portrait. There are other examples, but they're not always obviously self-portraits: there are numerous paintings in which artists have portrayed themselves as part of a crowd, say. One of the most famous is Michelangelo's self-portrait as the flayed skin of St Bartholomew in his *Last Judgement*

* Earlier artists had, in the main, used tempera: a mix of pigment and binder, usually egg white. It's a difficult medium to correct as it hardens quickly to a soft sheen, like an eggshell.

fresco in the Sistine Chapel in Rome (1536-41) - perhaps the first self-portrait as a caricature. But none are by women. And none depict the artist in the act of painting. An easel was an object that assisted the artist in creating a painting: it had not been considered a subject worthy of a painting itself.

We don't know if this young woman in Antwerp had seen any self-portraits. We don't know if she painted herself in secret. We don't know if she sketched herself before attempting her paint-ing - there were no paper mills in the Netherlands until the late sixteenth century and drawings weren't as common as you might assume - and we don't know where her painting of herself was hung when it was completed. We also don't know if she knew of any other women artists or even how often she had looked at herself: in the early sixteenth century, mirrors were rare and expensive.

The Liberating Looking Glass

Unless you're intent on creating an imaginative world, to paint a self-portrait, in the most literal sense - an image of what you look like - you need to be able see yourself. But seeing yourself isn't a straightforward activity: to look into a mirror can result in as much deceit as understanding. The mirror tells the truth as often as the person looking into it lies - and its invention opened up new ways of looking at, and thinking about and representing, your own face and body.

Mirrors as we know them are a relatively modern invention; until the mid-nineteenth century they were a luxury item. The earliest ones, which were discovered in Çatal Hüyük in Turkey, date from around 6200 BCE and are made from highly polished volcanic glass obsidian: looking into one is like gazing into black water. (This is apt: still, dark water, as the tale of Narcissus looking

at his own reflection in a pool attests to, could be considered the first mirror.) The oldest copper mirrors are from Iran and date from around 4000 BCE; not long after, the Ancient Egyptians began making them too; the Romans crafted mirrors from blown glass with lead backing. By 1000 BCE, mirrors – in various shapes, from different materials, and for different ends – were made throughout the world: by the Etruscans, the Greeks and the Romans, in Siberia, China and Japan. In South America, the Aztecs, Incas, Mayan and Olmec civilisations all used them, for both personal and spiritual use; in many cultures, mirrors were believed to be magical objects that granted access to supernatural knowledge. In Britain's Iron Age – from about 800 BCE to the Roman invasion of AD 49 – mirrors were made from bronze and iron. When glass-blowing was invented in the fourteenth century, hand-held convex mirrors became popular. In 1438, Johannes Gutenberg opened a mirror-making business in Strasbourg; in 1444 he invented the printing press. There's a symbolic connection between the two: both allow access to other dimensions, reflect the world back on itself and stimulate the expansion of knowledge. In a wonderful marriage of the looking glass and the printing press, by 1500 more than 350 European books had titles that referenced mirrors. In France, women of the court began to wear small mirrors attached to their waists by delicate chains, a fashion that was considered by some commentators to be so vain as to be depraved. In the sixteenth century, the island of Murano off Venice, long known for its glassware, became the centre for mirror manufacture. To put the ensuing craze for mirrors in perspective: in the early sixteenth century an elaborate Venetian mirror was more valuable than a painting by one of the giants of the Renaissance, Raphael, and at the end of the seventeenth century, in France, the Countess of Fiesque swapped a piece of land for a mirror. In 1684 the Hall of Mirrors was completed at the Palace of Versailles: it was comprised of more than 300 panes of mirrored glass, so that royalty could see

their glory reflected seemingly to infinity. The Hall's fame spread – and was copied – throughout Europe.

The first known oil painting featuring a mirror – and arguably the most famous – is Jan van Eyck's *Arnolfini Portrait* from 1434, which now hangs in London's National Gallery. (It's also the first portrait of people in a domestic setting.) It features a convex mirror in which you can see tiny reflections of the entire room, the backs of the couple who occupy it and two small figures standing in the doorway: quite possibly one of them is a minuscule portrait of the artist.

Leonardo da Vinci was, it's fair to say, obsessed with mirrors, both as objects and metaphors. He advised that 'the mind of the painter should be like a mirror which always takes the colour of the thing it reflects and which is filled by as many images as there are things placed before it'.

One of the greatest self-portraitists, Dürer, confessed that his paintings were 'made out of a mirror'. Vasari distinguishes between self-portraits painted 'alla sphera' (with a convex mirror about the size of a saucer) and 'allo specchio' (either flat or convex but more likely to be made from metal). It's fair to say that developments in mirror-making were directly reflected in developments in picture-making.

But still, despite their popularity, for centuries mirrors were difficult to make, poisonous (due to the mercury) and expensive. It wasn't until 1835 that a German chemist named Justus von Liebig invented a process that allowed, for the first time, mirrors to be mass-produced.

What is rarely mentioned in cultural histories of the mirror is how liberating their invention was for female painters. It meant that, for the first time, their exclusion from the life class didn't stop them painting figures. Now, with the aid of a looking glass, they had a willing model, and one who was available around the clock: themselves.

*

The young artist in Antwerp pictures herself illuminated in the midst of darkness. She has zoomed in on the upper half of her body; the painting itself, at only 31 x 25 cm, is not much bigger than a book. Despite the diffuse atmosphere, the tools of her trade surround her – they seem, in this faraway scene, reassuringly solid. Her easel is sturdy and steady, like a buffer between her and the world beyond; she holds her palette and a fistful of brushes as tightly as you might hold a dagger in a dark wood. In case anyone looking at the painting should be in any doubt as to who she is or what her intentions might be, she carefully inscribed some small words in Latin on its surface. Translated they read: 'I Caterina van Hemessen have painted myself / 1548 / Here aged 20.'

To our twenty-first-century eyes, this small self-portrait could be dismissed as a charming, slightly clumsy curio, a dusty offering painted at a time when few women were professional artists. However, despite appearances, it is a radical and ground-breaking work of art: it's widely considered to be the earliest surviving self-portrait of an artist of any gender seated at an easel – and Catharina is the first female Flemish painter whose work we know of. (As her own spelling of her name is inconsistent,* and as museums list her as 'Catharina', I'll stick with that.) What perhaps makes it even more extraordinary is that this young artist wasn't satisfied with just one self-portrait: like a twentieth-century conceptualist, she made two other versions of the painting in the same year. At a time when the contributions of women were rendered invisible, Catharina stubbornly painted herself again and again.

We have no idea if she knew how radical her self-portrait was. Writing at a distance of almost 500 years, at a time when millions

* She signed a later painting, *Portrait of a Lady* (1551), as 'Catarina'. Although Holland had the highest literacy rates in Europe at the time, women – even those from affluent households – were often taught reading and writing only to the most rudimentary level.

of images of young women proliferate daily, it is near impossible to imagine a time when a particular image or pose had never been seen before. The art historian Frances Borzello suggests: 'If it is true that this is the first portrait of an artist at work, it could be because she came from the northern tradition which specialized in depictions of St Luke painting the Virgin, and she had the wit to adapt this example of a working artist for herself.'

It's possible, of course - but ultimately, we can never know what inspired this self-portrait. It can be read on many levels: as a reference to art-historical iconography (St Luke), a celebration of skill and social standing (her fancy clothes), and a declaration of independence by a woman who would normally be defined through her father, husband or children. I like to think of it as a form of protest: 'I am a woman working,' she seems to be saying, 'and you can't stop me.'

What we know of Catharina's life is scarce. She is mentioned in passing by two sixteenth-century Italian art historians: Lodovico Guicciardini in his *Descrittione di tutti i Paesi Bassi, altrimenti detti Germania inferior* (Description of the Low Countries) of 1567, and a year later, by Vasari in his *Vite* (Lives) of 1568. As we don't know when Catharina died, it's unclear if she knew about her inclusion in these important books. At a time when females weren't allowed to study anatomy or to be apprenticed - gruelling training which often began as young as nine years old - like so many pre-twentieth-century women who managed to become professional painters, Catharina came from an artistic milieu. As we will see, this was not uncommon. Most of the women who worked as engravers, painters, sculptors and embroiderers from the Middle Ages onwards were the wives or daughters of artists - this was the only way they had access to a studio. Other daughters of artists who became respected painters themselves include Rose Adélaïde Ducreux (1761-1802), a composer and artist whose father was Joseph Ducreux; Barbara Longhi (1552-1638), the daughter of Luca

Longhi; Marietta Robusti (c. 1560-90), who dressed as a boy and was Tintoretto's favourite child; Antonia (1456-91), the daughter of Paolo Uccello who became an artist nun; and Justina (1641-c. 1690), Anthony van Dyck's only daughter. Many of their creations have been lost, destroyed or misattributed. The talent of some of these artists - such as Rosa Bonheur, Artemisia Gentileschi, Angelica Kauffman, Elisabetta Sirani and Elisabeth Vigée Le Brun - ended up eclipsing, often by some distance, that of their fathers.

Born in 1528 in Antwerp, in the Habsburg Netherlands (now Belgium), Catharina's father was the renowned painter, Jan Sanders van Hemessen (c. 1500-66). Her mother, Barbara de Fevre, died when Catharina was still young. She had a sister, Christina, who was possibly a musician - a painting by Catharina from 1548 of a young woman playing a spinet could be a portrait of her - and a much younger illegitimate half-brother, Augustus, who also became a painter, though little is known of his work now.

In the first half of the sixteenth century, Antwerp - under the rule of the Holy Roman Emperor Charles V of Spain - was the richest city in Europe and the centre of foreign trading houses and banks. The world's first stock exchange was built there in 1531. When banks boom, art blooms; Antwerp was cosmopolitan, its politics relatively tolerant and patrons were plentiful. As the city had, thanks to its thriving economy, only recently attracted important artists, it had no dominant pictorial tradition. This wasn't a setback - quite the opposite, in fact. Such a lack of tradition allowed for a greater sense of freedom and experimentation than might have been tolerated in a city with a more illustrious past to live up to.

Catharina was trained in her father's studio, accepted as a professional painter into the Guild of St Luke - one of the rare instances of a sixteenth-century institution accepting women - and had three students. She married Christian de Morien, an organist

who worked at Antwerp Cathedral and early on found a supporter in Mary of Hungary, Regent of the Low Countries and sister of Charles V. When Mary returned to her home in Castille, Spain, in 1556, she invited Catharina and her husband to accompany her to the court of her nephew Philip II of Spain. It's more than likely that she worked as an artist during her time in Spain, but only eleven small portraits and two religious paintings are attributed to her: a fire at the court possibly destroyed some of her work and it's probable that other works by her are misattributed. When Mary died in 1558, she bequeathed the young artist a generous pension for life. Catharina and her husband moved back to Antwerp and then to 's-Hertogenbosch, where Christian had work. But after 1561, the trail goes cold. It is not known when Catharina died – her death is usually listed as 'after 1587' – or if she had children, although becoming a mother may well be the reason her career stopped so abruptly.

The latest date for a surviving work attributed to Catharina is the exquisite *Portrait of a Young Lady* (c. 1560). In the twelve years that had passed since she painted herself at the easel, it is evident that Catharina had worked hard at her craft: as in her self-portrait, this elegant young woman, her identity unknown, gazes intently out at us from a monochrome background, but now all sense of timidity or clumsiness has vanished. She is dressed in extraordinarily elaborate clothes: sleeves of puffed black velvet and crisp white linen, embellished with blue ribbon, her collar lined with lace, gold buttons down the middle of her bodice, a heavy gold chain around her neck and waist, and a slim gold cap on her demure hair. She has a tiny waist and her hands are strangely large and soft, but her face is rendered with an austere, crystal-clear realism that gives the painting its power. Her steady, faintly melancholy gaze, so full of resolve and character, tells us that she is, despite the tight formality of her costume, very much her own person – a time traveller from more than four centuries ago who feels radically contemporary.

Although Catharina's life was unusual for the time, she wasn't entirely alone in her choice of career. Quite a few Flemish female artists were active in the sixteenth and seventeenth centuries yet, as is the case with Catharina, very little of their work survives - or, if it does, has possibly been attributed to other (male) artists. For example, the prolific Bruges-born Levina Teerlinc (c. 1510-76) was the only female court miniature painter in the Tudor Court under four monarchs - Henry VIII, Edward VI, Mary I and Elizabeth I - and yet, as she rarely signed her paintings, very few works are now attributed to her. One of the few Flemish women artists of the time whose work is clearly attributed is the aristocratic history painter Mechtelt van Lichtenberg toe Boecop (c. 1520-98), whose *Pieta* from 1546 is in the Centraal Museum in Utrecht. It is tempting to think that Catharina signed her youthful self-portrait all those centuries ago because she had a premonition that if she didn't, then her name might disappear - like so many women before and after her - from the history books. If only she had continued to do so, we might be aware of many more of her paintings.

The Equal of the Muses and Apelles

We do not know to what extent the woman artists of the past knew about each other. Did Catharina ever hear about another trailblazing painter, only four years her junior, who was working hard at her craft in Cremona in Italy? Her trajectory was to echo, in some ways, Catharina's - she too worked at the Spanish court - but there the story changes: the spirited and adventurous Sofonisba Anguissola was the most prolific self-portraitist between Dürer and Rembrandt and one of the most famous European artists - of either sex - of the late sixteenth and early seventeenth centuries. Almost as soon as she died, however, she disappeared from view. She too pictured herself at the easel: but she gave the subject a twist.

Sofonisba Anguissola was born in Cremona around 1531 (the precise year is unknown) into an aristocratic, but not particularly wealthy, family from Piacenza. She was the eldest of six sisters and a brother; her father and mother, Amilcare and Bianca, encouraged their children in the arts. This was not unusual for noble families: in his popular *Book of the Courtier* (1528) - a handbook for etiquette and behaviour - the courtier, diplomat, poet, scholar and soldier, Baldassare Castiglione, describes what was expected of a lady at court: 'I want this lady to be knowledgeable about literature and painting, to know how to dance and play games, adding a discreet modesty and the ability to give a good impression of herself.'

While first impressions might be favourable - young women are encouraged to learn - Castiglione's book makes clear that such talents are attractive not because they give the woman pleasure, but because they please the men around her.

It's a sign of her family's support that, extremely unusually for the time, Sofonisba's gender was not seen as a barrier to talent or success. When she was eleven, she was sent, along with her sister Elena (who later became a nun) to be apprenticed to the artist Bernardino Campi for three years. It was rare for two young girls to be placed in a household to which they had no blood relations, and for an artist to accept female pupils. In 1549 she studied again, this time with the minor fresco painter, Bernardino Gatti. Three of Sofonisba's siblings, Minerva, Europa and Lucia, also became artists, because Sofonisba taught them, and then they in turn taught their youngest sister, Anna Maria. Alongside Sofonisba, only Lucia was to achieve a modest success, but she died before she was thirty. Vasari wrote that 'dying, [she] had left of herself not less fame than that of Sofonisba, through several paintings by her own hand, not less beautiful and valuable than those by the sister'.

As a woman, Sofonisba was barred from the life studio, a restriction she side-stepped by using herself and her family as subjects. Her most famous painting, *The Chess Game* (1555), is a wonderfully

vivid and affectionate portrayal of her sisters, accompanied by their maid, Giovanna, playing chess - a game considered to be both intellectual and strategic, attributes not often associated with women at the time. Bejewelled in gold and pearls and dressed in costumes more extravagant than the girls would normally have worn to play in a garden, it's clear Sofonisba wanted to honour her sisters' beauty and lively personalities, while demonstrating her own dazzling gifts. Perhaps she was also aware of how ground-breaking her homage was: she was the first artist to portray her family as a primary subject. Her younger sister, Europa, smiles broadly at Minerva to her left - in itself a radical gesture, as such levity was not considered decorous. Minerva is seen in profile, but her right hand is raised, as if in mock surrender to her superior opponent. To Europa's right, Lucia, the older sister, looks directly out at us, faintly smiling; her right hand moves a chess piece, while her left holds a captured queen. The five hands we can see in the painting are all active: holding, moving, raising, touching. It's a rare, playful image of girls employing their wits against each other and having fun. The scene is set in a garden to a backdrop of a misty, mountainous landscape. As the landscape around Cremona is flat, we can only assume that Sofonisba was dreaming of future journeys to distant lands.

Vasari wrote of *The Chess Game* that it was 'executed so well that they appear to be breathing and absolutely alive'. His emphasis on the vivacity of the characters in the portrait is poignant. By the time he saw Sofonisba's homage to her sisters, Minerva and Lucia had both died.

Not yet out of her twenties, Sofonisba's fame was growing. At least twelve of her self-portraits survive and there are records of seven more. Her father Amilcare was so active in selling his gifted daughter's work that he is considered to be one of the first dealers in self-portraits. In 1554 he wrote to Michelangelo, who was then working in Rome, asking him to mentor his precocious daughter.

He included with his letter a sketch of a laughing girl. Michelangelo replied with a challenge: he would like to see her draw a crying boy, which to his mind was a more difficult task. In response, Sofonisba sent the famous artist a virtuoso drawing in black chalk on brown paper of her brother, who she had 'deliberately made cry' in order to sketch him. The little boy is comforted by his lively young sister, who is gently smiling. It's a drawing full of life, affection, nuance; the children's noisy, playful personalities leap from the page. *Asdrubale Bitten by a Crayfish* (c. 1554) apparently influenced Caravaggio's famous painting *Boy Bitten by a Lizard* of 1593.

Michelangelo was so impressed with Sofonisba's talent that, around 1554, she undertook the three-week journey to Rome from Cremona, where it is possible that the seventy-nine-year-old master informally taught the nineteen-year-old artist. On 7 May 1557, Amilcare wrote to Michelangelo thanking him for the 'honourable and thoughtful affection that you have shown to Sofonisba, my daughter, to whom you introduced to practise the most honourable art of painting'.

The Renaissance was a time when it was considered so unusual for a woman to excel at art that if she showed any talent whatsoever, she was praised as an aberration, a 'miracle', as Vasari famously observed. He rhetorically asked that if women 'know so well how to make living men, what marvel is it that those who wish are also so well able to make them in painting?' That Sofonisba never had children must, surely, have been cause for an extra level of astonishment: what was a woman if not a mother?

Despite the talented women artists who incontrovertibly flourished during the Renaissance, most aristocratic girls usually only had two options: marriage or the convent, something that was decided for them by the time they were in their mid-teens. But whichever route was chosen, a dowry would need to be paid – and the Anguissola family's financial state was precarious. It's

not beyond the realms of possibility that the encouragement of Sofonisba's father stemmed not only from pride in the skills of his daughters but from necessity: if their paintings could be sold, the family would prosper. The idea that a daughter could bring money in was highly unconventional: women at the time very rarely worked. Aristocratic women didn't even breastfeed as it was considered taxing and demeaning.

But by all accounts Sofonisba was not someone to be held back by anyone. In 1556 she painted a self-portrait at the easel. Although we don't know if the young artist was familiar with the work of Catharina van Hemessen or her painting of eight years earlier, the similarities between the two youthful self-portraits are startling: both women picture themselves softly illuminated in the darkness, as if nothing on earth could distract them from their art. Both appear interrupted in the midst of painting and are dressed demurely with small flashes of decoration, but neither is wearing jewellery. This lack of adornment is particularly noticeable on Sofonisba, who as a noblewoman would normally have worn, at the very least, a necklace and earrings. Perhaps she didn't want anything to distract from the focus of the painting: as an image of herself as an artist, not as a temptress, she is emphasising her intellectual, not her physical, properties. Both artists hold a *mahlstick*, something that Sofonisba omitted in later self-portraits, possibly out of vanity (she was too good to need any help). The palette rests on the easel, its blobs of paint the only sign of disarray; the red, especially, animates the composition like a drop of blood. Sofonisba, however, goes one step further than Catharina in her inscription, with words that counter the restraint of her demeanour:

> I, Sofonisba Anguissola, unmarried, am the equal of the Muses and Apelles in playing my songs and handling my paints.

Apelles was a renowned painter from Ancient Greece, who was

praised by the classical historian Pliny the Elder and cited by Vasari as a standard-bearer; the Muses, of course, were the nine Greek goddesses who personified literature, music, art and science. That a young woman in Italy, during a period when women had few freedoms, could claim herself as the equal of the ancient gods is a clear indication of Sofonisba's confidence in her talents. The fact that she is dressed in black - a colour which, at the time, was worn mainly by men - could also be read as a signal of the seriousness with which she took herself as an artist and her refusal to be defined by her gender.

Whereas the subject that Catharina pictures herself painting is vague - the beginnings of a head, most likely a virgin - the focus of Sofonisba's self-portrait is clear: she depicts herself working on a particularly tender portrait of a Madonna and Child. Mary's pose is youthful, human; she leans down, her face full of love and good humour, to embrace Jesus, whose face is upturned to his mother as if to be kissed. This painting within a painting is both a virtuoso turn and a clear statement of the artist's religiosity and chastity, something that was essential for female artists to emphasise at the time. Despite some important woman patrons - such as Catherine de' Medici, Queen of France (1519-89), who commissioned architecture as well as art, along with her rival, her husband's mistress Diane de Poitiers (1499-1566), and Isabella d'Este, Marchioness of Mantua (1474-1539) - men were central to the success or failure of an artist's career and they needed to be assured of the blameless character and decorous nature of the woman who was partaking in this radical activity for her sex: that of being an artist. Women who were serious about becoming professional artists often signified their chastity by painting - and depicting themselves painting - religious subjects.

In 1556, Sofonisba was to create her smallest painting - and one of the most mysterious works of the Renaissance: a tiny (8 x 6 cm) medallion self-portrait in varnished watercolour on parchment on

cardboard. The artist portrays herself in all her youthful modesty: wide-eyed, she looks out at us with an unnervingly direct gaze. She is unadorned, seen from the waist up, her golden hair tightly pulled back, a demure white collar against a black robe and a soft, dark green background. Yet any sense of restraint is undermined by the sheer strangeness of what the young artist holds in front of her: a large medallion emblazoned with a mysterious monogram of intertwined letters that covers most of her body. According to the art historian Patrizia Costa, it's a code that both expresses and hides a message: its meaning is accessible only to those who are clever enough - or intimate with the artist herself - to decipher. Interpretations still vary as to the monogram's meaning: it could be an anagram of her father's name, a reference to Michelangelo, either Sofonisba's sister Minerva or Minerva, the patroness of artistry and learning, or a Latin phrase that asserts the young artist's nobility. We may never know for sure. The Latin inscription around the edge of the medallion translates as: 'The maiden Sofonisba Anguissola, depicted by her own hand, from a mirror, at Cremona.' It's a wonderfully restrained statement for such a mischievous picture.

In 1558, Sofonisba travelled to Milan, where - possibly thanks to an introduction from Michelangelo - she met and painted the Grand Duke of Alba, the Spanish aristocrat and advisor to Philip II, king of Spain, the most powerful ruler in Europe. Around the time of Sofonisba's birth the Duchy of Milan, which governed Cremona, had become part of the Spanish Empire and her family had close connections to the Spanish court. Along with fourteen Spanish and five French women, she was invited to become a lady-in-waiting and painting instructor to the fourteen-year-old Isabel de Valois, the daughter of Henry II of France and Catherine de' Medici, who was about to become Philip II's third wife. In the 1568 edition of his *Lives*, Vasari writes effusively about this encounter, declaring that Sofonisba 'has laboured at the difficulties of design with greater study and better grace than any other woman of our

time'. We get an indication of her fame from a letter that the renowned poet and translator, Annibale Caro, wrote to Amilcare, thanking him for his hospitality and for the honour of meeting his daughters. He was happy to accept the offer of buying one of Sofonisba's self-portraits: 'Nothing do I desire more than the effigy of Sofonisba herself, so that I can simultaneously show two marvels together, the work and the artist.' However, the painting was returned after seven months, as Amilcare never received payment.

One of Sofonisba's more audacious paintings around this time is *Bernardino Campi Painting Sofonisba Anguissola* (c. 1559). A remarkably inventive combination of portrait and self-portrait, the young artist pictures her teacher in front of an easel painting her portrait, although there is no record of him ever doing so. That Sofonisba painted herself looming over her teacher is telling: a sly joke that mixes faux reverence with bold ambition. Ostensibly she is acknowledging her debt to Campi - he is pictured in the act of creating her - but curiously, the picture was made almost a decade after she had stopped working with him. By the time she had painted it, he had long ago moved to northern Italy and so she must have rendered his likeness from memory and possibly from other portraits. Despite the assumption that the painting is a homage, Sofonisba makes very clear that she doesn't need anyone to paint her picture as she can do it perfectly well herself. It has been suggested that the depiction of her teacher with a *mahlstick* is a dig at his mediocrity: a virtuoso painter would have no need of such a prop. Whereas Catharina had painted herself at the easel, Sofonisba literally inserted herself into the easel: its wooden structure is so close to her that it's like an extension of her body.

What happened to Sofonisba's wonderful riddle of a self-portrait after her death is symptomatic of the fate of so many paintings by Renaissance women artists. Despite her immense fame during her

lifetime, Sofonisba only signed around ten of her paintings.* If only she had been consistent. When *Bernardino Campi Painting Sofonisba Anguissola* came into the collection of the Pinacoteca Nazionale in Siena in 1864, it was variously attributed to Paolo Veronese, Jacopo Tintoretto and Bernardino Campi himself. It was only thanks to the scholarship of the nineteenth-century art historian Giovanni Morelli who identified the painting's subject, and the artist as Sofonisba, that it now hangs with its correct attribution. But without a signature, debates will always rage: recently, the art historian Michael W. Cole wrote about the dizzying inconsistencies in records of Sofonisba's work; he even doubts her authorship of the Campi portrait, questioning, among other things, why she would paint her teacher ten years after leaving his workshop. This also goes the other way: because she was painting in a style that was popular at the court, some scholars are convinced that one or two unsigned paintings attributed to El Greco and the Spanish court painter Alonso Sánchez Coello are, in fact, by Sofonisba.

But this is all in the future. In 1559, at the age of twenty-six, Sofonisba travelled to Spain where she 'drew a handsome salary'. (Her father must have been pleased, as he was paid 800 lire by the Spanish king for his daughter's work.) We get a glimpse of her high spirits and audacious manners by contemporary reports of her opening the dancing at Isabel de Valois's marriage to Philip II. Sofonisba became close to the queen and her two daughters and was to stay in Madrid for fourteen years during which time she created numerous portraits of the Spanish royal family and nobility and what are most likely five self-portraits. As well as her skills on the dance floor, she was apparently a popular courtesan, attributes that could only help in the male-dominated craft of painting.

* Sofonisba rarely signed her paintings and when she did so, she often added 'Virgo' - virgin or maiden - to her name: as a female painter, for the sake of her reputation, she had to reiterate her chastity.

It's tempting to think of Catharina van Hemessen and Sofonisba meeting, although it's unlikely: the Flemish artist had left Spain the year before the Italian arrived. Given the relative rarity of female painters working at court, we can assume that the young Sofonisba must have heard of Catharina, but no records of an encounter exist.

In 1568 the young Queen Isabel died giving premature birth; she was only twenty-three. Sofonisba was devastated; in a letter dated 4 October 1568, a fellow courtier Bernardo Maschi writes: 'Lady Sofonisba says she no longer wants to live.'

Around 1570, the Spanish king arranged for Sofonisba - who, in her late thirties, would have been considered scandalously unmarried - to wed a Sicilian nobleman, Fabrizio Moncada. (Interestingly, only two of Sofonisba's five sisters were to marry, a very unusual state of affairs for the time.) Moncada was apparently supportive of his wife's talents. With a generous dowry and an annual provision from the Spanish king, the couple moved to Paternò in Sicily. After five years of married (and childless) life, Moncada was travelling to Spain when the ship he was sailing in was attacked by pirates off the coast of Capri and he was drowned. (The events surrounding his death are often referred to as 'mysterious circumstances'.) Two years later, travelling to Cremona by sea, Sofonisba met and fell in love with the ship's Sicilian captain, Orazio Lomellino, who was ten years her junior and considered socially beneath her. Without asking permission from her brother Asdrubale, who was now the head of the family and her legal guardian, or the approval of Philip II, they married in Pisa. They moved to Genoa, where they lived for three decades and Sofonisba became the leading portraitist of the city and then, around 1615, they moved to Palermo in Sicily. Sofonisba painted her final, unflinching, self-portrait in 1620, at the age of eighty-five.

Sofonisba was famous throughout Europe; she was also an inspiration to other women with creative ambitions. Apparently Irene di Spilimbergo (1541-59) and Lavinia Fontana (1552-1614)

reportedly 'set [their] hearts on how to paint' after seeing one of Sofonisba's portraits. Lavinia, a Bolognese artist and the daughter of the renowned Mannerist painter Prospero Fontana, was to excel: she became the first woman to run a professional studio and the first woman to depict mythological subjects – including nudes.

Artists travelled from afar to meet and learn from Sofonisba. In 1624 the twenty-five-year-old Flemish painter Anthony van Dyck was invited to Sicily to paint the Spanish viceroy, Emanuel Filiberto of Savoy. (At the time, Spain ruled most of the territories below Rome.) Soon after the artist's arrival, the island experienced an outbreak of the plague; with no one allowed to leave or enter, Van Dyck was forced to stay for eighteen months in the island's capital, Palermo.

On 12 July 1624 he visited Sofonisba, now eighty-nine – although Van Dyck records her age as ninety-six – at the Lomellini Palace in Palermo, to paint her portrait. It's worth quoting at length how he captured the encounter in his sketchbook, as it gives such a vivid portrait of the older artist: interestingly, it was the only meeting he wrote at length about. He observes that she still has:

> ... a very sharp memory and mind, being most courteous and although she was lacking in good eyesight because of her old age, she nonetheless found pleasure in placing the paintings in front of her and, with great effort, placing her nose close against the painting, she was able to make out a little of it and took great pleasure that way. In making her portrait, she gave me several pieces of advice: not to raise the light too high, so that the shadows in the wrinkles of old age would not grow too large, and many other good suggestions, and moreover, she recounted the part of her life in which she was recognised as a miraculous painter from life, and the greatest torment she had known was not being able to paint anymore, because of her failing eyesight. Her hand was still steady, without any trembling.

Van Dyck's portrait of Sofonisba shows a steely old woman with fierce, hooded eyes and a resolute gaze. She is dressed demurely in black, with a crisp white ruffle; her head is covered with a white linen veil. As in her early self-portrait, she is surrounded by a dark background: she alone illuminates the void.

The painting is now in the National Trust collection at Knole, Kent. On their website is a brief line of description: 'This portrait closely resembles the pen drawing, dated 12 July 1624 in Van Dyck's Italian Sketchbook (British Museum) of the Italian artist Sophonisba [sic] Anguissola at the age of 96. Previously it was known as Catherine Fitzgerald, Countess of Desmond (d. 1636).' Despite the fame Sofonisba had experienced in her lifetime, after her death even her own face was, for a time, misattributed.

Sofonisba died in Palermo in 1625. Her husband inscribed her tomb with the words: 'To Sofonisba, my wife, who is recorded among the illustrious women of the world, outstanding in portraying the images of men.' It is widely quoted that Van Dyck said of his meeting with Sofonisba that he had 'received more wise advice from the words of a blind woman than from the works of well-known painters'.*

* Did Van Dyck's admiration of Sofonisba clear even a narrow path for other women to become accepted as artists? It's hard to tell, but he was enormously popular, and his opinion must have held sway. In 1632 he was invited to London by King Charles I of England to become his principal court painter. Van Dyck was astonishingly prolific; in under ten years he had painted more than forty portraits of the king and thirty of his queen, as well as numerous other works. He changed the course of English painting by portraying the world with a greater naturalism and vivacity than had ever been seen before in the country. He was granted a knighthood and when he died at the age of only forty-two, eight years before the execution of his patron, Charles I, he was buried in St Paul's Cathedral.

How to Paint an Apricot

Between 1642 and 1651 more than 100,000 people, out of a population of only five million, lost their lives in the English Civil War. In 1649 the king was executed and when the blade fell, the regular order of things was upturned forever. Horror aside, it was a time ripe for change. Traditional ideas were, if not quite up for grabs, at least wobbling on their foundations. In the midst of carnage, it must have become clear to many that the accepted ways of the world weren't necessarily the right ones.

Perhaps this is why Mary Beale, who was born eight years after Sofonisba died, gave herself permission to become one of the first women to work as a professional artist in Britain - and the first woman we know of who wrote about art.

In seventeenth-century England women were vocal and, despite their lack of voting power, political. In 1642 a group of women petitioned parliament about the economic effects of the Civil War; in 1643 they organised a peace march in London which resulted in some participants being beaten, arrested and killed. With the men off fighting, women were given responsibilities undreamed of in peace time: they ran estates and businesses and, in some cases, physically defended their property. King Charles I's execution was a brutal challenge to the divine right of kings, which inevitably meant that assumptions about equality or a lack thereof - not just between rich and poor but between women and men - were ripe for reform.

What was Mary Beale's childhood like? Did she know of any women who painted seriously? It wasn't what a girl did. It wasn't what a girl should aspire to. Yet, she persisted.

On 26 March 1633, Mary Craddock, who as Mary Beale would become one of the first professional female painters in Britain, was

born in Barrow, Suffolk. Her family was Puritan: her father, John Craddock, was a rector and amateur painter; we don't know much about her mother, Dorothy: she died when Mary was ten. Again and again, it is the father's interest in art that opens doors for the daughters.

In 1651, at the end of the English Civil War, Mary married Charles Beale, a cloth and paint merchant and amateur artist who had wooed her with a poem addressed to the 'Quintessence of all Goodness'. He described Mary's beauty as 'best arts Master Peece / More worth then Jasons Golden ffleece'. They had a son, Bartholomew, who died in infancy, and then two more, (another) Bartholomew and Charles. In 1655 the family moved to London's Covent Garden where Mary worked at her painting; she and her husband became part of a lively group of artists and intellectuals. Mary became friends with, and was possibly taught by, the Dutch painter Peter Lely (1618-80), who had bought paint from Charles and was happy to lend his paintings to Mary in order to copy - and learn from. Lely was one of the most fashionable artists of the time. When the monarchy was restored in 1660, he was appointed Principal Painter to King Charles II.

Although female artists in seventeenth-century England were extremely rare, Mary wasn't entirely alone. In the sixteenth century, the Flemish-born miniaturist Susanna Horenbout (1503-1554) - daughter of the artist Gerard Horenbout - was praised by Vasari, became a court painter to Henry VIII, and is considered to be the first woman to work professionally as an artist in England. (Famously, Albrecht Dürer bought her illumination *The Saviour* in 1521, writing in his journal: 'It is very wonderful that a woman's picture should be so good.') In terms of home-grown talent, the portrait painter Joan Carlile (c. 1606-79), about twenty-seven years older than Beale, is widely considered to be the first professional female artist to be born in Britain, although only ten of her paintings have survived. Did Joan Carlile ever meet Mary Beale? We

don't know, although given how few women were practising as artists at the time, and how close they lived to one another, it's hard not to imagine that she did. Joan's home and studio was in Covent Garden (at the time, the epicentre of London's artistic community) for two years from 1654 – Mary moved there in 1655 – and then again from 1665 in the parish of St Martin-in-the-Fields.

Although Mary worked hard at her painting from a young age, she didn't earn anything from it until she was thirty-seven, in 1670. However, her talent was recognised early on. Twelve years before she became a professional artist, she was mentioned by the historian Sir William Sanderson in his book *Graphice: the use of the Pen and Pensil or The Most Excellent Art of Painting* as one of four women working as artists at the time: 'in Oyl Colours we have a virtuous example in that worthy Artist Mrs. Carlile: and of others Mr[s]. Beale, Mrs. Brooman, and to Mrs. Weimes'. Who Mrs Brooman and Mrs Weimes were, however, we don't know. There are no other mentions of their lives or work – just a tantalising hint that they existed.

One of the reasons we know so much about Mary Beale is because she was a writer as well as a painter. On 14 August 1663 she penned around 250 words on how best to paint apricots. Titled *Observations by MB*, it is the first known piece of writing about art by a woman and one of the earliest pieces of writing about art techniques to be published in English. It's so full of technical advice that we can assume it was either to instruct her two sons, both of whom were to become artists (although one retrained as a doctor), or her students: Mary taught a group of young women, one of whom, Sarah Hoadley, became a professional portrait painter herself. Her advice:

> Bury oker is by no means to bee left out in y painting of apricots, because it adds a naturallnes to y complexion of y fruite, and makes y rest of y Color worke abundantly better. Those apricots I painted

before I made use of Bury oker were muche harsher colored & nothing so soft . . .

By 1665 the family had fallen on hard times - Charles had lost his job at the Patents Office and the Great Plague was decimating London's population - and so they moved to Hampshire. For the next five years Mary Beale painted in a studio in their home. Their marriage was obviously a happy one; the mere fact of a woman not only being allowed but encouraged to paint was a testament to her husband's support.

In 1667, Mary wrote a *Discourse on Friendship*, which she dedicated to her friend Elizabeth Tillotson. Very unusually for the time, in the text, Mary argues for 'equal dignity and honour' with her husband, along with more predictable avowals of piety. Friendship, she writes, is hard work and can only be fully experienced by those who 'strive against and restrain' their 'owne imperfections'. She makes clear that support and encouragement were at the heart of any real relationship, something which was easy to perform 'in a quiet sea' but not in 'tempestuous storms'. It's advice that's not out of place today.

The family returned to London in 1670 and opened a studio in St James. Mary's husband worked as her assistant. He mixed her paints, prepared canvases, kept her accounts and ran the household. Thanks to the thirty notebooks he wrote about the daily life of the studio, we have a glimpse into Mary's busy working life. Charles was also something of a scientist: from the age of sixteen he had kept a notebook titled *Experimental Secrets found out in the way of Painting* (c. 1647-1663). In it, he investigates the possibilities of accelerating the drying rate of oil paint, which at the time was very slow, and describes his experiments in creating the best pigments: for example, on 22 July 1659 he boils cochineal beetles and then mixes the ensuing liquid with 'Spanish Cakes' (chalk and alum) to see what might transpire. His experiments

eventually resulted in a successful paint-selling business. Mary's sons helped out with the studio, preparing and underpainting her canvases.

The Beales' circle of friends and patrons included aristocrats and clergymen, lawyers, artists and writers. For her business to succeed, however, it was essential for Mary to be known as a woman of blameless character: this she had achieved not only through her status as a wife and mother, but by a written testament. In 1667 the painter Samuel Woodforde – who had married Charles's cousin – published his *Paraphrase upon the Psalms of David*. In it, he somewhat mysteriously declared that four versions of the Psalms were by 'M.M.B.'. In his preface he revealed the identity of the mystery writer as: 'that absolutely compleat Gentlewoman [. . .] the truly vertuous Mrs. Mary Beale, amongst whose least accomplishments it is, that she has made Painting and Poesy which in the Fancies of others had only before a kind of likeness, in her own to be really the same'.

As she was publicly declared 'virtuous', it was now perfectly respectable to sit for Mary Beale: a massive boon for her career. She was finally a professional artist and was commissioned to paint portraits – especially clerical portraits, a clever move which cemented her respectability. She also made intimate studies of friends, family – and herself.

In 1675, at the height of her popularity, Mary painted her *Self-Portrait Holding an Artist's Palette*. It's a small work – only 45 x 38 cm – but has immense charm. The artist has pictured herself looking younger than her forty-three years; her skin smooth and unblemished and her loose and abundant hair, unmarked by grey, lightly reflecting the rich red of her dress. Her lustrous blue cape forms a throne, of sorts; she is in the midst of what appears to be a grand room, framed by a pillar and some drapery. So far, so conventional. But the painting is quietly subversive: in her left hand, Mary's thumb is looped through a small palette, covered in blobs

of paint, and she is holding a small cluster of brushes; in her right hand she holds a thin *mahlstick* in front of her, like an offering. She stares out at us, her eyes dark and steadfast, a very faint smile lingering on her lips. She is lovely, sensual, demure - and a working woman: an artist surrounded by the wealth her talents have afforded her. The painting was intended to be displayed alongside a small portrait she had made around the same time of her husband. He, too, looks younger than he would have been; if hung to the right of his wife's self-portrait, he would be looking towards her, his face amiable and warm, while she looks out at us. Despite its obvious affection, the double portrait reverses the traditional marriage roles of the time: Mary looks out at the world, while her husband - whose face is visibly affected by warts - gazes at his wife: the breadwinner.

Mary became very successful; her works are now listed in sixty-nine galleries and museums, including the Victoria and Albert Museum, the National Portrait Gallery and Moyse's Hall in Bury St Edmunds in Suffolk, which owns twenty-six of her portraits. In 1677 alone she had more than eighty commissions - which, when you take into consideration that each sitting was about three hours long and took four or five visits over a two-month period - is a staggering amount of work.

Mary Beale died in 1699 in Pall Mall, and was buried at St James's, Piccadilly. A memorial plaque in the church states that her tomb was destroyed by the enemy bombs that rained down upon London in the first phase of the Blitz, at 7.54 p.m., 14 October 1940.

I Want to Be Everything

Given historically low literacy rates, we are lucky that so many women artists could also write; our understanding of their lives is now all the richer for it. In 1873, at the age of fifteen, a young

noblewoman declared in her diary: 'What am I? . . . Nothing! What do I want to be? Everything!'

One hundred and fifty years after Mary Beale's death, on 12 November 1858, Marie Bashkirtseff was born in Gavronzi in the Russian Empire (now Ukraine). Despite dying a month short of her twenty-sixth birthday from tuberculosis, she was briefly to become one of the most famous women in Europe, renowned not only as a painter, sculptor and musician but, like Mary, as a writer, too. When a heavily edited version of the eighty-four notebooks she left behind was published posthumously in 1887 in France as *The Journal of Marie Bashkirtseff*, and then in 1890 in England, it became an instant bestseller. In an article published in *The Fortnightly Review* in 1890, one writer declared, 'It is this Journal with which the world is now ringing and which it is hardly too much to say is likely to carry the fame of Marie Bashkirtseff over the face of the civilised globe.'

A street in Nice, where she spent her last days, is named after her, and her tomb in the Cimetière de Passy in Paris has been proclaimed a historical monument by the French government. For a young and uncompromising woman to be so admired – despite her early death – was unprecedented.

From an early age Marie had travelled with her doting mother (who was also called Marie) throughout Europe; her parents had separated when she was still young, and her father, Konstantin, remained in Russia. The family had about them the whiff of scandal; Marie's mother had left her father and her uncle Georges had been in and out of prison; as a result, when they moved to Nice, they were socially ostracised. By the age of thirteen, Marie was fluent in Latin and Greek (as well as French and Russian) and was reading widely – she loved Dante, Homer, Plutarch and Zola. Around her fourteenth birthday she began keeping an extraordinarily witty, uninhibited and occasionally rambling diary; she wrote her last entry eleven days before she died. Filled with life, fury, opinion,

humour and ambition, her journal gives us a rare glimpse into the uninhibited musings of a nineteenth-century artist – she is as frank about her artistic ambitions and sexual desires as she is furious about the inevitable exclusions her gender imposes on her. In 1879 she writes:

> What I long for is the freedom of going about alone, of coming and going, of sitting in the seats of the Tuileries, and especially in the Luxembourg, of stopping and looking at the artistic shops, of entering churches and museums, of walking about the old streets at nights; that's what I long for; and the freedom without which one cannot become a real artist. Do you imagine that I get much good from what I see, chaperoned as I am, and when, in order to go to the Louvre, I must wait for my carriage, my lady companion and family?

By 1884 her fury still hadn't abated: on 31 May she writes: 'Had I had a sensible education I should be very remarkable. I taught myself everything.' On Wednesday 25 June, re-reading her diary, she is exasperated: 'As a man, I should have conquered Europe. Young girl as I was, I wasted it in excesses of language and silly eccentricities. Oh misery!' Earlier in the year, on 5 January, she had visited a Manet exhibition at the School of Fine Arts and describes it as 'incoherent, childish and grandiose'. Although she believes that some of his works are 'perfectly crazy', she concedes there are 'splendid bits' and 'given a little more, and he would be one of the great masters of painting'.

Marie had decided to become an artist in 1877, at the age of nineteen. Her ambition to be a singer had been thwarted by a misdiagnosis of chronic laryngitis – in fact, she had tuberculosis. She enrolled at the Académie Julian which, founded in 1868 by the artist (and former wrestler) Rodolphe Julian – who was married to the painter Amélie Beaury-Saurel – was one of the few institutions in

France to accept female students and, radically for the time, it also allowed them to study from a nude model. (I wonder how much pressure Amélie - who took over the directorship of the school at her husband's death in 1907 - placed on Rodolphe to accept women?) By comparison, the pre-eminent academy at the time, the École des Beaux-Arts, didn't allow women into its hallowed halls until 1897. Thanks to the Académie Julian's indifference to language requirements - other art schools had strict policies about fluency in French - it attracted a host of international students. Marie excelled in this lively environment: a wonderful photograph taken of her at the school shows her working intently at her easel, draped in a voluminous black cape, painting a portrait of a young woman.

There is a sombre urgency to Marie's *Self-Portrait with Palette* (1880). The young artist stands before us, looking directly out. Her expression is something of a challenge; it's almost as if she's up for a fight. She seems to know that she's worth looking at - and perhaps, too, she has a premonition that she doesn't have long to do what she has to do. Although not properly diagnosed with tuberculosis until 1882, she had been unwell for four years. (On Tuesday, 19 October 1880 she wrote sadly in her diary: 'Alas! All this will end, after dragging out a few more years of miserable existence, in death [. . .] I am like those too precocious children who are doomed to an early death.')

Despite her privilege, Marie is casually dressed and unadorned, in black, as if mourning her future. Her untidy hair is pulled loosely back. There is a palpable defiance to her stance; her black eyes stare at us with a directness that borders on fierce. She holds her large palette in her left hand like a shield. She does not let us see what she is painting, but the gleam of her white ruff is echoed by the startling smudge of white paint on the palette, the only bright spot in a gloomy studio. Behind her is a harp, a nod, perhaps, to her earlier musical ambitions; it could also be a symbolic - and

pre-emptively elegiac - allusion to heaven, which, throughout art history, has been pictured as populated by angels playing the instrument.

In 1880, Julian commissioned Marie to paint a portrait of students working in his academy. The result is *In the Studio*, a large painting that gives us an unusual glimpse of the working conditions for women at art school. Writing about the painting in her diary, the young artist observes: 'As for the subject, it does not fascinate me, but it may be very amusing [. . .] A woman's studio has never been painted . . .'

She completed the painting in 1881: a portrait of fourteen women artists of various ages, and one small boy holding a staff, who is modelling for the class, in a cramped room, filled with easels, chairs, lights, drapes and a skeleton, its walls covered with sketches. The artists are painting or wielding brushes; one girl's hand rests on a *mahlstick*; one girl looks at another's work, another glances out at us looking at her; others are deep in thought, concentrating hard. The central figure - apparently a self-portrait - is sitting on a low stool, dressed in a dark blue smock and an oyster-shaped hat. She is scraping her palette with a knife but has no easel before her; perhaps her class has just finished. She turns as if to converse with an older woman, who holds a sketchbook and a brush and looks at her a little sternly. We will never know what their exchange was: this is a glimpse into a world, not an explanation of its details.

In late December 1882 it was confirmed that Marie, who much to her horror had gone deaf, also had consumption. Despite her fear, she was bleakly optimistic: 'If ten years are still left to me, and if during these ten years I get love and fame, I will die content at thirty.' She refused to slow down and instead focused on her painting. She was studying with the French Realist painter, Jules Bastien-Lepage, who was also suffering from tuberculosis. They became very close and were to die within three months of each other in 1884; he was only thirty-six. His Realist influence is clear

in Marie's best-known work, *A Meeting*, which was exhibited in the Salon of 1884. The painting, which is rendered with an icy clarity, depicts six young boys, the three faces that we can see clearly being full of character. With their ragged clothes and worn-out shoes, they are obviously poor; huddled together, they discuss an object the older boy is holding, but his back is towards us and we can't see what it is. They are framed by a shabby wooden fence; in the distance, a girl walks away. It's an enigmatic scene, and an unusual subject for a young aristocrat. The painting garnered so much acclaim, it was rumoured that Marie was not the sole author of it - surely she was aided by a man. Marie was not awarded a medal. She was furious.

Marie was not someone who did anything in half measures, not even dying. In 1883 she wrote, with her usual mix of wild self-confidence and self-doubt:

> No, I shall not die until I am nearly 40 [. . .] And my will! It will be limited to asking for a statue and a painting of Saint-Marceaux and of Jules Bastien-Lepage, in a chapel in Paris, surrounded by flowers in a conspicuous place; and on each anniversary to have masses by Verdi and Pergolesi sung there and other music, on each anniversary in perpetuity by the most celebrated singers. Beside this, I will found a prize for artists - male and female. Instead of doing this, I want to live; but I have no genius, so it is better to die.

Marie died a year later, on 31 October 1884. She left behind around 230 paintings, drawings and sculptures - an extraordinary achievement given her youth and chronic illness - although a good many were later destroyed by German bombs in World War II.

Marie's mother more than fulfilled her daughter's last request: her tomb was built in division 11 of the Passy Cemetery in Paris, where the artists Édouard Manet and Berthe Morisot also lie, but in relatively modest plots. Marie's final resting place puts theirs in

the shade: an enormous chapel designed by Émile Bastien-Lepage that houses a recreation of the artist's studio, complete with her furniture, books, a palette, and the titles of her paintings inscribed on the wall. In the centre of the room is a bust of Marie by René de Saint Marceaux; it's flanked by those of her parents. Against the far wall hangs the young artist's final, unfinished painting: a gloomy study of women saints. In recent years the tomb has fallen into disrepair, despite having been declared a historic monument by the French government.

Her mother also fulfilled another of her daughter's desires. On 1 May 1884, Marie had written: 'What is the use of lying or pretending? Yes, it is clear that I have the desire, if not the hope, of staying on this earth by whatever means possible. If I don't die young, I hope to become a great artist. If I do, I want my journal to be published.'

In 1887, three years after her death, her mother published Marie's journal. It was, however, heavily edited to tone down the young artist's radicalism. Marie's feelings of frustration at a lack of gender equality were modified and her mentions of repeated visits in 1880 to the apartment of Hubertine Auclert, the leader of the militant women's suffrage group Le Droit des Femmes (The Rights of Women), were excised. Her mother also edited out her daughter's financial support of the socialist and feminist journal *La Citoyenne* (The Citizen): using the pseudonym Pauline Orell, Marie had published several reviews and, on 20 February 1881, a searing opinion piece railing against the restrictions placed on women artists.

That said, *The Journal*, even in its expurgated form, was explosive and was admired by the most unlikely of readers, including, among others, the British prime minister Gladstone, who declared that Marie's diary was 'a book without parallel'. The playwright George Bernard Shaw and writers including Katherine Mansfield and Anaïs Nin declared themselves fans, and Marie's amusingly

flirtatious letters to Guy de Maupassant, who she never met, were also published in 1891. In recent years an unabridged edition of the complete journals - all sixteen volumes - has been published in French, and excerpts from the years 1873-6 have been released in English, edited by Katherine Kernberger. The edition's apt title is a direct quote from Marie's journal: *I Am the Most Interesting Book of All.*

It's a testament to her ferocious, multifaceted talent that Marie is remembered less as a great painter than as a great writer. But for all her fluency, words were never quite enough. Look into her face and her fear, her impatience, her hunger for life are all there, both plain to see and yet rich with enigma and symbolism. I imagine her - so heartbreakingly young and yet so near death - tossing her pen aside and striding to her studio in order to wrestle with her self-portrait as if paint were the alchemical substance that might keep her alive forever.

2

Smile

The story of art is a tale of artists achieving success not only because they understood how to work within certain rules but because they knew precisely when to break them. Take, for example, the smile: a seemingly innocuous gesture, a small movement of the lips that indicates pleasure - yet, in certain cities at certain moments in history, for a woman to depict herself smiling was considered nothing short of scandalous. Sometimes the smallest transgression can be the most radical.

Attitudes towards most things are, of course, cultural: the smile is no exception. In Italy during the Renaissance, women were depicted as virgins, saints or angels: beautiful, soulful and often inscrutable, but not much fun. There are a few exceptions - most obviously Leonardo da Vinci's *Mona Lisa* (1503), whose faint smile is more remote than happy, and numerous paintings by Caravaggio, but in the main, levity was only rarely represented. In seventeenth-century Holland, a love of both morality tales and jokes resulted in a robust trade in paintings of people drinking and laughing, but in France, smiling - and in particular a smile that revealed the teeth - was sternly frowned upon. Of course, this might have had something to do with the fact that King Louis XIV had no teeth left by the time he was forty and it wasn't done to gloat. The king's affliction was not rare - for most people, a smile was not a pretty thing. Until Dubois de Chémant's invention of porcelain dentures in the late eighteenth century, false teeth - which were often made from animal bones, the most

popular being hippopotamus jaws – were badly designed and often stank.

For a woman to paint a self-portrait smiling was not simply an expression of joy. It could also be read as something more subversive: a gesture that declared, as charmingly as possible, that she would not be told what to do, or how to behave, by anyone.

Around 1554, Sofonisba Anguissola sketched *Young Woman Teaching an Old Woman to Read*: it is assumed to be a self-portrait. With great vividness the young virtuosa gestures to the bespectacled woman next to her who gazes intently at a thin pamphlet, and tenderly grasps her hand. In an age that demanded decorum – elbows tucked into her side, her modesty and virtue fully on display – in this small drawing not only does Sofonisba depict herself with animated arms, but she breaks one of the era's cardinal rules of representation: she is smiling broadly. In fact, she's almost laughing. Even more extraordinarily for the time: we can see her teeth. It's hard to imagine quite what a radical self-representation this was for the period. Throughout her life Sofonisba enjoyed teaching and this small drawing could be read as a testament to the joy it gave her.

We don't know how many other artists were aware of Sofonisba's transgression, but around ninety years after she created her wonderfully life-affirming self-portrait, an artist in Holland was to follow suit – and in so doing, she painted one of the best-loved self-portraits in art history.

The Lodestar

The great Dutch artist Judith Leyster was baptised the eighth of nine children to Jan Willemsz Leyster and Trijn Jaspers in Haarlem on 28 July 1609. Unusually for women artists of the time, her father

wasn't involved in art: he was first a clothmaker and then a brewer. Details of Judith's art training are lost, but she possibly studied with the portrait and history painter Frans Pietersz de Grebber in order to help her family after her father was bankrupted. Her earliest known paintings - *Serenade* and *Jolly Topper*, both of which depict men smiling broadly - are dated 1629 and signed with her distinctive monogram: Jl* - a play on her surname: 'leidstar' translates as lodestar - like the one that shone so brightly over Bethlehem - a star that guides.

In 1633, Judith became the only female member, alongside thirty men, of the Haarlem Guild of St Luke. This allowed her to sell her work on the open market, establish a workshop and take apprentices. In seventeenth-century Holland, Dutch painters delighted in portraying life in all its messy brilliance: people drinking, carousing, playing music, telling jokes and laughing. Many of these scenes have been interpreted as morality tales, but more often than not the joy lingers longer than the sermon. An early example is Gerrit van Honthorst's *Laughing Violinist* of 1609 - a work in thrall to Caravaggio's use of light and dark, but which, in its portrayal of the red-haired musician, crackles with mirth and vigour. Judith's work was heavily influenced by the loose brushwork, realism and spontaneity of the leading artist of the day, Frans Hals, who was around thirty years her senior, and his younger brother, Dirck.

Holland was newly independent from Spain and its economy - and by association its art - was booming: by the early seventeenth century, painting was, for the first time, supported not just by the church and the state but by ordinary citizens. The demand for artworks was high - the walls of every shop, tavern and home were covered in them. Judith was quick to find work and was soon employing three male apprentices and took on male students. She was spirited: in October 1635 she sued Frans Hals when one of her apprentices left her workshop for his - a bold move for a young woman against an older, more powerful artist. (Somehow they

both ended up getting fined.) Most of her paintings – which focus on a range of subjects but the best of which depict people smiling, laughing or playing games and music – are dated between 1629 and 1635.

In 1636, at the age of twenty-six, Judith married a local artist, Jan Miense Molenaer; they moved to Amsterdam, where there were better opportunities for selling their work. They had five children, only two of whom survived into adulthood; as well as running the household, Judith took over the management of her husband's studio. She possibly continued to paint after her marriage but, as far as we know, she never again signed a work. If she was still painting, the results have been lost, destroyed or attributed to other artists. The only verified work by her from this period is a delicate watercolour of a red tulip from 1643.

Judith died in 1660, at the age of fifty. Although celebrated during her lifetime, she was largely forgotten after her death. Until 1893 her paintings were assumed to be by either Frans Hals or her husband; her rediscovery is thanks to the art historian Cornelis Hofstede de Groot, who, in the late nineteenth century, recognised her monogram on the painting *The Happy Couple* from 1630, which had been attributed to Frans Hals. He eventually discovered seven works by her, six of which are signed with her monogram. Today there are around twenty works attributed to Judith Leyster. Surely there are many more, just waiting to be discovered.

Judith's wonderfully vivid self-portrait of 1633 was possibly painted as a presentation piece for the Guild. She is young – only twenty-four – and smiling broadly. Her delight and pride in her craft is evident. Wielding eighteen brushes, she's in the midst of painting a portrait of a smiling violinist and a young woman drinking wine – her own painting, *Merry Company*. Rather than her artist's smock, she is dressed in her finest clothes – as if in sartorial celebration of her craft and the wealth it has afforded her. She turns to greet us, her pose an echo of Frans Hals's *Portrait of*

Isaak Abrahamsz. Massa from seven years earlier. It's possible she also knew of Sofonisba Anguissola's self-portraits, as they are mentioned in Karel van Manders's *Het Schilder-Boeck* (Book of Painters), which had first been published in 1604, and which it's likely Judith had read.

Although by 1926 it was commonly known that the painting was Judith Leyster's self-portrait, it continued to be attributed to Frans Hals throughout the 1930s - possibly because of the drop in value that female authorship would inevitably entail. It wasn't definitively attributed to Judith Leyster until the National Gallery of Art in Washington acquired it in 1949.

They Call Me Madame Van Dyck

A century after Judith's death, another artist was born whose smiling self-portraits - to our eyes, charming, inoffensive and skilful - created a furore. A seemingly innocent gesture - a woman expressing pleasure in herself and in her child - was nothing short of revolutionary.

One of the most renowned painters of the eighteenth century came from modest beginnings: she was born in Paris in 1755 to Jeanne Massin, a hairdresser, and Louis Vigée, a minor artist. Did Elisabeth Louise Vigée - later, Elisabeth Louise Vigée Le Brun - know of Sofonisba's drawing or Judith's paintings? It's unlikely, given how quickly their fame dissipated, but Elisabeth would surely have approved of the ways in which they both thumbed their noses at convention.

Although France was in thrall to the Enlightenment - a time when writers and philosophers questioned the country's traditional political and social foundations - women were still not legally considered to be the equal of men. Inroads had been made, however: any discussion around class, liberty, race (particularly in

relation to slavery) and progress also inevitably touched on the role of gender. The century had seen a rise in female literacy - in main, thanks to the Catholic Church, which had increased the number of teaching orders - and middle-class girls were, for the first time, expected to read, write and be well versed in music and art. Despite their lack of rights, women could now keep up with current affairs, write letters and even maintain business records.

If the eighteenth century was a time of great debates, its radicalism was often blinkered: while one of the most famous philosophers of the time, Jean-Jacques Rousseau, questioned the divine right of kings, class inequality and conventional education, he still believed in the subordination of women, writing to a friend that 'women in general love no art, know nothing about any form of art, and have no genius'. However, in the other camp, the renowned aristocratic philosopher and mathematician Nicolas de Condorcet advocated for a liberal economy, a constitutional government and equal rights to be granted to all people, irrespective of gender and race. In 1781 he published a pamphlet denouncing slavery and in 1790 his persuasive *De l'admission des femmes au droit de cite* (For the Admission to the Rights of Citizenship for Women) was circulated, in which he argued for political and social rights to be extended in the new Republic to include women. (He was to die in 1794 in mysterious circumstances - possibly murdered - in a cell during the French Revolution.) His wife, Sophie de Condorcet, ran one of the many intellectual salons that were popular in Paris before, during and after the Revolution, and which were often hosted by women. Remarkably, given her husband's fame, Sophie survived the Terror; many of the dazzling women who attended her salon, such as the abolitionist, playwright and vocal activist for women's rights, Olympe de Gouges, were to meet their death at the guillotine.

Like so many women who were to excel at art, Elisabeth was instructed in painting from an early age by her father, who died when

she was twelve; otherwise, she was, in the main, self-taught. Her mother encouraged her precocious daughter's talent and accompanied her to view private collections, where she copied works by her favourites - Rembrandt, Rubens and Van Dyck. Banned from the life-drawing room, she spent hours making studies of plaster casts and statues in Paris's museums and by the age of only fifteen had set herself up as a professional portrait painter. However, in 1774, when she was nineteen, her materials were confiscated by government authorities. They had caught wind of the young artist's success; it was illegal to work as an artist without guild or academy membership - something that, as a woman, was very difficult to achieve. Not one to stumble at a hurdle, Elisabeth approached the Académie de Saint Luc and persuaded the powers that be to let her join - which they did. The academy had been founded in 1730 and was popular among young artists who weren't yet accepted into the country's most prestigious institution, the Académie royale de peinture et de sculpture (Royal Academy of Painting and Sculpture).

Paris's Royal Academy was arguably the most prestigious art institution in Europe and in 1706 it had voted not to admit women to its ranks. Eventually, rules were amended to allow no more than four women members at any one time, an arbitrary number that sorely restricted the possibilities for females to become professional artists. If an artist was successful in their application to this hallowed institution, it meant an immediate improvement of their circumstances. The prestige of being an academician meant more commissions - often royal and aristocratic - and the right to exhibit work in the twice-yearly Salon du Louvre. In 1777, however, the institution had been alarmed by the rise in the influence of the new Académie de Saint Luc and its power was such that it had the younger academy closed. Elisabeth was now adrift without the professional validity that membership endowed. Anxious about her financial situation and encouraged by her mother, the young artist reluctantly married an art dealer, Jean-Baptiste-Pierre

Le Brun. She recalls her reservations about matrimony in the memoir she published in her old age: 'So little, however, did I feel inclined to sacrifice my liberty that, even on my way to church, I kept saying to myself, "Shall I say yes, or shall I say no?" Alas! I said yes, and in so doing exchanged present troubles for others . . .'

The union was, unsurprisingly, not a success and her husband's promised riches never transpired; rather, he kept gambling - and losing - his wife's earnings. Yet she didn't let this affect her ambition. Her salons at her home in the Hôtel de Lubert, where she entertained artists and intellectuals, were famous and Elisabeth became a close friend of Marie Antoinette; they were the same age. In 1778 the young artist was commissioned, for the first time, to paint the queen's portrait - an extraordinary state of affairs, considering her lack of academy membership.

In 1780, Elisabeth gave birth to her only child, Jeanne Julie Louise (who became known as Julie). Pregnancy hadn't hindered the artist's ferocious work ethic. She later remembered that: 'The day my daughter was born, I was still in the studio, trying to work on my *Venus Binding the Wings of Cupid* in the intervals between labour pains.'

By all accounts, Elisabeth was a canny businesswoman and an instinctive diplomat; as a remarkable beauty, she also had a great talent for holding an audience captivated. But she was also obsessed with art history, challenging herself to not only match but exceed the accomplishments of the earliest artists. In 1782, at the age of twenty-seven, she painted *Self-Portrait in a Straw Hat*. It's an audacious picture - the young artist's homage (and, in many ways, challenge) to Peter Paul Rubens's 1622 painting of Susanna Lunden, *Chapeau de Paille* (Straw Hat), which Elisabeth had seen on her travels in Brussels. Whereas the woman in Rubens's painting looks out at us coyly, her arms crossed against her chest, Elisabeth's self-portrait is infectiously joyful. Framed by a limitless blue sky, the artist's shimmering rose-coloured silk dress, white lace, black

shawl, loose hair - a style she was apparently responsible for introducing to the French court - and relatively unadorned naturalism display her interest in fashion. As with most self-portraits by women of the time, she depicts herself in clothes she would unlikely to have worn while painting. The reality would have been far more casual: in her memoirs she describes how once she sat on her palette without noticing the mess on her dress. She holds out her right hand in something of an invitation. Her cheeks are flushed and her face is animated with a light smile that exhibits an unabashed delight at her chosen profession. She holds a large palette - thick blobs of paint at the ready - in the crook of her left arm, along with a fistful of brushes. The painting is something of an in-joke: despite the title of Rubens's painting, Susanna Lunden's hat appears to be beaver felt, not straw, the result perhaps of a misspelling: the French for straw is *paille* and for hair is *poil*. In her self-portrait Elisabeth has corrected Rubens's mistake: a luxurious straw hat, decorated with flowers and a large feather, adorns her golden curls.

Displayed in the Salon of 1783, one critic wrote approvingly of *Self-Portrait in a Straw Hat*:

> Mme Le Brun - is she not astonishing? ... the works of the modern Minerva are the first to attract the eyes of the spectator, call him back repeatedly, take hold of him, possess him, elicit from him exclamations of pleasure and admiration ... the paintings in question are also the most highly praised, talked about topics of conversation in Paris.

But the self-portrait wasn't simply a charming image of a young woman in full bloom: it was a canny business move. In her memoirs Elisabeth is quite frank about her motives:

> I painted myself with a straw hat on my head, a feather, and a

garland of wildflowers, holding my palette in my hand. And when
the portrait was exhibited at the Salon I feel free to confess that it
added considerably to my reputation. The celebrated Müller made
an engraving after it, but it must be understood that the dark shad-
ows of an engraving spoiled the whole effect of such a picture.
Soon after my return from Flanders, the portrait I had mentioned,
and several other works of mine, were the cause of Joseph Ver-
net's decision to propose me as a member of the Royal Academy
of Painting.

In 1783, by decree of the king - most likely at the urging of Marie
Antoinette - Elisabeth was accepted into the Royal Academy. Even
despite regal patronage, however, it hadn't been easy. The fact of
her gender wasn't the only hindrance: she was married to an art
dealer and members were forbidden to have close contact with the
commercial art world. It seems clear that the king overruled these
prohibitions, a fact that must have irritated some of her fellow art-
ists. In Elisabeth's memoirs, despite the decades that had passed,
the memory of her colleagues' opposition still rankles, although,
somewhat disingenuously, the artist doesn't mention the king's
assistance. She writes that:

M. Pierre, then first Painter to the King, made strong opposition,
not wishing, he said, that women should be admitted, although
Mme. Vallayer-Coster, who painted flowers beautifully, had al-
ready been admitted, and I think Mme. Vien had been, too. M.
Pierre, a very mediocre painter, was a clever man. Besides, he was
rich, and this enabled him to entertain artists luxuriously. Artists
were not so well off in those days as they are now. His opposition
might have become fatal to me if all true picture-lovers had not
been associated with the Academy, and if they had not formed a
cabal, in my favour, against M. Pierre's. At last I was admitted and
presented my picture *Peace Bringing Back Plenty*.

Elisabeth was admitted on 31 May 1783, the same day as her chief rival, the miniaturist and portrait painter, Adélaïde Labille-Guiard. They became immediate celebrities. (Adélaïde, who was six years Elisabeth's senior, was the first woman to be granted permission to establish a studio for herself and her students at the Louvre. Her *Self-Portrait with Two Pupils, Marie Gabrielle Capet [1761–1818] and Marie Marguerite Carreaux de Rosemond [died 1788]* of 1785 is rightly considered one of the most famous paintings of the time.) Between 1648 and 1793 – some 145 years – the two artists were among only fifteen women to be granted full membership.

Marie Antoinette was Elisabeth's vocal champion and she commissioned her to paint more than thirty portraits of herself and her family: images that, despite the inevitable pomp, display the family with a rare humanity and personality. The two women were close: in fact, Elisabeth's *Marie Antoinette en chemise*, which was shown at the Academy in 1783, was considered so intimate as to be scandalous. The young artist had painted her queen in a loose cotton dress that would normally only be worn in the privacy of her chamber; she is shown with a wide straw hat, no jewels and a bunch of roses. (Marie Antoinette's favourite dressmaker, Rose Bertin, who she light-heartedly appointed the court's 'Minister of Fashion', had also encouraged the queen to wear looser, more informal clothes.) To contemporary eyes, with its full sleeves, lace ruffles and gold ribbon at the waist, the dress looks elaborate, extravagant even. But in eighteenth-century Paris, the queen might as well have been posing in her underwear and, after an outcry, the portrait was removed from public scrutiny. But the story did not end there. While the painting was considered outrageous, it also prompted a craze: women who were accustomed to wearing tightly corseted dresses were charmed by the garment's fresh appeal and the sense of freedom it heralded. This outrageous new fashion became known as *chemise à la reine* but its impact was much darker than its airy appearance might suggest. Silk was the fabric worn

by aristocrats: cotton was considered a working-class, English material as, at the time, it was mainly supplied by the British-owned East India Company. Unwittingly, Elisabeth not only had depicted her queen in both a louche and an unpatriotic light but had also boosted the slave trade as demand for cotton increased.

To be a court painter in pre-Revolutionary France required focusing your talents on representing the king and queen in the best possible light. It was a tough job, as the king was very much out of touch with the suffering of his people. Supported by a majority of the nobility, Marie Antoinette's famously indecisive husband, Louis XVI, had resisted any real attempts to reform the government and to address the dire economic state of the country; this was the combined result of supporting America's war of independence from King George III - which, ironically, would help inspire the French Revolution - and the starvation and unemployment brought about by the coldest winter on record, when even the River Seine froze over. Some 98 per cent of the tax-paying population had no say as to how the country was governed, yet the financial burden of the country fell on the 'third estate' - the middle classes and the peasants. That the king often avoided the problems of the day by indulging his passion for hunting and, oddly, locksmithing, didn't help endear him to the people. Vile rumours, circulated by her enemies, swirled around Marie Antoinette. She was nicknamed 'Madame Deficit' and anonymous pamphlets distributed throughout Paris depicted her as a nymphomaniac and a lesbian who used a dildo to pleasure herself. As an Austrian, she was also viewed disparagingly as a foreigner.

To help counter the queen's plummeting reputation, in 1787 Elisabeth was commissioned by the Bâtiments du Roi - a division of the king's household - to paint a portrait that would show her as a model of motherly decorum. The result was *Marie Antoinette and her Children* - at almost three metres tall and two metres wide, the largest painting Elisabeth ever made. The young queen is demurely

dressed in a sable-lined, red velvet gown, designed by Rose Bertin. She tenderly holds her baby son, Louis-Charles, on her knee; her nine-year-old daughter, Marie-Thérèse, clings to her mother's arm and looks at her adoringly. While Marie Antoinette wanted the portrait to project an image of herself that was both demure and maternal, she couldn't help herself (nor I suspect could Elisabeth): her lush, feathered hat is characteristically enormous and, posed in the Hall of Mirrors of Versailles, she is pictured very much as a woman who takes wealth and privilege for granted. Louis Joseph, the king's heir, is seven years old; he points to the empty cradle that once held a baby girl, Sophie, who died during the painting's creation before her first birthday. Louis Joseph was to die two years after the painting was completed, most probably from tuberculosis. Louis-Charles died at the age of ten after being tortured and held in solitary confinement in Paris by the brutal revolutionary guard. Marie Antoinette, of course, was beheaded in 1793, ten months after her husband. Marie-Thérèse was the only family member to survive: she fled prison for Vienna at midnight on 19 December 1795, her seventeenth birthday, the result of a prisoner swap that had secretly been arranged between Austria, the home of her cousin, the Holy Roman Emperor Francis II (and her mother's birthplace), and the so-called Directory that was ruling France after the Terror.*

As a work of propaganda, Elisabeth's portrait was a failure: it was too little, too late. As a work of art, it's now one of France's most famous paintings and one of the most important – and popular – portraits in the collection at Versailles.

Despite her phenomenal talent, Elisabeth's gender and her role

* In 1799, Marie-Thérèse married her cousin, Louis Antoine, Duke of Angoulême; they had no children. Until her death at the age of seventy-two, she was fervently dedicated to restoring absolute monarchy to France. Understandably traumatised by the dreadful fate of her family, she kept the bloodstained shirt her father had worn to the guillotine close by her side.

as the queen's favourite often worked against her. In her memoir she wrote that: 'I was made the butt of calumnies of the most odious description.' A familiar theme in the story of women artists - or women in general - is that men, as if incapable of believing in their talent, accuse them of having 'loose morals' or of being impostors. One writer in the journal *Mémoires secrètes* stated that Elisabeth 'does not paint her own pictures, that she does not finish them at least, and that an artist who is in love with her (M. Ménageot) assists her'. Artistic brilliance has often been paired with licentious behaviour and rumours flew about Elisabeth's private life: cruel stories were published in newspapers that she had affairs with numerous men, including M. Colonne, the finance minister, whose portrait she had exhibited in the 1785 Salon; Charles Alexandre, Vicomte de Calonne, the Comte de Vaudreuil and the painter François Ménageot.

Yet, despite the constant slurs she was facing, in 1787 the young artist once again decided to shock the public: she painted a self-portrait cradling her young daughter, Julie (she was to paint another one in 1789). To our eyes, the painting is ostensibly a fairly straightforward, charming study of a mother's love, but in eighteenth-century France the fact that Elisabeth depicts herself smiling - and that you can see five of her teeth - was an affront to convention. A critic in *Mémoires secrètes* (which seemed to have it in for her) wrote that Elisabeth's smile was 'an affectation which artists, connoisseurs and people of good taste are unanimous in condemning'. Gravity and reserve were qualities to be lauded: a display of teeth and a hint of joy or hilarity suggested the subject was 'plebeian, insane (or at least not in rational control) or else in the grip of some particularly powerful passion'. We can be sure, though, that Elisabeth knew exactly what she was doing - and was more than aware of how very lovely she looked, teeth and all. The public might be scandalised, but it was a gamble she was willing to take, not only as an artist exulting in her skill, but for the sake

of her bank balance. Even today it is often the case that the more notorious the artist, the stronger the sales.

The year 1789 saw the beginning of the French Revolution, a time of brutal upheaval, bloodshed and political reform that was to embroil the country for ten years. It was a dangerous time for an artist so closely associated with the royal family. Elisabeth recalled that:

> The fearful year 1789 was well advanced, and all decent people were already seized with terror [. . .] I had little need to learn fresh details in order to foresee what horrors impended. I knew beyond doubt that my house in the Rue Gros Chenet, where I had settled but three months since, had been singled out by the criminals. They threw sulphur into our cellars through the airholes. If I happened to be at my window, vulgar ruffians would shake their fists at me. Numberless sinister rumours reached me from every side; in fact, I now lived in a state of continual anxiety and sadness. [. . .] But I must acknowledge that even with the furthest stretch of my imagination I guessed only at a fraction of the crimes that were to be committed.

On the night of 5 October that year the royal family was visited by a howling mob and forcibly escorted from Versailles to the Tuileries Palace in Paris to be held under house arrest. Elisabeth had her citizenship revoked; as the queen's favourite, she was understandably terrified. At the time, no one was allowed to leave France, except 'those who can prove they have devoted themselves to the study of the sciences, arts and trades [. . .] and who are absent only for the purpose of acquiring new knowledge in their profession'. With great foresight of the horrors to come, Elisabeth fled to Italy with her daughter and a governess. Her husband was later called before the Revolutionary authorities to explain her absence and, covering for her, said that: 'On account of her love for her art, she left for

Italy in the month of October 1789. She went to instruct and to improve herself.' They didn't fall for it but there was nothing they could do now that she was out of the country. Although she had saved her life, and that of her daughter, her situation was desperate. Despite having earned, in her estimation, more than a million francs, Elisabeth recorded that she left Paris with less than twenty francs: her husband had gambled her fortune away. So, what did she decide to do?

Paint a very cheerful self-portrait at the easel.

Elisabeth recalls that: 'I painted myself palette in hand before a canvas on which I was tracing a figure of the Queen in white crayon.' She turns to face us, her expression open and friendly; a light smile plays on her lips. The fact that her mouth is open and we can see her teeth was a reiteration of her scandalous self-portrait of 1787. Elisabeth was, of course, all too aware of her reputation and happy to exploit it - she needed, more than ever, for her work to be talked about in order to attract patrons and commissions. She looks beautiful, youthful and fresh; much younger, in fact, than her thirty-five years. Her costume is both simple and festive; decorated with a ruffled lace collar, a jaunty white ribbon fails to control her curls, and her wrists are adorned with yet more delicate white lace. It's no coincidence that she's wearing white - the colour of the Bourbon dynasty. Although her black dress is modest, austere even, an exuberant scarlet sash adds to the overall impression of playfulness; she recalls, in fact, the theatrical Pierrot clown figures so popular in Rococo painting before the Revolution banished that kind of fun. She holds a palette and a bunch of about ten brushes in her left hand. In a brownish, nondescript room her face glows like a beacon of light in a gloomy world. The brush in her right hand touches the surface of the picture; she is painting a portrait of Marie Antoinette. This might initially seem a curious choice of subject, given the turmoil in France - although no one could anticipate the scale of violence the Revolution would

unleash and at the time the execution of the king and queen would have been unthinkable. But most importantly, Elisabeth was well aware that the Grand Duke of Tuscany was Marie Antoinette's brother.

Elisabeth had painted the picture in Rome after visiting the famous Corridoio Vasariano - the Vasari Corridor - at the Uffizi Gallery in Florence. The kilometre-long passageway had been designed by Vasari in 1564 to allow Cosimo de' Medici and other Florentine noblemen and women to walk safely through the city, across the river from the Palazzo Vecchio to their home, Palazzo Pitti. In 1664, Cardinal Leopoldo de' Medici had initiated a collection of self-portraits to line the route; the tradition continues to this day and the collection now numbers almost 2,000 works. Although the building was designed to be government offices (hence, *Uffizi*), since the sixteenth century its extraordinary collection of paintings could be visited by appointment and, in 1765, had opened to the public; it formally became a museum in 1865.

Most of the self-portraits in the Uffizi corridor had been commissioned; Elisabeth, however, painted her self-portrait off her own bat, in order to gift it to the Grand Duke. This wasn't a simple act of generosity: Elisabeth was a genius at self-promotion and her painting - which was larger than many of the other self-portraits - had the desired effect: her smile was a hit, and the painting was happily accepted into the collection. She wrote in a letter of 16 March 1790 that: 'My painting for Florence enjoys the greatest success [. . .] never in my life have I been encouraged this much. [. . .] They call me Madame Van Dyck, Madame Rubens.'

Surprisingly, however, Elisabeth's contribution as a female artist was not particularly unusual for the collection: the Uffizi houses a higher concentration of work by women than any other historic gallery. We can thank, in part, Cosimo de' Medici's art advisor Filippo Baldinucci for setting a precedent. In 1681 he wrote to his employer: 'I would recommend, if possible, not to miss

the chance to include in the collection some celebrated female painters, such as Sofonisba Angosciola [sic] from Cremona, her sister Europa Angosciola, her other sister Lucia, Elisbetta Sirani from Bologna [and] Artemisia Lomi, who worked in Florence and Rome.'

As well as the artists mentioned, the gallery also includes self-portraits by seventeenth-century artists such as Lavinia Fontana, Arcangela Paladini and Marietta Robusti; and, from the eighteenth and nineteenth centuries, works by Mary Benwell, Rosa Bonheur, Rosalba Carriera, Angelica Kauffmann and others.

For Elisabeth it was the beginning of an illustrious twelve years in exile. She was accepted into the Accademia di Parma and the Accademia di San Luca in Rome; an inveterate traveller, she also worked in Florence, Naples, Vienna, St Petersburg and Berlin, supporting herself and her daughter by painting literally hundreds of portraits of the wealthy and famous along the way. She was distressed, however, when, in 1799, Julie, who had herself become an artist, married Gaëtan-Bernard Nigris, secretary to the director of the Imperial Theatres in St Petersburg. Elisabeth wrote in her memoir that: 'The whole charm of my life seemed to be irretrievably destroyed. I even felt no joy in loving my daughter, though God knows how much I still did love her, in spite of all her wrongdoing.' Without talent or fortune, Elisabeth was not only unimpressed by Nigris, but was convinced that a plot was afoot, in which Julie and Nigris were involved, to turn public opinion against her. (The details are hazy.) Whatever the truth of the matter, the marriage didn't last. Julie died in poverty at the age of thirty-nine, estranged from her wealthy mother. None of her paintings have survived.

In 1801, her French citizenship restored and her name removed from a list of counter-revolutionary *emigrés*, Elisabeth returned to Paris. So many of the people whose portraits she had painted had been executed. She wrote:

> I will not attempt to describe my feelings at setting foot on the soil
> of France, from which I had been absent 12 years. I was stirred
> by terror, grief and joy in turn. I mourned the friends who had
> died on the scaffold; but I was to see those again who still lived.
> This France, that I was entering once more, had been the scene of
> horrible crimes. But this France was my country!

Ironically, her membership of the Academy had expired as female
academicians were abolished altogether by the French Revolution.
You might have assumed that after so much travel, she would want
to stay put, but no - she was still restless. In 1802, Elisabeth trav-
elled to London for the first time, where she stayed for three years
and painted, among other portraits, the future King George IV.

After eventually returning to France and travelling intermittently
to Switzerland, she settled in the countryside, at Louveciennes.
In her eighties, Elisabeth wrote her three-volume autobiography,
Souvenirs de ma vie (Memories of my Life, 1835-7), apparently heed-
ing the advice of a friend who told her that 'if you do not do it
yourself, it will be done for you, and God knows what will be writ-
ten!' It became a bestseller. Looking back at the beginning of her
career, in the first volume she declares:

> I mention these facts to show what an inborn passion for the art
> I possessed. Nor has that passion ever diminished; it seems to me
> that it has even gone on growing with time, for today I feel under
> the spell of it as much as ever, and shall, I hope, until the hour
> of death. It is, indeed, to this divine passion that I owe, not only
> my fortune, but my felicity, because it has always been the means
> of bringing me together with the most delightful and most distin-
> guished men and women in Europe. The recollection of all the
> notable people I have known often cheers me in times of solitude.

Elisabeth died in 1842 at the age of eighty-seven and was buried

in the cemetery at Louveciennes. She left behind 660 portraits, around 40 self-portraits and 200 landscape paintings. Her tombstone epitaph - which she apparently wrote - declares, aptly: *Ici, enfin, je repose.* (Here, at last, I rest.)

Despite her fame and virtuosity, the first major retrospective devoted to Elisabeth Vigée Le Brun in France was staged at Paris's Grand Palais in 2015. When I visited the exhibition - room after room after room of brilliantly skilful paintings - I remembered the lectures I had attended on French art history. We were taught about the pre-Revolution Rococo artists - in particular Jean-Antoine Watteau, François Boucher and Jean-Honoré Fragonard - whose charmingly playful paintings depicting the amorous machinations of the aristocracy were superseded by the chilly heroics of neo-classical painters such as Jacques-Louis David. I could not recall one mention of a woman artist. Walking through the galleries of the Grand Palais, gazing at the sheer range of Elisabeth's self-portraits was profoundly revealing: again and again, she scrutinised herself, not only as a woman but as an artist in conversation with art history. And yet, despite her talent, fame, prolific output and international success, it still wasn't enough for her to be included in the history books. How many more times should she have portrayed herself before she was permitted to enter the canon? What else should she have done?

3

Allegory

Art: An agreeable Woman, seems to be ingenious by her very Looks, in a green Gown; in her right Hand, a Hammer, an engraving Tool, and a Pencil; holding in her left Hand, a Stake that supports a Vine. The agreeable Countenance declares the Charms of Art, attracting all eyes upon it, and causing the Author to be approv'd and commended. The three Instruments are for intimating Nature: the Stake supplies Nature's Defects, in holding up the tender Plant.

Cesare Ripa, *Iconologia: Or, Moral Emblems*, 1709

A Story, Stilled

She doesn't just paint; she is the *embodiment* of painting. The colour of her dress, the pendant she wears, what she holds in her hand: all of it is significant. Her paintings tell us something not only about the shape of her face or how she comported herself, but also about when and where she lived and what she was permitted - or not - to do. Every element in every one of her pictures is a fragment of a larger story; they are at once self-portraits and symbolic maps. They can be read on many levels: literally, as fragments, as metaphors, as self-promotion or even as a plea for pity. Her life is condensed into a single image, multiplied. She's a portal into another century, another place, another mind. She's a time-traveller, a conundrum and a tease. She's furious, she is mourning, she is

hell-bent on retribution; she's the embodiment of joy, her anger is charming, she's a code to crack. She's a survivor. She will not be pinned down. She's testament to what is possible.

A painting will always reveal something about the life of its creator, even if it's the last thing the artist intended. A self-portrait isn't simply a rendering of an artist's external appearance: it's also an evocation of who she is and the times she lives in, how she sees herself and what she understands about the world.

An allegory is a familiar story – a fable, a myth, a tale from the Bible or a famous episode in history. It can also be the embodiment of the seasons, the times of the day or the lifespan of a human: the story it tells will always, cleverly, indicate something significant about something else: it can be a riddle, a sermon or a symbol, a story or an admonition, an expression of private or public sentiment. Artists have long employed allegories in order to convey complex messages in a deceptively straightforward way; the story they tell, however enigmatic, is usually arresting. Like a film still, a painted allegory is essentially a scene plucked from a narrative, frozen mid-sentence. As the art historian Marina Warner makes clear in her book *Monuments and Maidens: The Allegory of the Female Form*, they are not, however, simply the preserve of the past. Walk down any aisle of a supermarket or a busy high street today, and you'll see that allegory is everywhere: the image of a young woman on a bottle of virgin olive oil, a shell for the logo of an oil company, a galloping horse as the epitome of a bank, or Nike, the winged goddess of victory in Greek mythology, evoked in a swoop on countless trainers.

In its employment of simile and metaphor, allegory – derived from the Ancient Greek and Latin for 'speaking otherwise than one seems to speak' – is the genre of painting that is closest to written or spoken language. In the Renaissance, in particular, it was clearly coded: painting and design, for example, are embodied by the figure of a woman, as are the seven liberal arts – grammar, logic,

rhetoric, geometry, arithmetic, astronomy and music. The muse of art, Erato, is female, as is Envy, who is usually depicted as a crone; Charity is a mother and War is a man. The Greek goddess Athena embodies wisdom and the law and culture of her city, Athens; she is also the patron of women's skills and work. She has been reborn again and again to suit the tastes and conventions of different centuries and cultures. Marina Warner writes that in London she:

> ... is the immediate model of those exemplifications of Justice, Prudence, Fortitude and Temperance who adorn such institutions as the National Gallery, London, where the goddess sits on the eastern corner of William Wilkins' serenely proportioned building, or of Somerset House and the Tate Gallery [now Tate Britain], where she surmounts the pediment of the entrances, or of various life insurance companies in Britain's great cities, where her presence pledges the integrity of their conduct.

Seemingly every abstract notion is gendered and personified: in Italian, 'old age' (*la vecchiaia*) and 'beauty' (*la bellezza*) are both feminine, as are all of the virtues, while vices are represented by both men and women (although idleness is personified by 'an old hag cloth'd in rags'). 'Time' (*tempo*) is masculine; even in English, which is a far less gendered language than many others, we are familiar with Father Time.

This visual relationship to written language is closely aligned to the idea that a good painting must be more than simply a display of technical skill; it must also be an exhortation to do good, to be better, to have a profound meaning. An ability to elevate painting to something more than the sum of its parts placed the artist above the medieval artisan, who was assumed to blindly cater to the whims of their patrons or bosses. There was also a practical reason for why painters stressed the intellectual aspect of their art: at various times throughout Europe, a craftsman would be taxed far more

heavily than a writer, musician or artist. But to have assumed that only artisans catered to the whims of their bosses or clients was, of course, disingenuous, as the Renaissance was wholly funded by patronage: very few artists ever painted anything without being commissioned to do so. That allegory is a pliable language made it the perfect vehicle for double entendre. A painting illustrating the story of Venus and Cupid, for example, could hang in a salon - history renders old stories respectable - even as its themes of sensual love satisfied the erotic appetites of a wealthy patron.

The notion at the heart of allegory is that complex ideas can be more easily understood and absorbed if conveyed in images and stories. One of the most prolific and admired painters of allegories, Peter Paul Rubens, expressed this idea succinctly in a letter of 1 August 1637:

> Those things which are perceived by the senses produce a sharper and more durable impression, require a closer examination and afford richer material for study than those which present themselves to us only in the imagination, like dreams, or so obscured by words that we try in vain to grasp them [. . .] but which often elude us and thwart our hope.

The ambiguity that lies at the heart of an allegory was a gift of creative freedom to artists at a time of high censorship. The Greek and Roman myths, for instance, are full of metamorphosis: gods often hide in plain sight, choosing at will to be seen as humans or animals.

Likewise, the notion of something, or someone, being more than the sum of their parts was a gift to many of the women artists of the past; it lent them a freedom to express themselves with a complexity that was unthinkable in daily life. Renaissance and Baroque women often painted themselves as the embodiment of the spirit of painting or music, say, or a saint, or the incarnation

of a sentiment such as love. Others employed allegory to express their anger about the restrictions placed upon them; using a highly intellectual coded language meant that they could vent their frustrations while remaining utterly respectable and even charming. At a time when a woman had no political clout, she could highlight her subjectivity in a painting in order to express something about the world she was part of while making a strong point about the power and complexity of her creativity.

Most artists, however, only received a rudimentary education, and could not have been expected to know the myriad myths, stories and histories at the source of many allegories - many of them from classical Greece and Rome, the most popular and widely sourced allegories in the Renaissance. Added to the mix were references to esoteric philosophy, theology and literature, astrology and the Bible. By the end of the sixteenth century, numerous dictionaries had been compiled to make the life of artists easier: the most popular of these was the *Iconologia: Or, Moral Emblems*, which was compiled by the renowned cook-and-butler-turned-writer, Cesare Ripa. It lists 'Various images of Virtues, Vices, Passions, Arts, Humours, Elements and Celestial Bodies as Designed by The Ancient Egyptians, Greeks, Romans and Modern Italians', was first published in 1593 and reprinted, translated and expanded upon many times until the end of the eighteenth century. The unauthored preface to the English edition of 1709 declares that: 'These images are the representation of our Notions; they properly belong to Painters who, by Colours and Shadowing have invented the admirable Secret to give Body to our Thoughts, thereby to render them visible.'

Ripa's dictionary - advertised as being useful for 'Orators, Poets, Painters, Sculptors and all Lovers of Ingenuity' and including 'Three Hundred and Twenty-Six Humane Figures, with their Explanations' - is dizzyingly intricate. His personifications range from the predictable - art, charity, despair, humility, jealousy and so on - to the startling: from 'Colmography' to 'Flegm', 'Poetical Fury' and

'Umbria'. Women, it would seem, are capable of embodying almost anything. Hypocrisy, for example, should be pictured as 'a meagre, pale woman', and superstition 'an old Woman, with a Nightingale on her head, an Owl and a Crow on each Side'. Strength is represented as 'A Woman in Armour; her Stature upright; big-bon'd; plump Breast; harsh Hair'. For Marina Warner, this expresses the Christian idea that 'as women are morally weaker, their strength is all the greater if they actually manage to be good'.

Despite the strict codes of allegory, to paint an image of yourself is to inevitably reveal something intimate, however veiled in a historical narrative it might be. It's telling that some of the most powerful allegories – especially by women – are also self-portraits. How, for example, might a brilliant young artist who has been raped by a man close to her family choose to exorcise her ghosts?

It's True, It's True

Her pictures blaze across the centuries; her fury, her brilliance, the sheer compelling power of the images she created has never dimmed. She was a prodigy who was brutally assaulted by those she should have been able to trust. She emerged from hell at the age of only nineteen and poured her feelings into paintings that both reflect the conventions of the time and transcend them. She is one of the great artists of the Baroque – and one of the first women to represent female experience through the lens of allegory.

Artemisia Gentileschi was born in Rome on 8 July 1593, the oldest of four children. Her mother, Prudentia, died in childbirth when Artemisia was twelve; her father, Orazio, was a painter. He was in thrall to his young friend, the legendary Caravaggio, who Artemisia most likely met and admired, and he taught Artemisia everything he knew. She quickly proved herself prodigiously talented – much more so than her brother Francesco, who had a minor career as an

artist. Despite raising him, and her two other brothers, the respon-
sibility of which had fallen on her young shoulders with the death
of her mother, Artemisia rapidly absorbed her father's lessons. She
painted her first major work, *Susannah and the Elders*, in 1610, when
she was seventeen; as it was not commissioned we can assume that
Artemisia chose the subject herself. The story - which was first
told in the second-century BCE *Book of Daniel* and then reappeared
elsewhere in various forms, including the Bible - was popular at
the time; from the Renaissance onwards, it had been a fashionable
subject for painters. It concerns Susannah, a young Hebrew wife
who, while bathing in her garden, is accosted by two lecherous
old men who have been allowed to enter by her housekeeper.
They falsely accuse her of taking lovers and threaten to reveal her
secret unless she has sex with them. She refuses, is put on trial and
sentenced to death for promiscuity. At the last minute, Daniel, the
hero of the story, insists that the men be questioned further. Their
stories are found to be inconsistent, Susannah is released, and the
old men are themselves put to death.

Artemisia's version of the story is electric; the sense of dread
claustrophobic. In Mary D. Garrard's view, her approach re-
jected the too-familiar treatment by other artists of representing
sexual abuse as 'hard-core eroticism' and 'blatant pornography'
and replaced it with an image that emanates empathy. The three
figures are crowded together in the centre of the painting. The
men, dressed in dramatic dark red robes, lean over a wall, peering
down at Susannah; as one whispers his terrible words to her, she
is permanently frozen, recoiling in horror, her face turned away,
hands raised high against the men as if to fend off the blows of
their words. One man leans into the other, whispering into his ear;
they are obviously conspiring. The young woman is vulnerable,
her nakedness all the more startling against the layers of the men's
rich robes; but still, she is strong. We know, even at pain of death,
she will not give in to them.

Although, thanks to her father's studio she might have had access to models, given she was the same age as Susannah, it's likely Artemisia studied her own body for the work. Although she was illiterate, she signed it with her initials. It's a painting that would prove horribly prophetic.

In 1611, Artemisia's father worked alongside the artist Agostino Tassi, decorating the vaults of Casino delle Muse inside the Palazzo Pallavicini-Rospigliosi in Rome. Orazio hired Tassi, who was around thirteen years older than Artemisia (his birth date is unclear), to teach his daughter painterly perspective. After a prolonged period of harassment, Tassi raped the young artist. For months after the attack, Artemisia continued to sleep with her attacker; we can only speculate as to her reasons. In the trial to come, when asked to explain her relationship with him, Artemisia replied: 'What I was doing with him, I did only so that, as he had dishonoured me, he would marry me.' To be a female artist in the Renaissance (and pretty much until the twentieth century), it was essential to be viewed as virtuous. To be otherwise meant to be spurned by polite society - and the patrons, who had to be convinced of your moral, as well as artistic, worth.

Nine months passed. When Orazio discovered that Tassi had no intentions of marriage, he accused the painter of raping his virgin daughter and stealing some of her paintings. He also accused Tassi's friend and co-conspirator, Cosimo Quorli, a papal servant, who had later tried to rape Artemisia but not succeeded, and who died before the conclusion of the trial. Orazio's main objection was the fact that Tassi had dishonoured his family by making Artemisia unmarriageable. As virginity was considered a necessary prerequisite for a new bride, Orazio was offended that 'his property' had been damaged. Essentially, it was the father, not the daughter, who was considered the main victim.

Much of the detailed, 300-page transcript of the seven-month trial has survived. In it, the terrible sequence of events becomes

clear. A female tenant named Tuzia Medaglia, supposedly a friend to, and chaperone of, the motherless Artemisia, had allowed Tassi into the building. Artemisia was working; Tassi shouted at her 'not so much painting, not so much painting', grabbed her palette and brushes from her and flung them to the floor. He then demanded to see a painting near the bedroom and once they entered, he pushed Artemisia into the room and onto the bed. The young artist struggled with him and, in the process, attacked him with a knife, injuring him slightly, but to no avail. Artemisia screamed for Tuzia, but the older woman did nothing to help: again, we have no idea why, but betrayal is a theme that runs through many of the artist's subsequent works. During the trial, it was revealed that Tassi was already a convicted rapist who had spent time in jail. He had kept quiet about the fact that he was married, but his wife had disappeared. Rumour had it that he had hired bandits to murder her and dispose of her body. After declaring that he had visited Artemisia's home in order to protect her honour and had never had 'carnal relations' with the young artist, he verbally abused her in front of the judge, declaring that she regularly slept with five men, as well as her father, who had once sold her for a loaf of bread. His story constantly contradicted itself and his insults became so cruel and unhinged, not only against Artemisia but also her dead mother Prudentia, that Orazio eventually added the charge of slander against Tassi and four of his 'witnesses'.

It had to be proven that Artemisia was a virgin before the attack and so she was subjected to a physical examination. To supposedly extract the 'truth' from her, she was also tortured with a 'sibille', a vice comprised of metal and rope that tightened around her fingers. The pain must have been excruciating – and only matched in horror by the seven-month scrutiny of her life. According to the transcript, the young painter repeatedly cried out: 'It's true, it's true.'

Tassi was eventually found guilty of the rape of a virgin. He was held in prison for eight months and exiled from Rome for five

years, but as he was close to the Pope and his nephew, this was never enforced. The trial didn't seem to have affected his career: he was commissioned to paint murals in the Pallavicini-Rospigliosi and Doria Pamphili palaces in Rome. Tassi died in Rome in 1644.

In an attempt to salvage his daughter's honour, Orazio arranged her marriage to Pierantonio di Vicenzo Stiattesi, a mediocre painter who traded in pigments – no record of his work survives. They were married the day after the trial ended, on 29 November 1612 in the Church of Santo Spirito in Sassia in Rome before moving to Florence. We can only imagine Artemisia's relief at putting her dreadful ordeal behind her. In order to highlight her connection to Florence she assumed her Tuscan grandfather's name of 'Lomi' – and then threw herself into exorcising the nightmare of the trial with paint. One of the first paintings she made after her arrival in Florence is *Self-Portrait as a Female Martyr* (c. 1613–14): it's Artemisia's 'first true likeness by her own hand'.

In 2018, to much fanfare, the National Gallery bought Artemisia's *Self-Portrait as Catherine of Alexandria* (c. 1615) – the first seventeenth-century Italian self-portrait by a woman in the gallery's collection of around 2,300 works, of which only twenty-four are by women. Painted in Florence when she was twenty-two – four years after she was raped – Artemisia depicts herself as Catherine, the fourth-century Christian martyr and scholar. Legend has it that Catherine was the daughter of the Governor of Alexandria during the reign of the Roman Emperor Maxentius. Disturbed by the emperor's persecution of Christians, the eighteen-year-old Catherine – the age when Artemisia herself was put on trial – met with the ruler to condemn his cruelty. Maxentius ordered fifty philosophers and orators to debate with the young woman: she apparently won the argument and even converted some of her opponents to Christianity (all of whom were immediately executed). After whipping and then imprisoning the young woman in order to force her to

submit to his power – to no avail – the emperor, in a curious twist, proposed marriage to Catherine. Unsurprisingly, she rejected him with the declaration that Jesus Christ was her spouse. The enraged emperor condemned her to death by being bound to a revolving wheel studded with iron spikes. At her touch, however, the wheel was destroyed by a burst of flames from heaven and she was unharmed. (The destruction of St Catherine's wheel is now celebrated every year in fireworks known as 'catherine wheels'.) By now, Maxentius had obviously had enough and ordered Catherine to be beheaded. She was then murdered – but in a final act of defiance, she bled milk, not blood.

In Artemisia's closely cropped self-portrait, she pictures herself as the young martyr. Seen against a deeply shadowed background, she depicts herself from the waist up; the intense framing creates a sense of intimacy; you can almost feel her breathing. Her left hand touches the broken wheel which is studded with two sinister iron spikes; her right hand holds a martyr's palm – a symbol of both peace and victory – and touches her left breast, above her heart. She is dressed in a loose red robe and a golden wrap; a long scarf, and a modest gold crown, adorn her head. She is wearing a celestial crown: a softly glowing halo. So far, so theatrical. But the power of the painting is focused in her expression: she looks directly at us with an intensity that is riveting. Her face is as illuminated as her halo; it's impossible to avoid her dark, clear-sighted eyes. She is young, made of flesh and blood, vulnerable to the horrible machinations of men and their politics – but she's very clearly not broken: far from it. This is a self-portrait as a show of strength: a young woman who, despite having been brutalised, has risen above her pain to picture herself centre stage – very much alive and in total control of her own representation.

In 1612 – just after her trial – and then again in 1620, Artemisia painted versions of *Judith Beheading Holofernes*. It's impossible not

to see these works as a testament to the young artist's feelings of rage and revenge towards men, who are embodied in the figure of one man, Holofernes, who she pictures in the act of being savagely murdered. The story concerns the biblical heroine Judith's seduction and then assassination (with the help of her maidservant, Abra) of the Assyrian General Holofernes, who had led Nebuchadnezzar's army into her home town of Bethulia - a fictitious city whose name is possibly a derivation of the Hebrew word 'Bethel', meaning 'House of God'. The subject of Judith's revenge was popular in the Renaissance, even though it had been relegated to the Apocrypha (from the Greek, 'to hide away'), a section for stories of doubtful origin in the Old Testament of some Protestant translations of the Bible. (The story has been completely expunged from the King James Bible.) It is likely that Artemisia had seen Caravaggio's version of the subject from 1598-9; however, in both of her early versions, she makes some radical changes. Whereas Caravaggio pictures Abra as an old woman and Judith as a delicate girl who looks faintly askance at what she is doing, in Artemisia's version the servant is as young and as vital as her mistress - and she takes an active part in the assassination, pinning the general down as her mistress, full of steely resolve, severs his neck with a large sword. While compositionally, Artemisia's two versions are near identical, in the later version her drawing and perspective are more sophisticated and - significantly - the sword is longer and the blood spurting from Holofernes's neck is painted in much greater, gorier, detail. Artemisia's interpretation of the story is one of the most violent in the Renaissance: far more ferocious than even Caravaggio's. Her second version of the subject had been completed in Rome where Artemisia had returned after seven years in Florence. The painting was bought by the Grand Duke Cosimo II de' Medici, although it was only with great difficulty - and with the help of her friend the astronomer and physicist Galileo Galilei - that Artemisia was able to extract payment from him. Apparently

the extreme depiction of the subject matter resulted in the painting being denied 'the honour of being exhibited' in the Uffizi.

In 1616, Artemisia had become the first woman to be admitted to the Accademia delle Arti del Disegno (the Academy of Art and Design). Although this granted her Medici protection, she still had to earn a living from commissions. Again and again, she painted images of powerful women: not only Susannah and Judith, but Clio, Corisca, Cleopatra, Lucretia - also a rape victim, whose story was told by the Roman poet Livy - and the Jewish heroine, Esther. She also taught herself to read and write and became a prolific letter writer. She gave birth to five children, including, in 1618, a daughter she named after her mother, Prudentia (also known as Palmira), who followed her in becoming a painter. Trained by her mother, none of her work has survived.

Despite Artemisia's success in Florence, the couple were unhappy, broke, dysfunctional and rocked with tragedy: three of their children died and Artemisia began a passionate and long-term love affair with a young nobleman, Francesco Maria Maringhi. In 2011, a group of letters written by Artemisia and her husband to him were discovered by the art historian Francesco Solinas in Florence; they grant us an intimate glimpse of her turbulent life. In 1620, Artemisia and Pierantonio, overcome by debts, fled to Rome, but things didn't go well. Their remaining son, Cristofano, died; only Prudentia was left. Pierantonio absconded, possibly fearing prison, and although her money problems eased with new commissions, Artemisia struggled as a single mother. Around 1627 mother and daughter moved to Venice, possibly in search of new patrons; Artemisia was welcomed as a star and important collectors, especially aristocratic and royal Spanish ones, bought her paintings. In 1630, to escape the plague which would wipe out half of the city's population, she moved again, to Naples, where, in 1636, she painted her first church commission: *Saint Januaris in the Amphitheatre at Pozzuoli* for the choir of Pozzuoli Cathedral. It's

a large, dramatic, even cinematic painting: Artemisia depicts the saint surrounded by a claustrophobic crowd and a herd of wild animals. Supposedly bears and lions, they're more like strange hybrids; they're meant to devour the saint, but instead they lick his feet and so the saint is killed by a sword. The animals in this tale show greater humanity to the living than the humans themselves. It's a vivid response to Artemisia's feelings about Naples, which she longed to leave because of its violence, 'the badness of life and the expense of things'.

Now famous - patrons and collectors were fascinated by both her ability and the fact that she was a woman - on 9 October 1635, Artemisia wrote to Galileo Galilei: 'I have seen myself honoured by all the kings and rulers of Europe to whom I have sent my works, not only with great gifts but also with most favoured letters, which I keep with me.' Artemisia's father Orazio had been working for the English court since 1626. In 1635, he wrote to his daughter with an invitation from Charles I for her to come to London. She finally arrived in 1638, the year Orazio completed much of the decoration of the Queen's House at Greenwich, possibly with his daughter's help. It's likely that she painted her *Self-Portrait as the Allegory of Painting* (La Pittura, 1638-9) during her time in London.

An allegory suggests that everything we touch or see or read has a deeper symbolic or moral meaning. Here, Artemisia's message is a blunt one: not only can a woman embody painting, she can create art too. The work itself may be relatively small - roughly 98 x 75 cm - but the scale and ambition are huge. It's an astonishingly active self-portrait of an artist at work: Artemisia is consumed with the canvas in front of her. She shows, unlike any other artist of the time, what a physical activity painting is. Her right arm is raised in the act of applying paint; her left holds the palette and a bunch of brushes. She leans lightly on a stone slab, which would have been used for grinding pigment; she has signed it with her initials. The brushwork is urgent and evocative. Artemisia's cheeks are flushed

and her hair is loosely tied back, but a tendril escapes; her dark brown eyes gaze upwards, both at the painting she is concentrating so hard on and into the light. She is surrounded by an ochre background – a blank canvas, if you will – onto which she is expending her energy. She's dressed in her studio garb; a brown apron over her silky green dress, its voluminous sleeves rolled up in order to facilitate her movement. A curious pendant dangles from a gold chain around her neck: it appears to be a tiny skull. The angle of her self-depiction is complex and original; the perspective is tilted, so we can't help but look up at her – or, perhaps, up *to* her? She has kept what she is painting vague.

Yet, despite its realism, Artemisia was, in fact, closely following the rules for artists set out in Ripa's standard emblem handbook *Iconologia*. In it, painting is defined as being embodied by 'a beautiful woman, with full black hair, dishevelled, and twisted in various ways, with arched eyebrows that show imaginative thought, the mouth covered with a cloth tied behind her ears, with a chain of gold at her throat from which hangs a mask and has written in front "imitation"'.

Artemisia, however, has gone off-piste: the mask that dangles from her neck on a long chain is blank: a clear statement, perhaps, that she is imitating no one. Ripa also specified that the tools of painting should be seen at the feet of the female figure to 'show that painting is a noble exercise and cannot be done without much application of the intellect', yet Artemisia depicts herself from mid-thigh up: her tools of the trade are not at her feet but in her hands.

The implication of the covered mouth is that painting is silent; it's an element that Artemisia, whose paintings are so vocal, also omits from her self-portrait. It is a defiant statement from a woman who was so brutally violated by her teacher: she is declaring, for anyone to see, that she, a woman, is not only a virtuoso painter herself, but also the personification of painting; not simply the

illustration of an allegory but a human being hard at work. Most self-portraits show the artist looking out at the viewer. Not so this one. Artemisia is far too busy to look to anything but her painting.

Not many of Artemisia's self-portraits survive but we know about them because of her voluminous correspondence. In 1639 her father died in London; Artemisia returned to Naples around 1640. Charles I had bought several of her works, including *La Pittura*. Her final years in Naples were professionally successful, but the letters she wrote to her patron Antonio Ruffo make clear her daily battles – with money and illness, with the cost of models and the violence and filth of the city. But Artemisia was never less than bold: 'I will show Your Illustrious Lordship what a woman can do', she declared in one. In another, she proclaimed: 'You will find the spirit of Caesar in the soul of a woman.'

Artemisia's final painting is dated 1652: it's another version of *Susannah and the Elders*. The date of her death is unknown; the last mention of her is a token payment towards an overdue tax bill in 1654. She possibly died in the plague that devastated southern Italy in 1656. She left behind around fifty-seven major paintings, most of which feature a woman as a powerful, often violent, protagonist: victorious, whatever life has thrown at her. No wonder so many of them are self-portraits.

The Sun of Italy and the Gem of Europe

It is hard for us to grasp, from our twenty-first-century perspective, how very young so many of the Renaissance and Baroque artists were when they painted their masterpieces. They were, in the main, trained from an early age; in an era of great plagues and limited medical knowledge, even if they survived childhood, many of them died in their twenties and thirties. Knowing how fleeting

their life might be must have given them a terrible and urgent sense of their own mortality.

A case in point is the gifted Bolognese artist Elisabetta Sirani, who painted her *Self-Portrait as an Allegory of Painting* in 1658, when she was only twenty. She pictures herself at the easel, with books and a quill close by, and in the background a small figurine, possibly of Minerva, the patron of the arts. Elisabetta looks effortlessly natural: in a wonderfully bold gesture, a laurel wreath – an ancient symbol of victory – graces her tumbling hair and her clothes are loose, low-cut and lavish. Nothing could be further from the demure robes of the women painters who worked so hard to represent themselves as virtuous. Perhaps playfully aware of the power of her physical beauty, she looks out at us with the ghost of a smile, her right hand hovering over the canvas, her left holding the partially obscured palette. Her face is pale, young, open; her eyes are wide, her expression lively. Our scrutiny of her is obviously an interruption, but she doesn't seem to mind; she looks vital and at ease, despite the heavy gold chain across her breast.

Elisabetta represents herself as both the embodiment of painting *à la* Ripa, and very much herself: full of personality and talent, young and fizzing with life. It's a defiant statement at a time when to be a woman artist was to be an object of amazement. Was she aware of Artemisia Gentileschi's painting of the same subject, which was created in 1638, the year that she, Elisabetta, was born in Bologna?

Elisabetta's life was brief: she died suddenly at the age of twenty-seven. But in her short time on earth she achieved an astonishing amount. Her family was artistic: her father, Giovanni Andrea Sirani, had been a pupil of the renowned painter Guido Reni, one of the most important artists of the seventeenth century. Giovanni had no sons and so he taught his daughters; two of Elisabetta's sisters, Barbara and Anna Maria, were also to become artists. Even as a child, Elisabetta's talent was recognised. By the age of seventeen

she had painted her first altarpiece. When she was nineteen, her father, crippled with rheumatic gout, could no longer paint, and as her mother, too, was bedridden, the young artist became the family's main breadwinner. It doesn't seem to have daunted her in the slightest: she didn't pause for breath. Her contemporary, the art historian Carlo Cesare Malvasia - Vasari's equivalent in Bologna - claimed to be the first to recognise Elisabetta's talent. 'It was I, I may as well say, who willed absolutely that her father, otherwise in this reluctant, tried her with brushes: I who encouraged her always to the worthy enterprise, I, in short, who saw myself considered worthier than any other for all conference and council in the weightiest matters and for the most important works . . .'

We don't know how her father felt being sidelined in such a blunt way - or how Elisabetta herself felt about Malvasia taking credit for her success.

Elisabetta's energy was limitless. As well as working from dawn to dusk, she also opened a school for women artists, the first in Europe outside a convent. Other women artists had taught female students, but no one had run a school on this scale before. Of her twelve students, Ginevra Cantofoli, Veronica Fontana and Veronica Franchi were to become professional artists themselves; her sisters Barbara and Anna Maria also joined Elisabetta in the studio and became proficient enough to be commissioned to paint altarpieces. One of the significant, even radical, aspects of Elisabetta's school is that it took in women who had artistic ambitions but who weren't from artistic families - a rare opportunity in the seventeenth century. But Elisabetta's accomplishments didn't stop with art: she was also a gifted musician and regularly played for gatherings of patrons, friends and family.

Seventeenth-century Bologna was prosperous: in the sixteenth century alone thirty-nine palaces were built in the city. It had a progressive, humanist culture; it had accepted female teachers at

its university since the twelfth century and women students from the eighteenth century. In 1732 the world's first female university professor, Laura Maria Caterina Bassi Verati, was appointed Chair of Physics of Bologna University. Unusually for the time, the city was also proud of its women artists, who blossomed in its relatively liberal atmosphere: we know of twenty-two women working professionally during this time. Bologna is the only Italian city that boasts a female saint who was also a painter. Interestingly, while Luke the Evangelist is considered by the Roman Catholic Church to be the patron saint of artists (along with - curiously - physicians, bachelors, surgeons and butchers), in Bologna he is usurped by St Catherine, an aristocratic saint who was, in fact, the city's first known female artist. Born Caterina de Vigri in 1413, she was also a nun, founder of the city's Poor Clare convent and a poet.

Elisabetta was exceptional, by any standards. She was renowned not only for her prodigious skill but for the speed at which she worked; it's almost as if she knew that she didn't have much time. Perhaps conscious of what happened to the legacy of so many women artists after they died, she compiled a list of around 200 of her works and signed and dated many of her paintings. At her premature death she left behind more than thirteen altarpieces, at least 150 paintings and hundreds of drawings and etchings - and the list is incomplete.

Women artists of the seventeenth century were, in the main, expected to paint portraits, which, so the theory went, demanded less invention than religious or historical subjects. Elisabetta was not one, however, to do anything in a conventional manner. She had access to her father's library where she was able to research ideas for her pictures: he owned texts that were essential to the Renaissance artist, including Pliny's *Natural History*, both Plutarch's and Vasari's *Lives*, Ovid's *Metamorphoses* and Cesare Ripa's *Iconologia*. Exploring a range of both secular and sacred subjects, Elisabetta became the first woman in Bologna to specialise in history painting.

(Out of her huge oeuvre she only painted thirteen portraits.) The focus of almost half of her output is religious in subject matter – mainly devotional pictures of the Madonna and Child, who she depicted in a warm and human fashion, but she also painted scenes from the Old Testament. Fifteen per cent of her output, however, consists of allegories and historical subjects. Many of these paintings feature powerful women including Cleopatra, Judith, Portia, Timoclea and others; although recorded, many of the paintings are now lost.

Elisabetta was so prolific that rumours abounded that she could not possibly have been the sole author of her work. To refute her disbelievers, on 13 May 1664, she invited an audience into her studio to watch her work on a painting commissioned by Cardinal Leopoldo de' Medici on the subject of Justice, Prudence and Charity. Elisabetta noted in her inventory that the Grand Duke Cosimo III de' Medici witnessed her finish the commission in one sitting and was so impressed that he commissioned Elisabetta to paint a Madonna. Very matter-of-factly, she writes that: 'he ordered me to make a Blessed Virgin Mary for himself, and I did it at once and in time, so that on the day of his return to Florence, he had it with him'.

Unsurprisingly, the young artist – phenomenally gifted, beautiful, vivacious – became something of a celebrity; she was even the focus of a cult who believed she was the reincarnation of the legendary Bolognese painter Guido Reni, whose tomb she was to share. Her studio was often filled with visitors: it's a wonder she found time to paint. Her patrons included, along with Cosimo, such luminaries as his uncle Leopoldo de' Medici, the Duchess of Braunschweig and the Duke of Mirandola; papal legates, senators and cardinals. As an indication of her standing in Bologna, one local businessman, Simone Tassi, bought five paintings by her and the local banker, Andrea Cattalani, owned seven of her works – and Elisabetta was the only female painter whose work

he collected. He commissioned her wildly original 1659 interpretation of the story of Timoclea; like Judith and Holofernes (which Elisabetta also painted a version of), it's a tale of female retribution that was first told in Plutarch's *Lives*. When Alexander the Great's army invaded Thebes in 335 BCE, a captain raped Timoclea, a 'matron of high character and repute'; he then asked her if she knew of any hidden money. She led him to a well in her garden and pointed into it. While her assailant was peering into its depths, she pushed him over the low wall, and then, as he lay injured, stoned him to death. This is the moment in the story that Elisabetta chose to tell. As the subject of a painting, it was a bold choice and one that upturned contemporary stereotypes of women, who were considered virtuous but physically weak and intellectually without initiative; men on the other hand were, of course, considered powerful and courageous. In most painted versions of the story, Timoclea is pictured at a different moment in the narrative: when the heroine, along with her children, is questioned by Alexander about his captain's murder and he is so impressed by her that he lets her go free. Until Elisabetta's painting, Timoclea's bravery had hardly been represented in Italian art. The young artist depicts her as self-possessed, beautiful and, despite her grace, strong - strong enough to shove a captain into a well. She is also calm, seemingly unruffled by her violent act. The captain, on the other hand, is pictured in the most humiliating pose imaginable: in the instant before he plunges into the well, he flails about, trying to save himself; he is upside down, his legs askew, his body framed by his red cape, which billows around him like the intimation of blood. His bare legs and arms reveal how young and fit he is, but he's no match for the dignified Timoclea, who gracefully sends him into the void.

Gaze at Timoclea's face for a while, and something becomes apparent: she is familiar. Elisabetta inserted herself into many of her paintings and this one is no exception. Seen side by side, the

protagonist in Elisabetta's self-portrait and her painting of Timoclea feature the same woman: the small chin, the pale, heart-shaped face, the dark hair and the lively eyes. Elisabetta is Timoclea.

On 25 August 1665, Elisabetta died suddenly with extreme stomach pains – which in recent years has been diagnosed possibly as a chronic ulceration of the stomach and duodenum. Her devastated father accused a servant in her household, Lucia Tolomelli, of poisoning her young mistress. She was put on trial for her murder, but the claims were eventually withdrawn. Rumours of foul play have persisted to this day; even her contemporary, the artist Ginevra Cantofoli, who was twenty years older than Elisabetta, was insinuated to have plotted her murder because of a rumoured love rivalry.

Elisabetta's funeral at the Basilica of San Domenico in Bologna was lavish. Despite her family's humble origins, the city turned out to pay its respects and, as mentioned, she was buried in the same tomb as Guido Reni, beneath a faux-marble Baroque sculpture titled *The Temple of Fame* that included a statue of the artist painting. 'She is mourned by all,' wrote the Gonfalonier of Justice to Cardinal Leopoldo de' Medici; 'the ladies especially, whose portraits she flattered, cannot hold their peace about it. Indeed, it is a great misfortune to lose such a great artist in so strange a manner.' A local poet, Piccinardi, penned *Il Pennelo Lacrimante* (The Crying Brush) to lament the death of the young artist. Malvasia included Elisabetta's biography in his book *Felsina pittrice: vite de' pittori Bolognesi* (Lives of the Bolognese Painters, 1678), and described her as 'the scorn of nature, the prodigy of art, the glory of the female sex, the gem of Italy and the sun of Europe'. Yet, despite her formidable achievements, Elisabetta's lack of a husband was still a source of disapproval.

For a young Western woman in the twenty-first century to be single at the age of twenty-seven is, of course, a normal state of affairs. Not so for women in seventeenth-century Italy. Malvasia even

went so far as to imply that Elisabetta's death was brought about by her celibate state. He wrote that her body may have generated the poison that he believed killed her, 'because of the extravagance of the workings of the matrix in this woman in particular so lively and spirited: mostly because of having to conceal the yearning for a husband proposed to her and by her father refused'.

While it's obviously impossible from this distance to know anything about Elisabetta's sexuality, it is fair to assume that she would have been familiar with the work of Sofonisba Anguissola, whose first marriage at forty would have been considered highly unorthodox. She would also have been aware of her Bolognese compatriot, the famous portrait painter Lavinia Fontana, who was born roughly eighty years earlier, in 1552, and who achieved widespread fame despite raising eleven children. We can only imagine the earlier artist's exhaustion - and how alarming her example might have been to a young, ambitious artist.

Elisabetta's dazzling achievements have been somewhat overshadowed by the drama surrounding her untimely death. I prefer to think of this brilliant and restless young artist as she portrays herself in her great self-portrait: intensely creative - and totally in charge.

My Grey Hair

Over the past six centuries, women have had little to gain from advertising themselves as ageing, as few patrons would have appreciated being reminded of either their own mortality or anyone else's - especially that of women, who, going by the paintings that populate most museums, are preferred young and beautiful. As a result, the female self-portrait is often an idealised image; the painter depicts herself as younger, happier, more charming than perhaps she was necessarily feeling at the time. (Elisabeth Vigée Le

Brun's cheerful self-portrait just after her desperate escape from the French Revolution and down to Italy is a case in point.) However, there are rare instances of artists defying convention and portraying themselves, with unflinching observation, getting older.

Around 1610, Sofonisba Anguissola painted the first self-portrait of a woman in old age. She is seventy-eight or so; her intelligent dark eyes blaze from her pale, wrinkled face; her thin lips are pursed, possibly due to her lack of teeth; her grey, thinning hair is held neatly beneath a veil. Her worn hands are stark against the stern black of her dress; in her right hand she holds a message to King Philip III of Spain, whose father had welcomed her into court when she was young: it reads 'To his Catholic Majesty, I kiss your hand, Anguissola'. Frances Borzello suggests that 'unable to journey from Italy to pay her respects in person, she paid them in paint'.

One hundred and twenty years after Sofonisba's self-portrait as an older woman, Rosalba Carriera - one of the most successful artists of any era - depicted herself not only as someone who has aged, but as the embodiment of the passing of the seasons, as if she were not only a woman but a landscape as well. In her 1730-1 pastel *Self-Portrait as 'Winter'*, which she made in her late fifties, her grey hair is echoed by the pale fur at her collar: hers is a fearless scrutiny of the ageing process. She is a landscape both frozen and yet full of feeling. Her gaze is blunt and direct; although she was to live for another twenty-five years or so, as if sensing her mortality, she pictures herself as the embodiment of the coldest season; a time when the earth might be hard and unyielding - dormant, but still very much alive.

Rosalba was born in 1673 in Venice to a family of modest means; her father was a clerk and her mother a lace-maker. She was a rare exception to the rule that most pre-nineteenth-century non-aristocratic women artists were the daughters of artists. From an

early age she helped her mother in her trade; perhaps it was the delicacy of the material she handled day in and day out that led to her interest in miniatures. Although she was possibly trained by Giuseppe Diamantini - described on the Uffizi website as 'the undistinguished Venetian painter' - Rosalba was in the main self-taught. She was, however, all too aware of what she was up against. 'What gives men the advantage over us,' she wrote, 'is their education, the freedom to converse, and the variety of their affairs and acquaintances.'

She began her career by painting tiny portraits on the lids of snuffboxes - she was the first artist to paint on ivory, as opposed to vellum.* Rosalba was soon in high demand and was commissioned to paint portraits of aristocrats and the nobility, including Maximilian II of Bavaria and the twelve most beautiful women of the Venetian court. She was elected to Rome's Accademia di San Luca in 1704, painted portraits of Louis XV as a boy and the renowned artist Antoine Watteau and was admitted to the French Académie Royale. Yet, despite her remarkable achievements, critics focused on her looks. One contemporary writer wrote of her that:

> Beauty, which is the common lot of women, was missing in Signora Rosa Alba Carriera. This deficiency, if it is indeed one, was well compensated for by the qualities of soul and by the superior talents with which nature had provided her [. . .] Moreover, love could not divert her from her course; a woman shielded by ugliness is safe from lovers.

Frederick-Augustus II, elector of Saxony, filled a room in his palace with a hundred of her pastels, a medium in which she excelled and which she helped transform into a respected and highly collectable

* While the killing of elephants for a painting support is something that most of us now would find repellent - and, of course, it's banned in most countries - 400 years ago, debates around animal welfare were rare to non-existent.

art form; she was also an influential teacher and mentor to young women artists. In Austria, Rosalba was championed by the Holy Roman Emperor Charles VI, who bought more than 150 of her works; she also taught the empress painting. In 1713 she painted the portrait of Augustus III of Poland; she instructed his wife, too. The king was to become her most enthusiastic patron (and he certainly had competition): he too bought more than 150 of her pictures. But as is clear in her *Self-Portrait as 'Winter'*, although she often flattered the subjects of her commissioned portraits, when she rendered her own features, she was brutally honest, rejecting any hint of idealisation. I have a feeling she didn't give a damn what her critics thought of her.

Rosalba's sister Giovanna was her great friend and helped manage her career; her beautiful pastel *Self-Portrait Holding a Portrait of her Sister* from 1715 is a delicate study of the warmth and affection the siblings had for each other. Although Giovanna is depicted as a picture within a picture, it's as if we've interrupted a conversation between them. The artist was devastated when, in 1738, Giovanna died. (Her other sister, Angela, was married to the artist Antonio Pellegrini.) Eight years later, Rosalba's grief was compounded by another tragedy; she became blind, a condition possibly brought on by the strain on her eyes from painting miniatures. She died in Venice at the age of eighty-four; her fame was such that in Great Britain she inspired something of a craze among women to become pastel portraitists, and her diary was published in 1793 to much acclaim. But for all her glittering success, her *Self-Portrait as 'Winter'* tells another story: one of clear-eyed self-determination, of someone less interested in the trappings of wealth than in the artist's role as an observer of time.

Self-Portrait Hesitating

Clear-eyed self-determination is something that every artist requires to forge a successful career. But to remain determined when society is determined to exclude you requires not only talent but an unwavering belief in what you are doing. The story of the founding of London's Royal Academy is a case in point.

On a cold London day in the winter of 1768, King George III was visited by the architect Sir William Chambers. He presented the king with a petition signed by thirty-six artists and architects seeking royal support to 'establish a society for promoting the Arts of Design', an annual exhibition and a school. Unlike Paris, London had no royally approved academy and the private academies that did exist were small; the feeling among the city's artists and patrons was that London needed an institution to rival the French model of artistic support.

The king readily agreed. On 10 December, Sir Joshua Reynolds was made president and the thirty-six founder members were named: they included two women, Mary Moser and Angelica Kauffmann. Johan Zoffany, one of the members, was chosen to commemorate the founding of the RA with a group portrait, *The Academicians of the Royal Academy* (1771-2), which depicted the founders in the life studio.

The two women are portrayed not among their male colleagues – who are seen gathering in the life studio, alongside a naked model – but by two small, monochrome, near-unrecognisable portraits on the wall. The reason? They were not allowed to enter the room to join their colleagues because the powers-that-be deemed that their fragile feminine souls would be shocked and corrupted by a display of unclothed male flesh. It makes you wonder how the women of the time ever got pregnant. It also makes you wonder why Angelica and Mary's male colleagues didn't suggest moving to

a location where the women would be allowed to be seen in their rightful place alongside the men.

It is not difficult to imagine how irritated Angelica and Mary must have felt at being included among their male colleagues by two small, monochrome, near-unrecognisable portraits on the wall. As Angelica's first biographer, Frances A. Gerard, observes: 'Zoffany has done very little justice to them – at least, to Angelica, whom he deprives of all her beauty and re-makes her a prim, hard-faced woman.' They look down at the men like small birds in a tree.

King George III liked the portrait so much that he bought it.

So who were these two women? Although Mary Moser did paint portraits, she was renowned for her flower paintings. My focus here is on Angelica Kauffmann, who was to become one of the leading history painters of her day: time and again she used allegory as a springboard to reflect on history, politics – and her own place in the world.

She was born on 30 October 1741 in Chur, Switzerland. Her father was an impoverished artist who encouraged his daughter's interest in art; her mother, Cléofa Lucci, was apparently equally enthusiastic. By the age of eleven, Angelica's prodigious talents were widely recognised; she was a gifted musician, spoke four languages, and was commissioned to paint portraits of aristocrats and members of the clergy, such as the Bishop of Como, Nevroni Cappucino. Her mother died when Angelica was thirteen and she and her father moved from Como to Milan and then to Schwarzenberg in Austria before returning to Italy, where Angelica became a member of the Accademia di Belle Arti di Firenze in 1762 – an extraordinary achievement for a woman of only twenty-one. As famous for her charm as she was for her artistic gifts, she became a fashionable portraitist for British tourists in Rome – then the centre of the Western art world – and became best friends with Sir Joshua Reynolds (they painted each other's portraits). In 1764 she painted

a portrait of the famous German art historian and archaeologist, Johann Joachim Winckelmann: she depicts him deep in thought in a dark room, writing in a book that is resting on a bas-relief of the Three Graces. Her fame was now assured.

In 1766, encouraged by Reynolds, Angelica moved to London, where she introduced the latest neoclassical ideas and established herself as a professional artist. Although 'self-advertisement was thought to be unfeminine', she was a canny self-promoter. Two months after her arrival, she wrote to her father: 'I have four rooms, one in which I paint, the other where I set up my finished paintings as is here the custom [so that] the people [can] come into the house to sit - to visit me - or to see my work; I could not possibly receive people in a poorly furnished house.'

A talented, beautiful and independent woman, it was inevitable she would have her detractors. She had to deal with a great deal of gossip; one rumour had it that she was 'intimate' with Reynolds and there was a scandal when she 'was alleged to be the half-nude woman in the corner of the Irish artist Nathaniel Hone's (1718–84) satirical portrait of Reynolds'.

The year before the inauguration of the Royal Academy, however, Angelica's life was marred by a terrible scandal: she was duped into marrying a man who presented himself as Frederick de Horn, a wealthy Swedish count - he was, in fact, a brute, a swindler and a penniless valet. They broke up within a few months and never saw each other again, but not before he had humiliated Angelica and stolen her savings. The betrayal was swiftly followed by distressing rumours of a bizarre conspiracy that was published in the *Manuel des Curieux et des Beaux Arts* magazine: namely, that Reynolds had somehow had a hand in the affair. Why he might have wanted to have anything to do with such a terrible episode is unclear. Frances Gerard - whose book on the artist was published in 1893 - documented the case, and mentions that 'Angelica herself, in the public papers, addressed a letter to the editor of the *Manuel*

des Curieux et des Beaux Arts denying there was any truth in these assertions'. Gerard then says:

> From other sources of information, however, there is not the smallest doubt that this contemptible mystification was planned for the humiliation of the artist and that Reynolds had a hand in the game. Whether it was he, or a friend of his, an artist, who had proposed for Angelica and been refused it is enough that out of revenge these two concocted the plot to disgrace her.

Gerard concludes by theorising that the terrible deception was masterminded by two Irish artists, Nathaniel Dance and Nathaniel Hone; Angelica had apparently rejected Dance's advances, and both wanted to slur Reynolds's name. Whatever the truth of the matter, Angelica and Reynolds weathered the crisis and remained friends for the rest of their lives.

Thankfully, in the wake of these devastating events, Angelica's friends rallied around and she gradually recovered financially – she was, by now, supporting her father and paying for the running of her household. She received commissions from Lords Exeter and Spencer and even painted King George III's portrait, something Reynolds didn't have the honour of doing until 1779. No doubt her appointment as a Royal Academician would have gone some way to restoring her pride and Angelica rose, once again, to become a popular society artist; her paintings were included in the annual RA exhibition every year from 1769 to 1782.

Although Angelica earned her living primarily as a portrait painter – we know of twenty-two portraits, of which nine are self-portraits – she considered herself primarily a history painter. In one year alone – 1768 – she painted *Hector Taking Leave of Andromache*; *Venus Directing Aeneas and Achates to Carthage*; and *Penelope Taking Down the Bow of Ulysses*. These are paintings that seem to have emerged fully fledged from a dream: all of the drama of the

Greek myths has been subsumed into something much quieter and introspective: tender scenes of human interaction.

While the tone of Gerard's biography is largely adoring, she is in parts quite surprisingly savage; after listing Angelica's qualities as an artist, she dismisses some of her paintings because they are 'dreadful', 'repeat themselves with wearisome fidelity' and 'her heroes look like girls dressed up as men' - something which shouldn't perhaps have been surprising, given that women were barred from the life-drawing room. But curiously, what Gerard seems most irritated by is Angelica's interest in allegory:

> Angelica's strange predilection for classical and mythological subjects, and the treatment of sitters in allegorical form, has often been commented on [. . .] Angelica perhaps lent herself to this fashion more than any other artist, for the reason that it was her taste. It was a false taste, however, portraiture was not to be dignified by transforming ladies of the eighteenth century into heathen goddesses and investing them with the attributes of the Pantheon. Angelica, however, was by no means the only artist who pandered, so to speak, to the fancy of her sitters, very few having the courage to resist this classical mania. We find Reynolds one of the chief offenders.

Perhaps it was fortunate that Gerard, despite her enthusiasm for some of Angelica's work, wasn't born until long after the artist had died.

In 1781, in London, Angelica married the Venetian artist Antonio Zucchi - a man, by all accounts, who was the opposite of her first husband. In July that year, accompanied by her father, they sailed for Ostend and eventually settled in Venice, where Angelica's portraits were in high demand. However, when her father died in the city in January 1782, Angelica couldn't bear to stay. Grief-stricken, they moved to Naples, where Angelica made sketches for a royal

portrait, and then to Rome, where she became close friends with the renowned writer Johann Wolfgang von Goethe - who she painted in 1787.

It was in Rome at the age of fifty-three that Angelica painted her large *Self-Portrait of the Artist Hesitating Between the Arts of Music and Painting* (1794). An allegory as much as a self-portrait, Angelica reflects on the choices she made as a young woman, when she was torn between her two loves - music and painting - at which she was equally gifted. The painting's theme is both literal - at some point, Angelica did have to choose between the two arts - and was inspired by the classical tale of Hercules choosing between Pleasure and Virtue. Angelica depicts herself as a young girl dressed in white in between the figure of Music - a somewhat passive, voluptuous woman in red holding a score, who gazes at her imploringly - and that of Painting, embodied by a far more dynamic figure in blue, with a billowing red sash. The latter's left hand grips a palette; her right hand urgently points to a far-off temple, atop a steep hill. Despite the fact that music was an easier profession for a woman to excel in at the time and had the added bonus of having no life studios to be barred from, Angelica's decision is clear: she gently squeezes Music's hand, as if in apology, while moving towards the steep hill that Painting gestures to: the road to becoming a painter might be difficult, but it's where she's headed.

Despite its allegorical focus, the painting is based on an episode in Angelica's youth when she had to decide whether to pursue an artistic or a musical career. Apparently undecided, she asked a priest for advice: he replied that painting 'was a nobler as well as morally safer profession for a young woman to follow'. The subject had been on her mind for a long time. Forty years earlier, Angelica had painted her startlingly self-aware *Self-Portrait Aged Thirteen*: it's an image of a young girl, seen from the waist up, dressed in Rococo finery - a blue silk dress, a pink bow, a black velvet ribbon at her

throat - who looks out at us with a bold, faintly questioning, expression. She's holding a musical score, which she has seemingly turned to show us. It's hard not to assume that she's asking us for our opinion as to what she should do.

When Angelica died in 1807, the sculptor Antonio Canova directed her funeral. A commemorative bust, sculpted by her cousin Johann Peter Kauffmann, was placed next to Raphael's in the Pantheon in the heart of Rome. Her fame was such that her biography was published in 1810 by the poet and biographer Giovanni Gherardo de Rossi; it was the basis of a romance by Léon de Wailly in 1838 and inspired Anne Isabella Thackeray's 1875 novel *Miss Angel*.

From the 1840s, numerous petitions for women to be accepted as students into London's Royal Academy had been submitted to the House of Commons - but they had all been turned down. In 1860, fifty-three years after Angelica's death, a twenty-nine-year-old aspiring artist, Laura Herford, was fed up. She wanted to enrol at the RA as it was the pre-eminent place to learn painting in London, but she was under the impression - as was everyone else - that women were not permitted to apply. She had been studying with the proto-feminist artist Eliza Fox in her flat in Regent's Park and had signed the petition published in the *Athenaeum* magazine in 1859 requesting, to no avail, that the school open its doors to women. She decided to take the law into her own hands. She applied with the required entrance forms and examples of her drawing. However, she amended her name to her genderless initial - and L. Herford Esquire was accepted as a student. When her sex was revealed, despite the school's resistance to accepting women, an extraordinary discovery was made: no specific rule excluding women had ever been written into the Academy's charter - and so the Royal Academy was forced to accept her. Laura was a trailblazer: although she was to die only ten years later, during her

lifetime thirty-four young women followed her example and were accepted into the school – and Laura's work was exhibited twelve times at the Royal Academy.

The battle for equality, however, was far from over. Women students might have found their way into the school, but they were not permitted to attend life-drawing classes – and learning how to draw the nude figure was a central skill-set to becoming a professional artist. In 1878 a petition signed by thirty-five women students – in language that is heartbreaking in its humility – beseeched the authorities that:

> We venture therefore knowing that you have ever been our true friend very respectfully to ask you to take into consideration the practicability of making some arrangement for which we might be enabled to study from the figure [semi-draped]. If you can make such an arrangement we assure you that we shall be very grateful for the favour conferred upon us, that we shall diligently and consciously avail ourselves of the help thus given to our striving after excellence.

Their request was denied. It was the first of many rejections over the next two decades. How exasperating it must have been. In 1883 the language of the petition is more combative and an economic case was made for life-drawing classes. Now with ninety signatories, the petition declared:

> We beg to lay it before your notice that almost all of us rely on the profession we have chosen as our future means of livelihood. Therefore a class which is considered so essential to the training success of male students must be equally so to us. We venture to hope that the separation of male and female students in the upper schools of the Academy may have removed an important objection against the granting of our request.

Although their request was, after 'considerable discussion', granted, it was soon rescinded after a new council had been formed – and they consulted the all-male artist members of the Academy. Women were finally granted permission to study 'the partially draped model' in 1893 – twenty years after the first petition. It took 168 years from the appointments of Angelica Kauffmann and Mary Moser for a woman to be elected to full membership of the Royal Academy: Laura Knight in 1936.

4

Hallucination

We navigate the world from inside our bodies. However extroverted, our interior worlds are the ones we're most familiar with: a space of ideas, plans and non-sequiturs, reveries, dreams and unconscious prompts that jostle like a crowd at a football match for attention. It's a wonder anyone can communicate even a sliver of the complexity of it at all.

It's a startling thought that despite our preoccupation with how we appear, we don't ever, if we don't want to, have to look at ourselves. We are at liberty to avoid mirrors.

Considering how fractured our lives frequently feel, a kaleidoscope might be a better reflection of reality than a single image. Surrealism understood - understands - this: the most bizarre juxtapositions can, conversely, be the most accurate way of communicating a sense of dislocation. Lives are messy things: they have a habit of veering off script. A lack of logic can express more about the human condition than something more literal or straightforward. As a case in point: when the world was busy blowing itself up in World War I, Dada - the anarchic, hilarious, howling protest movement that prefigured Surrealism - was launched by the performer and writer Hugo Ball and the poet and puppeteer Emmy Hennings at the Cabaret Voltaire in Zurich; with typical Dadaist resistance to convention, there is no consensus on the date, but it's usually agreed to have been sometime in 1916.

The Dadaists - a group in which brilliant women such as the collagist Hannah Höch and sculptor Sophie Taeuber-Arp were central

- argued for a language that represented an actual, as opposed to an ideal, version of life; embodying absurdity was, for them, the most accurate reflection of the horror that was engulfing much of the planet. Night after night, as battles raged across Europe, the Dadaists staged puppet plays, held parties and spouted absurdist poetry. The mask was central, literally and as a metaphor: the human condition, they suggested, could only be fully revealed by covering it up with something else. Dada's ammunition may have been laughter, but its goal was deadly serious. Writing in his diary in 1916, Hugo Ball famously declared: 'Every word that is spoken and sung here [Cabaret Voltaire] says at least this one thing: that this humiliating age has not succeeded in winning our respect.' For the Dadaists, absurdity was a way of simultaneously expressing the uneasy relationship that exists between the deep mysteries of the self and the often bewildering and bureaucratic machinations of daily life.

I Do Not See the (Woman) Hidden in the Forest

In 1929 the Belgian artist René Magritte made a collage: *I Do Not See the (Woman) Hidden in the Forest*. It depicts a naked woman looking to one side and covering one of her breasts with a hand. She is surrounded by sixteen head-and-shoulder photographs of men in suits and ties. They all have their eyes closed. They are the core group of Dada's heirs: the writers and artists known as the Surrealists.

The writer André Breton had founded the movement with the publication of his typically hyperbolic *Manifeste du Surréalisme* (Manifesto of Surrealism) in 1924. In it, he defines the term:

SURREALISM, *n*. Psychic automatism in its pure state, by which one proposes to express - verbally, by means of the written word,

or in any other manner - the actual functioning of thought. Dictated by the thought, in the absence of any control exercised by reason, exempt from any aesthetic or moral concern.
ENCYCLOPEDIA. *Philosophy*. Surrealism is based on the belief in the superior reality of certain forms of previously neglected associations, in the omnipotence of dream, in the disinterested play of thought. It tends to ruin once and for all other psychic mechanisms and to substitute itself for them in solving all the principal problems of life.

In another famous group portrait of nine Surrealist artists, in 1930 Man Ray photographed himself along with Jean Arp, Breton, René Crevel, Salvador Dalí, Paul Éluard, Max Ernst, Yves Tanguy and Tristan Tzara. Again, all men.

The first Surrealist exhibition took place in Paris in 1925 at the Galerie Pierre: no work by a woman was included. Yet, female artists were associated with the Surrealists from at least 1924. Perhaps this accounts for Breton's bafflement in his second Surrealist manifesto of 1930: 'The problem of woman,' he wrote, 'is all that is marvellous and troubling in the world.'

Despite the anti-authoritarian thrust of Surrealism, and its celebration of liberating the creative potential of the unconscious, it was, in many ways, narrow in its focus. It didn't question the power structures that reiterated the traditional roles of race, class, gender and sexuality: its founding members were overwhelmingly white, male and straight, and they perpetuated the art-historical cliché of woman as a passive receiver and man as an active maker. In Breton's first manifesto, women are mentioned in passing, and in relation to men, to whom his tract is obviously directed. Despite the fact that Breton had written of 'the eternal power of woman, the only power before which I have ever bowed', he and his fellow male Surrealists loved 'woman' as a symbol: the embodiment of untrammelled freedom, fecundity and productivity, a sensual or

savage girl-child whose power lay in her abilities to seduce, to con-found reason, to mystify. Women were, at best, youthful muses and helpmates, a source of inspiration and solace – but, with a few miraculous exceptions, never serious creators. What the Surreal-ists couldn't grasp was woman as simply a fellow human being – or as someone who had, say, artistic ambitions herself.

Many of the women, however, grew tired of their unreality in the eyes of the men. When asked in 1983 about her role as a teenage Surrealist muse in the 1930s, the sixty-seven-year-old British-born Mexican artist and writer Leonora Carrington – who had been the epitome of the beautiful wild-child – was dismissive. 'I didn't have time to be anyone's muse. I was too busy rebelling against my family and learning to be an artist.' In 1990, when she was ninety-one, the British/Argentine artist Eileen Agar, the only Brit-ish woman artist to be included in the 1936 International Surrealist Exhibition in London, was interviewed by Cathy Courtney about her life for *Artists' Lives*. When asked about her acceptance by the Surrealists, somewhat baffled, she remembered that: 'Men thought of women simply as muses, they never thought that they could do something for themselves, and I'm always astonished how they let me into the 1936 Exhibition.'

In the *Artists' Lives* interview, she says that Breton – a man ap-parently so gallant to women that he had 'elevated the hand kiss to a Surrealist rite' – had never seen the artworks created by his wife, Jacqueline Lamba, because 'she'd been too frightened, she'd kept them in a cupboard or something'. Eileen remembered hearing that someone had once said to Breton about Jacqueline that 'You know that she's a very good painter' and he had replied: 'I've never seen anything she's painted.' This is astonishing, considering that Jacqueline studied art and was included in the 1936 International Surrealist Exhibition. You can almost see Eileen shaking her head. She concludes with: 'It's amazing, isn't it? Yes, it's absolutely mad. To think of it nowadays!' It's telling that Jacqueline didn't have her

first solo show until 1944 (at New York's Norlyst Gallery), after she and Breton had split up.

Breton had concluded his manifesto with an ambiguous statement:

> Surrealism is the 'invisible ray' which will one day enable us to win out over our opponents. 'You are no longer trembling, carcass.' This summer the roses are blue; the wood is of glass. The earth, draped in its verdant cloak, makes as little impression upon me as a ghost. It is living and ceasing to live which are imaginary solutions. Existence is elsewhere.

Given such ambiguity, it's important to stress that despite the vocal protestations of the Surrealists themselves - who were, ironically, prone to ejecting members from their anarchic group for not toeing the party line - Surrealism evolved into a loose-fitting label, more an adjective than a noun. When asked how she defined it, Eileen Agar's answer was simple: 'It means the element of surprise in whatever you do.'

As a movement, Surrealism doesn't have a monopoly over representations of dreams and reveries, the intermingling of impossibility with hope or the playing out of wish fulfilment. Artists have long made art in response to life's complications and unreason, and many of the women associated with Surrealism baulked at describing themselves as members of the group: they were simply part of an organic network of friends, artists and lovers. Yet, however talented and artistically driven, juggling their roles as muses, wives and mothers often proved difficult. When asked how the female Surrealists envisioned their futures as artists, Eileen Agar said:

> Well, it would be difficult, because most men thought, 'Oh well, the women will get married and have children, and they'll forget

about art.' You see, once you have a child, you're fixed to the child, and you may draw a little something, but that's why I decided I'd never have children. I thought, 'You can't do both.' Once you have a child, the child comes first, and away goes your art. So, I just decided that I'd never have children, you see, then I could be as free as I wanted.

Gertrude Abercrombie, Eileen Agar, Leonora Carrington, Claude Cahun, Ithell Colquhoun, Leonor Fini, Valentine Hugo, Frida Kahlo, Sheila Legge, Dora Maar, Lee Miller, Meret Oppenheim, Alice Rahon, Stella Sneed, Dorothea Tanning, Toyen, Remedios Varo and others - the list of significant women artists associated with Surrealism is long and by no means complete. Yet, they don't appear in formal portraits of the Surrealist group until about 1936 and some of them - in particular Claude Cahun, Leonora Carrington, Leonor Fini and Frida Kahlo - had no interest in joining a movement that they perceived as being either prescriptive, macho or imposed upon them.

Despite their initial exclusion, the fact that Surrealism quickly took off worked in the women's favour. Exhibitions staged beneath its metaphorical banner were held not only in Paris, but in London, New York and elsewhere. The more exposure it got, the more women became involved - and recognised. In a portrait of the artists taken for the International Surrealist Exhibition in London in 1936, along with men including Rupert Lee, Ruthven Todd, Salvador Dalí, Paul Éluard, Roland Penrose, Herbert Read, E.L.T. Mesens, George Reavey and Hugh Sykes-Davies, are Diana Brinton Lee, Nusch Éluard, Eileen Agar and Sheila Legge. One other woman is included but she is nameless: simply, 'a friend of Dalí's'.

In 1939, Breton's influential *Anthology of Black Humour* was published and the term 'black humour' - the 'mortal enemy of sentimentality' in Breton's words - was born. With World War II looming, his timing was apt. In his introduction to the book,

Breton warned against employing humour to didactic ends: 'One might just as well try to extract a moral for living from suicide.' Yet, in a sense, his philosophy did have a practical side to it: 'There is nothing,' he wrote, '[. . .] that intelligent humour cannot resolve in gales of laughter, not even the void.'

The anthology serves as a taster of Surrealism's literary antecedents and contemporaries at the time of its publication: it opens with Jonathan Swift and then follows, chronologically, with writings by the Marquis de Sade, Charles Baudelaire, Lewis Carroll, Franz Kafka, André Gide, Marcel Duchamp and others: essays, short stories and aphorisms by forty-five writers. Only two entries are by women: Leonora Carrington, who was twenty-two at the time of publication, and the Greek child prodigy, Gisèle Prassinos, whose first collection of stories, *La Sauterelle arthritique* (The Arthritic Grasshopper), was published in 1935 when she was fifteen: its preface was by Paul Éluard and it was illustrated with photographs by Man Ray. Breton chose Leonora's brilliant, brutal short story 'The Debutante', which had been one of five stories published in her collection *The Oval Lady* in 1939: it was illustrated by Max Ernst. It concerned the travails of a young woman who, desperate to avoid a ball given in her honour, employs a female hyena she has freed from the zoo to take her place; she prefers to remain in her bedroom and read *Gulliver's Travels*. The hyena eventually agrees to her plan; the debutante is only slightly concerned when the animal rips a young maid's face off to use as her own. The female hyena is revealed at the dinner party as a beast, not a girl, because of her awful stench. Although the animal eventually escapes with 'a great bound', there's a sense that, before long, human and animal will be happily reunited; after all, when they first meet, they passed 'many pleasant hours' together and the hyena is the girl's 'only friend'.

In her art and in her writing, Leonora made clear, again and again, how - despite her boldness - unseen she felt; that her family never understood the sheer force of her creativity and how

essential it was to her sense of self. In an interview with Heidi Sopinka that took place in Mexico City when she was ninety-two, Leonora remembered: 'There was a time when female artists were totally invisible. There have always been female artists, but since females were considered to be an inferior animal, we don't know too much about them.' When asked if the male artists she knew when she was starting out were supportive, she replied, without mentioning any names: 'Few of them, not all of them. One of them once said, "There are no women artists." So, I told him, "All you have to do is open the door, walk down the passage, and you'll find the street!"'

Thanks to Peggy Guggenheim, a bright light was shone on the achievements of Surrealist women. At the suggestion of Marcel Duchamp, she organised the first of two exhibitions devoted to women artists at Art of This Century, her gallery in New York. Apart from Peggy herself, the selection committee was comprised totally of men: Breton, Duchamp, Ernst (to whom Peggy was married at the time), the critic and collector James Soby, the curator and art historian James Sweeney, the dealer and writer Howard Putzel, and Max Ernst's son Jimmy, the gallery's first director. The exhibition opened on 5 January 1943 and was bluntly titled '31 Women'. Its line-up was an astonishing Who's Who of artists from sixteen countries, including Leonora Carrington, Leonor Fini, Valentine Hugo, Frida Kahlo, Jacqueline Lamba, Louise Nevelson, Meret Oppenheim, Kay Sage, Dorothea Tanning, Sophie Taeuber-Arp and others. Georgia O'Keefe refused to be included, declaring that she didn't want to be shown as a 'woman artist'. However, despite the quality of the work on show, reviews were largely negative and patronising. The critic of *Art Digest* wrote: 'Now that women are becoming serious about Surrealism, there is no telling where it will all end. An example of them exposing their subconscious [sic] may be viewed with alarm . . .' In 1945 another all-woman show was staged at the gallery: it featured the work of thirty-three women,

was again straightforwardly titled – 'The Women' – and included new names such as Louise Bourgeois and Lee Krasner.

The difficulties of exploring the work of historic women artists, not only in Surrealism but more generally, is made clear by the art historian Whitney Chadwick in her landmark book from 1985, *Women Artists and the Surrealist Movement*. She discusses how their work was considered less serious than that of the men, that it often went undocumented, disappeared into private collections, was lost or destroyed. She explains the problems of resurrecting histories that were never initially considered to be part of the main narrative:

> . . . at times, an invented history has obscured or obliterated the realities of these women, and they appear as if seen through a distorting mirror, slightly out of focus, a little insubstantial. [. . .] Their own stories are often contradictory; the independence of these women serves as a constant warning to the art historian whose language is more often the generalized language of movements and groups rather than that of individuals.

She also – gallingly – discovered that digging into the work of the male artists was considered 'history' whereas her attempts to piece together the lives of the women constituted 'mere gossip'. Granted, this was 1985 – but in the grand scheme of things that's not very long ago at all.

There Are Things That Are Not Sayable

If an artist attempts to portray their inner world in a painting, it follows that all of their work is, in a sense, a self-portrait. For all of its shortcomings, Surrealism offered a new language to artists to express, in a manner as extreme as they wished, what might have

been considered inexpressible in an earlier age: the challenges of being alive, in all of its messy mix of glory, sadness, desire and violence.

You could say that Surrealists are born, not made; that the movement simply gave a name to the ways in which a group of very different artists were making sense of the world and their place in it. Take, for example, Leonora Carrington, who was born a fully fledged Surrealist before the term was coined, on 6 April 1917 to a wealthy Catholic family in Lancashire; her mother Mairi was Irish and her English father, Harold, ran a successful textiles industry. Her family home, Crookhey Hall, which was surrounded by seventeen acres of gardens and woodland, sounds like something from a fairy tale. It looked like one, too: it had turrets, an ornamental lake and a croquet lawn. Although the family (Leonora had three brothers) left the Hall when she was ten, it never stopped haunting her imagination; she was still making pictures of it in her eighties. Breton's line in the Surrealist manifesto that when we cease to sleep we become the 'playthings of our memories' is apposite. Many years later, in her 1965 manifesto *Jezzamathatics*, Leonora described how she:

> ... was born under curious circumstances, in an Eneahexagram, Mathematically. The only person present at my birth was our dear friend and faithful old fox-terrier, Boozy, and an x-ray apparatus for sterilizing cows. My mother was away at the time snaring cray-fish which then plagued the upper Andes and wrought misery and devastation among the natives.

Her family nickname 'Prim' was surely ironic; it couldn't have been further off the mark. From an early age, Leonora rebelled: she was expelled from various convent schools for misdemeanours including writing backwards and attempting to levitate. 'They wrote my father and said, "This child does not collaborate

with either work or play.'" Her mind's eye swirled with images and stories of animal-human hybrids, revenge and uninhibited joy, a mish-mash of myths, nursery rhymes, fairy tales, half-remembered Bible stories. She was taken to a zoo as a treat after her first communion; she fiercely loved and identified with animals - especially horses, which she rode as a child, and hyenas - as living creatures and symbols of inner and, to her mind, more elevated worlds. She strongly believed that everybody had 'an inner bestiary'. At the age of sixteen she was sent to Mrs Penrose's Academy in Florence 'to be finished' and she saw for the first time the work of the artists of the thirteenth and fourteenth centuries. Their faraway faces, make-believe landscapes and otherworldly colours - cinnabar, vermilion, faded blue, burnt umber and gold - gave shape to her visions and allowed her to see that a different kind of life to the one her parents had mapped out for her might be possible.

On her return, Leonora was expected to toe the line of a privileged girl: to be presented at court, to behave decorously, to find the right kind of man to marry, to have children and to run a household. Leonora would have none of it: she wanted to be an artist. Her father suggested an alternative: that she breed fox terriers. There is no record of her reply. He thought painting was 'horrible and idiotic' and that if you did it, you were either 'poor or homosexual, which were more or less the same sort of crime'. Leonora tried to ignore him, read Aldous Huxley's novel *Eyeless in Gaza* in the Royal Enclosure at the Ascot races, and loudly discussed the symptoms of syphilis with a friend in the lobby of a fancy hotel. In 1935 she was, against her wishes, presented to King George at Buckingham Palace and given a ball at The Ritz. She exorcised both experiences in 'The Debutante', the short story that was to so impress Breton. Its opening line: 'When I was a debutante, I often went to the zoo. I went so often that I knew the animals better than the girls of my age.'

She persuaded her long-suffering parents to allow her to study art in London at Amédée Ozenfant's school where she read books on alchemy. When she was nineteen she painted a portrait of her best friend Joan Powell reading Jean Cocteau's *Les Enfants Terribles* (The Terrible Children). In 1936 she visited the International Surrealist Exhibition at the New Burlington Galleries in London's Mayfair: it included the work of more than seventy artists, fourteen of whom were women. Her mother – not realising what she was unleashing – gave her daughter a copy of Herbert Read's newly published book *Surrealism*. (When she was ninety-two, Leonora remembered her response: 'I thought, Ah! *This* I understand.') The book's cover featured a reproduction of Max Ernst's painting *Two Children Menaced by a Nightingale* (1924). When Leonora saw it, she felt 'a burning inside'.

In June 1937, Leonora attended a dinner party hosted by the architect Erno Goldfinger, who was the husband of Leonora's art-school friend, Ursula. They had apartment number 3 in Highpoint; designed by Berthold Lubetkin, it was the first Modernist apartment building in England. Perched high above London on Highgate Hill, it was, aptly, a building for a new future. Max Ernst was also invited to the dinner; he was in London for the opening of his exhibition at the Mayor Gallery.

Leonora was twenty, a strange, wild beauty with loose thick black hair, long limbs and a nocturnal face; Ernst was forty-six, married with children and had a history of affairs (including, in the preceding four years with the singer and actress Lotte Lenya, and with artists Leonor Fini and Meret Oppenheim). He often painted images of supernatural young women; according to Breton, Ernst had 'the most magnificently haunted brain of our times'. Peggy Guggenheim's description of him in her memoir makes him sound like a character from one of Leonora's paintings: 'He had white hair and big blue eyes and a handsome beak-like nose resembling a bird's.' Their connection was instant. Without the knowledge of

Leonora's parents, the two escaped to Paris. Ernst promptly left his wife, the artist Marie-Berthe Aurenche, who was so enraged she stalked them; at one point, Leonora attacked her in a Parisian café. He and Leonora moved to a cottage and studio in St Martin d'Ardèche in Provence, where they drew dreamscapes on the cupboards and laid mosaics in the floor; Ernst sculpted cement casts of guardian birds and animals for the garden; they wrote stories and painted.

In 1938, Leonora's work was included in the International Surrealism exhibition in Paris at the Galerie Beaux-Arts. The show included 229 works by sixty artists from fourteen countries; attendance at its opening night required evening dress and promised hysteria, flying dogs and the presence of an automaton. In the same year, Leonora published her first book of short stories: *La Maison de la peur* (The House of Fear). Ernst illustrated it and wrote the introduction which he titled 'Preface: or Loplop Presents the Bride of the Wind':

> Who is the Bride of the Wind? Can she read? Can she write French without mistakes? What wood does she burn to keep warm? She warms herself with her intense life, her mystery, her poetry. She has read nothing but drunk everything. She can't read. And yet the nightingale saw her sitting on the stone of spring, reading. And though she was reading to herself, the animals and horses listened to her in admiration. For she was reading the House of Fear, this true story you are now going to read, this story written in a beautiful language, truthful and pure.

At one point, Ernst returned to his wife. Leonora processed his departure by writing a novella, *Little Francis*, a deliriously violent tale of abandonment and murder. Before long, he came back. They had fun. Friends such as the photographer Lee Miller and the painter Leonor Fini came to visit; the women loved wearing fancy dress

and playing practical jokes on each other: Leonora once served a guest an omelette filled with his hair, which she had cut off while he slept.

In photographs, Leonora looks like someone simultaneously from the distant past and the near future. In a portrait of her taken by Lee Miller in 1939, Leonora glances up, interrupted in the kitchen, one hand on a large mixing bowl. She's dressed in a voluminous, glossy black satin jacket and skirt and a white lace blouse: the elaborate buttons on her jacket shine like pearls. Her face is half in shadow, her dark hair a black halo. Her beauty is powerful and unearthly, her expression unblinkingly intense. Many years later, when asked if there was any point in her life at which she felt she wasn't rebelling, Leonora replied: 'When I met the Surrealists.'

When war broke out in 1939, the couple's romantic and artistic idyll fell apart. In 1940, Ernst, who was German, was interned by the French as an enemy alien, released and then recaptured. He was in danger from the Germans, too; between 1937 and 1941 his painting *La Belle Jardinière* (The Beautiful Gardener), which is now lost, probably destroyed, toured thirteen cities in Germany as part of the Nazis' exhibition of 'Degenerate Art'. Leonora visited Ernst countless times; she brought him painting materials and lobbied for his release. Eventually, mad with anxiety and fear, she was persuaded by a friend to escape to Spain. In her memoir *Down Below*, first published by the Surrealist journal *VVV* in February 1944, Leonora describes her total mental and physical collapse. She remembered that 'I was quite overwhelmed by my entry into Spain: I thought it was my kingdom; that the red earth was the dried blood of the Civil War. I was choked by the dead, by their thick presence in that lacerated countryside.'

She was convinced that 'Madrid was the world's stomach' and that she had 'been chosen for the task of restoring this digestive organ to health'. But she was gang-raped by a group of soldiers

who left her, lost, her clothes torn, in Retiro Park. She eventually contacted the consul of the British Embassy; she was considered mad and locked up in Madrid's Ritz hotel. From there, she was sent to a sanatorium run by nuns, but they couldn't cope with her. She was then transported to an asylum in Santander, where she spent months in the care of the sadistic Doctor Morales; she was drugged, stripped naked, tied to a bed. She remembered it late in life as the most awful thing that had ever happened to her. Her parents sent her nanny in a warship to rescue their daughter; they intended to get her to South Africa, where they had booked her into a clinic. Leonora gave her the slip and eventually got to Madrid, where she ran into a man she had met through Picasso in Paris: a poet called Renato Leduc, who was now working at the Mexican Embassy and moonlighting as a bull-fighting reporter. She managed to shake her minders via a restaurant bathroom and she and Leduc married - purely for convenience - in the British Embassy in Lisbon before catching a ship to New York. She was free.

In 1942, Leonora moved to Mexico, where many Surrealists also ended up. She became close to the Spanish artist Remedios Varo, who shared her fascination with alchemy, the Kabbalah and the mytho-historical writings of the Popol Vuh, subjects that emerged in her painting and writing like clues to half-remembered dreams. Leonora and Leduc divorced in 1943. She eventually married again, to the Hungarian photographer Cziki Weisz; they had two sons, Gabriel and Pablo, and lived with numerous cats and dogs: animals were, throughout her life, some of her dearest friends. She read the writings of Carl Jung, studied the Kabbalah and Buddhism, visited Tibet, and was one of the founders of the Mexican women's liberation movement. She described Robert Graves's idiosyncratic study of mythology, *The White Goddess: A Historical Grammar of Poetic Myth* (1948), as 'the greatest revelation of my life'. Her friend, the Mexican novelist Chloe Aridjis, explains that 'in its pages, Graves argues that the ancient cult of this goddess is inextricably linked to

"pure poetry", and declares matriarchy as the earliest form of social order'. Leonora didn't believe in intellectualising our understanding of the world; she felt it was a waste of time. All you could trust, she said, was your feelings. She thought it misguided to try to turn your response to art into a 'kind of game'. 'It's a visual world. It's different . . . It's to do with space, which changes all the time. I do not think in terms of explanation.'

Although she frequently travelled, she lived the rest of her long life - she died at the age of ninety-four - in Mexico City. Aridjis describes Leonora's home in her final years as 'a chessboard of Mexican sunlight and European shadow - much of the house was stone-chilly and austere, but then you'd step into a patch of sun or come face-to-face with one of her sculptures, an eruption of life emerging from the murk'.

In 1937 - around the same time that Leonora wrote 'The Debutante' - she began painting a self-portrait: it's now one of her most famous works. At only 65 x 81 cm, it is like peering through a small window. Leonora depicts herself in white jodhpurs, legs wide apart, a green riding jacket, a dark purple shirt covering her flat chest and short, pointy, vaguely Victorian boots: a home-counties uniform redesigned for flight. She sits on a red cushion on a vivid blue chair that has tiny arms and feet, in an empty tiled room. Although she is obviously inside, her thick dark hair blows away from her white, high forehead; she could be standing on a cliff in the wind. She looks directly at us; she is stern, with cherry red lips and brows like the wings of a thin dark bird. She holds her right hand towards a lactating hyena, which glances at us with eyes as blue and as piercing as Max Ernst's; animal and woman appear to be close in more than mere proximity. A white rocking horse - a recurring symbol of her childhood - floats in the air behind Leonora: a lifeless object indebted to the grace of its host animal. Out of the lavishly yellow-curtained window, a white horse gallops

through a green landscape between a sentry of misty fir trees. The painting is precise, the brushwork near invisible, but behind the hyena the image blurs; it's as if the animal has appeared, like alchemy, from air.

In 'Down Below', which was written a few years after she painted her self-portrait, Leonora recalls a vision she had in the asylum:

> . . . next to me, two big horses were tied together; I was impatiently waiting for them to jump over the fence. After long hesitations, they jumped and galloped down the slope. Suddenly, a small white horse detached himself from them; the two big horses disappeared, and nothing was left on the path but the colt, who rolled all the way down where he remained on his back, dying. *I myself was the white colt.*

Like spirit guides, animals populate Leonora's paintings and stories; they are allies, sympathetic beings in an abrasive world where the real beasts are the humans. She once said: 'A horse gets mixed up with one's body . . . it gives energy and power . . . I used to think I could turn myself into a horse.' The two horses and the hyena in her self-portrait are not menacing; they're pictured as organic extensions of the young artist's psyche. The rocking horse - its jaw missing, like a premonition of the enforced silence Leonora would suffer in the asylum - floats directly behind, or perhaps from, Leonora's head while its living, breathing alter ego gallops, like an embodiment of freedom, into the distance. The calm, elegant hyena, her face oddly human, her three breasts bloated with milk, walks towards Leonora like a psychic wet-nurse - the character from 'The Debutante' made flesh.

In her short story 'The Oval Lady', which Leonora wrote around the time she was painting her self-portrait, the narrator describes meeting a very tall girl named Lucretia, who, despite being

sixteen, has an enormous nursery full of 'hundreds of dilapidated and broken toys', including an old wooden rocking horse that 'is frozen in a gallop'. '"Tartar is my favourite," she said, stroking the horse's muzzle. "He loathes my father."' Looking at him, Lucretia observes: 'He'll travel a very long way like that . . . and when he comes back, he'll tell me something interesting.'

Later, Lucretia rolls in the snow and when she emerges, the un-named narrator is astonished: 'If I hadn't known it was Lucretia, I would have sworn that it was a horse. She was beautiful, a blinding white all over, with four legs as fine as needles and a mane which fell around her long face like water. She laughed with joy and danced madly around in the snow.'

A vicious old woman, perhaps a servant, interrupts Lucretia's horse-play, attacks her and takes her to her father, who very gently remonstrates with her. 'What I am going to do is purely for your own good, my dear [. . .] You're too old to play with Tartar. Tartar is for children. I am going to burn him myself, until there's nothing left of him.'

Lucretia falls to her knees and cries out 'Not that, Papa, not that [. . .] Have pity, Papa, have pity. Don't burn Tartar.' The tale finishes with Lucretia kneeling in a pool of water; the narrator is afraid she will 'melt away'. She then covers her ears 'for the most fright-ful neighing sounded from above, as if an animal were suffering extreme torture'. Although her mother visited Leonora in Mexico City when her son Pablo was born, she never saw her father again. In an interview two years before she died, Leonora said: 'There are things that are not sayable. That's why we have art.'

I Am the Subject I Know Best

All self-portraits are, to varying degrees, autobiographical in that they are reflections of how the artist sees herself and the world

around her. None are more explicitly so than those produced by another Mexican artist, Frida Kahlo, who was ten years older than Leonora. At her death in 1954 she left behind 200 or so paintings, sketches and drawings - of which around fifty-five are self-portraits.

She paints herself adorned, naked, solemn, repeated, dissected and celebratory; in love and despairing. Her paintings are at once diaristic, historical and political; they're as searing, as wounded and as joyful as a love song. Wracked with chronic pain from childhood, again and again she rendered her face as a mask of sorts, the repetition of its blank expression - a mix of teeth-gritting endurance, near-demented control and self-conscious repression - glowing like a moon in stark contrast to the dark torments her body experienced. (Her husband, the artist Diego Rivera, and his friends called her 'the great concealer', which is ironic given her talent for self-vivisection.) Art for Frida was not simply a way of painting the world; it was a form of catharsis, the doctor she craved who could, if not heal her, at least help alleviate some of the physical agony she experienced throughout her life.

At the age of six, Frida contracted polio. In 1925, when she was eighteen, she was involved in a cataclysmic accident: a tram crashed into the bus she was travelling on. A handrail pierced her body. Her pelvis, her collarbone, her spine and her ribs were broken; her leg, withered from her childhood disease, was fractured in eleven places; her shoulder was dislocated and one of her feet was crushed. It is impossible to imagine the pain she experienced. In the twenty-nine years it took for her to die of her injuries, she underwent thirty-two operations; eventually, in 1953, one of her legs turned gangrenous and was amputated. She was forced to wear corsets that cut into her skin. But it wasn't just her flesh that pained her. She had married the artist Diego Rivera in 1929; their relationship was tempestuous, adoring, furious; both had affairs. She made her feelings clear in the diary she began in her mid-thirties: 'Diego: the beginning, builder, my child, my boyfriend, painter, my lover, "my

husband", my friend, my mother, me, the universe.' Although she was initially intent on studying to become a doctor, the accident put a stop to her plans. Bedridden, with a mirror suspended above her, she painted and drew incessantly, something she had enjoyed doing as a child. She portrayed her body and her state of mind: the two were intricately intertwined. 'I paint myself because I am alone. I am the subject I know best.'

Frida refused to be defined by her damaged body and so she decorated it: her clothes were a joyful exclamation, a brilliant assertion that every day alive was a day worth celebrating. She wore necklaces, earrings and bangles; brightly coloured headgear, flowers and peasant blouses, vivid shawls paired with long skirts and ribbons. She vibrated with colour. She is the only artist I can think of whose clothes are as famous as her paintings.

The Surrealists were desperate to claim her as their own, but Frida would not have it: in itself, a Surrealist gesture. When she had her first major exhibition in 1938, at the Julien Levy Gallery in New York, André Breton wrote an essay for the catalogue, famously describing her work as 'a ribbon around a bomb'. He also defined her work as 'pure surreality', but Frida dryly rebutted him: 'I never knew I was a surrealist till André Breton came to Mexico and told me I was.' Frida was clear that the images she painted were not inventions: 'I never painted dreams,' she declared. 'I painted my own reality.' A lifelong communist, she was a revolutionary insofar as she longed for a new kind of society: one that treated its inhabitants fairly and which allowed the imagination to travel where it wished. Idealised images of Marx, Lenin and Stalin appeared in her work alongside those of Christ and the Virgin Mary, various saints, animals and invented symbols. All of them promised, to varying degrees, that change, that transformation, was possible. Most of them lied. Frida was nothing if not optimistic.

Frida wanted to be a mother, but she was too injured and she miscarried, time and again; she also had at least three abortions

that were deemed necessary for medical reasons. She mourned the loss of her unborn children; she painted her broken body as a stand-in for her broken heart. In her painting *Henry Ford Hospital* Frida attempts to exorcise the miscarriage she had in Detroit on 4 July 1932. She depicts herself lying on her back in a pool of blood; a large tear falls from her left eye. She is naked, her belly swollen, her hair spread around her head like a polluted puddle. Against a distant background of the city – where Rivera was painting a mural for the Ford Motor Company – her bed, emblazoned with the words 'Henry Ford Hospital', floats awkwardly across an arid nowhere land, beneath a dull blue sky. In her left hand are six red ribbons – perhaps a reference to umbilical cords – which are tied to six floating objects: the foetus of a male child; a purple orchid resembling a vulva, apparently a gift from Rivera; a scientific model of a uterus; a snail; the skeleton of a pelvis; and an autoclave, which is used to sterilise instruments. The self-portrait is small – roughly 30 x 40 cm – and it was the first time Frida had painted on a metal plate. The size of the picture and its very particular material evokes Mexican religious votive or *retablo* painting, which Frida had long been fascinated by: small paintings which traditionally depict a disaster that someone has survived and who wishes to give thanks. No one had painted the travails of birth or miscarriage before.

Although Frida's grief is plain to see, to pin down the meaning of the painting is to stifle it. Frida chose to communicate in paint, not in words. The phenomenal popularity of her art is surely to do with the fact that, through a fog of pain, she knew that she was expressing something universal; that humans are receptive to symbols, to metaphors, to enigma. Her language is at once sophisticated and blunt: a searing reflection of her fragile mortality entangled with her tempestuous, tortured celebration of life.

The imagination is as capable of reflection as it is of invention. Painting allowed Frida the freedom not only to articulate the chronic agony of her body but also to express the vagaries of her

relationship to the history and politics of Mexico and her compli-
cated emotional life; her love for her husband, as well as numerous
other men and women - including Leon Trotsky - played havoc
with her heart. Yet there is a fierce, troubled joy in everything she
painted; her diary is as playful as it is distressed. She loved jokes
and singing - she had a perfect falsetto - and listening to Mexican
love songs; she was as much a fan of Groucho Marx as she was
of Karl. She adored Laurel and Hardy, Charlie Chaplin, the Three
Stooges. The Mexican writer Carlos Fuentes wrote of her: 'Her
voice [. . .] was deep, rebellious, punctuated by *caracajadas* - belly
laughs - and by *leperadas* - four-letter words.'

In 1951, three years before she died, Frida painted *Self-Portrait with
the Portrait of Doctor Farill*. It is, curiously perhaps, the last painting
she signed and the only self-portrait she made in which she depicts
herself as an artist. Compared to much of her work, the painting
is restrained. Frida, who was forty-four at the time, is pictured
in her wheelchair in the corner of a room whose walls are
painted in simple tones of burnt yellow and grey. She is demure,
dressed in a heavy white poncho that vaguely evokes white
surgical scrubs; loosely covering her orthopaedic brace, it is deco-
rated with a thick rope and two tassels. Her jewellery is minimal:
a single necklace, a ring like a sunflower, a plain bracelet and drop
earrings. Her long dark skirt covers her legs and feet. Her expres-
sion is calm, introspective. She sits before her painting, which
is propped on an easel: a portrait of her surgeon Dr Juan Farill,
whose head she has portrayed as much larger than hers. He looks
towards her but not directly at her. In her right hand she has a
fistful of brushes, tipped with red paint, like bloody scalpels. In
her left, what appears at first to be a large red palette, is in fact her
heart. In case there's any doubt as to what the palette is formed
of, it lightly stains Frida's clothes. It's like a very calm nightmare.
There is a curious confluence between Frida's expression and her

doctor's: they are serious but a little dreamy. Their thick, dark eye-brows echo each other's.

In 1951, Frida was hospitalised for nine months in Mexico City; she underwent seven gruelling bone-grafts on her spine. Her portrait of her surgeon was the first painting she did when she was strong enough to lift a brush and, like *Henry Ford Hospital*, it's something of an ex-voto offering: Frida's thanks to her doctor. She wrote in her diary: 'I've been sick for a year now . . . Dr Farill saved me. He brought me back the joy of life. I am still in the wheelchair and I don't know if I'll be able to walk again soon. I have a plaster corset even though it is a frightful nuisance, it helps my spine. I don't feel any pain. Only this . . . bloody tiredness and naturally quite often despair.'

She had paid homage to her doctors before: in 1931 she completed *Portrait of Dr. Eloesser* and she inscribed her desolate *Self-Portrait Dedicated to Dr. Eloesser* - in which she stares out, bejewelled in a necklace of thorns - 'I painted my portrait in the year 1940 for Dr Leo Eloesser, my doctor and my best friend. With all my love'. Her painting of Dr Farill is different, though. It's a painting within a painting, and her doctor becomes - like Sofonisba's portrait of her teacher Bernardino Campi almost 400 years earlier - her own crea-tion. She paints with her heart, her blood. She cannot walk but she can express her thanks. It was a thanks, though, that was tempered with political fervour. Frida wrote that she was uneasy about her painting and she wanted to 'transform it into something useful for the Communist revolutionary movement, since up to now I have only painted the earnest portrayal of myself, but I'm very far from work that could serve the Party'.

How she felt her self-portrait would aid the revolution isn't clear.

Diego wrote that: 'Never before had a woman put such agonized poetry on canvas.'

Frida died at her home, Casa Azul in Coyoacán, Mexico City,

on 13 July 1954, seven days after her forty-seventh birthday. She was utterly worn out. On the final page of her diary, she painted a bloody green angel in thick boots. Its head aflame, it floats skywards, dissolving in the pink air of a blazing sunset.

The official cause of Frida's death was 'pulmonary embolism', but no autopsy was performed. Eight days before, suffering from complications from her amputated leg, she signed her last work: a study in oil on masonite of watermelons against a blue sky. A watermelon is a delicious thing, a celebration of summer, but Frida's use of it here is elegiac: in the Mexican Día de los Muertos, or Day of the Dead, the departed are commonly pictured eating the fruit. In a beautiful gesture of defiance, Frida inscribed the words 'Viva La Vida Coyoacán 1954 Mexico' - Long Live Life, the place of her birth and the year of her death - into the pulpy red flesh. The watermelons are pictured in different stages of ripeness; two of them are whole - the skin of the one that forms a void-like hole in the centre of the painting is dark and hard. Three are cut open and two are slices. Knowing the circumstances of the painting's execution, it's impossible not to read it as a symbolic self-portrait of someone who has experienced a lifetime of being cut up and open - from the poles that pierced her body in the trolley-car accident to the often life-saving scalpels of surgeons.

The last line Frida wrote in her diary was: 'I hope the leaving is joyful - and I hope never to return.' Three years later, Diego Rivera died of heart failure. His last painting, too, was a still life of watermelons.

5
Solitude

A painter's studio is private: one of the few places she is able to shut out the noise of the world. Its four walls, however shabby, constitute a kind of freedom. Within reason, she can do whatever she wants in there. She doesn't need to show anyone what she creates. She can ignore the laughter, the questions, the confusion, the anger. She holds her palette as if it's a shield and wields her brushes like weapons. She pictures herself glancing out at us, the inhabitants of a world all too ready to deny her ambition. Often, she appears a little impatient, as well she might be.

In her studio, in her room, in the infinite space of her imagination, she can be herself.

It's not surprising that occasionally she refuses to let her self-portrait go; she will not sell it or give it away, despite the protestations of those close to her, despite her lack of money or security or reputation. For reasons known only to herself, like a traveller with her passport, she needs her self-portrait close by.

A painting is a pause in life's cacophony. It does not demand conversation or justification. It does not hector her. She has stilled herself for it. It cannot and will not tell her what to do. She controls it. She creates her own image. Nothing can distract her. She concentrates, her paintbrush in hand, the mirror close by. She is defiantly, splendidly, bravely, heartbreakingly, joyously alone.

Fine and Fierce Things

> I have always searched for the dense depths of the soul that have
> not yet discovered themselves, where everything is still uncon-
> scious - there one can make the greatest discoveries.
>
> Helene Schjerfbeck

She was to paint herself thirty-six times - as young, middle-aged,
old and then close to death at the age of eighty-four. She was some-
thing of a star, but being a star was not what mattered to her.

Helene was born on 10 July 1862, in Helsinki, Finland (which
was then part of Russia). Her parents were Olga Johanna Printz
and Svante Schjerfbeck, an office manager in the Finnish State Rail-
way. There was very little in her childhood that might encourage
an interest in art. She never learned to speak Finnish; Swedish was
her language.

At the age of three, she fell down some stairs and broke her
hip. During her long convalescence, her father supplied her with
drawing materials. She later remarked that when you give a child
a pencil, you give her an entire world. Her hip never fully healed,
and she had a limp for the rest of her life. Her sister Olga died
before Helene was born and two other siblings died as infants. To
know what pain is from an early age is to learn empathy from the
start.

She was a child prodigy: at the age of eleven she enrolled in art
classes and, within the year, her talent was considered so remark-
able that her pictures were shown to the renowned Finnish artist
and teacher Adolf von Becker. He was so impressed he arranged
a free scholarship for Helene to attend the drawing school of the
Finnish Art Society in Helsinki - she was the youngest student
ever accepted by the institution.

Helene's father died of tuberculosis when she was fourteen,

leaving the family in a precarious financial state, but the young artist was granted a scholarship to Becker's studio. At the age of seventeen she won an art prize; a year later her work was included in the Finnish Art Society exhibition. She moved to Paris with a grant from the Imperial Russian Senate, enrolled in classes at Académie Trélat and then the Académie Colarossi. She lived there for six years and loved it. She made close friends with the artists Marianne Preindlsberger, Maria Wiik and Annie Anker. In 1881 she painted *Two Profiles*, a small, affectionate double portrait of Marianne and possibly Annie. It has a loose, snapshot quality; two young women against a dark background gaze at the world beyond the frame. Their dresses are white and dark blue, their hair loosely tied back, their faces full of curiosity and personality. Marianne, in the foreground, is smiling slightly. It is a picture of youth, of possibility, of hope.

Helene admired the work of the French naturalist artist Jules Bastien-Lepage. She showed him a couple of small paintings. He said 'these paintings have fine things alongside fierce things'. She never forgot this and quoted it decades later. However, she gradually left behind his meticulous approach to picture-making, preferring to distil the essence of her subjects with tone and colour. Details, pedantic things, became redundant.

In 1887, Helene was engaged to a man who then broke up with her by letter. Distraught, she asked her friends to destroy any correspondence in which his name appeared; they were so efficient that we have no idea who he was. She made the first of two trips to St Ives in Cornwall – a burgeoning artists' colony – to visit Marianne, who had married the British artist Adrian Scott Stokes. While there, in 1888, she painted *The Convalescent*, a work that was to bring her considerable fame. More sentimental than her later, great paintings, it depicts a tousle-headed child wrapped in a sheet observing a thin branch animated with budding leaves. *Girl from St Ives (Redhead)* (1890) – a smudged, atmospheric portrait

of a vivid, smiling girl with a cloud of red hair, a plain green dress and a yellow flower - is a better indication of what was to come.

Helene continued to move: at the Louvre, she copied the Botticelli Tornabuoni frescoes because 'the shades of the fresco and its seriousness tempted me and all that was something new for me'. In the 1890s she won commissions from the Finnish Art Society to travel to St Petersburg, Vienna and Florence, to make copies of masterpieces to be used as teaching aids. She admired an eclectic group of works by Frans Hals, Velázquez, Edward Burne-Jones and Fra Angelico; the chalky, fresco-like tones of Puvis de Chavannes were an influence.

In 1894 she moved back to Finland; her travels were over. She was appointed chief instructor at the drawing school of the Finnish Art Society, where she insisted on complete silence in her classes. She was constantly ill with hip pain and, as she had stopped receiving grants and bursaries, struggled financially.

In 1902 she gave up teaching and moved to Hyvinkää, a small town in the countryside, to look after her mother Olga. Although Helene was free of her teaching duties, it can't have been easy. The house was cramped; she was isolated from her friends and from the vibrant art scenes of bigger cities. To cap it all, her mother disapproved of her daughter's chosen career. Helene wrote to her close friend, the forester, painter, writer and art collector Einar Reuter: 'Household and nursing on one side, painting on the other. And on the painting, our income depends.'

She painted her mother's portrait three times: in each of them, Olga, dressed in black, does not acknowledge her daughter. She is looking away, to the side, looking down.

Helene didn't leave Hyvinkää for fifteen years. She was occasionally visited by friends and read widely, from fashion magazines such as *Chiffons*, to biographies, including those of Van Gogh and Gauguin. She was in constant dialogue with the art of the past: she

was enamoured by the Rococo playfulness of eighteenth-century art and the sombre technical brilliance of Holbein, Cranach and El Greco. Her skilful evocation of atmosphere prompted comparisons to Whistler; she believed that he had 'brought back the real principles of painting in art'. She claimed to have learned how to use black from the Dutch masters. In later years, she closely studied the paintings of Cézanne, Degas, Gauguin and Munch. She was fascinated by the ways in which they scraped, flattened and exhausted their surfaces in order to, conversely, invest them with more life. In 1927 she wrote to her friend Maria Wiik: 'Did you know that [Degas] washed his pastels and bleached them in the sun to get that "dead tone" which yields such fabulous colour . . . I, too, must kill the tone before it acquires strength, pure colour is nothing but raw and weak to me.'

In 1905 her work was included in an exhibition of women artists at the Ateneum Art Museum in Helsinki. It was the last time she agreed to be in such a show: 'After all,' she wrote to Einar Reuter, 'there are no exhibitions for "men only". Should not everything hinge on the artwork itself?'

In 1906, Finnish women were the first in Europe to be granted the vote. In 1911, Helene wrote to her friend Helena Westermarck: 'The only thing I hope that the vote for women will achieve is equality between men and women in the moral sense, for it will never lead us to any paradise. It is, after all, simply a question of fairness.'

In 1913 she met the art dealer Gösta Stenman; he included her work in a group show of Finnish Modernism at the Ateneum and staged her first solo exhibition – an astonishing 159 works – in 1917. Using the pseudonym H. Ahtela, Reuter published his biography of Helene to coincide with the show; it was based on their conversations and correspondence, of which there exist more than 1,000 letters. The exhibition was a great success: it garnered enthusiastic reviews and the paintings sold well.

Helene's feelings for Reuter, who was nineteen years younger, had intensified into romantic love, but they were not reciprocated. Much to her distress, in 1919 Helene discovered that he was engaged to a young Swedish woman, Tyra Arpi. The year before, she had painted Reuter's portrait. She imagined him as a sailor, bare-chested, sinuous; his body appears to almost vibrate softly with the energy she invests it with.

The news of her friend's engagement was such a shock to Helene that she spent three months recovering in a hospital in Tammisaari by the sea. Somehow, she and Reuter remained friends. She painted another portrait of him the following year: a small, sad head-and-shoulder study. His eyes, round, hard and dark, glance away from her. His mouth is sensual and half in shadow. Unattainable.

In 1921, Helene attacked an unfinished self-portrait: thin lines scar the painting's surface, most violently around her eyes. Her body, as dark as a hole, dissolves into a fog of pale green paint. It's as if there is no delineation between her own skin and that of her painting. In pain, she harms the image she has created of herself.

In 1923, Helene's mother died. Helene was so grief-stricken, again, she became ill. It would seem that every extreme feeling she had erupted in physical collapse.

In 1925 she moved to Tammisaari where she lived for sixteen years. In 1932, on her seventieth birthday, she hid from well-wishers. She was famous, lauded, wealthy. She painted incessantly. She was alone.

In 1927 and 1928 her friends Marianne and then Maria died. Her feelings of isolation intensified. Although she made clear her need for solitude, still, she was lonely. It is difficult to find people to love. It is difficult to find people who understand you.

Throughout her life as an artist, Helene had painted still lifes, portraits and landscapes; she was interested in fashion, in faces and masks; in what we choose to reveal and to hide of ourselves; in the possibilities of paint. She was, at times, amusing. In 1933 she

painted a portrait of her nephew Måns Schjerfbeck as *The Motorist*, despite the fact that he couldn't drive and didn't own a car.

But as she aged, she focused more and more on painting herself. On mortality.

In 2019 the Royal Academy in London hosted the first solo exhibition of Helene's work in Great Britain. Seventeen self-portraits, which ranged in date from 1884 to 1946, were hung in one room; the effect of trying to take them all in was dizzying, like fast-forwarding through someone's life. In 1884, Helene has the bloom of a twenty-two-year-old; a faint smile hovers on her lips, and she looks out at us with an open expression of curiosity.

In 1895 she was thirty-three; more reserved, stern even, but her skin is still fresh, her hair arranged in a golden bun. She is clothed in the plainest of black dresses; there is something of the religious novitiate about her.

By 1912 she was fifty and no longer demure. Something crackles and sparks from her, even now, over a century later. She turns to face us, as if suddenly interrupted. Her expression is at once bold and introspective. Made when she had been painting in isolation for ten years, Helene depicts herself in a deep blue robe; her pale face erupts from the darkness of her clothing like an exclamation mark, her cheeks and the tip of her nose flushed a vivid pink against her white skin. Her left eye is clouded, perhaps with anxiety, while her right eye is dark, blank even; an indication perhaps of vision turned inwards. The swirling, shadowy background, livened in parts with a splash of ochre, is more of a mood than a landscape. It's a portrait that is both solid and untethered; a picture of an imagination made flesh.

In 1915 something has changed. She's almost friendly; she looks at us directly, against a black background. Her skin, her hair, a tendril of which escapes her bun, her enigmatic expression - all of it breathes life. She is dressed in a soft white chemise with a smudged

green button. At her right shoulder a startlingly red paint pot holds a few brushes. It's even more alive than her flushed cheeks.

In 1937, when she was seventy-five, she paints a faintly night-marish self-portrait with palette. Seen from the shoulders up, her features dissolve in dusty tones of lilac; the surface of the paint-ing has the tired patina of a very old fresco. The artist's head is bony, severe even; her pale hair is tightly pulled back and her large gloomy eyes glance at something unseen to her left. Her soft mouth is downturned; the black of her collar has the faint threat of the noose. Only four small dashes of paint - blue, white, yellow and red - indicate the presence of her palette. They are like the promise of spring flowers on a winter's day.

In 1939 the Soviet Union invaded Finland; Helene escaped the bombing and found refuge in a barn. She was seventy-seven. That year she painted her *Self-Portrait with a Black Mouth*, her face long and angular, delineated with harsh black lines: her fearful eyes black, staring holes. She wears green; the plain background is dusty pink and brown.

She was evacuated to Elimo and then Tenhola. Over the next three years she returned to Tammisaari when she could. In 1942 she moved to the Luontola sanatorium in Nummela north of Hel-sinki. She asked her nurses to model for her and they agreed. She was invited by the Royal Swedish Academy of Fine Arts to enrol as a foreign member. Picasso's name followed hers on the member-ship roll. This made her very pleased.

In 1944, Helene's art dealer Stenman, who had been trying to persuade her to move to neutral Sweden for years, was finally suc-cessful. She took a suite at the Grand Hotel in Saltsjöbaden, about twenty minutes from Stockholm; she was eighty-two. The luxuri-ous hotel overlooks the sea, which was always a solace for her, but she was anxious and lonely and dying of stomach cancer. Europe was ravaged by the horrors of the war. For the next eighteen

months, Helene painted twenty self-portraits. In most of them she depicts herself as an apparition, an otherworldly being rendered in swirls of brown and beige. In one painting only her bottom lip is animated: a single red dot, like a drop of blood or a target, floats on her gaping mouth. Her eyes are smudges, her hairless skull, a skeleton. She stares beyond us, well aware of where she's headed. She painted her face again and again with the greatest economy, as if by repeating it she could keep it alive. Her features dissolve or emerge like a stone, in flat, hard panes. These are frightening paintings; she already looks dead. In *An Old Painter* from 1945 she's hardly human; a flayed skin, with gaping holes for eyes, swallowed by shadows. For her last ever drawing she rendered herself as something formed of just a few lines. She knew that she had almost disappeared.

On 23 January 1946, Helene Schjerfbeck died. Her easel, like family, was at her bedside.

The Strange Form

Did Gwen John and Helene Schjerfbeck know each other, or at least know of each other's work? We don't know. But it is hard not to speculate, as they shared an acute sensitivity to their surroundings and to themselves. They both relished their solitude and were spurned in love. They both used themselves as subjects. Their paintings share a sparseness that is at once robust and delicate; intimations that appearances are not all there is to understand about the world. They both stripped their visual language back in order to reveal what mattered to them. They both, at times, made paintings whose surfaces echo the dry, faded pigments of frescoes. They both made paintings titled *The Convalescent*. They both admired the atmosphere and tonal arrangements in paintings by the American post-Impressionist Whistler and revered the ethereal paintings

of the Symbolist Puvis de Chavannes. But Helene lived longer than Gwen, and her work reflects her fascinated horror with her own mortality in a way that Gwen's does not – perhaps Gwen's religious faith kept the horror at bay. But both artists make one thing very clear: it is only our flesh that separates us from the world – and flesh is a flimsy membrane.

Gwen's brother Augustus, two years younger than her, was a celebrity; a virtuoso draughtsman, a wild bohemian who wore gold hoop earrings, refused to shave and slept with everyone. He was a star; he was notorious, he held court, he was lauded. A fellow student described him as 'the young fawn, the lithe and elegant figure, a dangerous breaker of hearts with his looks and his ardour'. He called his sister 'the waif of Pimlico', as famous for her intensity and reserve as he was for his bravado. The louder her brother became, the more she retreated.

Gwen was born in Haverfordwest in Wales in 1876, the second eldest of four children, two boys and two girls. Her mother, Augusta, had trained as an artist and painted pictures on the walls of her children's nursery to amuse them; her 'cripplingly shy' father Edwin was a solicitor. When Gwen was eight, her mother died of rheumatic gout and exhaustion; her father, remote with grief, moved his family to Tenby, by the sea, where he occasionally worked and composed music for the organ. The young Johns roamed the beaches and hills in order to escape the family's stifling Victorian home, which was ruled by their melancholy father who insisted meals were eaten in a chilly silence. In his memoir *Chiaroscuro*, Augustus remembered their excitement at seeing an artist at work in the landscape: 'My sister Gwen and I, full of curiosity, would approach as near as we dared, to watch the mystery of painting. Even at that early age we were vaguely aware of Art and Beauty.' The children were looked after by two aunts, Augusta's sisters, Rosina and Leah Smith, who were filled with religious zeal,

active in the Salvation Army, and travelled in a pony trap they called the 'Halleluja Chariot'. Augustus declared: 'I felt that I was living in a kind of mortuary where everything was dead.'

In 1895, Gwen enrolled at the Slade School of Art in London; Augustus had already been there a year. He remembered: 'She wasn't going to be left out of it! We shared rooms together, sub-sisting, like monkeys, on a diet of fruit and nuts. This was cheap and hygienic.' In 1871, Edward Poynter, the institution's forward-thinking professor, had announced his intention to accept women as students - and he allowed them to study from the naked model. It would be another thirty-two years before the Royal Academy School grudgingly allowed women into the life room. In 1893, Frederick Brown became the school's new professor, and, along with his assistants, Henry Tonks (who was to become a legendary teacher at the Slade) and Philip Wilson Steer, they fostered an environment that was, remarkably for the time, supportive of women students. That said, it instigated a strict segregation of the sexes: men and women could only meet in the Antique Rooms. Apparently, Frederick Brown sternly admonished the student Alfred Hayward with the words 'this is not a matrimonial agency' when he was overheard wishing a young woman 'good morning' in the school's corridor.

For three years Gwen trained alongside a group of brilliant young women: Edna Waugh (later, Edna Clarke Hall) - who had enrolled at fourteen and was considered a prodigy; Ida Nettleship, who married Augustus; and Gwen Salmond, who married the artist Matthew Smith. Ursula Tyrwhitt became Gwen John's clos-est lifelong confidante. The students drew each other, lived and occasionally slept together, married and argued with one another. Although the young women received a string of prizes at the Slade - in her second year Gwen was awarded the Melvill Nettleship Prize for Figure Composition - it was Augustus who was consid-ered the genius. When the famous portrait painter John Singer

Sargent visited the Slade, he declared that Augustus's drawings were beyond anything that had been done since the Renaissance. Apart from Gwen, who never married or had children, most of the female creativity was subsumed, often reluctantly, into mother-hood and domesticity. From this distance it is difficult to imagine the societal and familial pressures these young women were under - despite their considerable artistic gifts - to lead conventional lives. Edna Clarke Hall (whose artistic ambitions were discouraged by her husband) and, to a lesser degree, Ursula Tyrwhitt, were the only married members of the group to achieve any level of acclaim.

In stark contrast to her charismatic brother, Gwen was known for her extreme reserve. As late as 1967 fellow student Ethel Hatch remembered her as 'very fragile looking and very quiet in her man-ners'. The severity of her appearance belied her strong feelings, especially about nature: although she was so poor she often went without lunch, she would think nothing of spending her last few pennies on a bunch of flowers. In spring, she cycled miles to see daffodils bloom in the wild.

At first she lived alone, in what Augustus described as 'slums and underground cellars'. In 1897 she moved into a flat on the first floor of 21 Fitzroy Street with her brother and sister Winifred, who was studying the violin, and her friend Grace Westry, for whom she formed a passionate attachment. Gwen's first portraits - paintings and sketches - were of Winifred: intimate, affectionate evocations of youth, livened by her fascination with fashion. Gwen took obvious delight in Winifred's startling black gloves, her vivid red scarf, thick brown cape and velvet bow. The siblings' relationship was intense. Their friend John Rothenstein, who was to become the director of the Tate Gallery, remembered that 'there were none I loved more than Augustus and Gwen John. But they could scarcely be called "comfortable friends".' Ultimately, Gwen had to leave Augustus in order to find her own way. Her brother took up too much space and not just physically; despite his unstinting

admiration for his sister and her work, he was forceful and dominating. He neither shared nor understood her need for solitude.

In 1898, Gwen moved to Paris with Ida Nettleship and Gwen Salmond to study at the Académie Carmen, which was run by one of Whistler's models, Carmen Rossi. The great Whistler himself - now in his mid-sixties - taught at the school twice a week. He famously believed that art should aspire to the condition of music - he titled his works as symphonies, compositions, harmonies, nocturnes and arrangements - and taught figure painting via 'the scientific application of paint and brushes'. He railed against sentimentality and moralising and - despite the atmospheric nature of his pictures - stressed the importance of being orderly and methodical. He forbade smoking, singing and talking, and insisted that the students organise the paint on their palettes to form 'a systematic transition from light to dark: quite as definite a sequence as an octave on a piano'. Gwen approved.

Augustus recounted how, on a visit to Paris, he spied Whistler in the Louvre and introduced himself to the older artist as the brother of one of his students. 'I ventured to inquire if he thought well of her progress, adding that I thought her drawings showed a feeling for character. "Character?" replied Whistler, "character?" What's that? It's tone that matters. Your sister has a fine sense of tone.'

Ida wrote a letter to their friend Michel Salaman about their life in Paris, describing how 'we all go suddenly daft with pictures we see or imagine and to do'. She describes Gwen 'sitting before a mirror carefully posing herself - she has been at it for half an hour. It is for an "interior".' Such an apt word for the study of a room with the introspective Gwen in it. Everything she did, even paintings without any humans in them, can be read as a variation on a self-portrait - they're all reflections of her inner world, a place of acute sensitivity not only to the people but to the places she came into contact with.

Her father visited her; it was not a happy trip. Gwen wrote to

Ursula that he hadn't really come to see her but 'because other re-lations and people he knows think better of him if he has been to Paris to see me! And for that I have to be tired out and unable to paint for days. And he never helps me to live materially - or cares how I live. Enough of this. I think the family has had its day . . .'

He came to dinner and for the occasion Gwen wore a dress that she had designed herself; it was modelled on a painting by Édouard Manet. Her father, outraged at its low neck, called her a prostitute. She furiously responded by telling him that she could never again accept anything from someone 'capable of thinking so'. Although she saw him a few more times, and they corresponded (mainly, on his part, about the weather), when he died in 1937 she didn't attend his funeral.

In 1899, back in London, Gwen moved into a basement flat in Howland Street that Augustus described as 'a kind of dungeon into which no ray of sunlight could ever penetrate'. But Gwen was more robust, and often more playful, than perhaps we assume her to be. Augustus wrote that 'her timidity and evasiveness disguised a lofty pride and an implacable will' and stresses her 'natural gaiety and humour'. She went to a party dressed as a character from a Goya painting, and when she holidayed with Augustus in Dorset she roamed the cliffs by moonlight and wove fireflies into her hair. In a letter to her friend the artist Michel Salaman, she lightly describes how she was swept off a rock and out to sea but swam back to shore. 'Today,' she added, as if her near-drowning was not worth going on about, 'the sky is low, everything is gray [sic] & covered in mist - it is a good day to paint - but I think of people.'

She constantly moved homes. In the summer holidays she was persuaded to visit Augustus and Michel Salaman in Le Puy-en-Velay in France; she travelled there with the artist Ambrose McEvoy, 'the Shelley of British painting', with whom she fell in love. She assumed her feelings were returned, but two months later he was engaged to another Slade student, Mary Spenser-Edwards. Augustus reported

that 'Gwen, like me, had been crossed in love, but, unlike me, was inconsolable, and spent her time in tears.' Elsewhere, he writes: 'Nobody suffered from frustrated love as she did.'

In 1901, Augustus married Ida Nettleship, who 'with her shock of black hair' was described by a mutual friend 'as wild as a Maenad in a wood pursued by Pan'. The young couple moved to Liverpool, where Gus had a job teaching. It didn't last long; Augustus was not the kind of man to be content with a secure or conventional life. In 1903 he became obsessed with another friend of Gwen's, the beautiful and enigmatic Dorothy McNeil – known as Dorelia – who had been an evening student at the Westminster School of Art.

In March 1903, Gwen had three paintings exhibited alongside forty-five of Augustus's paintings, pastels, drawings and etchings at the Carfax Gallery in London; always self-critical, at the last minute she withdrew one. Her brother was vocal in his praise of her work. He told his friend Rothenstein: 'Gwen has the honours or should have – for alas, our smug critics don't appear to have noticed the presence in the Gallery of two rare blossoms from the most delicate of trees. The little pictures to me are almost painfully charged with feeling; even as their neighbours are empty of it.'

Later that year, in September, on impulse, Gwen decided to walk to Rome. She asked Dorelia, who was famously comfortable with silence, to accompany her. Augustus objected – he didn't want Dorelia out of his sight – but off they went. Augustus relented and supplied them with money and cakes.

They landed in Bordeaux and began their slow journey, weighed down with their painting equipment. They lived simply, on bread, grapes and beer, and walked along the banks of the Garonne river. They sang for food, sketched portraits for money and slept under the stars, in haystacks and barns; occasionally they were woken by astonished farmers or gendarmes. By the time they reached Toulouse, they had abandoned their plans; they didn't have enough money to make it to Rome. In a letter to Ursula, Gwen said that 'it

seems further away than it did in England'. They rented rooms in Toulouse; Gwen read copiously. In her notebook she jotted down Sir Joshua Reynolds's dictum: 'Art in its perception is not ostentatious; it lies hid, and works its effects, itself unseen.' She painted three portraits of Dorelia, her friend's face as still and as lovely as the moon, reading, standing in a kind of reverie in a dark room, looking out, her hands crossed in front of her, gently illuminated, a vivid red bow at her shoulder. Augustus had encouraged Gwen to send a painting to the New English Art Club (NEAC) for their annual exhibition, but she wouldn't be rushed. It took her six years to send her portrait of Dorelia - *L'Étudiante* (The Student) - to the NEAC show of 1909.

Gwen wrote to Ursula about living in Toulouse with Dorelia. She said that, although it was 'rather hard', she had 'discovered a few little things about painting (which of course I ought to have known about before)'.

In 1904, Gwen and Dorelia lived together briefly in Paris. They adopted a wild little cat they named after their street: Edgar Quinet. Gwen adored her and before she disappeared in 1908, she sketched her scores of times. Her love for cats never abated. She always lived with at least one.

Before long, Dorelia - via a sojourn in Bruges with a Belgian artist, possibly Leonard Broucke - returned to live in a *ménage à trois* with Augustus and Ida. Gwen, perhaps surprisingly, given her friendship with Ida, had encouraged her. It wasn't an easy situation: when Dorelia became pregnant with Gus's child, Ida was plunged into a deep depression. The two women struggled but continued, in some way or another, to make art; Augustus was no help. He expected them to run the home and look after the children, not work at an easel, while he caroused at the Café Royale and slept with his models. In 1958 he declared that, despite their advantages, the talents that these young women were born with 'came to nought under the burdens of domesticity'. He took no responsibility for

having created these 'burdens' - and he seemed blind to what some of them creatively achieved, against all odds.

Ida and Dorelia became close. In 1905, not long after Dorelia had given birth to her son Pyramus, alone in a caravan on Dartmoor, the two women and Augustus, along with their four children, moved to Paris.

In 1907, aged thirty, and eighteen months after she had moved to the French capital, Ida, who was worn out by Gus's demands and infidelities - he wanted to bring a third woman into their family - died of puerperal fever and peritonitis, a week after giving birth to their fifth son, Henry. She was cremated at Père Lachaise cemetery. Dorelia lived with Augustus for the rest of his long life; he painted her again and again.

In Augustus's autobiography *Chiaroscuro*, Ida is mentioned only in passing.

It is not surprising, given the fate of so many of her married female friends, that Gwen so fiercely guarded her independence. She knew that if she 'were to do beautiful pictures', then she had to be 'free from family convention and ties'. Her need for solitude and time to paint were at the core of her existence.

In Paris, Gwen roomed, at first, in a series of poor, often unfurnished attics and small flats; she hardly ate and in winter she was chronically ill. Although living in the heart of a great city, she loved and craved nature: she even occasionally slept under the stars in the Luxembourg Gardens, 'in a little copse of trees'. She spurned companionship, late nights and the bars of Montparnasse; she was the least bohemian of bohemians. She was frugal and her austerity is reflected in her palette: spare, fragmented, sombre, but often lit with soft golden tones; the light of France, not England. Her images are like reveries made flesh; she focused on details such as the way shadows drift across a wall or a rooftop, or how an empty chair sags with the imprint of a departed body. She made endless drawings - around five studies for each painting. She returned to the

same subjects again and again. She only signed two works in her lifetime and she never dated them. As she couldn't always afford to attend a life class or employ a model, she often drew and painted herself, thin, pale and naked on a bed, looking from a window, reading a letter, sewing.

In 1904, Gwen, desperately poor, had begun work as a life model; although she had no objections to paintings of naked women, she was often uncomfortable with male attention and more and more agreed only to pose for women. Her list of clients is an indication of some of the women artists working in Paris at the time: the Finnish sculptor Hilda Flodin (who worked as an assistant to Rodin); the German painter 'Miss Gerhardie'; the German/Swiss artist Ottilie Roederstein; 'the two Miss Browns, Anna and Ida'; Isabel Bowser, the sister-in-law of the Symbolist poet Arthur Symons, and others.

At the suggestion of Augustus, Gwen broke her rule about not working for men, and posed for the sculptor Auguste Rodin. Although he had a long-term companion, Rosa Beuret, who he married in 1917, he had a habit of becoming sexually involved with his models. Gwen reminded him of his dead, devout sister Maria, who had died in her twenties of smallpox. He called Gwen by her first name, Marie, and *ma petite soeur* (my little sister), and told her she was a *belle artiste*. She called him *maître* (master). He was sixty-three; she was twenty-eight. She struck erotic poses for his monument to the memory of her former teacher, Whistler, who had died in 1903. He told Gwen she had an admirable body.

Gwen became all-consumed by Rodin; they became lovers. (The fact that she reminded him of his dead sister was obviously no deterrent.) She would do anything for him. Despite the public perception of Gwen as someone retiring and modest, she was no prude. On one occasion, Rodin had sex with her in front of his assistant Hilda Flodin and then drew the two women together in erotic poses. Gwen found the experience thrilling. Her biographer Sue Roe believes that: 'It is unlikely that this became a regular

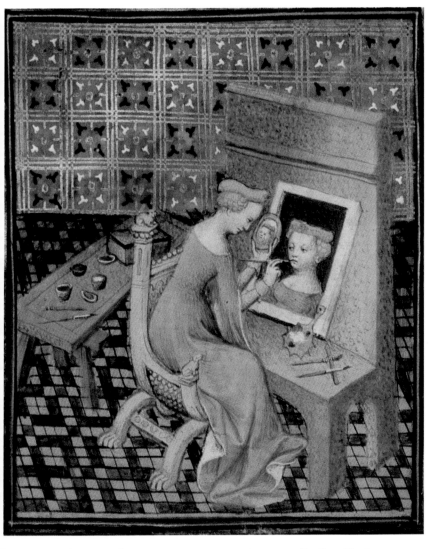

Illustration of Marcia from Giovanni Boccaccio, *De Mulieribus Claris*, c. 1403

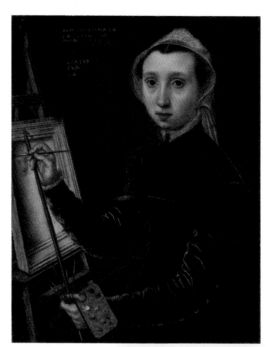

Catharina van Hemessen,
Self-portrait at the Easel, 1548

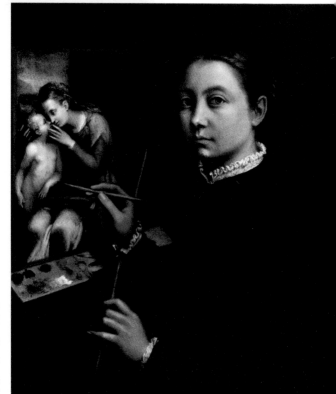

Sofonisba
Anguissola, *Self-
portrait at the
Easel Painting a
Devotional Panel,*
1556

Sofonisba
Anguissola,
*Self-portrait
with Bernadino
Campi*, c. 1559

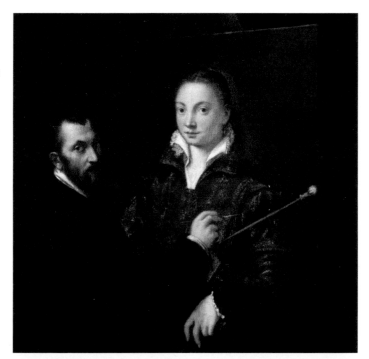

Judith Leyster,
Self-portrait,
1630

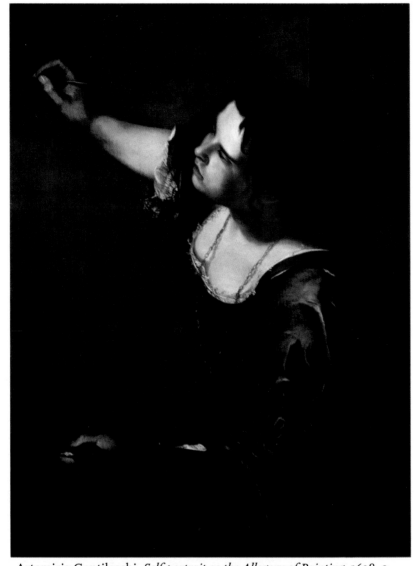

Artemisia Gentileschi, *Self-portrait as the Allegory of Painting*, 1638-9

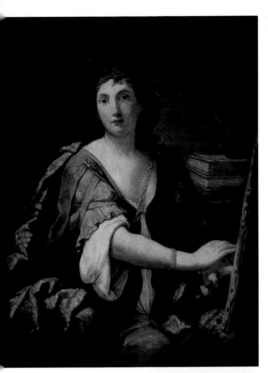

Elisabetta Sirani, *Self-portrait as the Allegory of Painting*, 1658

Mary Beale, *Self-portrait, Holding a Portrait of her Two Sons, Bartholomew and Charles*, c. 1665

Rosalba Carriera, *Self-portrait as Winter*, 1730-1

Élisabeth Vigée Le Brun, *Self-portrait in a Straw Hat*, 1782

Élisabeth Vigée Le Brun, *Self-portrait with her Daughter Julie*, 1786

Angelica Kauffman, *Self-portrait of the Artist Hesitating Between the Arts of Music and Painting*, 1794

Mari Bashkirtseff, *Self-portrait with Palette*, 1880

Gwen John, *Self-portrait*, 1902

Paula Modersohn-Becker,
*Self-portrait on Sixth Wedding
Anniversary*, 1906

Paula Modersohn-Becker, *Self-portrait with Two Flowers in Her Raised Left Hand*, 1907

Helene Schjerfbeck,
Self-portrait, 1912

Suzanne Valadon, *Family Portrait*, 1912

Margaret Preston,
Self-portrait, 1930

Nora Heysen,
Self-portrait, 1932

Amrita Sher-Gil, *Self-portrait as Tahitian*, 1934

Leonora Carrington,
Self-portrait, 1937–8

Loïs Maillou Jones,
Self-portrait, 1940

Helene Schjerfbeck, *Self-portrait with Red Spot*, 1944

Rita Angus, *Rutu*, 1951

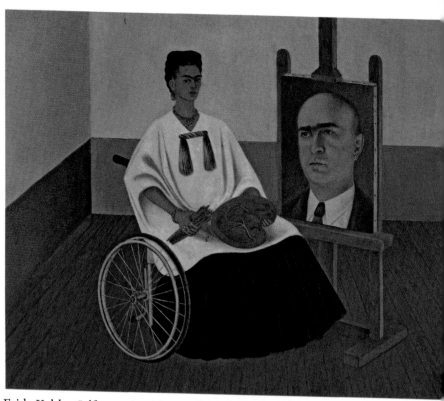

Frida Kahlo, *Self-portrait with
the Portrait of Doctor Farill*, 1951

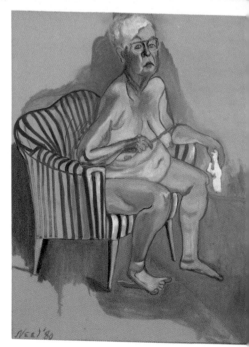

Alice Neel, *Self Portrait*, 1980

event, much more likely that the whole thing was choreographed with a particular set of drawings in mind.'

Gwen was unhinged with love. She wrote Rodin longing, despairing, self-deprecating and jealous letters - often three a day - and frequently waited desperately for him outside his studio and home:

> Cher Monsieur, I don't know what to do this afternoon, because you are not here. I want to come here at least one day a week for ever, just as you said, until I'm an old lady, by which time I'll be an artist, but if you told me you didn't need me any more I couldn't bear it. I'm worried about annoying you when you see me on Saturday because I'm not particularly amusing.

Rodin's feelings were more muted: '*Petite amie*, be strong, eat properly, and remember that I am your friend, very tired, unfortunately, but I do read your letters, which are very touching, and I do love you.'

Gwen struck up a friendship with the poet Rainer Maria Rilke, who - perhaps to gently tell her something - lent her a copy of *Love Letters of a Portuguese Nun*. Written in 1669, the five letters chart the doomed love affair between a nun and a French officer, who seduces and then abandons her. We don't know if Gwen saw a parallel between her situation and the nun's but by all accounts she found the book very beautiful. In 1902 the twenty-six-year-old Rilke had been granted access to Rodin in order to write his biography. Rilke's new wife, Clara Westhoff, had studied with Rodin and she introduced them. Rilke revered Rodin - he believed he had 'no equal among all artists living today'. In 1905 he was appointed the sculptor's secretary - but it didn't end well. After only nine months of dedicated service, Rilke was unjustly fired over a disagreement about a friendly letter he had sent to a client of Rodin's. Rilke felt he had been dismissed 'like a thieving servant'.

Between 1902 and 1908, Rilke had written letters to a nineteen-year-old German writer, Franz Xaver Kappus, who had asked him for advice. Posthumously published as *Letters to a Young Poet*, this slim book, full of musings and guidance about the intertwining of creativity and love, was to become Rilke's most famous work. Much of it could have been speaking directly to Gwen: 'love your solitude and bear with sweet-sounding lamentation the suffering it causes you. For those who are near you are far away . . .'

Gwen's love for Rodin was overwhelming; unsurprisingly, he found her too demanding. Apart from everything else, in 1904 his life had become entwined with that of the Duchesse Claire de Choiseul, who, along with his wife Rosa, took over the organisation of his life. Much to Gwen's despair, she was forced to realise that she was only a small part of her lover's life, and one he refused to confess to the world at large. But her ardour would not be quelled. You can sense Rodin's impatience. He told her she was mad; she implied it was his fault as he had made her so unhappy. It was as if all her years of restraint and reserve had exploded into one grand and desperate passion. She even declared that working for Rodin was more important than her own creativity. 'I am not an artist,' she lied, 'I'm your model, and I want to stay being your model for ever. Because I'm happy.' She stopped painting for several months between 1905 and 1906. When she resumed, she focused on a series of introspective self-portraits. She often drew herself naked.

Rodin's interest in Gwen waned around 1907, although he continued to visit her occasionally until his death in 1917. While he couldn't commit to her in the way that she desired, he cared for her: worried about her health and her cat, he paid her rent, found the occasional buyer for her work, recommended books and introduced her to Japanese drawings. Until the year before his death, he intermittently resumed the affair.

Gwen's home became her refuge and more; it defined her. In one letter to Rodin she wrote: 'It seems to me that I am not myself

except in my room.' In two intimate, lovely paintings of 1907-9 - *A Corner of the Artist's Room in Paris* - Gwen portrays a corner of her softly sunlit lodgings (one with flowers and one with a book) as tenderly as she might a lover's face.

In 1910, Gwen's luck changed. Augustus introduced her to a wealthy American collector of art and manuscripts, the lawyer John Quinn. He had been buying work by André Derain, Marcel Duchamp, Marie Laurencin, Amedeo Modigliani and Pablo Picasso, and he became Gwen's champion, telling her that she was 'the best woman artist who is painting in France today'. He added that: 'If I had to make a choice between the painting by you . . . and the Picasso, I should cheerfully sacrifice the Picasso.'

On 4 February 1910 this least boastful of artists wrote to Ursula: 'I cannot imagine why my vision will have some value in the world - and yet, I know it will. I think it will count because I am patient and *recueilli* [contemplative] in some degree - but perhaps I am boasting even in that - indeed I am, somewhat.'

In 1913, Gwen converted to Catholicism, and in the midst of her chaotic emotional life her religion was a refuge. God would tell her what to say and who to talk to and how to arrange her life as she 'saw what a difficulty there is in following the simplest rule by myself'.

She had moved to Meudon, on the outskirts of Paris, at the beginning of 1911; it meant that she was close not only to Rodin, who had built a studio at the Louis XIII-style château, Villa des Brillants, he had bought in 1895, but to the woodlands, which in spring were covered with bluebells and anemones, and to the nuns at the Dominican Sisters of Charity. Gwen visited an exhibition of Dutch paintings and modelled a small oil painting on a Dürer. She wrote to John Quinn that the mystical, Symbolist artist Puvis de Chavannes was 'the greatest painter of the century'. She painted seven portraits from a reproduction of Mère Pouseepin (1653-1744), the founder of the local convent. Gwen depicts her smiling.

She described herself to Augustus as 'a little animal groping in the dark'. From now on, she often painted portraits from photographs or clippings from magazines. Dressed in a wide-brimmed felt hat and a black cape, she also made countless drawings of people - especially children from the local orphanage, women and nuns - in churches. In 1912 she jotted down ten 'Rules to Keep the World Away' in her notebook. The list included the advice to 'have as little intercourse with people as possible' and, curiously, 'do not look in shop windows'.

World War I was declared. Despite Augustus's entreaties for her to come back to England, Gwen stayed in Paris; her modelling dried up, but it gave her more time to focus on her own work. Her technique evolved: silky oil paint was replaced with tonal areas of chalky pigment in which, like sun-bleached walls, some areas remain bare. She felt that any painting of worth must be done in complete silence. Excepting Rodin, only very occasionally, and her close friendship with Ursula Tyrwhitt - she believed that they 'entered into each other's solitude' - she saw no one apart from her community in Meudon: shopkeepers, nuns, neighbours. She explained to Ursula that 'my mind is not strong enough to keep its harmony when any difficulties and obstacles come'. When Rodin died in 1917, Augustus, who had been working as a war artist, came to Paris to comfort his sister, but she was surprisingly resilient. Perhaps because she had, for years now, been grieving Rodin's absence - actual, emotional - his death, in some complicated way, was a kind of relief. She could finally stop longing for the day they would be together. She wrote to Ursula: 'I feel as if I have been ill for a long time and am getting better.'

In 1918, Gwen, who loved the sea so dearly, paid a rare visit to friends - the painter Ruth Manson and her daughter Rosamund, who were staying with their friends, Madame de Willman Grabowska and her daughter Elisabeth, in a cottage at the small seaside village of Pléneuf in Brittany. She loved it. For the first time

in fourteen years, she was able to travel and to be herself, liberated at last from her obsession with Rodin. On one of her many walks, she came across the secluded, semi-derelict Château Vauclair; like something from a fairy tale, it had - still has - a turret and wild garden. She discovered its rooms were cheap and so, in January 1919, she moved in; she stayed for six months and only left because it was sold. On her many trips to the village, she made countless drawings of local children. Many of them look like her.

Life continued: she painted, she prayed, she read. She became close to Jeanne Robert Foster, a poet and close friend of Quinn's, who was in love with him. The years passed.

In 1922, Gwen wrote to Quinn: 'I am quite content in my work now and think of nothing else. I paint till it is dark . . . and then I have supper and then I read for about an hour and think of my painting and then I go to bed. Every day is the same. I like this life very much.'

Paint can be controlled in a way that other aspects of a life cannot.

Gwen's paintings of the 1920s became sparser and sparser: muted, gorgeous fragments of people and places that evoke a universe of feeling. Views from her studio window are almost abstract; only the titles tether the images to anything concrete. It's as if she can feel her physical relationship to the world gradually being eroded. In 1923 she wrote a note to herself: 'You are free only when you have left all. Leave everybody and let them leave you. Then only will you be without fear.'

She developed a complex system of observation, identifying tones on a scale of 1-3. Her notes read like small poems.

March 1923 Colour harmony: - Elderberries & their yellow leaves & pink campiens & their *cendre bleu* green leaves.

And another:

Methods.
the snowdrop in the earth
dry blob & 2nd 3rd
the road

2nd 3rd dry blob
the pink flower

And another:

The making of the portrait 1. The strange form 2 The pose and pro-
portions 3 The atmosphere and notes 4 the finding of the forms.

The strange form. Gwen, more than anyone, could understand
how the uncanny lurks in the everyday.

Despite her reticence, in the main thanks to John Quinn, Gwen's
reputation had grown steadily. In 1913 she had finally sold him a
painting: *Girl Reading at a Window* from 1911. (A long thin girl in
a black dress and a black bow by a window, absorbed in a book;
earthy tones illuminated by a white lace curtain that blows lightly
into the room like a faintly frothing wave.) It was included in the
1913 Armory Show – the first major exhibition of modern art to be
staged in the United States – which travelled to three cities, New
York, Chicago and Boston. Gwen's work continued to be included
in important exhibitions in Europe and America; in 1917, the Tate
Gallery acquired *Nude Girl* from 1909-10. When I first saw the
painting, as with so many of Gwen's works, I assumed it to be a
self-portrait – in fact, it's a study of Fenella Lovell, a young artist's
model: a thin, sad-eyed girl rendered in soft, even sickly, tones of
grey, brown and yellow. The intensity with which Gwen painted
her had, unusually, nothing to do with affection. She wrote to
Ursula: 'It is a great strain doing Fenella. It is a pretty little face but

she is dreadful.' The 'it is' is telling. Fenella is not a person; she's a subject.

Over the next few years, Gwen exhibited regularly in Paris and, in 1920, John Quinn began to pay her an annual stipend of $750. For someone who lived as frugally as Gwen, it was a small fortune. It gave her the kind of security she had not experienced since childhood.

John Quinn supported her until his death from liver cancer in 1924. Gwen, who hadn't realised he was so ill, was devastated when he died. The fourteen years during which he had collected her work were the most productive of her life. He had bought anything she would sell him: twenty paintings and eighty drawings.

In May 1926, Gwen's first solo exhibition opened at the New Chenil Gallery in London: it comprised around twenty oil paintings and twenty-four drawings. She did not travel to see it. Ursula wrote the preface to the catalogue; she opened with a quote by the French artist, Maurice Denis: 'I have always had the wish to organize my work, my thought, my life and, as Cézanne said, my *sensation*. The power to suggest connections between ideas and objects has always been the point of art.'

The show was enthusiastically reviewed. Michel Salaman, Gwen's friend from her Slade days, described her paintings as 'pale, quiet songs'. He wrote to her that: 'My thoughts went back to our youth with its aims and hopes – and you seemed to be the only one of that eager band who had been utterly faithful to those aspirations, who had not only not failed them but achieved more than we dreamt of.'

The Tate Gallery bought a portrait of Dorelia and the rest of Gwen's work sold well; she was in demand. Later that year, Gwen decided to visit Augustus and his family at Alderney Manor. Dorelia sent her directions and money for a fur coat, which was curious as Gwen, for the first time, had funds. Many years later her niece Vivien, one of Gus's daughters, who was herself to become

a painter, remembered Gwen as so 'extremely shy' she had to have meals in her bedroom. She describes her aunt as very tiny, like a 'miniature Augustus', but with 'eyes that filled with tears almost continuously as she talked, and very pale, bluey eyes and she wore very dark, dark, clothes'.

In 1926, Rilke died at the age of fifty-one from leukaemia. Gwen was grief-stricken. She wrote: 'I accept to suffer always but Rilke! Hold my hand! You must hold me by the hand!

'Teach me, inspire me, make me know what to do. Take care of me when my mind is asleep. You began to help me, you must continue.'

She made countless tiny sketches of Saint Thérèse of Lisieux, who was known as 'The Little Flower'. She had a brief and unrequited passion for a friend of Rilke's, Véra Oumançoff.

In 1927, Gwen's work was included in a show in New York of Quinn's collection; in the same year she had two paintings in an exhibition at the Secession in Vienna and then in Toronto. Yet, for some inexplicable reason, it was around this time that she retreated. Augustus, who admired - was perhaps even jealous of - Gwen's talent, kept encouraging her to exhibit and to sell, but she resisted; she did not like to let her paintings go. She agreed to have an exhibition in New York, at Ferargil Galleries, but the work never arrived. Most of her paintings from the late 1920s are unfinished. She attended the art classes of the Cubist André Lhote, whose ideas she was enthusiastic about. Her final subjects were landscapes and increasingly abstracted studies of flowers and stones. In 1932 she wrote: 'Do not be vague or wavering. Impose your style. Let it be simple and strong. The short strong stalks of flowers.'

Her last oil painting is a small study of a woman in a high hat seated by a window.

With money she had earned from selling her pictures, Gwen had bought a small plot of land on rue Babie, near her flat in Meudon, which had two small buildings on stilts: one became her studio,

the other her bedroom. Around the same time, at the suggestion of Augustus and Dorelia (and with her brother's financial help), she had purchased a home, Yewtree Cottage in England, to be near them; she had visions of Ursula living with her there, but it didn't transpire and much to Dorelia and Augustus's confusion, after spending six weeks preparing it for habitation, she never returned. In Meudon, she grew flowers and jotted notes about art and religion; her beloved cats - she had around five - and her religious community were her main companions, although she was on friendly terms with her neighbours, the Roches, and her nephew Edwin, who was studying in Paris. She had a brief but adoring correspondence with the local curé, the Canon Piermé. She believed that 'aloneness is nearer God, nearer reality'. She went to Mass; as she had throughout her life, occasionally she slept under the stars. Although she finally had money, she was indifferent to it. Friends from London sent her clothes, blankets, a stove. Her anxious family was in constant contact with her, as were her neighbours but they did not realise the extent of her maladies. She was ill with eye and stomach problems and bronchitis. She hardly ate.

In September 1939 she collapsed on a train to Dieppe. No one knew why she was headed to the city; Augustus believed that she needed to see the sea. She was taken to a convent and died three days later. She was sixty-three.

She had been travelling, inexplicably, without any luggage. Perhaps she knew what awaited her. According to Augustus, she had made provisions for her cats.

Thirty-nine years before she died, in 1900, Gwen painted a magnificent self-portrait. The young artist looks directly at us: her lips are slightly pursed, her hair pulled back, her right hand on her hip. She is dressed in a full-sleeved golden-brown blouse with an enormous, dark brown bow at her neck; only the thick, dark belt at her waist can contain her. This is not a self-portrait by someone timid.

This is not a self-portrait by someone who objected to her own company. This is not a self-portrait by an artist overshadowed by her brother.

Two years later, in 1902, Gwen John painted another self-portrait that is perhaps her most famous painting. She is twenty-four, in a red blouse that sings out loud against a muted brown background. At her neck is a black velvet ribbon, decorated with a classical brooch. A brown shawl slips off her right arm and her dark golden hair is loosely pulled back. She looks demure but the expression in her eye makes clear that she's anything but; it's tempered by something faintly quizzical. The left side of her face is softly illuminated; perhaps she is near a window. Small gold pendant earrings softly reflect the light. Despite the fact that the details of the painting are rendered with precision, lines blur at their extremity, tones are subdued. She stares out at us across more than a century with her clear, direct, grey-blue eyes.

She is showing us everything that she knows, yet there is so much more to come.

Gwen painted the picture in response to an invitation by the teachers at the Slade, and in particular Professor Fred Brown, to contribute to an exhibition of former students that they were organising. Augustus wrote to Michel Salaman in late April or May of 1902 that 'Gwen has done a wonderful masterpiece, which Brown has bought already'. In 1920, Professor Brown included Gwen's self-portrait as a detail in his own self-portrait; the painting remained in the teacher's possession until his death in 1941. It is possible that Gwen painted it in Liverpool, where she was staying with her brother and Ida, who had just given birth to her first child. Gwen was mourning her love for Ambrose McEvoy and had written to Salaman that: 'I don't pretend to know anybody well. People are like shadows to me and I am a shadow.' Yet, there is nothing of the shadow in this painting. This young artist is resolute, clear, complex and calm; she appears to be full of resolve. At a

time when women had very little autonomy, she is resolutely self-contained. This self-portrait is the only painting that Gwen ever signed: GMJ.

Writing after Gwen's death, Augustus declared: 'Few on meeting this retiring person in black, with her tiny hands and feet, a soft, almost inaudible voice and delicate Pembrokeshire accent, would have guessed that here was the greatest woman artist of her age, or, as I think, of any other.'

Augustus John died in 1961 at the age of eighty-three; he was wealthy, lauded, one of the most famous artists in England. But he felt that, on some level, he had failed. In 1942 he had declared: 'Fifty years from now, I shall be known as the brother of Gwen John.'

I've Scraped By, Up and Down

> Well, I painted myself because I knew her; I am only shy with people . . . Painting self-portraits is the one time when you can be with yourself absolutely and just paint; you don't even have to get a likeness . . . With self-portraits you can be alone with yourself and not have to worry about another person.
>
> Nora Heysen

Modernity is an arrogant master; for all of its flashy brilliance, it's censorious; in the blink of an eye it excludes those who haven't subscribed to its assumption of what constitutes progress.

When the curator and publisher Lou Klepac first visited the artist Nora Heysen in her Sydney studio in the mid-1980s, he expressed surprise that she hadn't had a solo exhibition in the sixty years that she had lived in the city. Nora replied: 'No one ever asked. And I don't push myself.' She added that she relished 'comfortable obscurity'. Despite her love for her family, and her heartbreak at the

breakdown of her marriage, no one was more comfortable with her own company.

Although she is now considered to be one of Australia's great portrait painters, it took sixty-two years before a painting by Nora Heysen was hung in the country's National Portrait Gallery. Yet for the first three decades of her life, she was something of a star. Showing prodigious talent from an early age, in 1938 she was the first woman to win the country's pre-eminent art prize, the Archibald, and, in 1943, as Australia's first female Official War Artist she created 250 paintings and drawings. However, after the war, her fame faded, and she was sorely neglected by the Australian art community until the late 1980s.

What happened?

In 1911, Nora was born into artistic royalty. Her father was Hans Heysen, Australia's revered, conservative painter of gum trees; her mother, the formidable Sallie, had been his student. Nora was the fourth of eight children. The family lived in a beautiful home, The Cedars, in 150 acres on the outskirts of Adelaide in South Australia. Her parents encouraged Nora's talent from the start, and she drew and painted alongside her famous father in his studio. She said that she learned more from him than from anyone else. Throughout her life, her talent was inevitably linked with his; he was one of the few artists in Australia who was a household name. Even today, the Heysen family home is open to the public. Nora's studio is given equal billing with her father's.

In 1994, Nora was interviewed for two hours at her home, The Chalet, in Sydney by Heather Rusden. Nora was eighty-three. Her voice is low, gravelly. Sometimes she takes a while to answer a question; occasionally she laughs. She is blunt, mischievous, thoughtful. Despite her achievements, she is modest. Now and then, we hear the sound of a match being lit and the light inhaling of a cigarette being smoked. A clock ticks loudly in the background; occasionally it tolls. A window must be open as her words

are spoken to a soundtrack of birdsong and the occasional wild squawk of cockatoos.

Nora moved into The Chalet with her husband, Robert Black, in 1954. It was a romantic place, a rambling, low wooden structure surrounded by terraces and a large, lush garden and a pond. Nora lived there until she died, surrounded by animals - at one time she had twenty-five cats. She said that nature was her religion.

Her earliest memory was of always wanting to draw and paint. She imagined that her last thought would be the need to put something on canvas and paper.

She describes her childhood as idyllic, filled with the companionship of her seven siblings, with art and nature. The family produced most of its own food; she milked cows, rode horses and painted. 'We lived art, talked art, drank art and all of the visitors were artists. That was my diet when I was young. My younger brother thought he might be an artist but the competition was too strong.' They were taught music; throughout her life, before she started a painting, she liked to listen to Mozart. Nobody smoked or drank. Nobody did anything to excess 'except my father painting'. The family was bohemian, but it wasn't interested in Modernism.

When her father demanded quiet, the children 'went bush' and fished for yabbies. Nora was sent to a convent school. She remembered: 'I didn't want to be a nun but I wanted to be a priest . . . because they seemed to have more fun.' She enrolled at the Adelaide School of Art; it allowed her to hone her drawing skills, but she described it as so uninspiring it was 'pretty killing'.

She was technically brilliant. She says - without a hint of boastfulness - that she could have painted a gum tree and signed her father's name to it and no one would have guessed it wasn't by him. Visitors would admire her work, thinking it was her father's. At first, she painted alongside him. Her mother, perhaps to protect Hans from undue competition, organised for Nora to work in her

own space. Nora believed her mother was bitter about the fact that running her husband's studio and home and raising eight children didn't allow her own creativity to bloom.

Famous actors, politicians and artists from around the world visited The Cedars. Laurence Olivier and Vivien Leigh dropped in, as did Helen Keller, the pianist Artur Schnabel, the ballerina Anna Pavlova, the artists Thea Proctor and Ellis Rowan, and the Australian prime minister, Robert Menzies. The renowned opera singer Dame Nellie Melba gave Nora a gift of a large painting palette. She used it all her life and it features in some of her self-portraits.

Her father believed that to be an artist you had to be physically fit. She said dryly: 'I'm thankful to this day as I have an enormously strong right arm.' Her painting arm. When her father was away on sketching trips, Nora worked in his studio. This is where she painted some of the self-portraits that made her name. She 'turned to painting faces and painting myself and then subjects from the village and figures in the landscape. I thought father had a copyright on the gum trees.' She painted every member of her family and filled the house with her portraits. She painted herself, which she described as akin to 'an animal marking out its territory'. She added:

> I was trying to make my own name then, you see, as against being the talented daughter of the famous Hans Heysen and I think something of that must have crept into it - that I wanted to create myself and by doing a self-portrait it was the best way I could think of, that I would make an image there of somebody and that was Nora Heysen, the daughter of Hans Heysen.

She initially disagreed with her father about how to structure a painting. He liked lines; she liked curves. She said: 'maybe it's the female element in me'. Later, she agreed with him.

Heather Rusden asked Nora what Adelaide was like in the 1920s for women artists. She replied: 'I think it was pretty tough, but

I was way up in the hills, and quite remote from Adelaide so I wouldn't have known of their struggles - but from what I've learnt since then they had it pretty hard, they weren't even admitted into some of the exhibitions. Women's work wasn't even shown. Can you imagine that?' She adds: 'I wasn't aware of the feminists at all.'

By the time she was twenty, in 1931, her work had been bought by the Art Gallery of New South Wales, the Art Gallery of South Australia and the Queensland Art Gallery. With the money she had earned, she bought herself a rich brown velvet jacket. In 1932 she painted a self-portrait of herself wearing it. She is in her father's studio; her head is framed by a corner of a reproduction of a Vermeer; in her left hand she holds a paintbrush. Her palette is animated with a splash of cadmium red; to her right, a still life of bottles and a sketch pad. She glances at us, as if interrupted. She is stern, workmanlike, monumental and - thanks to her hard work - dressed in her beautiful jacket.

In 1933 she was awarded the Melrose Prize for Portraiture for *A Portrait Study*. The painting is, in fact, a self-portrait: Nora, her hair pulled back, in a simple white jumper and a red skirt, holds a drawing board; she looks out at us as if we are the mirror reflecting her back on herself. To the left of a painting is a still life of glass bottles, a brown jug, brushes and paint. To the right, books and a small bunch of vivid yellow Australian flowers. Many years later, in 1998, it would become the cover of Frances Borzello's ground-breaking book, *Seeing Ourselves: Women's Self-Portraits*. Sixty years after she painted it, Nora told the journalist David Meagher:

> I rather like that portrait because it was all sort of handmade; I knit-ted the sweater and made the skirt . . . In that period the fashion was that you showed no breast, you had to bind up your bosom so it was flat. When I look at that portrait, I think I could have put a bit more in - I had a big one at the time. Why I went along with the fashion I'll never know, because I never have since.

In December 1933, Nora had a solo show of sixty-two paintings and drawings at the South Australian Society of Arts Gallery: twelve portraits, including two self-portraits, thirty still lifes and twenty drawings. It was a critical and commercial success. She made enough money to support herself for the next few years. She was twenty-two.

In 1934 she travelled to London with her parents. They spent most of their waking hours seeing the paintings she was only familiar with in reproduction. She loved, in particular, visiting the National Gallery and studying the 'Veroneses & the Titian *Bacchus and Ariadne* [from] 1523; I specially looked at the Alfred Stevens portrait of a woman and was more than ever in love with it . . .' Back in Australia, she had particularly admired the artist George Lambert; now she was exposed to Vermeer and Piero della Francesca, and they became 'her gods'. For both Nora and her father, the great flower painter Henri Fantin-Latour was their idol. On 18 August 1935 she wrote to her parents from London that: 'Yesterday I went into the National and had a good look at the Fantin flowers and when I came back I had a great desire to put my foot through all mine.' For drawing, she liked Rembrandt, Michelangelo, Augustus John.

But modern art didn't resonate with her: 'the Cezannes, Van Goghs and Picassos left me bewildered. Chaos. Ridiculously high prices.' Later, she commented to her parents that 'Picasso is holding an exhibition at present. I went to see it and came away feeling that he was a charlatan. I simply couldn't take the work seriously . . . What strangely conflicting views there are about.' She complained that 'everyone seems to be aping someone else and trying to be clever and original with nothing to say for themselves'. When her family returned to Australia, her father's enigmatic parting words were: 'Your innocence will be your protection.'

Nora enrolled in the Central School of Arts and Crafts. For the first six months, no one spoke to her. She was profoundly lonely and found the winter horribly cold. She knew that compared to

most students she was privileged; she had her father's connections and was financially secure. Life looked up with the arrival of a close friend, a fellow art student from Adelaide, Evie Shaw (later Stokes). She was five years older than Nora and a widow. Her parents disapproved of the friendship, as they thought Evie was gay. Nora rebutted their criticisms; the young women were inseparable. They modelled for each other, supported each other, travelled together. Nora's *London Breakfast* of 1935 is a sensitive portrait of her friend in her blue dressing gown, her face softly illuminated in the weak English light reading a book and drinking a cup of tea; to her right is a delicate still life of bread, a vivid orange pumpkin, a blue bowl of white flowers.

Nora said that she learned more in two years in London than she did in five years in Adelaide but 'the world is the biggest education you can get'. Every time she moved home, she painted a self-portrait 'to create my own territory ... to establish myself in my surroundings'. She became friends with the artist Orovida Pissarro, who also came from a family of famous male painters. She was Lucien Pissarro's daughter, and Camille Pissarro's granddaughter; she signed her name simply 'Orovida' in order to be judged on her own terms. She was eighteen years older than Nora and didn't hold back: she told the young Australian that her painting was 'muddy and 50 years behind time' and that her palette was 'too low in tone'. Nora took her advice and her colours brightened. In January 1936 she wrote to her parents: 'My palette is getting higher and higher in key. I'm still working on my self-portrait. After seeing the Pissarros I repainted the wall behind the head in broken colour - gave it much more vibration and light.'

The finished painting is a study in concentration: Nora glances towards us, her face illuminated against a background of pale, shimmering tones of white and blue. She is dressed in a blue smock, a twisted white and blue scarf at her neck. Her left hand holds a fistful of brushes; her right, her large palette. Again, her head is

framed by the corner of another painting on the wall. Nora was always acutely conscious of the artists who had come before her. She believed that draughtsmanship, combined with individual expression and the elusive element of light, were the most important parts of a painting. In this self-portrait, she combined all of these qualities and more; it is both technically proficient and psychologically complex.

Yet, despite the quality of the work she was producing, Nora was constantly knocked down by the criticisms of men, some of whom were impatient with her lack of interest in Modernism. She wrote - heartbreakingly, humorously - to her parents that one of her teachers, Bernard Meninsky, had said 'that I had a good idea of drawing and proportion but unfortunately, I had been taught the wrong way, but it was likely with a few years of training I might be able to see the way he does and do Meninsky drawings'.

A friend of her father's, the Royal Academician James Bateman, was also stinging in his criticisms. In 1935 he and his wife came to dinner and then they visited Nora's studio. Bateman was savage, telling Nora that her work lacked tone, her technique was mechanical, and that she was trying to evoke light and vibration 'the wrong way'. Again, she wrote to her parents about the episode, concluding that 'he is biased against women painters . . . we nearly came to blows discussing women artists and their merits'.

When Nora was in her eighties, she revealed that she had been the subject of yet another attack. Her father had introduced her to the renowned painter, art historian and former director of London's National Gallery, Charles Holmes, whose history of the National Gallery was her 'most used book'. She recounted that:

I took my work to Charles Holmes . . . he asked me what I wanted to do . . . and I said figures and landscapes - he just laughed at me and it crushed me. Absolutely. It was very untimely criticism. And, well, I lost my confidence entirely. I [went] on painting but my big

ideas, you know, Australian landscapes and figures . . . it was very
sad and devastating. Devastating.

Holmes must have been harsh, as he wrote her a letter of apology,
but within a month he had died. Nora was deeply depressed. She
was broke, disheartened, cold. She told her parents that she 'felt
all the faith and heart taken out of me'. Her father sent her some
money and she enrolled in the Byam Shaw School of Art - some-
thing that Holmes had suggested she do - to start all over again. In
old age, she remembered her time in London, and her struggle to
make a name for herself, beyond that of her father's. She tells the
story of deciding to change her name to 'Norah H' but when she
sent some paintings back to Australia, her father assumed she had
made a mistake and corrected her signature. She also tried to show
her work to some galleries on Bond Street, but they were 'very,
very distant and haughty' and not interested in a 'little Australian
upstart'. With so little encouragement, and in such isolation, her
skin thickened. She learned to trust her instincts and to embrace
her solitude.

In 1994 a self-portrait by Nora was found, still rolled up in her
studio. *Down and Out in London* was, in 1937, the last painting she
completed in England. It's a melancholy, low-key scene: Nora, half
seated on a kitchen bench, gazes into the distance. Her right sleeve
is rolled up; she is surrounded by the detritus of domesticity;
washing on a line above a stove behind her, a large bowl, a kettle,
an empty glass. There is no indication that she is an artist. She
looks tired, deflated. The only flowers are reproductions; faded
images of lost blooms on a tablecloth. It's telling that she depicts
herself in a kitchen - the room that no doubt many men would
have preferred her to stay in. But, despite the melancholy scene,
she didn't give up. Self-portraits can be a form of exorcism.

In late 1937 she and Evie travelled through Italy looking at
paintings. She wrote to her parents that: 'I feel now sure of what I

want. I only need the time and quiet to work it out for myself.' She returned to Australia and stayed at The Cedars for a few months where she painted another self-portrait. Gone is the dejection of her London painting. Against a pale yellow background - a nod, perhaps, to the welcome heat of the Antipodean sunshine - she looks directly at us: she is dressed in a blue cardigan, buttoned to her neck. Her brown hair is pulled back. Her gaze is steady. She is young, strong, straightforward. She is unbowed.

In 1938 she moved to Sydney. For her twenty-seventh birthday her father gave her a book on the work of Botticelli.

When she arrived in the city, in stark contrast to London, the artist, publisher and promotor Sydney Ure Smith 'was a very great help' to Nora and with his encouragement she joined the Society of Artists. He introduced her to countless people; he was a man who 'had no fight about women painters, in fact he recognised Grace Cossington Smith, Margaret Preston and Grace Crowley - they were at the helm, at the top'.

With her famous father, she could have met scores of people, but, in her words, 'I wasn't a social bird ever.' She loved painting flowers but was told that they were inappropriate to exhibit, as 'mostly women were doing flowers'. She delighted in her own company, working hard, swimming, reading. Art for her was a way of filtering the world, of focusing on what gave her pleasure. She was never a bohemian. She loathed parties. Painting was all the stimulation she required. Having been brought up in the household of one of the most successful artists in Australia, wealth and fame held little interest for her. In a way, she had already experienced them.

In 1938, at the age of twenty-eight, she won the most prestigious art prize in Australia, the Archibald, with a portrait of the socialite Madame Elink Schuurman. Nora was not only the youngest artist to ever win the competition but also the first woman to be awarded the prize in its seventeen-year history. Her painting beat 144 works

by eighty-four artists. When her name was announced, she was swimming in the harbour. The renowned sixty-three-year-old artist and teacher Max Meldrum had also entered the competition. His response to Nora's win was ungracious, patronising and bad-tempered. The Brisbane *Sunday Mail* of 22 January 1939 reported his words beneath the heading 'Domestic Ties Downfall of Women Art Careerists':

> If I were a woman, I would certainly prefer raising a healthy family to a career in art. Men and women are differently constituted. Women are more closely attached to the physical things of life. They are not to blame. They cannot help it, and to expect them to do some things equally as well as men is sheer lunacy. A great artist has to tread a lonely road. He needs all the manly qualities, courage, strength and endurance. He becomes great only by exerting himself to the limits of his strength the whole time. I believe that such a life is unnatural and impossible for a woman.

In his ugly way he was, ironically, right about great artists treading a lonely road, but he obviously didn't know Nora. He probably never knew that, with her usual modesty and self-effacement, the young artist wrote to her parents that, despite his vitriol, of all the entries in the prize, Meldrum 'had the best exhibit'. Another painter in the competition, Mary Edwards, was also vitriolic, saying to Nora that if she had a sense of honour, she would return the prize. In a letter home, Nora wrote:

> This Archibald Prize has brought not only blessings on my shoulders but by some trick it seems to have made me a few enemies. There are still irate and seething letters in the papers against my portrait and the judges' decision; the papers rang to know what I think of it. I have nothing to say, so probably they will grow tired of it.

In her eighties, thoughtfully dragging on her cigarette, Nora mildly reflected on Meldrum's words. 'That was a surprise to me; I wasn't aware of this [kind of attitude] as it wasn't in my home . . . Among artists I wasn't conscious that women were being treated differently. Art's art to me, whoever does it, men or women or what.'

A few days after *The Sunday Mail*'s report, *The Australian Women's Weekly* added insult to injury. It ran a feature on Nora's win under the title 'Girl Painter Who Won Art Prize is Also a Good Cook'. A photograph of the young artist shows her peeling vegetables. She is quoted as saying 'Most artists can cook even if all cooks do not paint.' They ran three of Nora's favourite recipes 'for foreign dishes': Hungarian goulash, duck with olive sauce and Chilean stuffed green peppers.

Nora wrote to her parents that:

> After two days of rather bewildering notoriety and excitement, today the reaction has settled in. I'm glad to have a quiet day in my studio. I have been beset with reporters and photographers and their battery of cross-questioning. Now I have a vague idea of the life of a movie star. Thank goodness that it lasts for a brief day . . . and I can settle back and paint in comfortable obscurity.

Nora is surely one of the only painters in the history of art who longed for 'comfortable obscurity'. She received a slew of commissions because of the Archibald Prize but was frank about the difficulty they entailed. Although she was 'always interested in faces', she said 'I'd rather make roads than commissioned portraits.'

In 1943, Nora became the first Australian woman to be appointed an official war artist. She travelled to New Guinea and painted and drew nurses and, in particular, women working; 245 of these works on paper and canvas are now in the collection of the national War Memorial in Canberra. Much to her frustration,

she developed terrible dermatitis and had to return home to recover.

After the war ended, Nora and her work fell into obscurity. Lou Klepac, the curator who was responsible for resurrecting her career, puts this down to a few factors: that she was naturally reticent and that she exhibited, at the behest of her father, with the conservative Academy of Art in 1938, and not the more radical Contemporary Art Society. It also can't have helped that she was uninterested in Modernism, socialising or promoting her work, loved painting flowers and earned a living, in the main, from portrait painting, which fell out of favour in post-war Australia. Also, her name was inevitably intertwined with that of her father's, whose gum trees were sorely out of step with the contemporary art produced in Australia by Expressionist artists such as Arthur Boyd, Joy Hester, Sidney Nolan and Albert Tucker, and then later by abstract and conceptual artists. In 1989, Lou Klepac wrote:

> In almost 60 years she has had only eight individual exhibitions because she has never gone out to look for one. She has had them when they were offered to her. In over 50 years of living in Sydney she has never had such an exhibition because no one has ever asked her. There is hardly an artist living in Sydney of any standing and half her age who has not had twice as many exhibitions.

Nora's gradual falling out of fashion also coincided with her marriage. In 1943 she had found love with a scientist, Robert Black. He was married with a child. His wife didn't grant him a divorce until 1953; Nora and he married the next day, 'a wish of ten years standing'. They travelled extensively and, at various times, lived in the Pacific Islands. Although she kept working throughout her marriage, Nora's identity as an artist was dominated by her role as a wife. She said: 'I think marriage has got to interfere with career. As long as your partner is not in the same field as yourself, I think

there are more complications there.' She says that she wasn't as 'fully concentrated' as she had previously been and that 'an unevenness came in'.

One wonderful thing happened: in 1954 they found The Chalet to live in. Nora fell in love with it immediately; it reminded her of her family home back in the Adelaide hills. The first painting she created in her new home was a self-portrait: she pictures herself workmanlike in a thick jacket, holding her famous palette in her right hand and a brush at the ready in her left; empty rooms, waiting to be filled, recede behind her.

Their home was filled with animals; seemingly countless cats and Nora looked after bandicoots and possums. She described herself as 'a general provider for animals and all the strays'. She had always wanted to have children, but she couldn't conceive. She said that some of her paintings were like children to her; the ones that 'have given you the most painful birth . . . you want to keep them . . . you've got nearer to what you want and you'd like to have it around you for a while, until you do something better'.

Throughout the 1950s and 1960s, Nora had a few solo shows, mainly in South Australia and organised by her brother Stefan, who ran the Heysen Gallery, and by another brother, David. She also continued to enter competitions. In 1962 she was interviewed for *The Age* newspaper. The article was titled: 'I Don't Know if I Exist in My Own Right'. She says that that feeling 'haunted her for many, many years'. This, despite all that she had achieved.

In 1967 she sketched her father when he was ninety; she was travelling and wanted to have his likeness close by. A photograph was not enough. She loved her father dearly; she felt that they shared the same temperament. She said that what she shared with her mother was her malice. Her mother died in 1962; her father in 1968.

In 1970 her work was included in a group show at Prouds Gallery in Sydney. An article in *The Australian* newspaper described it

as an exhibition of 'some artists who still paint the old-fashioned way'. Nora said: 'I wouldn't pretend to be an abstract painter or on the popular bandwagon. I'm on my own private bus and I'm quite happy.'

In 1972, Robert Black left Nora for his young assistant. Nora was overwhelmed with despair. She survived because she 'had my painting'. She believed that 'great emotional upheavals' are good for your work. She led a quiet life communing with her animals and her painting but found some solace in the close friendship she developed with a child, Steven Coorey, whose family were Nora's neighbours. In the late 1960s he had visited her to enquire about a kitten; in 1972, when he moved to Tasmania with his family at the age of fifteen, they began writing to each other. In 1975 he moved in with Nora. They were very close; he sent her cards on Mother's Day and when he moved to San Francisco, he addressed his letters to her as 'The Angel Nora'. They shared a love of gardening, animals and art, and exchanged photographs of paintings they were working on. When she painted her last self-portrait in 1987, for the David Jones Sydney Second Annual Survey Exhibition – an image of herself in her garden in a blue smock – Steven wrote to her: 'your fabulous Impressionist self-portrait – I love it and obviously so do the judges! I'm sure it's given a lot of its reviewers something to think about – like Why [sic] wasn't this artist given more exposure and due long ago!'

In 1986, Steven introduced Nora to his boyfriend Craig Dubery, proposing that he might stay with her. He moved in and the older artist and the young man became close; in later years he became Nora's confidant and carer. When Steven died from an AIDS-related illness in 1997, Nora's grief was immense.

As Nora aged, painting became more difficult. 'I haven't got any more confidence that I can paint over the years. In fact, one becomes more and more convinced that it's a very hard business to produce a good painting.' She considered art to be a disease, a drug

and an escape, but she wouldn't have it otherwise because to be an artist is to experience moments of 'extreme joy and exhilaration'. She described herself as someone inclined to melancholy and the depths of despair and explained how painting took so much out of her that it didn't leave her much time to give to people.

It wasn't until 1989 when she was seventy-eight, when Lou Klepac's monograph on her was published and the S.H. Ervin Gallery in Sydney staged her retrospective titled 'Faces, Flowers and Friends', that Nora finally started to garner critical attention. With classic humility, she quietly remarked that 'recognition has come a bit late but it's still very nice'. In 2000, when Nora was eighty-nine, Klepac curated a retrospective dedicated to her life and work at the National Library in Canberra. It was life-changing. Nora said: 'I only just thought that I am a person, painter in my own right since Lou Klepac discovered me and put on this retrospective show and produced the book. I'd never been published before. I'd never had a retrospective show [. . .] I was always haunted with being the talented daughter of the famous Hans Heysen.'

In 2001, days after her ninetieth birthday, Nora took part in a radio interview. It was the first time she had revealed that her father had told her that he would have preferred one of her brothers to be the artist in the family. He said that 'for a woman it would always be a divided interest because biologically they were conditioned to bearing children and running a home and that was what women did'.

Nora didn't seem to mind too much; she and her father had loved and respected each other, and she was always one to put things in context. That said, it's hard not to wonder how her isolation as an artist, the failure of her marriage and her childlessness had affected her. When asked to sum up her life, she replied with typical, beautiful, understatement: 'I've scraped by, up and down.' Although her solitude had, at times, broken her heart, it also granted her the freedom to be herself: an artist.

6

Translation

The museums of Australia are filled with nineteenth-century colonial art. You can sense the struggles of long-dead painters attempting to transpose the artistic language from the other side of the world onto an alien landscape. Often, their trees don't look like any tree you'd see in Australia, the animals are oddly deformed, and the light is more like that of the rainy English countryside than New South Wales. Indigenous Australians are often absent from these pictures, reinforcing the devastating falsehood that the continent was uninhabited when it was colonised; if they are present, they're usually depicted as 'noble savages' or benign characters in a rural scene. Indigenous art, with its infinite riches, was considered by most settler artists to be a language so foreign as to be incomprehensible and was relegated to the study of anthropologists.

Before the twentieth century, very few artists in colonial Australia painted self-portraits; there was no market for them and the professional art world was small. Non-Indigenous women artists were also few and far between. (Women's creativity is, and has always been, central to First Nation cultures in Australia.) There were, though, as there always are, exceptions. Adelaide Ironside, who was born in Sydney in 1831 - considered to be the first Australian woman to travel to Europe to study art - made a few delicate self-portraits in pencil. The first professional female artists in the country, the miniaturist Mary Morton Allport (born in 1806), and the sculptor Theresa Walker (born in 1807), also made likenesses

of themselves. But their names were soon relegated to the dusty storerooms of history.

The opening of art schools and a growing economy in the late nineteenth and early twentieth centuries led to a brilliant blooming of a new generation of Australian artists who were invested in reflecting the complexity of the country: one that combined a local vernacular with the European tradition. Of course, this was not a unique situation; as the twentieth century progressed, artists around the world grappled with the legacy of colonialism, asking themselves how to translate a European artistic tradition into a language that made sense in countries that had long had their own traditions.

Tradition Thinks for You, but Heavens! How Dull!

The Australian artist Margaret Preston was born Margaret Rose McPherson into a solidly middle-class family in Adelaide in 1875. Margaret – who was known as Rose McPherson until her marriage at the age of forty-four – was integral to the blooming of Modernism in Australia and was to become one of the country's best-loved, at times controversial and outspoken artists. It could be said that as she herself changed, so did her name: Rose became Margaret, McPherson became Preston. Perhaps this is apt: all mature artists are, to a certain degree, a translation of their younger selves.

The Australia of Rose's youth was a mix of optimism – the sense of a young democratic country full of possibility – and a place of terrible tragedy: the genocide and dispossession of its original inhabitants. Although Aboriginal peoples have lived on the continent for more than 60,000 years, they were not recognised in the country's national census until 1967. It wasn't until 1983 that voting for Aboriginal people became compulsory, as it is for other Australians. Another tragedy was the country's racist 'White Australia

Policy' - an immigration law that was established in 1901, gradually dismantled from 1949 and then abandoned in 1973. Yet Australia was the first country in the world to give (some) women the right to vote: non-Aboriginal women who owned property were welcome at the ballot box in South Australia's local elections from 1861. In 1902, Australia became the second country in the world to give (non-Indigenous) women the vote. In Melbourne, the National Gallery of Victoria Art School was founded in 1867 and women were accepted as students. Unusually for the time, they were also permitted to study life drawing from naked models. By 1900, female students far outnumbered the men.

From an early age Rose - whose birth name resonates with her lifelong preoccupation with flowers - questioned what it meant to be Australian. Her love for her country was fierce and complicated. As well as grappling with her artistic language, from 1923, as Margaret Preston, she wrote copiously and published opinionated, occasionally misguided, always impassioned articles in art journals and popular magazines about art, poetry, pottery, flower arranging, 'Basket Weaving for the Amateur', 'The Best Conditions for Furnishing a Bedroom' and what it meant to be an Australian artist. 'Why,' she railed, 'does the tobacco-juice art (Vandyck brown) flourish in Australia in preference to the light and colour sect? Because the apparition of colour was nearly killed in the Victorian era, and most of the art here has not emerged from that period.' She was also a great advocate for Indigenous arts and the country's cultural and geographical links to Asia. It's important to put her radicalism in context: during the first part of the twentieth century it was common for Australians who were descended from Britons to call England 'home', even if they had never been there, for Aboriginal art to be not considered art at all, and for Asia to be a place on the map your ship passed on the way to Europe. Margaret's exhortations were a blast of much-needed fresh air.

In 1927, in an article published in *Art in Australia* and wonderfully

titled 'From Eggs to Electrolux', Margaret reflects on the single event that made her decide to become an artist. Her mother had taken her, at the age of twelve, on a visit to the National Gallery of Sydney (now the Art Gallery of New South Wales). Writing about herself in the third person, she describes how her 'first impression was not of the beauty or wonder at the pictures, but how nice it must be to sit on a high stool with admiring people giving you "looks" as they went by'. She also liked 'the smell of the place . . . it must have been the kind of floor polish used on the linoleum'. Soon, though, she learned to like everything else that came with being an artist. She was taught 'to draw the outward show of dancing fauns, Donatello heads, etc' and was surrounded 'by tradition and taught only through tradition'. In Melbourne she enrolled in the National Gallery of Victoria Art School and studied under the Impressionist Frederick McCubbin - who she described as 'one of the kindest, cleverest artists Australia has produced'. She then decided to 'teach for her living and paint her pictures as she would, to choose her own subjects and do them in her own way, leaving all thought of selling out of her mind'. But she was restless. It was time to explore the world.

In 1904, at the age of almost thirty, Rose left Australia for the first time; she sailed to Italy accompanied by her friend, patron and possible lover, the artist Bessie Davidson, a former student of hers who was four years younger. They were to live, travel and work together for almost a decade. Like so many artists before and after them, a trip to the other side of the world was considered essential for the development of the young artist. As the art historians Rex Butler and A.D.S. Donaldson observe, the history of Australian art didn't only take place in Australia.

Although Rose found Venice 'glorious beyond our expectations', she was underwhelmed by the art. 'Nothing,' she dryly observed decades later, 'impresses the ignorant.' Titian 'and his fellow artists roused little enthusiasm'. In Munich, the women enrolled at the

Künstlerinnen-Verein and then a school for illustration, as the State Academy of Art was barred to female students. They discovered 'the German attitude towards women not progressive. Everything is for the men.' They complained that 'no one seemed to understand Australian German or appreciate Australian art'. Noting that there were 'two strong elements', 'the dead realists and the lively moderns', Margaret later wrote: 'Naturally, I condemned as mad and vicious the moderns and willingly went with the deads.' She changed her mind six months later: 'I am starting to think that perhaps the mad and vicious show has something in it.'

The only art she admired was Dürer's painting of two apostles, 'one having a whole landscape painted on the pupil of his eye'. Rose and Bessie moved to Paris, where seemingly countless Australian women artists had gravitated: in 1913, less than ten years off, an exhibition at the Salon des Artistes Français included six of them. At the urging of the Australian artist Rupert Bunny, who was living in France at the time, the two women enrolled at a teaching atelier, La Grande Chaumière in Montparnasse. They also travelled endlessly, moving from 'country to country, from gallery to gallery'. They were dazzled by Matisse's use of colour, fascinated by a Gauguin retrospective, and studied the paintings of Ingres and Renoir, 'growing more and more muddled'. In Spain, they 'worshipped at the shrine of Velasquez', but 'Goya, not very far away, had the last word'. Rose's work was exhibited in the Salons of 1905 and 1906. Their coffers running dry, the women returned to Australia for a few years to make some money. Rose - who lived at Bessie's family home for three years as her parents had died - taught painting, had an exhibition but didn't sell much, and was criticised for the brightness of her flower paintings. But the pull of Europe was strong. In 1910, Bessie returned to Paris, where she lived for the rest of her life. (She died in Montparnasse in 1965 and was buried in the same grave as her partner of two decades, Marguerite Le Roy.) In 1912, Rose, who had been commissioned by the

South Australian government to buy paintings for its collection, followed suit. She travelled to Paris with her close companion, the artist potter Gladys Reynell, with whom she lived until 1919. Happily back in the French capital, Rose was enamoured by the Japanese art in the Musée Guimet, where she learned that 'there is more than one vision in art', and admired Cézanne, Picasso and the Scottish colourist J.D. Fergusson. She vowed that 'from this time onwards her work would be based on colour principles'. She had distilled her learning into one dictum: 'Decorative work - it is the only thing worth aiming for.' Due to a bureaucratic confusion about her use of her middle name, Rose began to sign her work 'Margaret McPherson'.

In 1913, Margaret and Gladys moved to London. Margaret's work was included in several exhibitions; she also taught painting, in the main to women students. When World War I broke out, the friends studied ceramics at Roger Fry's Omega Workshop, took a nursing course, and taught shell-shocked soldiers arts and crafts. By now, her highly recognisable visual language was taking shape. The technically brilliant still lifes she painted during the war years - of flowers, food, cutlery and crockery - are dazzling ripostes to the dreadful darkness that had engulfed Europe. Painting in bright, tonal colours and restless for change, Margaret had become a Modernist. When the Armistice was declared, she returned to Australia, but not just for practical reasons. She believed that the country 'needs its artists, writers and poetesses and when they settle in foreign lands, they are betraying the land of their birth'.

In 1919, at the age of forty-four (although she declared her age to be thirty-six on the marriage certificate), Margaret married a wealthy businessman, William George Preston. (Referring to his wife's relationship with Gladys, he later declared that he had 'broken up a twosome'.) The couple set up home in Sydney and for the next four decades they travelled extensively, and often to remote locations,

researching the arts and crafts not only of Australia, but of Asia and the South Pacific, the Americas, North Africa, the Middle East and Europe. They were financially secure so Margaret had no need to earn a living: this gave her the freedom to concentrate on what interested her. She wrote (again, in the third person) that she was now free to paint 'what she pleases and how she thinks. She does not imagine that she has advanced in her art - only moved. The ladder of art lies flat, not vertical.'

In 1923, in a wonderfully sarcastic paragraph in her essay 'Why I Became a Convert to Modern Art', Margaret wrote plaintively:

> Australia is a fine place in which to think. The galleries are so well fenced in. The theatres and cinemas are so well fenced in. The universities are so well fenced in. You do not get bothered with foolish new ideas. Tradition thinks for you, but Heavens! How dull! To keep myself from pouring out the self-same pictures every year, I started to think things out.

She felt that her art didn't suit the times, which she described as 'a mechanical and a scientific age', a 'highly civilised and unaesthetic one', and that her 'mentality had changed and her work was not following her mind'. Her main preoccupation was the need for Australian artists - including herself - to find a form of expression that, while acknowledging its European roots, reflected life in the southern hemisphere. She asked and then answered her own question: 'When is a work modern? When it represents the age it is painted in.' The time had come to 'express her surroundings' - and she did so with a concentrated abandon. Living in the lush harbourside Sydney suburb of Mosman, the riotous paintings and woodcuts of native flowers Margaret produced over the next decade or so reflect the semi-tropical abundance of her surroundings. Petals, stems and vases are at once flattened and animated; tonal contrasts are ramped up, sensual and sun-baked - vivacious

snapshots of European Modernism on holiday, luxuriating in the hot Antipodean light.

Margaret had her first major exhibitions in Sydney and Melbourne in 1925 with her friend and fellow artist, Thea Proctor. The shows were a hit. One critic exclaimed: 'She is as full of colour as a kaleidoscope.' Another described her as 'the natural enemy of the dull'. The effect of Margaret's seductive, vivid woodblock prints, which she framed in Chinese red lacquer, was tremendous: the Australian public was brought around to the possibility that local products and concerns were as valid a subject as European imports. Thea professed that Margaret had 'lifted the native flowers of the country from the rut of disgrace into which they had fallen'.

'Now comes the younger generation,' wrote Margaret in 1928, 'demanding the right to their country, to an expression in their own methods and disliking apron strings'. In her pursuit of a homegrown Modernism, Margaret returned time and again to still life. In 1929, pushing against the idea that flower painting was anodyne and - because of its association with women - somehow a lesser art form, Margaret wrote in *Art and Australia*: 'Why there are so many tables of still life in modern paintings is because they are really laboratory tables on which aesthetic problems can be isolated.'

When in 1932 Margaret and her husband moved to the bush suburb of Berowra, north of Sydney, she became increasingly interested in Aboriginal art, quoting from it and reinterpreting it for her own ends, travelling to remote sites and incorporating Indigenous motifs into her work. However, her learning curve was steep. Her - from our perspective, frankly racist - articles of the 1920s and 1930s reveal a fascination with Indigenous art that is tempered with, at times, a staggering ignorance and insensitivity. She did not seem to understand that this deeply complex language could not be glibly translated into a Western Modernist vernacular. While she admired the energy and inventiveness of the designs, she refers to

Aboriginals as 'savages' and describes their art, ignoring its complex spirituality, as 'primitive'. In one article she blithely suggests that sacred objects such as a 'Kimberly dancing board could give you a suggestion for a curtain . . . or a cushion cover'. By 1941 her thinking had deepened and she admits, with something of an apology: 'I am humbly trying to follow them [Indigenous artists] in an attempt to know the truth and paint it, and so help to make a national art for Australia.' Elsewhere she acknowledges that: 'The art of the aborigine [sic] has for too long been neglected. The attention of Australian people must be drawn to the fact that it is great art and the foundation of a national culture for this country.'

Her prints became more schematic, larger, less colourful, full of rich browns, ochres and burnt umber; she began to represent flowers not cut in vases but wild, in their natural state. As with all experiments, she wasn't always successful. Her quotation of Aboriginal art remains contentious: some critics see it as a clumsy appropriation of a language she had no right to employ, whereas others believe that her highlighting of its significance reflects a ground-breaking recognition of Indigenous art's depth and complexity.

In an article titled 'What Do We Want for the New Year?', published in *Woman* magazine in 1953, Margaret wrote: 'It has been said that modern art is international. But as long as human nature remains human every country has its national traits. It is important for a great nation to make a cultural stand [. . .] My wish is to see a combined attempt by our artists to give us an art that no other country in the world can produce.'

In 1930, Margaret was invited by the Art Gallery of New South Wales to paint a self-portrait. It was a curious request. She had never before demonstrated any interest in self-portraiture and she was famous for her still lifes. But it was considered something of an honour: the self-portrait was one of eleven paintings commissioned

by the gallery with a view to 'perpetuating the names of Australian artists who have distinguished themselves in art'. Margaret was the only woman and the only modern artist asked to be part of the pantheon. Sixteen years after she completed her self-portrait she made clear why she had agreed to do it: she had felt that the country needed more portraits of Australian female artists 'as proof that women who think for themselves do not necessarily look like something out of the dust-box, which seems to be the general impression'.

Depicting herself wasn't something that came easily. She obviously struggled to translate her complexity as an artist and as a woman into a single image. When the painting was finished, she wrote unenthusiastically that: 'My self-portrait is completed but I am a flower painter - I am not a flower.' However, despite its apparent austerity, Margaret's painting reveals both what she believed to be important - in art, in life - and, unlike so many of her precursors, how hemmed in she felt by the genre. Hers was an outward-looking temperament: in the briskness of her writing and the hard, clear edges of her paintings and prints, there is little room for ambiguity, for the vagaries of the flesh or the complications of feeling. She is direct, workmanlike and unadorned; she also looks more youthful than fifty-five - perhaps her restless, ever-curious creativity kept her young. A black painting apron over her simple black dress is austere, functional; its geometric neckline the epitome of modernity. Her dark-golden hair is fashionably bobbed and her cheeks are flushed pink, as if with embarrassment at such scrutiny. She holds her brushes and her palette - which is smudged with the green and red paint she used in her flower painting - in her left hand. She pictures herself against a backdrop of a drab brick wall the colour of pale flesh; she gazes into the distance as if she's willing herself to be somewhere else. In many ways this is a painting that could have been made almost anywhere in the world, apart from one important detail. Behind the artist, vivid against a

green window frame, is a terracotta pot of six bright red and yellow correas: a native Australian wildflower known as Christmas Bells. In this dull suburban context the flowers are - like the artist herself - resolutely and exuberantly alive.

To Be Known by Name

Ten years after Margaret completed her self-portrait, halfway across the world, a young artist in Washington set up her easel to paint herself. Like Margaret, Loïs Mailou Jones was also preoccupied by questions of nationhood but from a very different perspective. She was a young Black woman in a country in which racial segregation was widespread and lynchings were not uncommon.

The thirty-five-year-old artist's self-portrait is a small - 44.5 x 36.7 cm - forceful work made from casein (a fast-drying, water-soluble paint) on board. Loïs pictures herself in her studio, dressed in a red shirt, a light blue painting jacket and simple hooped earrings; her eyebrows are elegant and arched and her black hair is as glossy as a crown. Her workspace is crowded and dimly lit, although her face is illuminated by a soft glow. She stares intently out at us with an expression that is forthright; almost smiling, she emanates a sense of her own power. Her right hand, out of view, clutches four brushes. In the background, two small traditional African sculptures of indeterminate provenance stand side by side; something of a premonition, in a sense, of the importance that Africa would have for Loïs when she began her travels throughout the continent in 1970, aged sixty-five. Although the figures are obviously sculptures - they're on a small plinth - in the low light of the studio, the divisions between the present and the past seem to blur; they could be ancestral spirits bearing witness to the young artist's creativity. They're observing the painting Loïs is working on - an image we are not privy to. They're positioned in front of

what could be either a large painting or wallpaper. Swathes of deep blue, purple and green swirl around the intimation of a disproportionally large chair – what is real and imagined here is vague. The brushwork is loose and urgent; the painting is signed twice, in the top and bottom left. It's as if Loïs wanted to make doubly sure that her name would never be lost and the authorship of her painting never in doubt.

Loïs was born on 3 November 1905 in Boston. Slavery had only been abolished forty years earlier and its evil legacy was still apparent in the country's racial edicts, instigated by white supremacist government officials. Segregation laws dictated where, depending on the colour of your skin, you could legally eat, walk, rest or travel, despite the famous line in the Declaration of Independence that 'All men are created equal; that they are endowed by their creator with certain inalienable rights; that among these are life, liberty and the pursuit of happiness . . .'

The pursuit of happiness? It's hard enough being a woman artist. Multiply that ad infinitum if you're a person of colour born in the USA in the first years of the twentieth century.

Loïs grew up in a family that nurtured ambition. Her father, Thomas Vreeland, was a building superintendent, who, after studying at night school for nine years, became the first African American lawyer to graduate from Suffolk University Law School. (He then worked as a real-estate lawyer and agent.) Loïs's mother Carolyn was a hairdresser and a hat designer who often took her young daughter to the homes of wealthy white clients; the story goes that seeing the paintings on their walls stimulated Loïs's early efforts at drawing. These visits were double-edged, though: decades later, Loïs remembered how her mother had to enter by the side door and could only eat in the kitchen.

Carolyn was a powerful influence on her daughter's thinking and 'awakened in her a desire to make something beautiful'. Loïs's

brother, John Wesley, was nine years older than her, so she was often left to her own devices. The highlight of the year was the family's summer holiday at Oak Bluffs in Martha's Vineyard, where Loïs's maternal grandmother Phoebe Ballou was a housekeeper for the wealthy Hatch family, who supported Loïs's interest in art. The Vineyard was to have a lifelong influence on the young artist. She wrote: 'What a joy it was to see the buttercups and the fields of daisies and the beautiful blue of the ocean. Indeed, it was a great inspiration. I just fell in love with nature. That island is greatly responsible for my love of nature and for art as a career.'

Loïs also became lifelong friends with another Black girl at the Vineyard: Dorothy West, whose energy was a match for the young artist. At the age of fourteen, she had her first story published in the *Boston Globe* and later on, she became a renowned novelist and short-story writer. She and Loïs died within months of each other in 1998; they were the longest-surviving members of the Harlem Renaissance, the social and cultural explosion which bloomed in the Harlem neighbourhood of New York from around 1918 until the mid-1930s.

During the summer Loïs loved sketching. While her parents supported their precocious daughter's ambition to be an artist – her mother hung Loïs's watercolours on a clothesline to create informal outdoor exhibitions – praise also came from unexpected quarters. Quite by chance Jonas Lie, the president of the National Academy of Design, came across the young artist drawing and told her she was talented. Another visitor to the Vineyard was the African American singer and composer, Harry T. Burleigh, who had introduced the great Czech composer Antonín Dvořák to spirituals. Burleigh liked to talk with the local children and advised Loïs to 'go to Europe if you want to arrive'. But perhaps most significantly, when Loïs was in her early teens, she met the renowned sculptor Meta Vaux Warrick Fuller, who also summered at the Vineyard. Living in Paris at the turn of the century, Meta

had been a protégé of Auguste Rodin's; in 1907 she became the first African American woman to be commissioned by the federal government to create a public sculpture for the Negro pavilion at the Jamestown Tercentennial Exposition. She won a gold medal for the 150 figures she sculpted, which embodied the progress of African Americans since their 1619 arrival in Jamestown, Virginia. She was also one of the most significant figures in the Harlem Renaissance.

When told of Loïs's ambitions, the older artist 'was most considerate and encouraging' and invited Loïs to visit her studio in Framingham. The teenager never forgot it. For the first time she witnessed that it was possible to be a Black woman and an artist. Like Burleigh, Meta also told Loïs that, as a Black artist, if she wanted to succeed, she needed to travel to France. Many years later, Loïs recalled the harsh lesson that Meta had taught her: 'This country wasn't interested in exhibiting our work or allowing us any of the opportunities that the white artist enjoyed. I made up my mind at that moment that I would go to Paris.'

It would take her more than a decade to get there. Nonetheless, from the outset, Loïs sizzled with energy. She attended the High School of Practical Arts in Boston, enrolled in evening classes at the School of the Museum of Fine Arts, and had her first exhibition at the age of seventeen. She received a four-year scholarship to the Boston Museum School, from which she graduated with honours, and also achieved a design certificate in 1927. She worked as an assistant to the dress designer and professor Grace Ripley, discovered African costumes and masks, and 'quickly incorporated their unique qualities into her own art'. She enrolled in graduate courses at the Boston Designers Art School and began selling her designs to prominent New York companies. But none of this was enough. Loïs was nothing if not ambitious, writing: 'Only the name of the design was known, never the artist. That bothered me because I was doing all of this work and not getting any recognition. And I

realised I would have to think seriously about changing my profession if I were to be known by name.'

This she achieved by focusing her considerable talents on painting. She had applied for a teaching position at the Boston Museum School, where, despite having excelled as a student, she was turned down and patronisingly advised by the director, Henry Hunt Clarke, 'to travel south to help her people'. Not one to be deterred, she founded the art department at Palmer Memorial Institute in North Carolina; within two years she had organised an exhibition of the students' work, which was seen by Professor James V. Herring who, in 1930, was establishing the fine arts department at Howard University in Washington. He offered Loïs a job on the spot: for the next forty-seven years she taught design, watercolour and drawing to generations of students, many of whom were to become prominent in their field: in particular, the artists Elizabeth Catlett, Howardena Pindell and Alma Thomas. Loïs also travelled regularly to New York, where she befriended leading lights of the Harlem Renaissance, including the poet, children's book writer and playwright Countee Cullen, the poet, writer and activist Langston Hughes, and the artist and educator Aaron Douglas. But possibly her most influential new contact was Alain LeRoy Locke, the first African American Rhodes Scholar, radical writer, educator and art expert, leading cultural critic and professor of philosophy at Howard for more than forty years - and the unofficial leader of the Harlem Renaissance. He was relentless in his exhortations to African Americans to explore and represent their legacy and their experiences in their art and literature. In 1925 he wrote: 'If, after absorbing the new content of American life and experience and after assimilating new patterns of art . . . then the Negro may well become what some have predicted, the artist of American life.'

But Locke was frustrated at the slow rate of progress. In 1933 he declared that he felt that African Americans had 'either avoided racial subjects or treated them gingerly in what I used to call "Nordic

Transcription"'. It was surely no coincidence that soon after meeting Locke, Loïs enrolled in a design class at Columbia University to study masks from African, Inuit and Native American cultures. She painted thirty small illustrations of them in watercolour: images she was to draw on in later works.

Inspired by Meta Warrick Fuller's renowned sculpture of 1914, *Ethiopia Awakening* – an Egyptian figure of a semi-swaddled woman, like a mummy, emerging from her cocoon and into life – in 1932, Loïs painted her first African-themed painting, *The Ascent of Ethiopia*. It's a kaleidoscopic blue, gold and green work that includes references to Ancient Egypt, jazz musicians and musical notes, a painter's palette, high-density living and a cosmic ray.

In 1937, Loïs was awarded a General Education Foreign Fellowship to study in Paris for a year. It was life-changing. She remembered boarding the French ship *The Normandy* and 'the wonderful feeling that I had the minute that I got on the boat: it was French soil. I was treated so beautifully. The courtesies that were afforded me and the whole atmosphere was conducive to an absolute freedom. How good it was to be shackle-free.'

Thanks to the favourable exchange rate, life was cheap in the French capital. Loïs found a place to live and work in a studio overlooking the Eiffel Tower; it was the kind of romantic apartment she'd always dreamed of. She enrolled at the Académie Julian and revelled in the freedom; in Paris she felt her work was judged on its merit, not her race. She also forged a lifelong friendship with the French artist Céline Marie Tabary, whose family welcomed the young American into their fold.

Loïs's approach to making art was relatively fluid. By translating various artistic styles into her own idiosyncratic language she was exploring her place in the world: it could be said that for her, a landscape painting or a still life was as much a self-portrait as a more straightforward rendition of her own face. When she first moved to Paris, she was painting in a loose post-Impressionist

style, 'thrilled by the beautiful greys of the sky, the greys of the buildings, that sort of mysticism', but she soon changed tack and began to focus more deeply on her racial and cultural roots. In 1938 she painted what was to become her best-known work, *Les Fétiches* (The Fetishes). This small, dream-like painting - 65 x 54 cm - depicts five Dan, Baule and Yaure African tribal masks floating against a black background, alongside Ivory Coast talismans and a headdress from the Congo, which merge and overlap with each other. Influenced by the French *Négritude* movement - which, like the Harlem Renaissance, aimed to honour African traditions and culture in the face of global racism - *Les Fétiches* was the first of Loïs's paintings to combine traditional African forms with Western ones. In the early twentieth century, Modernist artists in Paris - most notably Pablo Picasso - were fascinated and inspired by African art. However, they rarely grappled with its cultural significance or appreciated its sophistication. With unthinking racism they termed it 'Primitivism'. In *Les Fétiches*, however, Loïs turned the tables, referencing the sculptures in her studio as indicators of her pride in, and debt to, her African ancestry.

She remembered the painting's reception:

> I carried it down to the Académie Julian and the professors seemed surprised and remarked 'this doesn't look like a Loïs Jones painting, how did you happen to do this?' I mentioned that certainly after Picasso had made such fame in using the African influence in his works, as well as so many of the French artists, Modigliani, Matisse and Brancusi, that certainly Loïs Jones, if anyone, should have the right to use it.

Back in the United States, life for a young Black woman was much tougher than it was in France. Nonetheless, Loïs had a solo show of her Paris paintings at the Vose Gallery in Boston, which was well received, although the sense of goodwill soon faded. She

recalled: 'It wasn't lasting, I mean, that was about the biggest thing that happened. I discovered that not only being black but being a woman created a double handicap for me to face. My career in painting hasn't been easy.'

Because of segregation – be it enforced or subtle – Loïs often avoided going to exhibition openings and, as a Black woman, many competitions and opportunities were closed to her. She described her experience of trying to show her work in New York: 'I went to 57th Street with my impressionist works, street scenes, beautiful paintings of Paris. And they said, "Your work is excellent, but you know, we can't show it. We can't take you on".'

In 1941 not a single living Black artist had gallery representation in New York. The first group show of African American artists to be held at a museum, 'Contemporary Negro Art', had taken place at the Baltimore Museum of Art in February 1939; it was curated by Mary Beattie Brady – director from 1922 to 1967 of the Harmon Foundation, an organisation dedicated to advancing African American culture and education – and Locke. In the exhibition brochure, Locke wrote that the show served 'as a declaration of principles as to what art should be in a democracy and as a gauge of how far in this particular province we have gone and may need to go'.

Loïs's painting was one of the few by a woman to be included in the show.

Around 1940, the year she painted her self-portrait, Loïs met up with Locke, who was writing a book on Black artists and wanted to include one of her paintings of Montmartre. She remembered him saying: 'It is a good painting, but I wish you would do more with the black subject, Loïs Jones. All of you artists have got to do something about this movement. You've got to contribute as artists.'

He also brought up the fact that 'Matisse and Modigliani and Picasso and so many of the French artists were getting famous by using the African influence in their work and it was really our

heritage and we should do something about it'. Of course, this was something that Loïs had already been grappling with, but Locke didn't consider that either *Les Fétiches* or her self-portrait had gone far enough. He wanted her to push even harder, to examine her world more closely and reflect it, in all of its complexities, in her art. She took his words to heart; after all, she knew all too well how hard it was for a person of colour to succeed in America. In 1941, in a gesture of defiance, Loïs entered her landscape painting *Indian Shops, Gay Head, Massachusetts* into Washington's Corcoran Gallery's annual art prize, despite the fact that the museum - like so many of them - prohibited African American artists from participating in competitions. Her friend from Paris, Céline Marie Tabary, who was white, had come to Howard to teach and, because of the war, ended up staying for seven years. (Céline shared Loïs's studio, which they dubbed 'Little Paris'; it became a popular meeting spot for African American artists to paint and draw.) Céline delivered the painting to the gallery and the judges awarded Loïs the Robert Woods Bliss Landscape Award, oblivious to the fact that she was Black. In 1994, four years before her death, the Corcoran Gallery issued a public apology to Loïs and staged the exhibition 'The World of Loïs Mailou Jones'.

In 1944, Loïs painted *Mob Victim*, a searing portrait of a dignified Black man about to be lynched. He gazes skywards, his wrists bound with rope. He's alone in the midst of a verdant landscape, framed by trees: nature itself reconfigured as the gallows. In the same year she painted *Two Faiths*, a still life that combines decorative African fabric and an African statue of an androgynous figure holding its belly, a classical European bust and a flower in a vase - an image that embodies her split allegiances. From now on, most of Loïs's work focused on the large and small stories of Black lives - from a painting made mourning the assassination of Martin Luther King Jr, to a portrait of a young Black woman cleaning a fish, to an evocation of Josephine Baker dancing and to

celebratory, almost psychedelic collages made in response to her travels through Africa.

From the late 1940s, Loïs exhibited widely in the United States. She also returned regularly to France, the country that had reinforced her faith in herself. The country's embracing of the artist was embodied in the monograph on her work, *Loïs Mailou Jones: Peintures 1937–1951*, that was published in 1952 by Presses Georges Frère; it included more than a hundred reproductions of her works.

In 1953, Loïs married the Haitian graphic artist Louis Vergniaud Pierre-Noel. They had met as students at Columbia in 1934; their wedding took place at Céline Tabary's family home in Cabris in the South of France. Interviewed in 1977, Loïs remembered that 'the mayor served champagne and the whole village celebrated' even though they were the only people of colour in the village. It was an experience that contrasted sharply with the racism Loïs experienced in Washington, which she described as 'horrible. You couldn't eat at any of the restaurants, you couldn't go to any theatres, and if you did, you had to sit at the balcony in the very back.'

The couple lived between the US capital and Haiti. Loïs loved the island; she taught art, painted its inhabitants and landscapes, delved into its spirituality and, in 1954, was commissioned to create a portrait of its president, Paul Magloire, and his wife.

In 1970, Loïs was awarded a Howard University Fellowship to work on a major research project: 'The Black Visual Arts'. Her aim was to document the contemporary art of the African diaspora and, for the first time, she travelled to the continent. She interviewed hundreds of artists in the Congo, Ethiopia, Ghana, Ivory Coast, Kenya, Liberia, Nigeria, Senegal, Sierra Leone and Sudan. Two years later she extended her research into Dahomey (renamed Benin in 1975), Tanzania, Uganda and Zaire. She disseminated her findings in exhibitions and lectures and the 1,000 or so of her photographs entered Howard University's archive of contemporary

and ancestral African art. The trip inevitably impacted on her work as an artist. In 1977 she said that: 'You know, it was always the thought of the Afro-American artist to go to Paris [. . .] but now, the artists go to Africa. We feel that it's there where we can get a great inspiration which will prove a great strength in our work in this movement which we are now going through.'

In 1974, Loïs's painting *Ubi Girl from Tai Region, Nigeria* became the first work by an African American artist to be acquired by Boston's Museum of Fine Arts. It was the institution where, decades earlier, she had studied and whose director had suggested she move to the South 'to help her people'. It's a high-key, enigmatic portrait of an unnamed girl from the Tai Region of Liberia who is taking part in a rite of passage to womanhood: joy and apprehension mingle in equal measure. Her powerful head is disembodied, floating above the outlines of two Congolese masks; to her right is the profile of a large wooden mask from the Ivory Coast. Fragments of vibrant geometric patterns form a frieze down the left side of the painting. The girl's eyes are lowered and her face is painted white, with red crosses. The painting is – given its indifference to cultural borders and the implication of the closed eyes – something of a delirium: a synthesis of African, American, Caribbean and French influences that come together to form a new kind of reality. Loïs described it as 'a combination of designs from Zaire and the Côte d'Ivoire' which she brought together as a 'sort of union of Africa'. Nothing could be further from the dreamy, thoroughly European paintings of her younger years.

Loïs died in 1998 at the age of ninety-two. She was renowned and widely honoured: her work was in the collections of major museums and had been the focus of numerous retrospectives.* She

* In 1972 the Museum of the National Center of Afro-American Artists in Roxbury, Massachusetts, and the Museum of Fine Arts in Boston collaborated on a joint retrospective of Loïs's work. In 1989 the Howard University Gallery of Art celebrated her forty-seven years of teaching with yet another retrospective.

had been feted by both the US and Senegalese presidents* and, to cap it all, on 29 July 1984, Loïs Jones Day was proclaimed in Washington, DC. During her long life she had experienced first-hand the momentous transformations of her country – but she knew all too well that significant changes still needed to happen. When she was interviewed in 1977, she talked with great passion about the importance of staging shows to 'rectify what has long been a grave social injustice, because the black artists have really been gravely overlooked'. Discussing the exhibition 'Two Centuries of Black American Art' that one of her students, David Driskoll, curated for the Los Angeles County Museum that same year, she exclaimed, with a kind of weary impatience: 'Two centuries of Afro-American art, black American art, on view to many people who had no idea that there were black painters who possessed such talent, and who were capable of doing paintings and prints and sculpture comparable to the best in the world.'

Thirteen years later, in 1990, the Smithsonian American Art Museum bought the painting she had created so long ago in Paris: *Les Fétiches*. The eighty-five-year-old Loïs's response was blunt. 'I am very pleased,' she said, 'but it is long overdue. When I think what I struggled through, the prizes I've won, the recognition elsewhere, I can't help but feel this is an honour that is forty-five years late.'

I return to her self-portrait, made fifty years earlier. When she painted it, Loïs had so much to face ahead of her; the world was engulfed in a war and she was fighting her own battles with race and gender. Her painting is defiant, proud: she gazes both at herself and out at us with a look that is unflinching and determined. As she makes very clear, she's entirely aware of her power.

* In 1976 she was commissioned to paint a portrait of President Léopold Senghor of Senegal for his seventieth birthday in Dakar. In 1980 she was invited to a reception at the White House by President Jimmy Carter, who was honouring ten African American artists.

To Draw Seeing Every Feather

In 2006, in a poll conducted by the TV show *Frontseat*, the people of New Zealand voted Rita Angus's 1936 painting *Cass* – which depicts a man, dwarfed by the rolling hills of the Canterbury landscape, waiting at the eponymous train station – as the country's favourite work of art. Yet, for most of her life, Rita received little critical attention. She battled with poverty and mental health and had her first solo show at the age of forty-nine. But she wasn't simply a painter of amiable landscapes: again and again she scrutinised herself and her place in her country. Her fifty-five self-portraits are a dazzling record of her time on earth. When she died in 1970 most of her paintings and drawings were still in her possession.

On 12 March 1908, Rita, a third-generation New Zealander of Scottish descent, was born in Hastings in North Island. She was the eldest of seven children: three girls and four boys. Her father, William, was a carpenter who eventually owned a construction company; her mother, Ethel, was creative: a gifted gardener who once painted each of the doors of their home a different colour. They were voracious readers and championed their daughter's interest in art. Her talent was recognised from an early age: her sister Jean remembered that 'Rita drew as soon as she could hold a pencil, and never stopped'. In primary school she was taught the rudiments of painting and how to 'draw seeing every feather'.

In 1927, Rita enrolled in the Canterbury College School of Art in Christchurch – then a lively city with an art gallery, art school and a youth orchestra – to train as a teacher. There were no full-time artists in New Zealand at the time and practically no infrastructure for the selling and buying of art. Although she didn't complete her diploma, she continued to study until 1933, including in classes at

the Elam School of Fine Arts in Auckland. Forty years later, she re-
called her influences: 'the important factor in my training has been
the academic and especially seeing reproductions (screened) in art
history lectures. I was absorbed in the work of Vermeer portraits
and Cézanne.'

Rita was taught by a charismatic professor and art critic, James
Shelley; his lectures ranged across cultures, epochs and religions.
He admonished his students to question everything, asking them
why a modern painting should compete with a camera. He believed
that a work of art, whatever its subject, was a portrait of the artist.
These were all lessons that Rita took to heart. The students pored
over reproductions of Modernist masterpieces from Europe and
read the British Journal *The Studio*. To paraphrase Kenneth Clark,
one postcard could infect a whole group.

Rita realised much later that what she thought was modern pre-
dated her school years by decades.

Rita was shy. She designed and made unusual dresses 'with in-
teresting collars'. She worked very hard. Around 1928 she painted
a quiet head-and-shoulders self-portrait in muted greens and soft
cream: her hair is softly bobbed, her head slightly turned; she
looks directly out at us. She wears a string of pearls, a crisp white
blouse, a dark cardigan. She is neat, respectable, in no way a bohe-
mian. Within a year, she had jazzed herself up. Although she had
never left New Zealand, her new self-portrait is self-consciously
European. She has ditched the pearls and looks out at us, faintly
anxiously, in a bright red beret and a blue artist's coat. The back-
ground is yellow. James Shelley praised it in the *Christchurch Times*:
'Miss Rita Angus has made a couple of brave studies of the subtle
relations of complementary colours in flesh painting and the play
of reflected lights.'

A year later, at the age of twenty-two, Rita married the artist
Alfred Cook; it's possible their union was never consummated.
She and her husband moved to Auckland; Rita studied at Elam Art

School. They returned to Christchurch, where she was introduced to Chinese landscape painting. Its washes and approximations intrigued her. But Rita was looking for a language that wasn't imported from somewhere else; an authentic response to the landscape she was born into. As the composer Douglas Lilburn - who was to become a lifelong friend from the 1940s onwards - put it many years later: if you weren't Māori, there was the sense that 'we're not really New Zealanders at all, that we are only the process of becoming'. In 1927 an informal set of avant-garde local artists - including Ngaio Marsh, who was to become one of the 'Queens of Crime Fiction' alongside Agatha Christie - formed themselves into 'The Group' in order to explore and promote an approach to self-expression that was free from a European academicism. It was to run, in various incarnations, for fifty years; its later members were to include Colin McCahon and Toss Woollaston, two of New Zealand's most famous painters.

In 1931 a terrible earthquake rocked the South Island and killed 256 people. Rita's mother was injured and the family home partly collapsed. Rita and her husband sketched and painted pictures of the wreckage; she was fascinated by the abstract shapes the devastation had created.

In 1932, Rita exhibited some of her works at The Group's annual exhibition. She blossomed. She played the ukulele, loved parties and took lessons in Grecian dancing. In 1933 she painted *Gasworks*, which was exhibited at the Canterbury Society of Arts' annual show that year. In the four years since her rather conventional self-portrait, she had blown her visual language apart: tone, atmosphere and geometry had replaced her earlier, more sentimental, naturalism. Turning her gaze from the dramatic landscape that surrounds Christchurch, she focused instead on the exterior of a drab factory. The scene is rendered in softly graded slate greys and browns; the land and sky merge in a lifeless gloom. In the foreground a small, stooped, faceless figure walks into the distance, a heavy tool on

his shoulder. It's a bleak study of isolation and industry - and it was a hit. As the New Zealand poet and publisher Denis Glover recalled:

> The first time I even heard of Rita was when I saw *Gasworks*. I was young and more ignorant than I am now, if that were possible. Most of us students were in a mood of fierce idealistic realism. The Woolston Gas Works was as stark and grey as Stalin's uniform. . . . But the Gas Works . . . here was something! In one puff was blown away all the genteel piddle-painting English, to this day not sure if they are New Zealanders or First Four Colonels' Daughters. [Angus] set out to impose order and clarity and immense discipline on what she saw. There were no emotional overtones. The looker could provide them for [themselves].

In the same year Rita painted an arresting portrait of her sister, Edna, who was sixteen months younger and one of the first women in New Zealand to obtain a pilot's licence. *The Aviatrix* is a study in green and brown; a jaunty young woman in an aviator's uniform looks lightly out at us, her goggles on her head. She is smart and knowing; mischievous even. (A woman navigating the heavens!) It's a wonderfully restrained celebration of female emancipation and modernity in which not even the sky is the limit. Rita's signature style was now firmly in place: tough, pliable lines, high-key colours, a clarity that trembles on the edge of hallucination. Nothing is extraneous. What is implied is infinite.

In 1934, Rita almost died from a faulty heart valve. Her sister Jean, who was studying at the art school, nursed her. When Rita recovered, she and her husband separated, despite the stigma of divorce at the time. Although they had no children, domesticity was still expected from a wife, even the wife of a fellow painter, and Rita was determined to persist as an artist. She later remembered:

He assumed an authority over me, which with other factors broke
my health. He disliked some of my paintings . . . and at his request
I destroyed work for I was his wife. Also, I agreed for peace to give
up painting, which I did. A few months after this, in the fourth
year of marriage, I became seriously ill (life & death for 5 days).
There was no return but death. That is what happened.

The Great Depression hit. Jobs were scarce and money tight. Rita
supported herself from sales and handouts from her mother. She
found work as a children's illustrator for the Christchurch maga-
zine *Press Junior* but she disliked it intensely. She quit and worked
as a fashion illustrator. She taught painting at a girls' school. She
lived alone in a small flat, and called herself Mrs Mackenzie, after
her paternal grandmother, although she continued to sign her
paintings as Rita Cook until 1947, eight years after she was di-
vorced. Three exhibitions had an impact on her: the Empire Art
Loan Collection of British Art, a travelling show of Japanese prints,
and a collection of Chinese jade, porcelain and painting. She began
a four-year relationship with a bank clerk, Harvey Gresham. He
was fun, supportive, solvent: he helped Rita with her rent and had
a car, which meant that they could drive to remote areas where
she could draw and paint. She read Sigmund Freud and Carl Jung
and studied Eastern philosophy. She ran a picture library from her
flat. In 1936 she spent ten days in the village of Cass with some
friends. Back in her studio she painted the picture of the village's
small railway station that, in another century, would be voted the
country's most popular painting. It was exhibited in March 1937
at the Canterbury Society of Arts. It was priced at eight guineas. It
didn't sell. Rita continued to paint self-portraits.

In *Self-Portrait (in green jacket)* from 1936-7 she looks directly at us,
slightly smiling. She is tightly buttoned up in a smart green suit; at her
neck, a red scarf is faintly, worryingly, noose-like. Her head, softly
haloed, glows against a deep purple background. As a portrait, it is

controlled, symmetrical and rational; it's also - with its high contrast and unnatural colours - vaguely unearthly. In another self-portrait of the same year (in the collection of the Dunedin Art Gallery) she pictures herself as the epitome of elegant cool: against a silhouette of dull buildings, she glances at us sideways; her expression is detached, ambiguous. Her silk green shirt is echoed in a green earring; her hair is slick and bobbed, she's warm in a camel-coloured coat and brown gloves. She holds a cigarette in her left hand - curiously, she wasn't much of a smoker, and so this is something of a pose, a nod, perhaps, to the image of a new and liberated woman - and its smoke curlicues into the strange, beige sky. In her right hand she holds a dark-green beret. Forms are simplified, but somehow they render the self-portrait even more complex. The painting is unnerving; it's like observing something very familiar through a telescope. All the facts are there and they're quite plain, really, but it's all somehow something other than itself.

No one else in New Zealand was painting like this.

Yet despite her financial difficulties, Rita was so attached to her pictures, she refused to exhibit or to sell many of them.

In 1938, Serge Diaghilev's Ballets Russes de Monte Carlo and the Covent Garden Russian Ballet toured New Zealand. Rita was so entranced that she took ballet lessons herself and sketched the dancers in rehearsal. Refugees from Europe flooded into New Zealand and many came to Christchurch, bringing with them sophisticated ideas about art and culture. Rita joined the Peace Pledge Union, a pacifist women's group which, from 1937 until 1939, published a magazine *Woman Today*; its slogan was 'Peace, Freedom, Progress'. She painted herself in profile in a green sleeveless blouse against a green background and titled it *Cleopatra*: she believed the women of Ancient Egypt had 'unusual freedoms'. In 1944 she wrote to her close friend, the young composer Douglas Lilburn: 'I was born at the time Egyptian tombs were opened, and the treasures of a long, materialistic mysticism unearthed.'

She had an exhibition of watercolours of landscapes but, again, sold nothing. World War II erupted. Rita was broke and depressed; she couldn't live off her art, but making art was all she wanted to do. She sold one landscape at an exhibition of The Group in 1938: *Lake Wanaka*, a winter scene of a leafless tree in front of a slate-grey lake, brown hills and ice-blue mountains. In 1939, Gresham left her for another artist. Rita had to move out of her flat, as she couldn't afford it. She didn't have another home of her own until 1943. Her sister Edna, the subject of *The Aviatrix*, died of an asthma attack on Christmas Eve, 1939. Rita was inconsolable.

In 1941, Rita picked tobacco and designed toys for a pacifist organisation, the Woodkraft Co-operative Society. She became a vegetarian. She met Douglas Lilburn and they briefly became lovers, but he was gay. Rita became pregnant – which she welcomed – but miscarried in 1942. She asked Lilburn to father another child. He refused, but their close friendship endured until the end of her life.

Rita stayed with her parents to recover from her miscarriage. She took a vow of chastity and wrote to Lilburn: 'I am quietly regaining my virginity because I wish to serve the arts.' She never had children. Many of the women artists of her generation were also childless: often it was simply too difficult to juggle a marriage, motherhood and creativity.

Her friends worried that she was 'ill and near starvation'. In 1943 her concerned father – her parents always supported her – bought a cottage for Rita to live in rent-free in Clifton Hill in Sumner, thirteen kilometres from Christchurch. Her new home overlooked the Pacific Ocean. Rita wept with relief and slept for days. She grew her own food. She had time to paint. She began to see her role as an artist as akin to that of a 'High Priestess', to 'cause no pain to others', to live simply, trust, speak the truth and to 'live up to my history of women'. She painted herself, the landscape, trees, flowers, still lifes. She rendered a single flower with the same intensity that she painted a face. She painted the landscape with the scrutiny

of a scientist looking at a petal. Her work was, in turns and some-times simultaneously, realistic, symbolic, surreal.

In 1944 she had appeared before the Industrial Manpower Appeal Committee to defend her refusal to work in a rubber fac-tory that supported the war effort. Her rationale was that, as an artist, it was her work to create life and not destroy it. She signed her statement 'in sincere and hopeful faith in communal, racial and international brotherhood'. Her case was dismissed and she was ordered to report for work - but she refused. She stayed at a paci-fist retreat, picked apples and wrote poems. In a letter to Lilburn she wrote: 'I have seen my first apple tree. I imagine an off-shoot of the human race, beautiful people, living by the bush, with simple inborn highly artistic qualities, love of rain and sun, growing and maturing, and dying in harmony and contentment with Nature. They may live in Heaven.'

In 1945 she was fined £1 for refusing to comply with the Com-mittee's order - they were lenient as they could have demanded £50. Although she had little money, between 1945 and 1949 - the heyday of The Group's exhibitions - again, she refused to sell any of her work.

In 1946, Rita began her series of 'goddess' pictures: two large oil paintings and a watercolour. The first, *A Goddess of Mercy*, was, in part, a homage to her sister Edna's memory. It took two years to complete. With an intermingling of biblical and Buddhist refer-ences, its meticulous surface is rendered in flat, feverish colours. It depicts a beautiful, clear-eyed young woman in a white top and a floral skirt - inspired by the fabric of Edna's house-coat - standing in front of a winter vista of rolling hills, two of which echo the shape of young breasts. Smiling beatifically, she is flanked by two small deer and crowned by the spiky, leafless branches of a willow tree. Edna holds a single yellow crocus, traditionally a symbol of joy and youthfulness. Distant birds interrupt the cold blue of the

sky. There's something faintly spooky about the painting's un-compromising evocation of spirituality. Everything - the young woman, the animals, the sky - is so idealised it could be saccharine if it weren't so unnerving. Mysticism here is imagined as some-thing both precise and hallucinogenic. Rita described it as a study in the 'triumph of the living over the dead'.

Rita began painting her two other 'Goddess' paintings, *Rutu* and *Sun Goddess*, in 1945 and 1946 respectively.

Six years of war, Rita's faith in humanity, her abhorrence of violence and belief in the power of women to implement change were the wind in the sails of her 'Goddess' pictures: the idea that the immense goodness the world is capable of could be embod-ied by one symbolic figure. Rita had spent her days at art school poring over reproductions of Western art and would have seen seemingly countless pictures of Renaissance Madonnas. With her three 'Goddess' paintings she was readjusting the iconography and the religion to reflect life on an island in the Pacific in the south-ern hemisphere: elements of Western art - especially Byzantine - merge with Polynesian and Buddhist references in a trippy, hard-edged *melée* of East and West, North and South.

Despite her father's gift of a home and the security it afforded, Rita had become more and more fragile. In late 1949 she was found wandering the streets, disoriented. She had been painting all day and hadn't eaten a thing. She was committed to Sunnyside Mental Hospital and, after a few months, responded well to treatment. But she still wasn't strong. In 1950 her mother took her home to nurse her.

Rita completed her self-portrait as a goddess, *Rutu*, in 1951 as she was recovering from her breakdown. Even though it's not par-ticularly large - 71 x 56 cm - she had worked on it for five years. Its title is both an echo of the artist's own name and a Māori ap-proximation of the biblical character of Ruth - the embodiment of compassion - a young Gentile widow who left her country for

Israel and converted to Judaism. Like a medieval icon filtered through twentieth-century counter-culture, Rita depicts herself as brown-skinned and blonde-haired – a mixed race, enigmatically smiling woman standing beneath the blue sky and in front of Waikanae Beach near her parents' home. Surrounded by lush Pacific-island flora, it's an idealistic take on the possibility of racial integration – one that would have been perceived as radical in the 1950s, when official government policy was that Māori culture should be subsumed into the ruling Pakeha (non-Māori) culture. According to her art dealer, Helen Hitchings, 'many of us . . . (Rita included) visualised an idealistic state in New Zealand where the two races would all end up somehow half Pakeha and half Polynesian'. The painting is mystical, ambiguous and coded. Behind Rutu's head a yellow circle can be read as a Christian halo or an allusion to the blazing Pacific sun – the painting was, in fact, exhibited twice titled as *Sun Goddess*. The fish that adorn the black band of Rutu/Rita's tight red top could be references to the sea that surrounds New Zealand, to the artist's astrological sign, which was Pisces, or to the Christian faith. She holds a water lily, a flower that has multiple meanings – truth, beauty, rebirth, regeneration and optimism – in different faiths, most of which, of course, would apply to Rita herself, who had been through such an ordeal in the lead-up to the completion of the painting. The origins of its scientific name, *Nymphaea*, derive from the Greek word 'nymph' – a female spirit that inhabits water.

In 1947, Rita had been asked to outline her approach to making art for the *Yearbook of the Arts in New Zealand*. She wrote:

> I like to paint with the seasons and devote time to the observation of skies, country, sea and peoples. [. . .] as a woman painter I work to represent love of humanity and faith in mankind in a world, which is to me, richly variable and infinitely beautiful.

*

Rita eventually settled in Wellington in 1955 and exhibited regularly until her death in 1970 from ovarian cancer. She made her only trip overseas at the age of fifty, when she won a travelling scholarship to London. She spent much of her time in the National Gallery, looking at paintings she had only ever seen in reproduction.

When she died in 1970, Rita's family discovered 600 unsold paintings, drawings and sketchbooks in her studio. In 2008 a major retrospective at the Museum of New Zealand Te Papa Tongarewa celebrated the centenary of her birth; it was followed by a tour to the main centres around New Zealand. In late 2021 the first retrospective devoted to Rita Angus to be staged outside her home country is due to open at London's Royal Academy with more than seventy works. The exhibition's press material declares that Rita Angus changed the artistic landscape of her country forever.

Self-Portrait as Tahitian

One day in Paris in 1934 a young Hungarian-Indian woman painted a self-portrait. She pictured herself as a Tahitian, despite the fact that she had never been to the South Pacific. Placing herself centre-stage, her waist-length hair is pulled back in a ponytail. She gazes into the distance, her sombre, beautiful face animated by her deep red lips. As if rebutting the sensuality of the image, her hands are crossed demurely in front of her. Apart from a small cloth draped across her lower body, she is naked, standing against an ochre backdrop of wallpaper that is faintly decorated with what could be Chinese watercolours. Her body is faintly outlined with a light green shadow of a man. He is blocking the light.

The self-portrait is both a literal depiction of the artist and something more layered, more self-conscious. It's at once utterly in thrall to, and subtly mocking of, the paintings of Paul Gauguin, who, in

the last decades of the nineteenth century, had portrayed, again and again, various semi-naked women in French Polynesia. In this self-portrait art history is revered, reworked, discarded. Young brown-skinned women had, for centuries, been considered objects of desire, signifiers of 'primitive' passion, reduced to stereotypes. Here, the young artist has taken back control of her representation. There is no shame in her nakedness: her skin is what she inhabits. She is a creature of the West and the East. Despite her nakedness, she is reserved, but it's disingenuous: she is steely, her body strong. She is subservient to no one. She is sisterly, expressing solidarity towards the Polynesian women in Gauguin's paintings who lived on an island she had never visited. She is Sikh, she is Hungarian, she is a painter and she is the subject of a painting – her painting. She is her own muse. She's not a type: she's a person.

Now one of India's most acclaimed modern artists,* Amrita Sher-Gil was born on 30 January 1913 in Budapest in what was then Austria-Hungary. Her Hindu name is derived from the holy Sikh city of Amritsar: the place of immortality. Her father Umrao Singh Gil was a Punjabi Sikh aristocrat, Sanskrit scholar and avid photographer – he shot some eerie, atmospheric portraits of Amrita and her younger sister Indira as children; dressed in extravagant costumes, they look like characters in a fevered fairy tale. Her Hungarian mother, Marie Antoinette, trained as an opera singer; the family spoke Hungarian and English. In 1918, although the Hungarian side of the family was most likely Jewish, the girls were baptised as Catholics. In 1921, with the political situation in

* Sher-Gil was the inspiration for Javed Siddiqi's play *Tumhari Amrita* (1992) and her work is a key theme in the Indian novel *Faking It* by Amrita Chowdhury. Aurora Zogoiby, a character in Salman Rushdie's novel *The Moor's Last Sigh*, was also inspired by her. The National Gallery of Modern Art, New Delhi, has more than a hundred of her paintings. In late 2021 a major exhibition devoted to Amrita Sher-Gil will be staged at K20 in Germany.

Hungary increasingly volatile, the Sher-Gils decided to move to India: to Summer Hill in Simla.

Amrita's fiercely nonconformist approach to life was evident from an early age. In 1924 she was briefly sent to the Santa Annunciata School in Florence, Italy, and although she loved studying Renaissance paintings, she loathed the school's rigid discipline and was threatened with expulsion for drawing a nude. Back in India, she again ran into trouble: she was expelled from her convent school for criticising Catholic rituals. Home life was difficult: Amrita's mother was unstable, and often threatened to commit suicide, while her father retreated into his scholarly pursuits or to his study to observe the night sky. Amrita devoted most of her time to making art: in one drawing she depicted a woman alone in a forest; in another, contemplating suicide with a dagger. She was also political, vocal in her admiration of the independence activist and later the first prime minister of India, Jawaharlal Nehru, who she befriended in the final years of her life.

Her Hungarian uncle, Ervin Baktay, was an Indologist and an artist. On a visit to India, he recognised his niece's talent. He introduced her to the principles of the Modernist Hungarian Nagybánya School of painting and stressed to her the importance of drawing from life. With his encouragement, Amrita sketched her family and household servants. Baktay also talked her parents into allowing Amrita to study art in Paris. Unusually liberal for the day, they agreed to relocate to the French capital in order to support their gifted daughter.

In 1929, at the age of sixteen, Amrita sailed to Europe with her family. She enrolled to study painting at the Académie de la Grande Chaumière and later under Lucien Simon at the École des Beaux-Arts – she said of her teacher that he 'never taught' but made his students 'think for ourselves'. It was a curious art-historical moment: Cubism and Impressionism were, by now, fully accepted into the canon and Surrealism was in full swing. Yet, Amrita's

interest lay not with the dream-driven artists haunting the cafés of the Left Bank. It was the paintings that Gauguin and Van Gogh had made before she was born, the nudes of Suzanne Valadon, Rabindranath Tagore's Modernist drawings, and the rich traditions of classical Indian painting and sculpture that attracted her. She worked assiduously, visiting the Indian section at the Louvre as often as she sought out the work of the post-Impressionists. But she was resistant to accepted narratives, writing: 'Although I studied, I have never been taught painting in the actual sense of the word, because I possess in my psychological make-up a peculiarity that resents outside interference. I have always, in everything, wanted to find out things for myself.' She never stopped searching for a new kind of image: one that would encompass not only the traditions of Europe and India, but which would allow her, a mixed-race woman, to express herself freely. When she died suddenly in 1941, at the age of only twenty-eight, she left behind 174 documented works.

Judging by Amrita's self-portraits in Paris, she changed her mood, her look, her personality at the drop of a hat: endlessly translating herself, she pictures herself as coy, exuberant, stern and seductive, indolent and hard-working, Asian and European. Today, she might be considered a conceptual artist in the vein of Cindy Sherman: almost one hundred years ago, she was simply a gifted young painter trying out various personae in order to fully understand herself.

Amrita was wonderful looking: vivacious, glossy-haired with eyes like polished black stones. She knew her power. In 1931 she wrote to her cousin, and later husband, Victor Egan, that 'I will enjoy my beauty because it is given for a short time and joy is a short-lived thing. However, thank god (for myself) that I have other things apart from beauty.' She had numerous affairs with both men and women, many of whom she painted: her

frank depiction of female bodies was considered scandalous. In a series of self-portraits begun in 1930, when she was seventeen, she portrays herself variously as a hard worker, an artist, a seductress, an intellectual, a heart-breaker; in Western fashions and draped in a sari. In one painting she gives no hint that she's in Europe; the painting is suffused with the heat and atmosphere of India. Her thick, glossy black hair spills down her back, her red lips part to show white teeth. Her slim body is scarcely covered by a flimsy cloth and her shoulders are bare; she is adorned in a red and white necklace and multi-coloured bracelets. Revelling in her loveliness, she depicts herself frozen forever in the act of laughing.

Another painting, also made in 1930, is a sober study in brown and burgundy. Amrita is now a reserved European girl in a fur coat and a beret. She looks out at us, unsmiling: only a glimpse of an evening dress and a row of pearls hint that the evening might turn out to be more fun than is implied. In yet another self-portrait she pictures herself at the easel, wrapped in a red shawl, her right hand on her heart as if to indicate the depth of her feeling towards her craft. Her left hand is engaged in painting a picture we are not privy to. She looks out at us with deep concentration. We have become her mirror.

In 1932, Amrita painted two powerful testaments to female friendship. Her three-quarter-length portrait of her close confidante, flatmate and fellow student, Marie-Louise Chassany, is at once dramatic and despondent. Marie-Louise's face is angular, her eyes far away, her lips a slash of voluptuous red. Her short dark hair frames her face, stilled in the moment of emerging from the gloom. Her extended right arm comes to a stop with her hand, claw-like, on a thin knee. Her upper body glows like someone too close to a hot fire. She almost crackles with tension. The portrait was prescient. Marie-Louise was to die of a brain tumour in 1936 at the age of twenty-seven.

By contrast, the sensual *Young Girls* is something of a homage not only to the small moments that make up a life but to the ideal of inter-racial and same-sex harmony. It's an intimate portrait of Amrita's sister, Indira, and her French friend Denise Proutaux. Indira wears a deep red and green silk dress, a chain of dark beads around her neck, and satin, dark red shoes; her black hair is as smooth as an oil slick. She's eating cherries and talking to Denise, who is partially undressed. Her waist-length golden hair obscures her face, which is in profile; it also frames a small, pale breast. Her dress, of blue silk and white lace, cascades down her body like a waterfall. The room is lush, dark: the carpet is a deep crimson and the shifting, aquatic colours of the wall like the memory of a rock-pool at night. The girls' faces are illuminated as if by the moon or early-morning sun; perhaps they've been up all night but still have things to say. The angle of the painting is faintly voyeuris-tic: it's as if we're peering down at them through a high window. Denise later recalled: 'I met Amrita in October 1931 . . . She was 20 years old, small, thin and particularly beautiful. But it was not her beauty which grabbed me, but a quality radiating from her being. She was full of vitality and a feeling of confidence. She had strong views on everything but they were never simple generalizations or banalities.'

In 1933, *Young Girls* received a gold medal at the Paris Salon and Amrita, at just twenty, was made an Associate of the Grand Salon. It was a considerable honour. She was the youngest ever member – and the only Asian artist – to have received such recognition. It also meant that she was now allowed to exhibit two paintings a year in the exhibition.

Amrita's focus, though, was less on honours than on forging a unique painterly language: one that incorporated her empathy for people less privileged than herself, the ones who frequented the streets and studios of Paris. In 1933 she painted three un-blinking studies of a consumptive model: her emaciated body and

troubled eyes are portrayed with a blunt realism. Around this time Amrita's life was difficult. She had been pushed by her mother into a disastrous engagement with an Indian noble, Yusuf Ali Khan, contracted a venereal disease and had an abortion, possibly aided by Victor Egan, who was a doctor. The engagement was annulled. She wrote candidly to her mother that she was interested in sleeping with women, as well as men. It's likely she had a relationship with the pianist Edith Lang on a visit to Budapest; she was also briefly involved with a fellow student, Boris Taslitsky; they painted each other and she gave him a self-portrait she made in 1931. She portrays herself as elegant, scarlet-lipped, with a direct, unsmiling gaze. Her 1932 portrait of Boris, *Young Man with Apples*, was exhibited at the prestigious Salon des Tuileries and deemed a success. With its simplified yet monumental forms, which clearly owe a debt to Cézanne, Boris is pictured deep in thought. His face is sensitive and sensual; it's as if he's forgotten about the three apples in his hands. His white shirt billows like a sail. As a ninety-year-old man, Boris told Amrita's biographer, Yashodhara Dalmia, of his first encounter with the young artist:

I met her in 1930 at the Beaux Arts where I was a student. When she entered there was an enormous silence, because she had a great presence. I was 19 and perhaps she was 17. I was surprised at how well she painted even at that age. I fell in love with her. This was the only mixed atelier, and there were three others where the boys and girls would sit separately. After a while I decided to leave the atelier, cross the river and go to the Louvre. But during that year, she made three portraits of me and one of my mother. I was obliged to sell these portraits. I also made two or three portraits of her during that period. [. . .] I was very poor, and because of that [her mother] once said to me, 'Don't touch her.' [. . .] She was very curious about the way people lived. I was very much in love with her and for a little while it was reciprocated and then one day she

said to me that she was in love with her cousin in Hungary and that she would marry him. Voilà!

In 1934, after five years in Paris, Amrita was 'haunted by an intense longing to return to India, feeling in some strange inexplicable way that there lay my destiny as a painter'. She avowed that while Picasso, Braque and Matisse had Europe at bay, 'India belongs to me'. But she wrote to her parents that she couldn't have appreciated what she was returning to if she hadn't studied in Paris: 'Modern art has led me to the comprehension and appreciation of Indian painting and sculpture. It seems paradoxical but I know for certain that had we not come away to Europe, I should perhaps never have realised that a fresco from Ajanta or a small piece of sculpture in the Musée Guimet is worth more than the whole Renaissance!'

Amrita was surprised by the India she returned to. It was not the place she remembered. In a famous passage she described her impressions:

It was the vision of a winter in India – desolate, yet strangely beautiful – of endless tracks of luminous yellow-grey land, of dark-bodied, sad-faced, incredibly thin men and women who move silently looking almost like silhouettes and over which an indefinable melancholy reigns. It was different from the India, voluptuous, colourful and superficial, the India so false to the tempting travel posters that I had expected to see.

She abandoned European fashions, dressed only in saris, and travelled widely: she was fascinated by the Mughal and Pahari schools of painting, miniature traditions of Indian art, the cave paintings and temples of Asanta and Ellora, the colourful markets of Simla and the villages of Punjab. She railed against what she called 'tourist painting', which she defined as the 'unutterable mediocre specimens of fifth-rate Western art that still abound in the local

exhibitions, providing doubtful, if not harmful, aliment to the artistically underfed and underdeveloped mind'. In 1935 she wrote an impassioned letter to Victor Egan:

> I was born with a certain thirst for colour and in Europe the colours are pale - everything is pale. Because we cannot paint in the West as we paint in the East - the colour of the white man is different from the colour of the Hindu and the sunshine changes the light. The white man's shadow is bluish-purple while the Hindu has golden-green shadow. Mine is yellow. Van Gogh was told that yellow is the favourite colour of the Gods and that is right.

Her confidence in her talent was occasionally arrogant. She submitted a selection of her paintings to the Simla Fine Art Society Annual Exhibition and was awarded a prize for a work she considered inferior to the others she had entered. Offended, she returned the cheque with a letter declaring that in the future, she would be obliged to exhibit her paintings only in the Grand Salon, Paris, 'of which she was an Associate' and 'in the Salon des Tuileries, to which she had been invited to participate in the past, a distinction, I may say, that few can boast of'.

In her essay 'The Evolution of My Art', which was published posthumously in the magazine *Usha* in 1942, Amrita outlined her approach to painting: 'Although I went through an academic phase in the first few years of my stay in Paris, I had never imitated nature servilely; and now I am deviating more and more from naturalism towards the evolving of new and significant forms, corresponding to my individual conception of the essence of the inner meaning of my subject.'

If, in her writing, she was forthright, her paintings were more compassionate: in many ways they are a kind of lamentation for the suffering she witnessed. She wanted 'to interpret the life of Indians, particularly the poor Indians pictorially; to paint those

images of infinite submission and patience; to depict their angular brown bodies, strangely beautiful in their ugliness, to reproduce the impression their sad eyes created in me'.

She chronicled the hillmen, who worked like horses, pulling the rich up hills in small carriages. She painted fruit sellers in the marketplace and women shopping, sitting, talking, nursing their children or fanning themselves, often worn out with their pitiable labour but never undignified. Her palette was hot, pulsing with raw sienna, ochres, vivid pinks, burnt oranges. She excised landscape in order to concentrate on the people who inhabited the fields and the cities. Her forms became flatter and more decorative. Her best paintings emanate an equal sense of community and alienation: people in crowds, with their families, alone with themselves.

In 1936 she had a solo show at the Taj Mahal hotel in Bombay: it was a hit. The critic Karl Khandalavala, who was to become her close friend and confidant, described Amrita as 'perhaps the most outstanding woman painter in the country' and declared that those who 'seek art should make it a point to see the work of this artist'. In 1937 her painting *Group of Three Girls* won the gold medal at the annual exhibition of the Bombay Art Society.

It's important to remember that Amrita was not yet thirty when she died, and her visual language was still evolving; understandably, her work was uneven. Her weakest paintings indulge in stereotypical representations of the poorest inhabitants of India; the best are a fresh, nuanced and idiosyncratic fusion of Indian classical painting and European Modernism. She is a divisive figure: lauded by some, simplistically, as India's Frida Kahlo, and dismissed by others for being superficial and supposedly lacking innovation, she was criticised for being a mixed-race aristocratic woman who never properly learned an Indian language and who indulged in what we might now describe as poverty porn. In 1937 one reviewer stated that her technique was 'foreign' and 'did not

show signs of assimilation to the traditions which belong to this country'. Ironically, 1937 was the year she painted her great South Indian trilogy, *Brahmacharis*, *Bride's Toilet*, and *South Indian Villagers Going to the Market*: sensual group portraits full of rhythm and atmospheric colour – burnt ochres, rich, earthy browns, vermilion and hot white – that were inspired by her study of the Ajanta murals. In 1938, Amrita wrote to Karl Khandalavala: 'I am starving for appreciation, literally famished. My work is understood and liked less and less as time goes on.'

In 1938, Amrita married Victor Egan; they had been close since childhood. Her parents were opposed to the union: apart from the fact that he was her first cousin, he wasn't rich. However, theirs was an open and honest relationship: he understood her indifference to convention and her need for personal and intellectual freedom. The depths of his understanding were tested with his discovery, soon after they were married, that she was pregnant. The father was a married journalist, John Walter Collins, who Amrita had met in Simla. Victor organised an abortion. They agreed not to have children and to reject monogamy.

For the first year of their married life they lived in Hungary, where Amrita painted *The Potato Peeler* – a gentle study of a maid, her face illuminated, deep in thought as she prepares the vegetables, her hands pink with cold, all of it framed against a sea-green wall. Amrita also painted, with grim prescience, *Merry Cemetery* – an image of oddly cheerful gravestones at night and the small, vivid flowers that decorate them. The year 1939 saw the creation of one of her most powerful paintings: *Two Girls*, a stark portrait of two thin, angular young women, one white, the other dark skinned. They are naked, deep in thought, united; their forms stripped back but not depersonalised. The white girl stands with her arm around the Black girl who sits on a chair, covering herself with a sheet. A study in swirling, organic earth colours, it's a raw and intimate portrait that could, in some ways, be read as

both a paean to same-sex love and a self-portrait: a union of two halves, European and Asian.

With Europe on the brink of war, Amrita and Victor sailed to India. They intended to stay with Amrita's parents in Simla, but Marie Antoinette was unwelcoming, so they moved to Saraya in Gorakhpur, Uttar Pradesh, to stay with Amrita's cousin. In 1941 they moved again, to Lahore, then a major artistic centre.

In the final year of her life, Amrita painted an extraordinary suite of paintings portraying women bathing, marrying, sleeping. Describing what was to become one of her most celebrated paintings, *Woman Resting on Charpoy*, Amrita wrote to Karl Khandalavala: 'I have just finished a picture – a girl in red flowered clothes (the Punjab dress, tight red trousers, shirt and veil) is reclining in a charpoy, its posts of an incandescent red rose ground like tongues of flame . . .'

A major solo show at the Punjab Literary League was planned for December. On 5 December 1941, weeks before the opening, Amrita died suddenly from peritonitis and dehydration. She said she had contracted acute dysentery from eating a pakora, although it is possible she bled to death, the result of a failed abortion. She was just twenty-eight years old.

Her final painting, which is unfinished, is a view from her window; four buffalos, one with a crow perched on its head; some small, ochre-coloured mud houses, the intimation of a tree and a woman in a red veil. The mood is soft, tender; the landscape, almost abstract, is enlivened with sections of bright vermilion. Edges blur: the world beyond is intensely alive and deeply felt, a place in which borders are fluid and demarcations vague. Amrita herself is not visible in it – but she is everywhere. To express your sense of place in the world is, it would seem, an endless act of translation. A self-portrait is not always a depiction of a body.

7

Naked

In 1989 the anonymous feminist art collective the Guerrilla Girls produced an electrifying poster. Emblazoned over a crop of a famous eighteenth-century painting of a female concubine by the French painter Ingres, her head replaced by that of a ferocious gorilla, it posed a deceptively simple question: 'Do women have to be naked to get into the Met Museum?' It elaborated: 'Less than 5% of the artists in the Modern Arts section are women but 85% of the nudes are female.'

The Metropolitan Museum of Art is, of course, far from unique. Most museums are filled with paintings and sculptures of naked women and only a tiny percentage of them were made by women themselves – and most of these are from the twentieth century. For millennia, for reasons of propriety, women were forbidden to depict themselves or anyone else naked while men were given a free rein to paint and sculpt us however they saw fit. (The Renaissance artist Lavinia Fontana is the exception to the rule. She included naked figures in her large-scale religious and mythological works and is considered the first woman to do so. Artemisia Gentileschi soon followed suit.) Similarly, the classic texts on the nude in art focus exclusively on images or sculptures of women made by men. In Kenneth Clark's famous *The Nude: A Study in Ideal Form*, which was first published in 1956 and covers art from Ancient Greece to the late 1930s, not a single woman artist is mentioned. In the index, mentions of 'woman' are listed as: condemnation of; crouching; old; nudes of; prehistoric; statues of; as virgin.

Women haunt galleries and museums as idealised beings: we are young, smooth, slim and hairless; virtuous, sinuous, remote. We embody myths, fairy tales, biblical stories and allegories; we are saints, goddesses and seductresses. We are beautiful, we are wicked, we are fallen and risen, we are holy, we are unattainable. We are almost always a type. We are very rarely ourselves.

Open to Everything

In 1906 a young German artist painted a three-quarter-length self-portrait. A study in soft greens and bright yellow, Paula Modersohn-Becker imagines herself pregnant against a golden backdrop; an evocation of a spring day, a celebration of birth and growth. She is naked from the waist up; a long amber necklace falls between her small breasts. A white cloth is wrapped around her waist. She is young, healthy, sturdy. She cradles her belly with her strong hands, her head at a quizzical angle, with a soft expression of curiosity. Her features are raw, free of make-up or artifice; her hair is pinned up, her eyes large and brown, shining with intelligence and personality. Her painting, like Catharina van Hemessen's self-portrait almost four centuries earlier, is inscribed. Translated it reads: I painted this at age 30 / on my 6th wedding day. P.B.

Paula painted her life-size *Self-Portrait on her Sixth Wedding Anniversary* in Paris – but the pregnancy she depicts is a symbolic one. What the thirty-year-old artist was expecting when she painted her masterpiece was not a child but the fulfilment of her creativity. At a time when women were patronised, sidelined or ignored, her painting is a defiant expression of a young artist's potential, an acknowledgement of the energy and ambition that consumed her.

Her initials 'P.B.' are a return to her maiden name, Paula Becker. She is celebrating her anniversary with a declaration that she is

free of her husband, Otto Modersohn. Nothing and no one can stop her, least of all matrimony.

Today, the painting is admired for its modernity, the skill of its execution and its psychological power. However, *Self-Portrait on her Sixth Wedding Anniversary* is a particularly ground-breaking work: it is the earliest known painting of a naked self-portrait by a woman.

Paula Becker was born in Dresden in 1876, the third of seven children (six of whom survived childhood). Her mother Mathilde was a minor aristocrat, her father, Woldemar, a building and works inspector for the railways. With some reservation, they supported their daughter's artistic ambitions. In 1888 the family moved to the German port city of Bremen from where, aged sixteen, Paula travelled to London to stay with her aunt Marie for a year to study 'good housekeeping' - a kind of finishing school for middle-class girls. Instead, she stayed for only nine months and, for the last two, enrolled in an art school in St John's Wood where the women outnumbered the men by ten to one. (Women were not yet permitted to enrol in the Royal Academy School.) Paula's focus was evident from the start. She wrote to her family in October 1892 that 'what occupies my thoughts are my drawing lessons'. All the students studied together, except in the life room: while the men were allowed to work from a naked model, the models posing for the female students were required to be dressed in 'ordinary bathing drawers, a cloth of light material nine feet long by three feet wide, which shall be wound round the loins over the drawers, passed between the legs and tucked in over the waistband; and finally a thin leather strap shall be fastened round the loins in order to ensure that the cloth keep its place'.

In 1893, at the request of her parents, Paula completed a teacher's course. In 1896 she moved to Berlin and enrolled at the Verein der Berliner Künstlerinnen (Union of Berlin Female Artists), which

offered art classes to women. Female students were not yet admitted to the government-run art schools in Germany. Although she only intended to stay for two months, she stayed for two years. She flourished. Her parents were cautiously supportive, although her father's letter, summarising her gifts, must have been deflating: 'I don't believe you will be a divinely inspired artist of the first rank,' he wrote to her in 1896, as 'it would have shown in you well before this – but you do have a sort of cute way of drawing that may be useful to you in the future and you ought to try and develop it.'

From the age of sixteen, Paula penned copious letters and a lively journal – a self-portrait in words. She is open, often funny and impassioned; some of her observations verge on the ecstatic. Colour, form and light affect her as acutely as the weather. On 20 February 1897 she wrote to her family: 'Colours are becoming beautifully clear to me, their relationship, their character, and much more that can only be felt, not spoken. My new teacher, Jeanna Bauck, calls it a physical comfort. Your child is suspended in this comfort every day.' The teacher and student became friends; she was one of the first serious women artists the young painter had met. Paula's description of her is affectionately honest: 'Unfortunately, she looks like most artists, rather shabby-shaggy. Her hair, which probably wasn't cared for when she was young, looks like plucked feathers. Her figure is large, heavy, uncorseted, and she wears an ugly blue-checked blouse. But for all that, she has a pair of merry, clear eyes, and she is constantly observing.'

In 1897 she visited Worpswede, a village near Bremen which was becoming famous as a colony of landscape artists who wanted to turn their backs on the increasing industrialisation of German cities. Paula fell in love with it immediately. 'Worpswede! Worpswede! Worpswede! . . . Birches, birches, pines and old willows. Beautiful brown moors, exquisite brown! Canals with black reflections, asphalt black. The Hamme with its dark sails. It's a wonderland, and land of the gods.'

When Paula met her future husband, the landscape painter Otto Modersohn, he was married; he and his wife Helene had a young daughter, Elsbeth. Paula's first mention of him is lightly dismissive: she writes that she 'didn't get a feeling of him' but there was something 'gentle and sympathetic about his eyes. His landscapes . . . have a profound mood'.

She exults in nature, in painting, in the moon and the sky, in a sense of infinite possibility. She describes coming across a peasant wedding and dancing with the father of the bride, who bellowed happily in her ear: 'We're both doing great!' She signed off one letter to her family, 'Life is almost too beautiful for your child'.

She returned to Berlin to finish her final year of art school and then travelled to Vienna where she was transfixed by the paintings of Cranach, Dürer, Leonardo, Rubens, Titian and Van Dyck: 'History, communing with great people of the past, holds something magical, something fascinating for me.' She was brought down to earth. Her father had financial problems and worried he could no longer support her studies. Paula, undaunted, declared she would work as a governess but was saved by a small and unexpected inheritance from a godmother. Her zest for life was irrepressible. She danced all night at an artists' costume ball, dressed as Rautendelein, an elfin creature who lures an artist away from his family. She wore a garland of roses in her hair. Despite her love of nature, she decided that 'painting people is finer than painting a landscape'. She often used her own body as a springboard to explore her visual language – in her short life, she painted thirty self-portraits, along with numerous studies of children, nursing mothers, old women, friends. She often incorporated still lifes into her portraits: quiet homages to the objects, the food, that nourish, decorate, enhance our worlds. She was obsessed with flowers. She painted them over and over again: bright, in vases, woven into hair, held by children, mothers, old women – herself. Their symbolism is mutable but

historically, their beauty and ephemerality were an embodiment of the memento mori - literally, 'remember you must die'. Paula was all too aware that the fleeting nature of life is something to both celebrate and to mourn.

In 1898, Paula's mother rented her a house in Worpswede. She studied under a local artist, Fritz Mackensen, who made her draw solidly for a year. She worked hard and, while serious, was acutely attuned to life's absurdities. She wrote in her journal about an old man who modelled for her and after three hours complained: 'Ah, sittin's no fun. My ass is all blind.' She read Marie Bashkirtseff's diary, which electrified her. 'It interests me very much and I get very excited reading it. She made such an enormous use of her life. I've wasted my first 20 years. Or has the foundation on which my next 20 are to be built been quietly laid?'

Four days later she wrote: 'Her thoughts run in my blood and make me deeply sad. I say as she does: if only I can become something!' In a fortnight she is still thinking about Marie. In her journal she describes a 'wildcat of a hangover that wrapped its long tail around my neck and nearly strangled my soul. Marie Bashkirtseff, I accuse her.' She delighted in life so passionately she found it hard to go to bed. 'My energy wants to fight on, to be conscious of itself again and again, to be awake, not asleep. Oh, stay with me forever! My life is like the flight of the young eagle. I enjoy having wings. I enjoy flying, I cheer the blue skies. I'm alive.'

Despite her preference for painting people, she also painted some heartfelt landscapes: stark fields, a leaden sky, the river glistening in the early evening, silver birches rising from the damp green earth like exclamation marks; a startled red house against a grey sky; stabled cows peering out at the pasture.

She wrote to her father that she had visited Otto Modersohn, who pleased her immensely, and became close to the young sculptor Clara Westhoff, a fellow student of Meckensen. They painted together, went to dances, confided in each other. 'This afternoon,'

she wrote to her mother, 'Fräulein Westhoff poled me far up the Hamme. We picked yellow irises, swam, felt blessed in the wet elements, and stuck yellow waterlilies in our hair.' She had only one thought: 'To lose myself in my art, to disappear into it, until I can express approximately what I feel – perhaps in order to disappear completely.' In another letter she describes how she and Clara climbed up a church tower and rang the bells until they were tired, not realising it was the signal for fire. A scandal ensued. They were the talk of the town.

In 1899 she made a life-size drawing of a naked girl. It is a blunt study of a small, thin child, her back swayed, her belly protruding, her arms crossed across her chest. She looks away, into the distance. Her hair is pulled back in a plait; her feet are sturdy. She is unclothed, but her nakedness is depicted without a shred of sentimentality or eroticism. She is simply a child at home in her flesh.

Otto Modersohn visited her and praised her work. She had her first exhibition – she was only to have three in her lifetime – of two landscapes and seven studies, at the Bremen Kunsthalle, alongside works by Clara Westhoff and Maria Bock. The show was savaged by the mural artist and critic Arthur Fitger. He described their paintings as 'things that the primitive beginner, blushing modestly, might show her teacher or advisor'. He stated that the paintings were unworthy of public display and made him feel seasick and nauseous. Paula's response in her journal was uncharacteristically brief. 'The first exhibition of my pictures [. . .] Arthur Fitger ran everything into the ground.' She and Clara decided to move to Paris.

By 1896, Parisian women had finally won the right to study art alongside men at the École des Beaux-Arts. But their journey to equality wasn't easy. In an article published in 1901 the art historian Eugene Muntz wrote:

The Paris newspapers severely criticized the disgraceful conduct of a few hundred art students who hooted the young girls who went to school for the first time. This demonstration, which was based on the most selfish grounds - namely, fear of seeing women take their share of the prize-money, scholarships, and other rewards with which the school is richly endowed, led the government to close the painting and sculpture studios for a period of one month.

Equality obviously still had some way to go. Women may have been permitted to study, however begrudgingly, but, until 1903, they were still barred from entering art prizes such as the prestigious Prix de Rome.

On the first day of the new century, after a seventeen-hour train journey from Bremen, Paula arrived in the French capital. At first, the city shocked her: 'Everyone around me is rushing in and hurrying in the foggy, damp air. Much, much dirt, within, deeply within. Sometimes, I shudder. I feel that more strength than mine is needed to live here, a brutal strength.' Clara, who lived next door, was at the Académie Rodin studying sculpture and Paula enrolled at the Académie Colarossi where, for the first time, she drew and painted naked models alongside male students. She was on a tight budget: she ate just one meal a day and didn't heat her tiny room on the boulevard Raspail. She worked incessantly: she took drawing and painting classes in the morning and the evening and studied anatomy at the École des Beaux-Arts when she could. Her talent was recognised: she was awarded a medal by four professors at Colarossi. She and Clara moved to a complex of artists' studios on the rue Campagne-Première, where Paula could paint in her room. She sketched classical sculptures at the Louvre, which she described as her 'alpha and omega'. She visited as many exhibitions as possible. For seven months Paris was overtaken by its Exposition Universelle - a celebration of art, commerce, technology, that

included a dizzying exhibition of French art from 1800 to 1890, with paintings by Gauguin, Manet, Matisse, Berthe Morisot, Seurat and other post-Impressionists. Years later, Paula recalled how seeing Cézanne's paintings at Vollard's gallery affected her 'like a thunderstorm' but she wanted to see something by Degas 'other than ballerinas and absinthe bars'. She was dismissive of her fellow students: 'Morning among the females there's a lot of wild hair and unpolished boots, a few clever heads and little talent. They work like a herd of cattle without any idea about what matters.'

For her twenty-fourth birthday Clara serenaded her with a panpipe and gave her a hyacinth bulb in a green glass (which Paula painted), an orange and some violets. That night they drank champagne. But Paula was occasionally frustrated with her friend. 'I don't know if Paris is right for her', she wrote. 'I find her too big and bulky, inwardly and outwardly. But she does have a strong nature. She seizes everything that comes her way.' She became close to another young artist: the painter Marie von Malachowski.

At Paula's invitation, Otto Modersohn visited Paris without his family. Three days after his arrival, word arrived from Worpswede that his wife Helene had suddenly died. Paula and Clara returned to Germany.

Back in the peace of Worpswede, Paula, exhausted, convalesced after the strains of living in Paris. Otto sat by her bedside and read to her. It was considered too soon after the death of his wife for him to be courting another woman, so they kept their budding relationship secret. They penned letters to each other and placed them under a special stone on the moor. She wrote: 'We both have a good future ahead of us . . . you are quietly kissed and your dear head is gently caressed. I am yours, you are mine, of this you may be certain.'

Paula met Rainer Maria Rilke, who was visiting mutual friends, the artist Heinrich Vogeler and his fiancée Martha. Rilke called

Paula and Clara 'the fair painter and the dark sculptor'. Paula described him as 'a subtle, lyric talent, delicate and sensitive, with small impressive hands' and his poems as 'tender and full of presentiments. Sweet and pale.'

In the midst of the pleasures of Worpswede, Paula wrote a strangely prescient passage in her journal:

> I know I will not live very long. But is this sad? Is a celebration more beautiful because it lasts longer? And my life is a celebration, a short intense celebration. My sensuous perception is becoming sharper, as if I were supposed to take in everything, in the few years that are offered me. At present my sense of smell is amazingly fine. Almost every breath brings me a new perception of linden, of ripe grain, of hay and mignonette. I absorb everything. And if love blooms for me before I go and if I paint three good pictures, then I can leave willingly with flowers in my hands and hair.

Paula and Otto were engaged. She described him to her aunt Marie as 'a man and a child. He has a pointed red beard and sensitive, dear hands, and is 17 centimetres taller than me . . . art and love are the two pieces he plays on his violin.' She painted non-stop. She reassured her mother that 'getting married should be a reason for me not becoming something'. To prepare her for marriage, Paula's parents sent her to Berlin for two months to learn how to cook. Frustrated, she told Otto that she was 'feeling very tamed and very confined. I'd like to blow up the walls and see a bit of heaven'. Rilke was living there. She visited him every Sunday. She said that 'hearing his voice was like a bit of Worpswede for me'. Clara and Rilke were engaged. The two couples married in the spring of 1901, as did their friends Heinrich and Martha Vogeler. Paula became stepmother to Otto's young daughter Elsbeth. She painted her again and again: a small, fond figure with hens under an apple tree, in the garden with a glass ball; with goats, cats, a rabbit; naked.

Paula and Clara's friendship suffered after their marriages. Paula vented in her journal that 'I don't seem to fit into her life any longer. I just have to get used to it. I really long to have her still be a part of mine because it was beautiful with her.' She wrote her friend, who had a month-old child, an impassioned letter:

> It seems to me that you've laid down so much of your old self, like a cloak spread for your king to step on. For your sake, for the world's, for art's and for my own, I'd like you to wear your golden cloak again. Dear Rainer Maria Rilke, I agitate against you. I feel it necessary to agitate against you – I intend to do so with the thousand languages of love . . .

Rilke, not Clara, replied with what reads like controlled fury: 'Permit me to say a few words about your letter to my dear wife [. . .] Will you believe me that it is hard for me to understand what you are actually talking about? [. . .] We had to burn all the wood on our own hearth in order to warm up our house for the first time and make it liveable. Do I have to tell you that we had cares, heavy and anxious cares?'

He admonished her for not allowing relationships to change with circumstance: 'You will continually have to experience disappointments if you expect to find the old relationship; but why don't you rejoice in the new one that will begin when someday the gates of Clara Westhoff's new solitude are opened to receive you?' He continued with what was to become one of his most famous invocations:

> I hold this to be the highest task of a bond between two people: that each should stand guard over the solitude of the other. For if it lies in the nature of indifference and of the crowd to recognise no solitude, then love and friendship are there for the purpose of continually providing the opportunity for solitude. And only those

are the true sharings which rhythmically interrupt periods of deep isolation.

Paula didn't reply.

In March 1902 she observed in her journal: 'During my first year of marriage, I've cried a lot and often - as in my childhood, I cry big tears [. . .] my heart longs for one soul whose name is Clara Westhoff. We're no longer able to find each other. And perhaps this loneliness is good for my art, perhaps wings are growing in this serious stillness.'

Later that month her gloom had deepened: 'It's my experience that marriage doesn't make one happier. It takes away the illusion that previously sustained one's whole reality, that there is a companion for one's soul.' In the same month Otto had written about Paula in his diary: 'She is understood by no-one. Mother, brothers and sisters, aunts - all are in silent agreement: Paula will accomplish nothing. They don't take her seriously. And the same in Worpswede - her work is never asked about. [. . .] I rejoice about my Paula, who is really a great painter [. . .] In her intimacy, she is monumental.'

Early in 1903, Paula decided she needed the stimulation that she had begun to feel was lacking in Worpswede. Otto wasn't keen on big cities - he had written to Rilke about Paris, describing it as 'that dreadful wild city' - but he allowed her to go. Everything he needed was in the countryside.

Clara and Rilke were there. Rilke was writing his book on Rodin and Clara was working on her sculpture: they had left their daughter Ruth with her grandparents. The three friends met up. Paula wrote coolly to Otto: 'They're very friendly to me. But Paris plagues them both with uneasy anxieties. "There are voices in the night." The same joyless fate rules both these human beings. And this joylessness can be quite contagious.'

Later she sarcastically described them as 'singing the blues, and in harmony, too'. She threw herself into her painting, working all

hours in her studio. She focused on working from the nude. She was impressed by an exhibition of old Japanese paintings, charmed by small works by Degas, Daumier and Millet, and 'came closer' to Rembrandt and the Dutch masters. She decided that Rodin was the greatest living French artist. Rilke had introduced Paula to the sculptor with a letter, describing her as 'the wife of a very distinguished German painter'. He omitted to mention that she, too, was an artist. Rodin showed Paula around his atelier and was 'friendly and charming'. Later that year, Rilke was commissioned to write a monograph about artists living and working in Worpswede. He penned five essays on five artists, including Otto. He didn't mention Paula. She dryly observed: 'I actually find more Rilke in it than Worpswede.'

Paula begged Otto to join her in Paris, but he wouldn't. She complained, again, about the Rilkes, who 'only half listen' as 'they're so preoccupied with themselves'. She wrote in her journal that 'a great simplicity of form is something marvellous [. . .] I feel I must look for all the remarkable shapes and overlapping planes when drawing nature. I have a feeling for how things slide into and over each other.' She returned to Worpswede in March.

Her life was calm, regulated. She painted every day, ran the household, planted tulip bulbs and anemones. Inspired by Isadora Duncan, she danced in the garden. But it wasn't enough. Early in 1905 she returned again to Paris and enrolled at the Académie Julian. It was where Paula's heroine Marie Bashkirtseff had studied and also had the advantage of 'not having so many dreadful Englishwomen'. She was drifting away from Otto and told him that 'I look at you as through a fog, as into another life'. He was increasingly impatient with her drive and ambition. He complained in his journal: 'Paula's art no longer makes me as happy as it did before. She will not take any advice - it is very foolish and a pity. A colossal waste of creative power. What she could do! Paints life-size nudes, which she can't do, any more than she can paint life-size heads.'

She experimented with her materials: as well as canvas, she painted on cardboard, Masonite, silverfoil, wood and slate. She was upending everything. She even attacked the painting's surface with the wrong end of her brush.

She returned to Worpswede. Rilke and Clara visited. Paula painted Clara's portrait, Ruth playing at her feet. Paula depicts her friend in a white dress against a dark background. She holds a lush red rose and looks away. She has brows like a bird's wings, large, rather anxious eyes and loose dark hair. She is young and yet somehow quite ancient: her lovely face evokes the hard, smooth planes of a classical sculpture. Clara recalled sitting for her friend: 'one tear after another rolled down while she explained to me how very important it was for her to be "out in the world" again, to go back to Paris'.

Paula wrote to her mother, 'I get the strong desire from time to time to experience something else. That one is so terribly stuck when one is married is rather hard.' She complained to her sister Milly: 'Totally disregarding whether or not one has talent, I do find art very difficult.' Yet, the paintings she was making were extraordinary: decisive, inventive, searingly heartfelt explorations of bodies, objects and art history – and her place in it all.

Rilke visited Paula's studio. Astounded, he wrote to a friend that: 'Most remarkable was to find Modersohn's wife in a completely original state of her painting, painting ruthlessly and boldly things which are very Worpswede-like and yet which were never seen or painted before. And in this completely original way strangely in affinity with Van Gogh and his direction.'

'Modersohn's wife' was restless – with her painting and her marriage. She turned thirty. Clara wrote to Rilke that Paula had confided in her that for five years Otto 'was not able to perform sexual intercourse because of his nerves' and that her 'only real desire is: not to be married'.

Without a word, Paula left Otto and travelled to Paris. Rilke met

her train at the Gare du Nord with a bunch of flowers and a hundred marks, applauding her escape. He left on a lecture tour for a month. When he returned, Paula was the person he wanted to see. She asked herself: 'I am standing between my old and my new life. What will it be like? And what will I be like in my new life? Now it is all about to happen.' Otto pleaded with Paula to come home. He enlisted friends and family to pressure her to return. Only Rilke and Clara supported her decision to leave her marriage. She asked Rilke who she was. 'I am not Modersohn and I am also no longer Paula Becker. I am I and I hope to become so more and more.' From this point on, Rilke addressed her as Paula Becker. She wrote to Otto: 'Try to get used to the possibility of the thought that our lives can go on without each other.' She wanted to enrol in the École des Beaux-Arts but the age of thirty was the cut-off point. She attended anatomy classes and art history lectures, aimed to 'achieve a much purer colour' in her painting, and admitted that she had 'all sorts of things to learn'. She repeatedly begged Otto to accept her decision that they part and to send her money.

Her paintings became even tougher, more explorative, risk-taking: as modern as the most modern paintings of the time. She grappled with the tenets of Expressionism – bright colours, dark lines, stripped-back details – and made them her own. She painted her sister Herma, her face a tender approximation, holding an orange flower that glows softly, like something sacred. She had a brief affair with the social scientist Werner Sombart, and she painted him, too. He is plain, as is the grey-blue background, but his dark beard, his hair, his neck are electrified with thin orange lines that flash with life.

She grew close to the sculptor Bernhard Hoetger and thanked him for 'being on this earth'. She told him he had done her 'so much good' as she was 'a little lonely'. She painted two portraits of his wife, Lee Hoetger. In one she holds a small purple flower, her

face as blank as a mask; in another more exuberant painting, Paula pictures her in a bright blue dress. Deep in thought, she seems oblivious to the explosion of red, pink and purple flowers that surround her. Paula told her sister that she was living 'the most intensely happy period' of her life and asked her to send sixty francs for an artist's model. She explained to her mother that she was 'beginning a new life' and that she was 'living in ecstasy'. She painted a head-and-shoulders portrait of Rilke. Against a pale green background, his face is mask-like, his large eyes like red-rimmed stones, his mouth slightly parted, as if in the middle of an utterance. He has a stiff white collar and a beard like a board. The paint marks are visible, rough, urgent. It's a portrait that is both very modern, and yet somehow very old: it could be carved from wood.

She painted herself holding a lemon, her face dark against a yellow background, her necklace a string of small lemons. Her earrings swing like commas. Her heavy-lidded eyes are weary.

In 1906-7 she became her primary subject: she painted nineteen self-portraits, seven of which are nudes. So many men for so many years had painted women wearing nothing, yet very few women had done this before: painted their bodies from lived experience. Her level of self-scrutiny is apt, given the brave leap she had made, but the radicalism with which she explored her freedom was unprecedented. She painted herself as if she were pregnant. She painted herself naked, adorned. She painted herself with red flowers in her hair, framed by deep blue leaves, her left hand holding a small red bloom between her small pink breasts, her right bringing another flower towards her face, as if to smell it. She painted two full-length nude self-portraits: in the smaller one she wears a hat, and her features have dissolved. She holds a lemon and an orange like talismans. In the other, with her amber necklace, the small blast of bright fruit and her strong body, she is easily recognisable. It was the largest painting she made and the first which included a splash of red - menstrual blood? - in her pubic hair. In both

self-portraits, against a deep sea-blue background she carves into her flesh as if it were as robust as marble.

She explores space, skin, her body. She is in dialogue with the artists of the past and with the best of her contemporaries, such as Matisse and Picasso. (The staggering painting she made in 1906 of a naked, statue-like child, holding a plate with a lemon and an orange, vivid with pink shadows and backlit with a shining goldfish bowl, precedes Matisse's famous study of goldfish in a bowl by six years.) Her scrutiny, her uncompromising originality and her technical skill were as good as anyone painting in Paris at the time. So many men were painting naked women: she turned the tables. She is subject, object, creator.

None of these phenomenal paintings were exhibited in Paula's lifetime. She had spent her life looking harder – at the world, at her friends, at herself – than most people, but she herself was only very rarely seen.

Two small photographs exist of Paula in her studio. She is naked, posing for her paintings. We don't know who took the photographs or why. But despite the power of seeing her in the flesh, somehow, the photographs are like pale imitations of the paintings.

In June a desperate Otto arrived for a week unannounced then returned to Worpswede. In October he came back again with their friends the Vogelers. Paula asked him to stay in separate quarters, but it didn't happen. He asked Paula to move back to Worpswede with him in the spring. Finally, worn down, she agreed.

In November 1906 two of her figure paintings and two still lifes were included in a group exhibition, again at the Bremen Kunsthalle. It was only the second show she had taken part in. This time, thankfully, there was no savaging. The director of the museum wrote: 'In this young artist there is an exceptional energy, a highly cultivated sense of colour, and a strong feeling for the decorative function of painting.' It was the only positive

piece of writing she had ever received about her work. The exhi-
bition travelled to Berlin, to Galerie Fritz Gurlitt, but was ignored
by critics.

It is hard not to read resignation in her letter to Clara, telling
her of her plans. Women at the time were under the jurisdiction
of their husbands. To be financially and emotionally independent
was almost unthinkable. She had tried to escape but failed. Paula
explained that she was back with Otto and that she 'was no longer
full of so many illusions':

> I realised this summer that I am not a woman to stand alone.
> Apart from the endless worries about money, it was precisely my
> freedom that lured me away from myself. And I would so like to
> succeed, to create something that is me alone [. . .] The main thing
> is: peace for my work, and that I have most of all while at Otto
> Modersohn's side.

By March 1907 she was expecting a child. She and Otto returned to
Worpswede.

Her pregnancy was fraught and Paula often felt unwell but she
worked when she could. She painted *Old Poorhouse Woman in a
Garden with Garden Ornament and Poppies*. A woman, as immovable
as a hill, her face in violent shadows, is surrounded by weighty
flowers: she holds one on her lap like a gorgeous sword. The paint-
ing throbs with colour: vermilions, blues, pinks and greens jostle
for attention. *Girl in a Red Dress Standing Under a Sunflower* is equally
powerful: an intertwining of flesh, spirit, nature. For her final self-
portrait, Paula zoomed in on herself. With thick, expressive paint,
she evokes her simple blue and white dress, her neat hair, her
direct gaze. The blustery paint itself conveys the extremity of what
she is feeling: there is anguish in her decorum. Her right hand rests
on her swollen belly: this time, she really is pregnant. In her other
hand, she holds two dark red flowers, like an offering; one of them

is carved into the mottled pink paint of her cheek. It's the earliest known self-portrait by a pregnant woman.

On 21 October 1907, Paula wrote her last letter to Clara. It mainly concerns her thoughts on Cézanne. She signed off with: 'When it's not absolutely necessary for me to be here, I must be in Paris.' In her final letter to her mother, two weeks before she gave birth to her daughter Mathilde, again she is thinking of painting: 'I'd like to go to Paris for a week. There are fifty-six Cézannes on exhibit.'

On 2 November 1907, Paula gave birth to her daughter, Mathilde; she was named after her mother. She was bedridden for nineteen days. Clara visited her and promised to return, to read her Rilke's thoughts on the Cézanne exhibition. Finally, Paula had permission to rise. She combed her hair, pinned it up and decorated it with roses. She walked into a candlelit room with Otto and her brother. She held her baby, collapsed and died from an embolism. Her last words were 'what a pity'. She was thirty-one. She left behind more than 700 works. She had only sold three in her lifetime.

A year after Paula's death, Rilke wrote a howling, 271-line requiem to his friend:

> I must accuse:
> oh not the man who withdrew you from yourself
> (I cannot find him; he looks like everyone),
> but in this one man, I accuse: all men.

The Model Models for Herself

After Paula's death, everything changed, but then change was in the air: she was part of the groundswell. Did she have anything to do with it? It's hard to say: she posthumously achieved fame – edited versions of her letters and journal were bestsellers, many

of her paintings were acquired by major museums and Rilke's requiem, although he doesn't name Paula, aroused curiosity – but during her lifetime, very few people knew about her or her work.* In many ways she embodied the societal transformation that began to accelerate at the beginning of the twentieth century. Women were pushing hard against the seemingly impregnable laws that had hemmed them in for so long; with ever greater vehemence they demanded the right to represent themselves where and how they liked. In 1909 in France, Gwen John sketched and painted herself, thin and naked in her room; in the same year the most famous artist's model in France also began a series of astonishing self-portraits.

If anyone has the right to depict herself naked, it's a model: those nameless women whose faces and bodies have sold countless paintings over the centuries, and whose lives we very rarely know anything about.

Born Marie-Clémentine Valadon in 1865, Suzanne Valadon, as she would become, was the illegitimate daughter of Madeleine, a seamstress and cleaning woman, and a father she never knew. In 1870, still shamed by giving birth out of wedlock, Madeleine moved her family from their home of Bessine-sur-Gartempe to Montmartre. It was a turbulent time; France was embroiled, and then defeated, in the Franco-Prussian War and the Third Republic was established in 1877. For seventeen years, under the direction of Georges-Eugène Haussmann, Paris had been a vast building site,

* First published in 1913, and then in various other incarnations, Paula's letters and journal entries became enormously popular. Posthumously, she became a star and her paintings entered the collections of numerous museums. In 1937 the Nazis destroyed much of her work and some of her paintings were included in the notorious 'Degenerate Art Exhibition'. In 1975 the poet Adrienne Rich wrote a long poem: 'Paula Becker to Clara Westhoff'. The German bio-pic *Paula*, directed by Christian Schwochow, was released in 2016 and the French novelist Marie Darrieusseq's biography *Being Here is Everything: The Life of Paula Modersohn-Becker* was published in 2017.

transformed from a medieval city into a modern one; 12,000 build-
ings had been knocked down, displacing thousands of the city's
poorer citizens. High above Paris, Montmartre, however, was left
untouched. Attracting refugees from the city centre, this vibrant
working-class village - full of gardens, bars, cafés and studios - fast
became the epicentre of modern painting.

Reports differ about her early years, but it's generally agreed
that after a rudimentary education, from around the age of ten or
twelve, Marie-Clémentine, who had made drawings on anything
she could find for as long as she could remember, earned a living
doing various jobs: sewing, making wreaths, selling vegetables,
waitressing, washing dishes and working as a stable hand. Her
dream, though, was to become an acrobat. She was a 'wild, tiny
figure [. . .] bobbing along on a horse's back, executing handstands,
headstands, somersaults and cartwheels'. She recalled: 'I thought
too much, I was haunted, I was a devil, I was a boy.' She worked
for six months at the Cirque Fernando, Montmartre's permanent
circus, but when she fell from a trapeze at the age of fifteen, her
focus turned to art. Initially with the help of her friend Clelia,
who was a model, from 1880 to 1893 she posed for artists includ-
ing Pierre Puvis de Chavannes, Pierre-Auguste Renoir, Henri de
Toulouse-Lautrec and others. She is the star of some of the era's
most famous paintings: Puvis de Chavanne's *The Grove Sacred to
the Arts and Muses*, Renoir's *The Large Bathers*, *Dance at Bougival* and
Girl Braiding her Hair, and Toulouse-Lautrec's *The Hangover*. She
is pictured variously as a mythical creature, a naked temptress, a
sweet-faced coquette, a virginal beauty and a sour-faced drunk. As
she struck poses, she observed how the artists sketched, prepared
their palettes and mixed paint. She was learning her craft.

Maria, as she was known, frequented the cafés and nightclubs
of Montmartre: the now legendary Lapin Agile, the Chat Noir, the
Café de la Nouvelle Athènes - favoured by the loose group of artists
known as the Impressionists - and others. The only other model of

the time who became well known as an artist, Victorine Meurent - the star of many of Manet's paintings, who was twenty years older than Maria - was also a regular. Maria was high-spirited and bored by convention: she once entered the Moulin de la Galette by sliding down the bannisters, dressed in nothing but a mask. She became close to the charismatic Spanish critic and artist Miguel Utrillo; not to be outdone, he rode a donkey backwards into the same nightclub and wheeled a barrow of fish into the elegant L'Élysée Montmartre. Maria followed him, laughing.

In 1883, Maria gave birth to her son, Maurice, who was also to achieve fame as an artist. It's not clear who the child's father was but in 1891, Miguel Utrillo 'acknowledged' him, perhaps more out of kindness than patrimony: it was impossible for Maria to marry or to be considered respectable as long as she had an illegitimate child.

Not long after Maurice was born, she drew a head-and-shoulders self-portrait in charcoal and pastel.

For once, no one is looking at her but herself.

She is eighteen, the new mother of a child born out of wedlock. She is working class and desperately poor. Yet, she depicts herself with pride: her golden hair is neatly pulled back, her blue dress demure. She looks out at us - or at herself in the mirror - with a clear, stern expression. She is a beauty, but she underplays her looks. Her signature in the top right corner is firm: Suzanne Valadon, 1883. Curiously, though, when she made this drawing, she was still known as Maria, not Suzanne, so it's likely she signed it later.

Around 1895, Maria became Suzanne. Toulouse-Lautrec chose her new name after the biblical story of Susannah and the Elders - the painting that Artemisia had so furiously painted almost 300 years earlier. From our perspective, it's a horrible thing to do: to name a young woman after another young woman whose fame rests on the fact that she was sexually assaulted by older men. But it

stuck: she liked it and it was hers. She and Toulouse-Lautrec were close, most likely lovers: she posed for him and he was the first to recognise her talent as an artist. He pinned three of her drawings to his studio wall and asked his visitors to guess who made them. He also let her borrow his books: she read his copies of Nietzsche's *Genealogy of Morals*, Ludwig Büchner's *Force and Matter* and Baudelaire's poems.

Despite her formidable talent, Suzanne's reputation as an artist was, until very recently, clouded with tedious moralistic judgements about her virtue, or rather, her perceived lack of it. As one of her biographers, June Rose, wrote: 'Long after she became an artist herself, these images of her, beautiful and dissolute, lingered in the minds of critics, and her own conduct as a woman cast a shadow over her achievement as an artist.' It is galling to compare her reputation with her male contemporaries', very few of whom lived what could conventionally be called blameless lives, and whose paintings are rarely judged by the behaviour of their creators.

As a female artist in Paris at the turn of the century, Suzanne wasn't alone. Like Paula Modersohn-Becker and Gwen John, women gravitated to the city for its relative freedoms and the richness of its art scene. In 1879 alone fourteen women had been awarded gold medals at the Paris Salon. Various movements came and went at the turn of the century - Fauvism, Cubism, Futurism, Orphism, Dada and others - but it was Impressionism which had dominated the Parisian art scene from the 1860s. Discussing her influences later in life, Suzanne admitted that it was 'the palette of the Impressionists that enchanted me'. The group included a number of brilliant women - Marie Bracquemond, Mary Cassatt, Eva Gonzalès and Berthe Morisot - but they came from privileged backgrounds, were roughly twenty years older than Suzanne, and none of them drew or painted themselves naked. Also, despite their immersion in bohemia, most female artists were still chaperoned;

what they were allowed to see and do was tightly controlled. But Suzanne was her own woman: financial constraints aside, she was free to come and go - and to draw and to paint - as she pleased. That said, some of the artists she modelled for, and often slept with, were scathing about the idea of women being artists. Renoir - for whom she modelled for five years - wrote to a friend that: 'I think of women who are writers, lawyers and politicians as monsters, mere freaks . . . the woman artist is just as ridiculous.'

Through Toulouse-Lautrec, Suzanne met Paul Bartholomé, who in turn introduced her to his friend Edgar Degas. Thirty-one years older than Suzanne, he was a brilliant artist but a divisive figure: virulently antisemitic and, despite the radicalism of his art, conservative in his politics. But he was to play an important role in Suzanne's life; he championed her work from the start. On the day they met, she made her first sale: Degas bought her drawing, *La Toilette*, of a girl getting out of the bath. (He eventually bought twenty-six of her drawings and prints.) Legend has it that he told her: 'You are one of us.' She recalled: 'That day I had wings.' He was the one artist to continue to call her 'Maria' - teasingly, 'Terrible Maria' - gave her private lessons in drawing and painting, taught her soft-ground etching, and corresponded with and encouraged her until the end of his life. In 1894, with his and Bartholomé's encouragement, Suzanne exhibited five fluent, unsentimental drawings of her son and mother at the annual salon of the Société Nationale des Beaux-Arts: its founders included Puvis de Chavannes and Rodin. Suzanne was the only woman to have work accepted into the exhibition - and as a self-taught workingclass woman at that, her achievement was unheard of. The model had become the painter.

The focus of Suzanne's gaze was predominantly working-class women - old, young, bathing, resting, combing their hair. In dense, sinuous lines she honoured the resilience of their spirits and their bodies. Nothing is titillating or idealised: these women and girls

might occasionally be depicted naked, but they're also exhausted; their skin is simply what they live in.

Suzanne made portraits of people who were important to her. In 1892 she painted her lover, the composer Erik Satie. His skin is a pinkish green, his lips cherry red, his hat sloppy. His small round glasses, frock coat, white collar and messy hair lend him the air of a bohemian vicar. He had proposed marriage to Suzanne with a description of his assets: 'I breathe with caution, a little at a time, and I dance very rarely.' He gave her absurd gifts, including a necklace of sausages and a bag filled with 'the wonderful smells of the world'. They sailed boats at the Luxembourg Gardens but he was as poor as she was and she had a child to look after. He wrote to her: 'Everywhere I see only your exquisite eyes, your gentle hands and your little child's feet.' He decorated his letter with a coat of arms that translates as: 'Eagle I cannot be, turkey I deign not to be, chicken I am.' After six months, Suzanne left Satie for a wealthy stockbroker, Paul Mousis, who she married in 1896. Satie was devastated; he never, as far as we know, had another love affair. He pinned a lock of her hair to an announcement that he placed in his window. In red and blue ink it read: 'My love affair with Suzanne Valadon . . . ended on Tuesday 20th June.' In the same year he composed one of his best-known pieces of music: *Vexations*. It's accompanied by the instruction: 'In order to play the theme 840 times in succession, it would be advisable to prepare oneself beforehand, and in the deepest silence, by serious immobilities.' Never published or played in Satie's lifetime, it was made famous by John Cage in 1949.

Mousis rented Suzanne a studio and living quarters on rue Cortot in Montmartre. He also set up a home for the family in a village, Pierrefitte, thirteen kilometres outside Paris - a quick train ride from the Gare du Nord. Suzanne's mother Madeleine moved in and Maurice was sent to boarding school. Suzanne, who loved animals and frequently drew and painted them, sometimes

travelled between Paris and the village on a small carriage pulled by a mule, accompanied by five wolfhounds. She also kept goats and a deer, gardened and made her own furniture. She employed her two maids, Catherine and Louise, as models: the etchings she made of them bathing, drying and resting, were sold by the influential dealer Ambrose Vollard. In 1898 she was accepted into the Exhibition of the International Society of Sculptors, Painters and Engravers in London, and her work was shown alongside that of Degas, Manet and Toulouse-Lautrec. But Maurice was bullied and Madeleine was lonely in the countryside: they missed life in Montmartre. By the age of fifteen, Suzanne's son was an alcoholic and increasingly plagued by his mental health.

For thirteen years, Mousis gave Suzanne the financial and emotional security that should have allowed her, for the first time, to focus on her art. Nonetheless, she was pressured to be a bourgeois wife and her work suffered as a result. Degas wrote increasingly wistful letters to her: 'Do you still draw, excellent artist?' And another: 'From time to time, I look at your study in red chalk, which is still hanging in my dining room; and I always say to myself: "That she-devil Maria could draw like a little daemon." Why don't you show me your work anymore? I am nearing 67.' In 1901, Toulouse-Lautrec died from syphilis and alcoholism. He was thirty-seven. Suzanne cried for a week.

Although she savoured the security at first, being a respectable wife didn't suit her. In 1909 she fell in love with André Utter, an electrician, an artist and a friend of her son; he was twenty-one years younger than her. She left her husband, moved back to Montmartre, and set up a new home with André, Madeleine and Maurice. She was fired up. Between 1903 and 1907 she had made only five paintings but in 1909 alone she painted eight major works. In many of these her delight in her sexuality, in her new freedom, is palpable.

In the sensual *Adam and Eve*, Suzanne pictures herself as a

smiling, happily naked Eve. Her hair streaming down her back, she plucks the forbidden fruit like a treat to be savoured. Adam - modelled by her new lover - gently guides her hand with his; his genitals are hidden by a fig leaf that was apparently added later, to appease censorious gallery-goers.

In 1911 she painted *Joy of Life* - a study of four women, who have been bathing and are observed by a naked man (André again). It's something of a homage to Édouard Manet's scandalous *Le Déjeuner sur l'herbe* (1863), which depicts two fully clothed men having a picnic with two women, one of whom is naked, the other lightly dressed in a chemise. A year later, Suzanne painted a naked young woman reclining on a red couch, gazing down at another woman kneeling on a carpet, her cards laid out before her. Her nakedness is comfortable, unseductive; the colour of her long plaits is echoed in the red of her pubic hair. She is dignified, strong, full of power. The fortune teller holds the queen of diamonds: a card that signifies wealth, authority and wisdom. The compositions of these high-key, expressive paintings are crammed with details - the grey-blue flowered wallpaper, the burgundy couch, the rich blue-and-orange carpet, the long red hair, the dense green grass: there's a palpable sense of pleasure in the physical world. Suzanne used herself as a model in each of these paintings. She also modelled for André: his naked portraits of her reveal a woman utterly at home in her body.

At the age of forty-six, in 1911 she had her first solo show at the Galerie du Vingtième Siècle - the Gallery of the Twentieth Century - which was run by a former clown with a good eye, Clovis Sagot. He had been supportive of artists including Picasso and Juan Gris and was enthusiastic about Suzanne's work. The show didn't sell well but she was becoming better known.

In *Portrait de Famille* (Family Portrait), which Suzanne painted at the age of forty-seven, she depicts herself surrounded by two young men and an old woman - all of whom are looking away,

as if too absorbed in their thoughts to concede the artist's presence. To her right is André, who, with the declaration of World War I she would soon marry, in part to get paid as a soldier's wife. Maurice, who was now achieving some success as an artist himself, is to her left: his dejected pose and despondent expression hint at his problems with mental health and addiction. Behind her is Madeleine, her fierce, bent, elderly mother, who was to die three years later. Only Suzanne, the painter, stares directly out at us, her right hand on her heart. This is my family, she seems to be saying: this is me.

World War I was declared and André left for the front. Unfit for service, Maurice stayed put. He wrote his rambling autobiography, *The Story of My Youth*, in which he describes his mother as 'a noble person, perhaps the greatest pictorial luminary of the century and of the world' and himself as 'a faded rosebush, a repugnant drunkard [. . .] an object of public scorn and ridicule'.

Degas died in 1917. Suzanne was inconsolable at the death of her champion and mad with worry about her husband.

Peace was declared and André returned home. Maurice was in and out of asylums but his work was selling better than his mother's, despite (or perhaps because of) the fact that it was far less radical: romantic street scenes of Montmartre.

In 1920, Suzanne was elected a member of the Salon d'Automne. She sold some works at auction, but her prices were lower than her son's. In 1921 she had a solo show at John Levy's gallery. The critics were enthusiastic: 'The painting of these noble nudes is so clean, so clear, so natural, the colours so bold, the line always expressive . . . Suzanne Valadon is a very great artist, on a level at least with Berthe Morisot.' 'This extraordinary woman breathes life into everything she paints.' 'The pitiless line, precise and firm, may emphasise the defects, the wrinkled belly, the sagging breasts - a good drawing is not always pretty - but the flesh is always alive and beautiful just because one senses the breath that animates it . . .'

In 1922 the influential critic Robert Rey wrote the first monograph dedicated to Suzanne's work. In 1923 she painted one of her best-known works: *The Blue Room*. A model in green-and-white striped pyjamas and a pink chemise lounges on her bed smoking a cigarette amid a riot of patterned colour: the blue bedspread, the autumnal backdrop. She gazes into the distance, wrapped up in her thoughts; she's possibly resting between poses. But to her side are two books: one red and one yellow. Suzanne the former model makes clear that the subject of the painting is not simply a compositional device: she's a person with an inner life, too. It was the first of her paintings to be bought for a national collection. Suzanne's star was in the ascendant. The art dealer Bernheim-Jaune offered to pay her and Maurice a million francs in return for an agreed amount of work: they accepted. Their work was also now selling across Europe.

In 1923 – in part to get Maurice out of Montmartre, where he was prey to too many temptations – they bought a château in St Bernard, north of Lyon. It was tumbledown, romantic, with no running water or electricity. But it didn't matter, as they were rich; the castle was filled with flowers, they had a housekeeper, a chauffeur in white livery and their cats ate caviar on Fridays. Crowds of friends would visit on the weekends and Suzanne's extravagance and generosity became legendary: she tipped a train driver, sent fifty street children to the circus and the butcher's wife to the Riviera.

Yet, despite her success and the longevity of her career, in many ways she was still excluded. 'Fifty Years of French Painting' was staged at the Louvre, curated by the critic Louis Vauxcelles, who believed that if women must paint, then their work should express 'refinement and sensibility'. He didn't include Suzanne's work, which he considered coarse and unfeminine, either in his show or in his book on the history of French painting since the Revolution that was published the following year.

Despite their financial success, life at home became increasingly tough. Maurice was given to wild, drunken rages and André, who managed their affairs, was jealous of his talented wife and stepson: his own paintings paled next to theirs. He also couldn't bear the stress that Maurice's instability placed on his relationship with Suzanne. The three of them were volatile and their fights were notorious; they became known as 'the Unholy Trinity'. André was often violent; he smashed up paintings, furniture, his stepson, his wife. Maurice, too, was known to destroy his mother's work. As the years went by, André had numerous relationships with other women and stayed with Suzanne less and less.

In 1925, at the age of almost sixty, Suzanne painted an unflinching self-portrait: bare-breasted, raw, scowling. In 1927 she painted herself again, looking in a mirror which is flanked by a still life of fruit. The paint is swift, bright: her ageing face, which she renders in hard, clear lines, is resolute.

In 1929, Suzanne had two major exhibitions in Paris, at Galerie Bernier: a retrospective of drawings and engravings and then, later in the year, a show of her paintings. The critic for *Beaux-Arts* magazine was savage. He pronounced that her work was out of step with the art of the time and, while admitting that her talent was 'indisputable', wrote that the most disturbing thing was that she painted 'hideous shrews in tones of great vulgarity' because 'she wants to'. He then went on to describe her female nudes as caricatures and insisted that she always chose to add an 'unpleasant' detail. Baffled, he asked: 'Does it spring from her poverty or her spite?'

Undeterred, at the age of sixty-six, in 1931 Suzanne painted another remarkably frank self-portrait. Against a rough lemon background, a vague glimpse of either a landscape or a painting over her right shoulder, she outlines her body in heavy, fluid lines. As with Paula Modersohn-Becker's self-portrait, her only decoration is a simple necklace. Her bare breasts droop and her lightly

wrinkled face is capped with her smooth dark hair, cropped like a beret. Her thin dark eyebrows hover above her tired blue eyes like the open wings of a blackbird. She looks directly at us: she has nothing to hide.

In 1935, Maurice was married; his controlling new wife, Lucie, kept him away from his mother. Despite the turmoil of life with her son, Suzanne missed him dreadfully and her health deteriorated. In 1937, however, her spirits were boosted by the French state, who bought some of her most important works, including *Adam and Eve*. In 1938 a retrospective of her work was staged in Paris at Galerie Bernier. The reviews were enthusiastic but tempered by glib generalisations. 'Rarely has painting by a woman been less feminine,' declared the reviewer for *La Renaissance*. He continued approvingly: 'Valadon's art is sure, cruelly realistic. However glittering her colours, they never destroy the line. She follows the chromatic formulas of Cézanne without imitating Cézanne in the least.' *Ce Soir*'s critic declared: 'Of all the women painters, Suzanne Valadon is the most justifiably famous of our time and also the most personal.'

In April that year, with her retrospective still open, Suzanne was working in her studio in Montmartre when she had a stroke; she died later that day. She was buried in the Cimetière de Saint-Ouen. Georges Braque, Marc Chagall, André Derain, Pablo Picasso, waiters, models and shopkeepers were among the mourners at her funeral. Lucie didn't allow Maurice, who was mad with grief, to attend. In the newspaper *Paris-Soir* her death garnered less notice than her son's marriage three years earlier. She left behind 478 paintings, 273 drawings and thirty-one etchings.

The painting she was working on when she had her stroke is a study of a naked young woman, standing by a fig tree.

In 1937, the year before Suzanne died, she was visited by the art critic Francis Carco. He found her frail and resigned. 'My work is finished,' she told him, 'and the only satisfaction it gives me is

never to have betrayed or surrendered anything which I believed. You will see that is true one day, perhaps, if anyone ever takes the trouble to do me justice.'

The Painting and the Painter

... oh, I was full of theories
of grand experiments
to live a normal woman's life
to have children - to be the painting and the painter ...

<div align="right">Alice Neel, c. 1930</div>

The history of art is the history of many women not receiving their dues, if ever, until later in life. At times, running a household meant - and often continues to mean - that there is no time for creativity until the children have left home. Some women, however, have managed to paint right through motherhood; struggling to balance their talent with the demands a family brings. These women are super-human.

One of the most insightful portraitists of any age, the American artist Alice Neel, is a case in point: she was seventy before she received the recognition - via a cover of *Time* magazine - she was owed.

Despite completing hundreds of portraits - of family, friends, writers, artists, neighbours and their children, students, homeless people, feminists, salesmen, poets, pregnant women, shrinks and singers - Alice painted her first solo self-portrait at the age of eighty, sitting in the striped blue chair where so many of her subjects had sat before her. Her body might be more frail than it used to be but her spirit is as robust as it ever was. Collapsing conventional borders between what is usually considered private and public, the artist is unabashedly naked, her swollen belly and sagging

breasts reproduced with a realism untempered with vanity. 'Old age,' she said, 'is hard. You lose all your escapes.' Like Suzanne Valadon's self-portrait in her sixties, it's a painting that refutes idealised representations of ageing: in a culture that deifies youth, the artist looks at us through her glasses – as if to reiterate her clear-sightedness – with a steely directness. It's also full of life: the bright green and orange floor, the jaunty blue of the chair and her shadow: it's more exuberant than elegiac, a challenge to anyone who might dismiss or patronise anyone for being old. Although she was left-handed, her right hand brandishes a paintbrush, while her left holds a rag (a nod, perhaps, to the mirror image of the self-portrait). Alice worked on the picture for five years. 'Frightful, isn't it?' she told one interviewer. 'I love it. At least it shows a certain revolt against everything decent.'

Born in 1900 in Pennsylvania, into a middle-class family without much money, Alice was the fourth of five children. After working as a clerk for three years and studying art at night school, she enrolled in the fine-art programme at the Philadelphia School of Design for Women. She felt bad about it: in her later years she said that 'my conscience bothered me that I should be fooling around with art, when really everyone needed money'. In 1925, Alice married the Cuban painter, Carlos Enríquez, who she had met at summer school in 1924: she later described herself as 'the most repressed virgin that ever lived'. In old age she said, laughing, that Carlos realised that 'he married a rabbit who turned out to be a lion'. They moved to Havana, where she tried to balance the expectations of his disapproving bourgeois parents with her ambitions as an artist. Their daughter Santillana was born in 1926 after the family had moved back to New York, where they experienced poverty and tragedy: Santillana died of diphtheria just before her first birthday. Neel soon gave birth to her second child, Isabetta, in New York City. In 1930, without telling Neel, Carlos returned to

Cuba, taking their child with him. Neel was devastated. She had a nervous breakdown and attempted suicide. She took over a year to recover in a hospital and a sanatorium in Philadelphia. Decades later she remembered: 'Being born I looked around the world and its people fascinated and terrified me.' When she could paint again, she made endless pictures of mothers, children, her love, her grief, as starved as a spectre. These images are so raw and so sad they're hard to look at. In 1934 she painted a controversial portrait of her estranged daughter: five-year-old Isabetta stares out at us naked, her eyes clear and bright, her vulva as unflinchingly depicted as the rest of her body. Nakedness, to Alice, was not by any distance the most brutal form of exposure.

In 1932, Alice moved back to New York with her new lover, a drug addict and sailor named Kenneth Doolittle. She had painted a portrait of him the year before. With his white, skeletal face, stern eyes and bulbous hand clutching a walking stick, nothing, no one could be colder or less seductive. With great foresight, he's also vaguely threatening: his red tie interrupts the monotony of his dull brown overcoat like a bloody knife wound. Yet in a watercolour she made in the same year, the mood has changed: she depicts her lover lounging in bright underwear, his erection visible through the yellow cloth, his face a louche study in sexual invitation. In 1934, in a jealous rage, Doolittle burned or slashed a large number of her watercolours, paintings and drawings in the apartment the couple shared in Greenwich Village.

In 1933, Alice, who had been living in great poverty, was one of the first artists to be hired for the Works Progress Administration (WPA). A government initiative headed by President Roosevelt's advisor Harry Hopkins, it was to provide employment to millions of Americans during the Great Depression. Alice was required to make a painting every six weeks: it was life-saving. Her paintings meld the personal with the political: she portrayed meetings investigating the causes of poverty; demonstrations against fascism; a

young man dying of tuberculosis. She was observant and compassionate: she knew all too well what it was to be hurt, marginalised, ignored.

Alice was never coy either in her depictions of naked bodies or of her sexual relationships. In 1935 she painted herself with a new lover, John Rothschild, naked, urinating, alienated. In the late 1930s she moved from Greenwich Village to Spanish Harlem. In 1938 she painted a self-portrait asleep, her hair like a campfire, entwined with her boyfriend, the Puerto Rican musician José Santiago, with whom, in 1939, she had a son: Neel Santiago. (He later changed his name to Richard Neel.) She soon broke up with José and began a relationship with the communist photographer and filmmaker, Sam Brody. In 1941 they had a son, Hartley Neel, but Sam was often absent and, when he was at home, often abusive. Alice juggled painting with motherhood, often to the detriment of her children's wellbeing. When the WPA funding ran out in 1943, for more than ten years she lived on welfare, help from friends and by giving occasional art lessons. She couldn't afford a studio or to pay for models and so she painted neighbours, friends and family in her small apartment, endlessly exploring what she described as her 'over-weening interest in humanity'. Without a shred of sentimentality, her portraits reveal the deepest compassion for those in trouble, pain or penury. Her gaze is unflinching. She looked at faces long and hard and each brushstroke reveals something unique about her sitter: the slant of their mouth, the expression in their eyes, the way they cross their legs or place their arms. For her, the body is the great signifier not only of the mind but of the culture that created it. Describing her painting process in the documentary made by her grandson, Andrew Neel, in 2007, she sounds like a spiritual medium: 'I go so out of myself and into them that after they leave, I sometimes feel horrible. I feel like an untenanted house.'

In 1944, Brody photographed Alice, small and pale, surrounded

by her paintings. She is workmanlike in a checked shirt, neat hair and loafers. She sits cross-legged, looking out at us with a weary, quizzical expression. The crowd of faces of her own making seem to jostle for attention; the walls too small, the ceiling too low to contain everything she has to say, every nuance of feeling she is trying to express.

In post-war New York, portraiture fell out of favour and was superseded by what were assumed to be more radical approaches to making art, such as abstraction. Alice, though, was indifferent to fashion, and her portraits – which celebrate humans in all of their imperfect, stumbling, hopeful glory – are a vital chronicle of a time: a portrait of sorts, not just of individuals but of a city. She worked in isolation for decades. Until her seventies, in the main, she hardly exhibited her work, and when she did, it was in little-known group exhibitions or left-wing galleries.

In 1962, when Alice was sixty-two, the critic Hubert Crehan wrote an enthusiastic article for *ArtNews* entitled: 'Introducing the Portraits of Alice Neel'. She had been painting for forty years. Despite the misstep in his essay's title, he recognised what risk-taking had been involved in painting portraits 'as works of art during a time when this genre is widely suspected of not being art at all'. As Peter C. Marzio, director of the Museum of Fine Arts in Boston, wrote in his introduction to a major Alice Neel exhibition in 2010: 'What was the best way for an American artist to be ignored during the middle of the twentieth century? First, to be female. Second, to paint portraits. Third, to be an independent thinker with a sharp intellect. Alice Neel filled the role like an actor straight out of central casting.'

In 1970, Alice was commissioned to paint Kate Millett, the author of the key feminist text *Sexual Politics*, for the cover of *Time* magazine. It made her famous. From then on, Alice not only painted her friends and neighbours, but other artists, writers, gallerists. She memorably portrayed Andy Warhol with his shirt off and his

eyes closed; it was two years after he was shot, and his scars are as raw as a riverbed. In 1971 a solo show of Alice's paintings was held at her alma mater Moore College of Art and Design, Philadelphia. In 1974 she had her first retrospective at the Whitney Museum in New York. With a display of fifty-eight paintings, not only had she 'made it' at the age of seventy-four but, she said, the exhibition finally convinced her that 'she had the right to paint'. Alice Neel died in 1984.

Andrew Neel's documentary about his grandmother opens with footage of Alice painting: the camera zooms in on her hands. Despite her advanced age, they're restless, active, holding brushes, hovering, applying pigment, busy creating something from nothing: a portrait of a young woman, the paint a magical substance that reveals both the artist's and the sitter's thinking. Then the scene shifts: we're in Bermuda in 1981. A close-up on Alice's face: her grey hair is wiry and wild, as if she's been swimming in the sea. Her round face is soft, her expression behind her large spectacles intense. She looks at her invisible interviewer and says: 'The greatest torture is feeling and then the self, I realised how advanced that was, because the self is greater torture. It's like an albatross around our neck.' Off camera we hear a man's voice: 'Because we cannot get rid of it.' She looks at him and suddenly smiles in agreement. Despite being eighty-one, she looks young and full of hope.

She strides through her cramped apartment. There are paintings everywhere: stacked in the hallway, on the walls, piled in rooms like battlements. Canvas as a buffer from the world, paint as interpreter, as friend and protector. Later in the film, she says that for years she had to apologise for her paintings being 'psychological as it was considered a weakness' even though the 'world we live in is almost purely psychological'. For Alice, it wasn't just the eyes that were a window into the soul: it was the face, the body and the skin, the way a person moves across a room. In her self-portrait

she reveals herself unflinchingly: she is in her body, and her body has served her well. Her nakedness is not undignified. It's honest.

It is so rare in the history of art to hear a woman explain why she did what she did when everything was stacked against her. Alice put it bluntly: 'You inherit the world. Somehow, you find a place for yourself.'

Epilogue

Her story weaves in and out of time, of place. She's travelling on a horse-drawn coach to Paris or Florence. She's holed up in a bunk, seasick on a ship en route to London or Mexico City or Bombay. She's craving city lights, the open sea, a smoky bar or solitude; she's striding to her studio through the streets of Bologna, New York or Naples, the lanes of Worpswede or Meudon, the alleys of Palermo. She's lugging her easel through a muddy field. She's haunting the museums in her paint-stained dress, indifferent to the disapproving glances of fellow visitors as she scrutinises how El Greco or Titian or Van Dyck or Cézanne solved the problems that she too is facing. She's railing against her corsets, her chaperones, her parents, her husband and her brothers; she's hammering on doors, dreaming in her bedroom, working day and night in her studio. She loves men, women, being alone. She's writing in her journal, as journals keep her secrets; she's arguing, she's furious, she's accepting, she's alone, she's pregnant, she's plotting revolution and raising children. She can't afford a model and she's barred from the life studio. So she sits at her easel, picks up a mirror, looks at herself, puts pigment on her palette and picks up a brush. She paints a self-portrait.

Time and again, she's ignored or insulted; her entrance is barred and she's ridiculed or rebuffed, but still, despite everything that is thrown at her, she gets up and moves forward, into the future. Occasionally you can glimpse her paintings in museums, but it's still too rare an occurrence. She's as brave as the bravest explorers.

Even in death, she's vocal. Unless you actively choose not to see her, she's impossible to ignore. There are so many of her. I've hardly touched upon it. She's here.

Notes

Prologue

1 'a matter of looking for them': Christine de Pizan, *The Book of the City of Ladies*, trans. Rosalind Grant-Brown (Harmondsworth: Penguin, 1999), p. 77.

3 'There is no end to the deceits of the past': Vernon Lee, 'In Praise of Old Houses', in *Limbo and Other Essays: To Which is Now Added Ariadne in Mantua* (London: The Bodley Head, 1908), p. 41.

5 'by the light of the lamp': Pliny the Elder, *Natural History*, AD 77, https://tinyurl.com/y5kq6c9r

5 'with the aid of a mirror': Frances Borzello, *Seeing Ourselves: Women's Self-Portraits* (London: Thames & Hudson, 1998/2016), p. 22.

5 made with a mirror: James Hall, *The Self-Portrait: A Cultural History* (London: Thames & Hudson, 2014), p. 14.

5 early thirteenth century: In the collection of the Walters Museum, Baltimore, USA, https://art.thewalters.org/detail/26205

5 like a trapeze artist: Frances Borzello, *Seeing Ourselves: Women's Self-Portraits*, p. 24.

6 painting her self-portrait: Ibid. p. 20.

6 Iaia of Cyzicus: https://artmirrorsart.wordpress.com/2011/11/22/doing-self-portraiting-marcia-in-the-mirrors

6 the first self-portrait in oils: In the collection of the National Gallery, London.

7 'are very slow to acquire': Sheila ffolliott, '"Più che famose": Some Thoughts on Women Artists in Early Modern Europe', in *Women Artists in Early Modern Italy: Careers, Fame, and Collectors*, ed. Sheila Barker, The Medici Archive Book Project (Turnhout: Harvey Miller Publishers, 2016), p. 16.

7 her mother by writing: Marina Warner, *Monuments and Maidens: The Allegory of the Female Form* (London: Weidenfeld & Nicolson, 1985), p. 202.

7　　'women and their ways': Christine de Pizan, *The Book of the City of Ladies*, p. 6.

7　　'sunk in unhappy thoughts': Ibid. p. 7.

8　　'the actual women they slander': Ibid. p. 9.

8　　'in order to protect it': Ibid. p. 11.

8　　'and worthy of praise': Ibid. p. 11.

8　　'brilliance has not been forgotten': Ibid. p. 76.

8　　'outstripped all men': Ibid. p. 76.

8　　'in the world can be found': Ibid. p. 77.

8　　'looking for them': Ibid. p. 77.

9　　onto a cherry stone: Properzia de' Rossi, Carved Cherry Stone Pendant, first half of the sixteenth century, in Carole Collier Frick, Stefania Biancani and Elizabeth Nicholson, *Italian Women Artists from Renaissance to Baroque* (Milan: Skira, 2007), p. 94.

9　　'endless number of examples': Giorgio Vasari, *Lives of the Most Eminent Painters, Sculptors, and Architects*, trans. Gaston du C. de Vere (London: Philip Lee Warner, 1912-14), vol. V, pp. 123-5, https://tinyurl.com/y5etjajp

9　　'won the highest fame': Ibid.

9　　'were envious of her': Ibid.

9　　'living and natural objects': Frances Borzello, *Seeing Ourselves: Women's Self-Portraits*, p. 28.

10　　twenty-three women artists: Germaine Greer, *The Obstacle Race* (London: Martin Secker and Warburg Ltd, 1979. This edition, London: Picador, 1981), p. 4.

10　　was published: Mrs Ellet, *Women Artists in All Ages and Countries* (New York: Harper Brothers, 1859), p. 2.

10　　tender natures: The book's opening line is a melancholy admission: 'I do not know that any work on Female Artists,' writes Elizabeth, 'either grouping them or giving a general history of their productions - has ever been published, except the little volume issued in Berlin by Ernst Guhl, entitled *Die Frauen in die Kunstgeschichte* (The Women in Art History).' *Women Artists in All Ages and Countries* was followed in 1876 by the author and artist Ellen C. Clayton's two-volume *English Female Artists*, which also opens with a sobering sentence: 'Artists, especially English artists, and above all English Female Artists, as a rule lead quiet uneventful lives, far more so than authors.' Going by the lives of the women I've included in this book, she couldn't have been wider of the mark. In 1904 perhaps the most

ambitious attempt to cast light on the achievements of women art-
ists was published: Clara Erskine Clement's encyclopaedic *Women
in the Fine Arts: From the 7th Century B.C. to the 20th Century A.D.*,
which includes over 1,000 biographical entries. In 1905 the British
art critic Walter Shaw Sparrow edited *Women Painters of the World,
from the Time of Caterina Vigri, 1413-1463, to Rosa Bonheur and the
Present Day*: it attempts to cover four centuries of women's art in
twelve countries across Britain, Europe and the US. While again well
intentioned, the book reiterates the fallacy that women have exclu-
sive qualities – delicacy, sensitivity, intuition – that cannot compete
with men's robust engagement with the world. Between 1907 and
1950 an astonishing thirty-seven volumes of the cumbersomely
titled *Allgemeines Lexikon der bildenden Künstler von der Antike bis zur
Gegenwart* (General Dictionary of Artists of the Twentieth Century)
was published in German and then translated into numerous other
languages: as its editors were Ulrich Thieme and Felix Becker, it is
known as the Thieme-Becker lexicon. It was to become the most
widely cited reference book of its kind, even in English-speaking
countries. Yet, as the art historian Edith Krull discovered when she
was researching her 1986 book *Women in Art* (Edition Leipzig), 'a
sizable number of women artists [are] not listed in the lexicon'. Of
the staggering 148,180 biographies written by 400 specialists, only
6,000 focus on women artists – less than 5 per cent.

10 they ever had before: Rozsika Parker and Griselda Pollock, *Old Mis-
tresses: Women, Art and Ideology* (London: Pandora, 1981), pp. 3-6:
'Curiously, the works on women artists dwindle away precisely at
the moment when women's social emancipation and increasing
education should, in theory, have prompted a greater awareness
of women's participation in all walks of life. [. . .] A glance at the
index of any standard contemporary art history textbook gives the
fallacious impression that women have always been absent from the
cultural scene.'

11 Cabinet of Curiosities: Michael W. Cole, *Sofonisba's Lesson* (Princeton
and London: Princeton University Press, 2019), p. 166.

11 in the fifteenth century about ninety: Edith Krull, 'The Beginnings of
Female Artistic Creativity', in her *Women in Art*, p. 11.

11 most likely a man: Fredrika Herman Jacobs, *Defining the Renaissance
Virtuosa* (Cambridge and New York: Cambridge University Press,
1997), p. 2.

11 with watertight attributions: Sheila Barker, 'Lucrezia Quistelli (1541–94), a Woman Artist in Vasari's Florence', in *Women Artists in Early Modern Italy: Careers, Fame, and Collectors*, ed. Sheila Barker, p. 47.

12 attributed to her, today: Dominic Smith, 'Daughters of the Guild', *The Paris Review*, 4 April 2016, sourced online, https://www.the parisreview.org/blog/2016/04/04/daughters-of-the-guild

12 Marie-Denise Villers (1774–1821): Laura Auricchio, 'Eighteenth-Century Women Painters in France', in *Heilbrunn Timeline of Art History* (New York: The Metropolitan Museum of Art, 2000-), http://www.metmuseum.org/toah/hd/18wa/hd_18wa.htm (October 2004).

12 'with equal competence': H.W. Janson, *History of Art: The Western Tradition*, Preface and Acknowledgement to the First Edition (London: Pearson Education, 1962), p. 12.

13 'no great women artists?': Maura Reilly interviews Linda Nochlin, 'Linda Nochlin on Feminism Now and Then', *ARTnews* magazine, 26 May 2015.

14 'science, politics, or the arts': Linda Nochlin, 'Why Have There Been No Great Women Artists?', *ARTnews* magazine, January 1971.

15 commissioned to make frescoes: Claudio Strinati, 'On the Origins of Women Painters', in Carole Collier et al., *Italian Women Artists from Renaissance to Baroque*, p. 124.

15 vegetarianism and atheism: For more on this topic, see Linda Nochlin's essay 'Women Artists after the French Revolution', in *Women Artists, The Linda Nochlin Reader*, ed. Maura Reilly (London: Thames & Hudson, 2015), p. 110.

15 See, for example, Dr Kate McMillan, 2019 Freelands Foundation Report on the representation of female artists: https://freelands-foundation.imgix.net/documents/Representation-of-female-artists-2019-Clickable.pdf

16 (Hortense Haudebourt-Lescot): James Hall, *The Self-Portrait: A Cultural History*, p. 57.

18 by a woman holding one: Frances Borzello, *Seeing Ourselves: Women's Self-Portraits*, p. 27.

19 'swelling with fearsome speed': Laurence Madeline, 'Into the Light: Women Artists 1850–1900', in *Women Artists in Paris 1850–1900*, catalogue published on the occasion of the travelling exhibition 'Women Artists of Paris, 1850–1900', pp. 2–3.

Chapter One: Easel

22 gloss and subtlety: Mark Pendergast, *Mirror, Mirror: A History of the Human Love Affair with Reflection* (New York: Basic Books, 2003), p. 3.

24 throughout the world: Ibid. p. 8.

24 expansion of knowledge: Ibid. p. 38.

24 titles that referenced mirrors: Ibid. p. 124.

24 as to be depraved: Ibid. p. 141.

24 the Renaissance, Raphael: Ibid. p. 44.

24 land for a mirror: Sabine Melchior-Bonnet, *The Mirror*, trans. Katharine H. Jewett (New York: Routledge, 1994), p. 1.

25 a domestic setting: James Hall, *The Self-Portrait: A Cultural History* (London: Thames & Hudson, 2015), p. 40.

25 'things placed before it': Mark Pendergast, *Mirror, Mirror: A History of the Human Love Affair with Reflection*, p. 138.

25 'made out of a mirror': Ibid.

25 made from metal: James Hall, *The Self-Portrait: A Cultural History*, p. 32.

26 'Here aged 20': Catharina van Hemessen, *Self-Portrait*, 1548, in the collection of Öffentliche Kunstsammlung, Basel, Switzerland.

26 in the same year: One is in the Hermitage in St Petersburg, Russia; the other the Michaelis Collection in Cape Town, South Africa.

27 'working artist for herself': Frances Borzello, *Seeing Ourselves: Women's Self-Portraits* (New York: Harry N. Abrams, 1998), p. 43.

29 Philip II of Spain: Ibid. p. 57.

29 *Portrait of a Young Lady* (c. 1560): In the collection of the Baltimore Museum of Art.

30 Dürer and Rembrandt: James Hall, *The Self-Portrait: A Cultural History*, p. 98.

31 the precise year is unknown: Michael W. Cole, *Sofonisba's Lesson* (Princeton and London: Princeton University Press, 2019), p. 4.

31 'good impression of herself': Baldassare Castiglione, *The Book of the Courtier*, trans. George Bull (Harmondsworth: Penguin Classics, 1967), p. 216.

31 to accept female pupils: Michael W. Cole, *Sofonisba's Lesson*, p. 11.

31 Anna Maria: More on Sofonisba teaching her sisters, and then other artists, in Michael W. Cole, *Sofonisba's Lesson*, p. 7ff.

31 'by the sister': Vasari, *Lives of the Artists*, 1568, quoted in Carole Collier Frick, Stefania Biancani and Elizabeth Nicholson, *Italian Women Artists from Renaissance to Baroque* (Milan: Skira, 2007), p. 124.

31 *The Chess Game* (1555): In the collection of the National Museum in Poznan, Poland.

32 women at the time: That said, in his *Book of the Courtier*, Baldassare Castiglione did approve of women playing the game.

32 as a primary subject: Michael W. Cole, *Sofonisba's Lesson*, p. 4.

32 a captured queen: The sisters are identified in Michael W. Cole, 'The Chess Game', in *A Tale of Two Painters: Sofonisba Anguissola and Lavinia Fontana*, ed. Leticia Ruiz Gómez (Madrid: Museo Nacional del Prado, 2019), p. 110.

32 'and absolutely alive': Frederika H. Jacobs, 'Woman's Capacity to Create: The Unusual Case of Sofonisba Anguissola', *Renaissance Quarterly*, vol. 47, no. 1, Spring 1994, p. 77. JSTOR, www.jstor.org/stable/2863112.

32 had both died: Michael W. Cole, 'The Chess Game', in *A Tale of Two Painters: Sofonisba Anguissola and Lavinia Fontana*, ed. Leticia Ruiz Gómez, p. 110.

32 in self-portraits: James Hall, *The Self-Portrait: A Cultural History*, p. 99.

33 a more difficult task: José Manuel Matilla, 'Old Woman Studying the Alphabet with a Laughing Girl', in *A Tale of Two Painters: Sofonisba Anguissola and Lavinia Fontana*, ed. Leticia Ruiz Gómez, p. 118.

33 *Asdrubale Bitten by a Crayfish* (1554): In the Capodimonte Museum, Naples.

33 of 1593: Sofonisba Anguissola, *Boy Bitten by a Crayfish*, c. 1554, in Carole Collier Frick et al., *Italian Women Artists from Renaissance to Baroque*, p. 112.

33 'art of painting': Sourced from https://tinyurl.com/y4u57v75, Buonarroti Archives, Florence. From Ilya Sandrea Perlingieri, *Sofonisba Anguissola: The First Great Woman Artist of the Renaissance* (New York: Rizzoli, 1992), p. 67.

33 'make them in painting?': Frederika H. Jacobs, 'Woman's Capacity to Create: The Unusual Case of Sofonisba Anguissola', p. 78.

34 at the easel: Now in the collection of Łańcut Castle in Poland.

35 by her gender: Mary D. Garrard, 'Here's Looking at Me: Sofonisba Anguissola and the Problem of the Woman Artist', *Renaissance Quarterly*, vol. 47, no. 3, 1994, pp. 556–622. JSTOR, www.jstor.org/stable/2863021

35 Marchioness of Mantua (1474–1539): Sheryl E. Reiss, 'Female Patrons Throughout History', *frieze masters*, issue 7, 2018, https://frieze.com/article/female-patrons-throughout-history

36 parchment on cardboard: In the Museum of Fine Arts, Boston.

36 to decipher: Patrizia Costa, 'Sofonisba Anguissola's Self-Portrait in the Boston Museum of Fine Arts', *Arte Lombarda*, no. 125 (1), 1999, p. 56. JSTOR, www.jstor.org/stable/43132413.

36 artist's nobility: Ibid.

36 the Spanish court: Leticia Ruiz Gómez, ed., *A Tale of Two Painters: Sofonisba Anguissola and Lavinia Fontana*.

37 'woman of our time': Giorgio Vasari, 'Life of Madonna Properzia De' Rossi, Sculptor of Bologna', in *Lives*, p. 121.

37 'the work and the artist': James Hall, *The Self-Portrait: A Cultural History*, p. 99.

37 never received payment: Ibid.

37 such a prop: Mary D. Garrard, 'Here's Looking at Me: Sofonisba Anguissola and the Problem of the Woman Artist', pp. 556–622.

37 extension of her body: Interestingly, when *Bernardino Campi Painting Sofonisba Anguissola* was being conserved at its home in the Pinacoteca Nazionale in Siena in 1996, it was revealed that Sofonisba had painted an earlier composition: in it, her left arm reaches up to merge with Campi's, as if the subject of the painting itself is directing the hand of the teacher. For five years, between 1997 and 2002, the painting was exhibited with Sofonisba's three arms, until it was eventually, once again, covered up, as conservators agreed that the later version was what the artist intended.

38 Bernardino Campi himself: Michael W. Cole, *Sofonisba's Lesson*, p. 180.

38 after leaving his workshop: Ibid. p. 67.

38 in fact, by Sofonisba: Ibid. p. 12.

38 'drew a handsome salary': Edith Krull, 'The Beginnings of Female Artistic Creativity', *Women in Art* (Edition Leipzig, 1986), p. 11.

38 for his daughter's work: Ibid. p. 12.

38 marriage to Philip II: *Women Artists in Early Modern Italy: Careers, Fame and Collectors*, ed. Sheila Barker, The Medici Archive Book Project (Turnhout: Harvey Miller Publishers, 2016), p. 33.

38 five self-portraits: Michael W. Cole, *Sofonisba's Lesson*, p. 118.

38 craft of painting: Sheila Barker et al., *Women Artists in Early Modern Italy: Careers, Fame and Collectors*, p. 6.

39 'no longer wants to live': Barbara Tramelli, 'Sofonisba Anguissola, "Pittora de Natura": A Page from Van Dyck's Italian Sketchbook' in S. Barker, ed., *Women Artists in Early Modern Italy* (Turnhout: Brepols Publishers, 2016), p. 35.

39 they married in Pisa: Leticia Ruiz Gómez, ed., *A Tale of Two Painters: Sofonisba Anguissola and Lavinia Fontana*, p. 24.

40 one of Sofonisba's portraits: Frederika H. Jacobs, 'Woman's Capacity to Create: The Unusual Case of Sofonisba Anguissola', p. 76.

40 'without any trembling': Barbara Tramelli, 'Sofonisba Anguissola, "Pittora de Natura": A Page from Van Dyck's Italian Sketchbook', p. 39.

41 'well-known painters': Ibid. p. 42.

43 'Jasons Golden ffleece': Tabitha Barber, *Mary Beale: Portrait of a Seventeenth-Century Painter, her Family and her Studio* (Geffrye Museum Trust, 1990), p. 10

43 'should be so good': Albrecht Dürer, *Memoirs of Journeys to Venice and the Low Countries*, trans. Rudolf Tombo (The Floating Press, 2010), p. 96, sourced online, https://tinyurl.com/ybr6u33g

43 paintings have survived: Her *Portrait of an Unknown Lady* from c. 1650 is the earliest work by a woman in Tate's collection. When it went to auction in 2014, it was attributed to an unknown male artist, but Bendor Grosvenor, the presenter of BBC's television show *Fake or Fortune*, attributed it to Carlile and bought it - the Tate acquired it from him.

44 'and to Mrs. Weimes': Helen Draper, '"Her Painting of Apricots": The Invisibility of Mary Beale (1633-1699)', *Forum for Modern Language Studies*, vol. 48, issue 4, October 2012, pp. 389-405, https://doi.org/10.1093/fmls/cqs023

44 published in English: Ibid. p. 390, https://tinyurl.com/y4vgcrbk

45 'nothing so soft'; Ibid. p. 390.

45 'equal dignity and honour': Ibid. p. 399.

45 'owne imperfections': Ibid. p. 399.

45 busy working life: Although only two survive, mentions of the contents are made by the eighteenth-century engraver and writer George Vertue.

46 paint-selling business: Mary Bustin, 'Experimental Secrets and Extraordinary Colours', in Tabitha Barber, *Mary Beale: Portrait of a Seventeenth-Century Painter, her Family and her Studio* (Geffrye Museum Trust, 1990), p. 43.

46 underpainting her canvases: *Mirror Mirror: Self Portraits by Women Artists* (London: National Portrait Gallery, 2002), p. 26.

46 'really the same': Helen Draper, '"Her Painting of Apricots": The Invisibility of Mary Beale (1633-1699)', pp. 389-405.

46 *Self-Portrait Holding an Artist's Palette*: In the collection of Moyse's Hall Museum, Bury St Edmunds.

48 'Everything!': Dormer Creston, *Fountains of Youth: The Life of Marie Bashkirtseff* (London: E.P. Dutton, 1937), p. 11.

48 'the civilised globe': Rozsika Parker and Griselda Pollock, Introduction to *The Journal of Marie Bashkirtseff*, trans. Mathilde Blind (London: Virago, 1985), p. vii.

49 'lady companion and family?': Marie Bashkirtseff, Paris 1879, *The Journal of Marie Bashkirtseff*, Introduction by Rozsika Parker and Griselda Pollock, trans. Mathilde Blind, p. 347.

49 'taught myself everything': Marie Bashkirtseff, 31 May 1884, *The Journal of Marie Bashkirtseff*, Introduction by Rozsika Parker and Griselda Pollock, trans. Mathilde Blind, p. 671.

49 'Oh misery!': Marie Bashkirtseff, 25 June 1884, *The Journal of Marie Bashkirtseff*, Introduction by Rozsika Parker and Griselda Pollock, trans. Mathilde Blind, p. 676.

49 'masters of painting': Marie Bashkirtseff, 5 January 1884, *The Journal of Marie Bashkirtseff*, Introduction by Rozsika Parker and Griselda Pollock, trans. Mathilde Blind, p. 647.

50 *Self-Portrait with Palette* (1880): In the collection of the Musée des Beaux-Arts, Nice.

50 'an early death': Marie Bashkirtseff, *The Journal of a Young Artist 1860–1884*, trans. Mary J. Serrano (New York: Cassell Publishing Company, 1890), p. 220.

51 *In the Studio*: In the collection of the Dnepropetrovsk State Art Museum, Ukraine.

51 'never been painted . . .': Marie Bashkirtseff, Paris 1880, *The Journal of Marie Bashkirtseff*, Introduction by Rozsika Parker and Griselda Pollock, trans. Mathilde Blind, p. 444.

51 had consumption: Marie Bashkirtseff, 28 December 1882, *The Journal of Marie Bashkirtseff*, Introduction by Rozsika Parker and Griselda Pollock, trans. Mathilde Blind, p. 574.

51 'content at thirty': Marie Bashkirtseff, 28 December 1882, *The Journal of Marie Bashkirtseff*, Introduction by Rozsika Parker and Griselda Pollock, trans. Mathilde Blind, p. 575.

52 *A Meeting*: In the collection of the Musée d'Orsay.

52 aided by a man: Marie Bashkirtseff, 17 May 1884, *The Journal of Marie Bashkirtseff*, Introduction by Rozsika Parker and Griselda Pollock, trans. Mathilde Blind, pp. 664–5.

52 'it is better to die': Marie Bashkirtseff, 21 August 1883, *The Journal of Marie Bashkirtseff*, Introduction by Rozsika Parker and Griselda Pollock, trans. Mathilde Blind, pp. 626-7.

52 World War II: In 1908 her mother donated many of her daughter's works to what is now the National Museum in the Hermitage in St Petersburg.

53 'to be published': 1 May 1884.

53 women artists: Rozsika Parker and Griselda Pollock, Introduction to *The Journal of Marie Bashkirtseff*, p. xiii.

54 'a book without parallel': Marie Bashkirtseff, *The Journal of a Young Artist 1860-1884*, trans. Mary J. Serrano, her preface, n.p.

Chapter Two: Smile

56 and often stank: Colin Jones, *The Smile Revolution in 18th-Century Paris* (Oxford: Oxford University Press, 2014), p. 137.

56 a self-portrait: Uffizi Gallery, Florence.

56 the joy it gave her: Michael W. Cole, *Sofonisba's Lesson* (Princeton and London: Princeton University Press, 2019), p. 166.

56 on 28 July 1609: Ellen Broersen, 'Judita Leystar: A Painter of Good, Keen Sense', in *Judith Leyster: A Dutch Master and Her World*, published in connection with the exhibition held at the Frans Hals Museum in Haarlem, May-August 1993, p. 15.

57 *Serenade*: Judith Leyster, *Serenade*, 1629, Rijksmuseum, Amsterdam.

57 *Jolly Topper*: Judith Leyster, *Jolly Topper*, 1629, Rijksmuseum, Amsterdam, on long-term long to the Frans Hals Museum.

57 a star that guides: Ellen Broersen, 'Judita Leystar: A Painter of Good, Keen Sense', in *Judith Leyster: A Dutch Master and Her World*, p. 17.

57 take apprentices: Sara van Baalbergen is also occasionally cited as a slightly earlier member, but none of her paintings survive.

57 by ordinary citizens: James A. Welu, Introduction, *Judith Leyster: A Dutch Master and Her World*, pp. 11-12.

57 getting fined: Ellen Broersen, 'Judita Leystar: A Painter of Good, Keen Sense', in *Judith Leyster: A Dutch Master and Her World*, p. 20.

58 signed a work: Sheila ffolliott, '"Più che famose": Some Thoughts on Women Artists in Early Modern Europe', in *Women Artists in Early Modern Italy: Careers, Fame, and Collectors*, ed. Sheila Barker, The Medici Archive Book Project (Harvey Miller Publishers, 2016), p. 20.

58 Hofstede de Groot: James A. Welu and Derk P. Snoep, Preface, Pieter

Biesboer and James A. Welu, eds, *Judith Leyster: A Dutch Master and Her World*, p. 7.

58 Judith Leyster: Ibid.

58 self-portrait of 1633: Judith Leyster, *Self-Portrait*, 1633, National Gallery of Art, Washington.

58 *Merry Company*: Judith Leyster, *Merry Company*, 1630, Louvre, Paris.

60 'have no genius': Laurence Madeleine, 'Into the Light: Women Artists 1850–1900', in *Women Artists in Paris 1850–1900*, catalogue published on the occasion of the travelling exhibition 'Women Artists of Paris, 1850–1900', p. 7.

62 'present troubles for others . . .': *The Memoirs of Madame Vigée Le Brun*, trans. Lionel Strachey (New York: Doubleday, 1903), p. 10.

62 'intervals between labour pains': Angela Rosenthal, 'Infant Academies and the Childhood of Art: Elisabeth Vigée-Lebrun's *Julie with a Mirror*', *Eighteenth-Century Studies*, vol. 37, no. 4, 2004, p. 17. JSTOR, www.jstor.org/stable/25098091

62 *Self-Portrait in a Straw Hat*: In the National Gallery, London.

63 the mess on her dress: *The Memoirs of Madame Vigée Le Brun*, trans. Lionel Strachey, p. 9.

63 and for hair is *poil*: National Gallery, London, https://www.national gallery.org.uk/paintings/elisabeth-louise-vigee-le-brun-self-portrait-in-a-straw-hat

63 'pleasure and admiration': Simon Schama, *Citizens: A Chronicle of the French Revolution* (London: Penguin Books, 1989), pp. 255–6.

64 'Royal Academy of Painting': *The Memoirs of Madame Vigée Le Brun*, trans. Lionel Strachey, p. 17.

64 *'Peace Bringing Back Plenty'*: Ibid.

65 famous paintings of the time: In the collection of the Metropolitan Museum of Art, New York.

65 more informal clothes: Simon Schama, *Citizens: A Chronicle of the French Revolution*, p. 182.

66 demand for cotton increased: Caroline London, 'The Marie Antoinette Dress that Ignited the Slave Trade', in *Racked*, 10 January 2018, https://tinyurl.com/yyydc68x

66 middle classes and the peasants: Susan Nagel, *Marie-Therese: The Fate of Marie Antoinette's Daughter* (London: Bloomsbury, 2009), p. 52.

66 to pleasure herself: Ibid. p. 57.

67 'most odious description': *The Memoirs of Madame Vigée Le Brun*, trans. Lionel Strachey, p. 20.

68 'unanimous in condemning': Colin Jones, *The Smile Revolution in 18th-century Paris* (Oxford: Oxford University Press, 2014), p. 1.

68 'particularly powerful passion': Ibid. p. 129.

69 'were to be committed': *The Memoirs of Madame Vigée Le Brun*, trans. Lionel Strachey, p. 26.

69 'in their profession': Mary D. Sheriff, *The Exceptional Woman: Elisabeth Vigée Le Brun and the Cultural Politics of Art* (Chicago: Chicago University Press, 1996), p. 223.

70 'in white crayon': *The Memoirs of Madame Vigée Le Brun*, trans. Lionel Strachey, p. 28.

71 'Madame Rubens': Mary D. Sheriff, *The Exceptional Woman: Elisabeth Vigée Le Brun and the Cultural Politics of Art*, p. 229.

71 'in Florence and Rome': Roberta Piccinelli, 'Female Painters and Cosimo III de' Medici's Art Collecting Project', in *Women Artists in Early Modern Italy: Careers, Fame and Collectors*, ed. Sheila Barker, p. 152.

72 'all her wrongdoing': *The Memoirs of Madame Vigée Le Brun*, trans. Lionel Strachey, p. 67.

72 unimpressed by Nigris: Angelica Goodden, *The Sweetness of Life: A Biography of Elisabeth Vigée Le Brun* (London: André Deutsch, 1997), p. 192.

73 'was my country!': Ibid. p. 83.

73 King George IV: Joseph Baillio, Katharine Baetjer and Paul Lang, eds, *Vigée Le Brun* (New York: The Metropolitan Museum of Art, catalogue published in conjunction with 'Vigée Le Brun, Woman Artist in Revolutionary France', 2016), p. 214.

73 'what will be written!': Mary D. Sheriff, *The Exceptional Woman: Elisabeth Vigée Le Brun and the Cultural Politics of Art*, p. 7.

73 'in times of solitude': *The Memoirs of Madame Vigée Le Brun*, trans. Lionel Strachey, p. 2.

Chapter Three: Allegory

75 'holding up the tender Plant': Cesare Ripa, *Iconologia: Or, Moral Emblems* (London: Benjamin Motte, 1709), n.p.

76 'seems to speak': Erika Langmuir, *A Closer Look: Allegory* (London: National Gallery, 2010), p. 7.

76 Erato, is female: Frances Borzello, *Seeing Ourselves: Women's Self-Portraits* (London: Thames & Hudson, 1998), p. 63.

77 'integrity of their conduct': Marina Warner, *Monuments and Maidens:*

The Allegory of the Female Form (London: Weidenfeld & Nicolson, 1985), p. 87.

77 Father Time: Erika Langmuir, *A Closer Look: Allegory*, p. 9.

77 patrons or bosses: Ibid. p. 10.

77 writer, musician or artist: Ibid. p. 11.

78 'thwart our hope': Letter to Frances Junius, librarian to Thomas Howard, Earl of Arundel, 1 August 1637, quoted in part by Erika Langmuir, *A Closer Look: Allegory*, p. 18.

78 sentiment such as love: The Bolognese Mannerist painter, Lavinia Fontana (1552-1614), is considered to be the first woman to paint allegories.

79 expanded upon many times: Erika Langmuir, *A Closer Look: Allegory*, p. 13.

79 'render them visible': Unauthored, 'To the Reader', in Cesare Ripa, *Iconologia: Or, Moral Emblems*, n.p.

79 'Lovers of Ingenuity': Cesare Ripa, *Iconologia: Or, Moral Emblems*, frontispiece, n.p.

80 'manage to be good': Marina Warner, *Monuments and Maidens: The Allegory of the Female Form*, p. 65.

80 the lens of allegory: Frances Borzello, *Seeing Ourselves: Women's Self-Portraits*, p. 53.

80 met and admired: Gabriele Finaldi, 'Director's Foreword', in *Artemisia* (London: National Gallery, 2020), p. 7.

81 and her two other brothers: Elizabeth Cropper, 'Artemisia Gentileschi: La Pittora', in *Artemisia*, p. 12.

81 chose the subject herself: Elizabeth Cropper, 'Life on the Edge: Artemisia Gentileschi, Famous Woman Painter', in *Orazio and Artemisia Gentileschi*, catalogue, 'Orazio Gentileschi, Artemisia Gentileschi' (New York: Museum of Art, 2001), p. 276.

81 emanates empathy: Mary D. Garrard, *Artemisia Gentileschi: The Image of the Female Hero in Italian Baroque Art* (Princeton: Princeton University Press, 1989), p. 188.

82 'he would marry me': *Artemisia: The Rape and the Trial*, http://www.webwinds.com/artemisia/trial.htm (possibly taken from Mary Garrard's book on Artemisia).

82 had been damaged: Marina Warner, *Monuments and Maidens: The Allegory of the Female Form*, p. 170.

83 flung them to the floor: Elizabeth Cropper, 'Life on the Edge: Artemisia Gentileschi, Famous Woman Painter', p. 267.

83 four of his 'witnesses': Jonathan Jones, *Artemisia Gentileschi*, from the series Lives of the Artists (London: Laurence King Publishing, 2020), p. 45.

84 Orazio arranged her marriage: Patrizia Cavazzini, 'Orazio and Artemisia: From "such an ugly deed" to "honours and favours" at the English Court', in *Artemisia*, p. 39.

84 exorcising the nightmare: Letizia Treves, 'Artemisia Portraying Herself', in *Artemisia*, p. 67.

84 *Self-Portrait as a Female Martyr*: Letizia Treves, 'Artemisia Portraying Herself', p. 69. The painting is in a private collection in the USA.

85 'catherine wheels': Erika Langmuir, *A Closer Look: Allegory*, p. 7.

86 the King James Bible: Marina Warner, *Monuments and Maidens*: *The Allegory of the Female Form*, p. 160.

86 the subject from 1598–9: Now in Palazzo Barberini, Rome.

87 in the Uffizi: The Uffizi Museum website, https://www.uffizi.it/en/artworks/judith-beheading-holofernes

87 Medici protection: Elizabeth Cropper, 'Artemisia Gentileschi: La Pittora', p. 14.

87 with a young nobleman: Jonathan Jones, *Artemisia Gentileschi*, pp. 59–64.

87 group of letters: Francesco Solinas, 'Bella, pulita, e senza macchia: Artemesia and her letters', in *Artemisia*, p. 46.

87 fled to Rome: Patrizia Cavazzini, 'Orazio and Artemisia: From "such an ugly deed" to "honours and favours" at the English Court', p. 41.

87 new commissions: Patrizia Cavazzini, 'Orazio and Artemisia: From "such an ugly deed" to "honours and favours" at the English Court', p. 42.

87 bought her paintings: Jonathan Jones, *Artemisia Gentileschi*, p. 88.

87 Pozzuoli Cathedral: In the collection of the Capodimonte Museum, Naples.

88 'the expense of things': Jonathan Jones, *Artemisia Gentileschi*, p. 89.

88 'which I keep with me': Elizabeth Cropper, 'Life on the Edge: Artemisia Gentileschi, Famous Woman Painter', p. 269.

88 decoration of the Queen's House: Elizabeth Cropper, 'Artemisia Gentileschi: La Pittora', p. 26.

88 (La Pittura, 1638–9) in London: In the Royal Collection, UK.

89 'has written in front "imitation"': Royal Collection Trust website, https://www.rct.uk/collection/405551/self-portrait-as-the-allegory-of-painting-la-pittura

89 'application of the intellect': Elizabeth Cropper, 'Life on the Edge: Artemisia Gentileschi, Famous Woman Painter', p. 278.

90 'the soul of a woman': Elizabeth Cropper, 'Artemisia Gentileschi: La Pittora', p. 27.

90 version of *Susannah and the Elders*: This is in the Pinacoteca Nationale of Bologna.

90 overdue tax bill in 1654: Jonathan Jones, *Artemisia Gentileschi*, p. 118.

91 she was only twenty: In the Pushkin Museum, Moscow.

92 'the most important works': Germaine Greer, *The Obstacle Race* (London: Picador, 1979), p. 215.

92 on this scale before: Ibid. p. 218.

92 from artistic families: Ibid. p. 14.

92 friends and family: Ibid. p. 218.

92 built in the city: Babette Bohn, 'The Antique Heroines of Elisabetta Sirani', *Renaissance Studies*, vol. 16, no. 1, 2002, p. 58. JSTOR, www.jstor.org/stable/24413226

93 during this time: Babette Bohn, 'Elisabetta Sirani', *Renaissance Studies*, vol. 18, no. 2, June 2004, pp. 239-86.

93 many of her paintings: Babette Bohn, 'The Antique Heroines of Elisabetta Sirani', p. 59.

93 Cesare Ripa's *Iconologia*: Ibid. p. 60.

94 painted thirteen portraits: Ibid. p. 58.

94 Prudence and Charity: Roberta Piccinelli, 'Female Painters and Cosimo III de' Medici's Art Collecting Project', in *Women Artists in Early Modern Italy: Careers, Fame and Collectors*, ed. Sheila Barker, The Medici Archive Book Project (Turnhout: Brepols Publishers, 2016), p. 151.

94 'he had it with him': Germaine Greer, *The Obstacle Race*, p. 217.

94 senators and cardinals: Babette Bohn, 'The Antique Heroines of Elisabetta Sirani', p. 59.

94 whose work he collected: Ibid. p. 60.

95 story of Timoclea: In the Capodimonte Museum, Naples.

95 'character and repute': Babette Bohn, 'The Antique Heroines of Elisabetta Sirani', p. 63.

96 stomach and duodenum: Germaine Greer, *The Obstacle Race*, p. 222.

96 rumoured love rivalry: Ibid.

96 'so strange a manner': Laura M. Ragg, *The Women Artists of Bologna* (London: Methuen & Co, 1907), p. 234.

96 'the sun of Europe': Royal Collection Trust, https://www.rct.uk/collection/906360/a-self-portrait

97 'by her father refused': Germaine Greer, *The Obstacle Race*, p. 222.

98 a woman in old age: In the Gottfried Keller-Stiftung collection, Winterthur, Switzerland.

98 'she paid them in paint': Frances Borzello, *Seeing Ourselves: Women's Self-Portraits*, p. 24.

98 *Self-Portrait as 'Winter'*: In the Old Masters Picture Gallery, Dresden.

99 'the undistinguished Venetian painter': https://www.virtualuffizi.com/rosalba-carriera.html

99 'affairs and acquaintances': Catriona Seth, 'What Do I Know? Who am I?', *Arts et Savoirs*, trans. Colin Keaveney, https://journals.openedition.org/aes/770, p. 4; Frances Borzello, *Mirror Mirror: Self Portraits by Women Artists* (London: National Portrait Gallery, 2002), p. 23.

99 'safe from lovers': Frances Borzello, *Seeing Ourselves: Women's Self-Portraits*, p. 81.

100 *Self-Portrait Holding a Portrait of her Sister*: Uffizi Gallery, Florence.

100 pastel portraitists: Frances Borzello, *Seeing Ourselves: Women's Self-Portraits*, p. 25.

101 Sir William Chambers: *A Brief History of the RA*, https://www.royalacademy.org.uk/page/a-brief-history-of-the-ra

102 'hard-faced woman': Frances A. Gerard, *Angelica Kauffmann: A Biography* (London: Ward & Downey, 1893), p. 119, https://archive.org/details/angelicakauffman00gera/page/119

102 supporter of Angelica: On its website, with wonderful understatement, the Royal Academy admits that: 'We have a chequered history when it comes to equality of the sexes.'

102 Nevroni Cappucino: Frances A. Gerard, *Angelica Kauffmann: A Biography*, p. 6.

103 the Three Graces: In the collection of Kunsthaus Zurich, Switzerland.

103 'thought to be unfeminine': Frances Borzello, *Mirror Mirror: Self Portraits by Women Artists*, p. 27.

103 'poorly furnished house': Ibid. p. 26.

103 'satirical portrait of Reynolds': Ibid. p. 27.

104 'in these assertions': Frances A. Gerard, *Angelica Kauffmann: A Biography*, p. 101.

104 'to disgrace her': Ibid.

104 slur Reynolds's name: Ibid. p. 104.

105 'girls dressed up as men': Ibid. p. 74.

105 'the chief offenders': Ibid. p. 73.

106 *Arts of Music and Painting*: In the National Trust Collection, Nostell Priory.

106 Pleasure and Virtue: Whitney Chadwick, (see notes 61, 70: different author) *Mirror Mirror: Self Portraits by Women Artists*, p. 11.

106 'a young woman to follow': Angelica Goodden, *Miss Angel: The Art and World of Angelica Kauffman* (London: Random House, 2011), Kindle Edition, location 5495.

107 open its doors to women: Amy Bluett, 'Striving after Excellence: Victorian Women and the Fight for Arts Training'.

108 accepted into the school: Germaine Greer, *The Obstacle Race*, p. 319.

108 'striving after excellence': Amy Bluett, 'Striving after Excellence: Victorian Women and the Fight for Arts Training'.

109 'the granting of our request': Ibid.

Chapter Four: Hallucination

113 'the principal problems of life': André Breton, *Manifeste du Surréalisme* (Manifesto of Surrealism) in 1924, accessed online, https://tinyurl.com/r6epgjb

113 from at least 1924: Whitney Chadwick, *Women Artists and the Surrealist Movement* (London: Thames & Hudson, 1985), p. 8.

113 'troubling in the world': Ibid. p. 36.

113 'I have ever bowed': Marina Warner, Introduction to Leonora Carrington, *The House of Fear: Notes from Down Below* (New York: E.P. Dutton, 1988), p. 7.

114 'learning to be an artist': Ibid. p. 66.

114 'the 1936 Exhibition': Eileen Agar interviewed by Cathy Courtney, 1990, *Artists' Lives*, reference C466/01 © The British Library Board.

114 'to a Surrealist rite': Whitney Chadwick, *Women Artists and the Surrealist Movement*, p. 14.

114 'think of it nowadays!': Eileen Agar interviewed by Cathy Courtney, 1990, *Artists' Lives*, reference C466/01 © The British Library Board.

115 'Existence is elsewhere': André Breton, *Manifeste du Surréalisme* (Manifesto of Surrealism) in 1924.

115 'in whatever you do': Eileen Agar interviewed by Cathy Courtney, 1990, *Artists' Lives*, reference C466/01 © The British Library Board.

116 until about 1936: Whitney Chadwick, *Women Artists and the Surrealist Movement*, p. 9.

116 'a friend of Dalí's': Ibid. p. 8.

116 'living from suicide': André Breton, Introduction to *The Anthology of Black Humor*, trans. from the French by Mark Polizzotti (San Francisco: City Light Books, 1997), p. xiv, accessed online, https://tinyurl.com/rtg8xbr

117 'not even the void': Ibid.

117 the girl's 'only friend': Leonora Carrington, 'The Debutante', in *The House of Fear: Notes from Down Below*, pp. 44-5.

118 '"and you'll find the street!"': Heidi Sopinka, 'An Interview with Leonora Carrington', *The Believer*, 1 November 2012, accessed online, https://believermag.com/an-interview-with-leonora-carrington-3

118 suggestion of Marcel Duchamp: Peggy Guggenheim, *Out of this Century: Confessions of an Art Addict* (London: André Deutsch, 1979), p. 279.

118 'may be viewed with alarm': Whitney Chadwick, *Women Artists and the Surrealist Movement*, p. 64.

119 was lost or destroyed: Ibid. p. 9.

119 'than that of individuals': Ibid. p. 9.

119 'mere gossip': Ibid. p. 7.

120 and a croquet lawn: Anwen Crawford, 'Leonora Carrington Rewrote the Surrealist Narrative for Women', *The New Yorker*, 22 May 2017, accessed online, https://www.newyorker.com/books/pageturner/leonora-carrington-rewrote-the-surrealist-narrative-for-women?reload=true

120 'playthings of our memories': André Breton, *Manifestos of Surrealism*, trans. Richard Seaver and Helen R. Lane (Ann Arbor: University of Michigan, 1972), p. 15, accessed online, https://tinyurl.com/ygdvd4ez

120 'devastation among the natives': Matilda Bathurst, 'Mythmaking and Leonora Carrington, An Exquisite Corpse', *The Believer*, 7 July 2017, accessed online, https://believermag.com/logger/mythmaking-an-exquisite-corpse

120 and attempting to levitate: Heidi Sopinka, Introduction to 'An Interview with Leonora Carrington'.

120 '"either work or play"': Heidi Sopinka, 'An Interview with Leonora Carrington'.

121 after her first communion: Marina Warner, Introduction to Leonora Carrington, *The House of Fear: Notes from Down Below*, p. 1.

121 'an inner bestiary': Ibid.

121 might be possible: Ibid. p. 5.

121 breed fox terriers: Matilda Bathurst, 'Mythmaking and Leonora Carrington, An Exquisite Corpse'.

121 'the same sort of crime': Marina Warner, Introduction to Leonora Carrington, *The House of Fear: Notes from Down Below*, p. 5.

121 a fancy hotel: Whitney Chadwick, *Women Artists and the Surrealist Movement*, p. 67.

121 'girls of my age': Leonora Carrington, 'The Debutante', in *The House of Fear: Notes from Down Below*, p. 44.

121 books on alchemy: Whitney Chadwick, 'Leonora Carrington: Evolution of a Feminist Consciousness', *Woman's Art Journal*, vol. 7, no. 1, 1986, pp. 37-42. JSTOR, www.jstor.org/stable/1358235

122 '*This* I understand': Heidi Sopinka, 'An Interview with Leonora Carrington'.

122 'a burning inside': Marina Warner, Introduction to Leonora Carrington, *The House of Fear: Notes from Down Below*, p. 5.

122 apartment building in England: Joanna Moorhead, *The Surreal Life of Leonora Carrington* (London: Virago, 2017), p. 37.

122 Meret Oppenheim: Ibid. p. 38.

122 'brain of our times': Marina Warner, Introduction to Leonora Carrington, *The House of Fear: Notes from Down Below*, p. 6.

122 'resembling a bird's': Peggy Guggenheim, *Out of this Century: Confessions of an Art Addict*, p. 216.

122 in a Parisian café: Marina Warner, Introduction to Leonora Carrington, *The House of Fear: Notes from Down Below*, p. 8.

123 'truthful and pure': Max Ernst, 'Preface or Loplop Presents the Bride of the Wind', in Leonora Carrington, *The House of Fear: Notes from Down Below*, p. 25.

123 while he slept: Marina Warner, Introduction to Leonora Carrington, *The House of Fear: Notes from Down Below*, p. 15.

124 'When I met the Surrealists': Heidi Sopinka, 'An Interview with Leonora Carrington'.

124 'Degenerate Art': Marina Warner, Introduction to Leonora Carrington, *The House of Fear: Notes from Down Below*, p. 15.

124 in February 1944: For more information about Down Below's complicated history, see Marina Warner, Introduction to Leonora Carrington, *The House of Fear: Notes from Down Below*, p. 17.

124 'that lacerated countryside': Leonora Carrington, 'Down Below', in
 The House of Fear: Notes from Down Below, p. 170.

124 'digestive organ to health': Ibid.

125 happened to her: TateShots, *Leonora Carrington: Britain's Lost Surreal-
 ist*, https://www.youtube.com/watch?v=lqXePrSE1R0

125 to rescue their daughter: Leonora Carrington, 'Down Below', in *The
 House of Fear: Notes from Down Below*, p. 201.

125 of the Popol Vuh: William Grimes, Leonora Carrington obituary,
 New York Times, 26 May 2011, accessed online, https://tinyurl.com/
 uxj5y2t

125 women's liberation movement: Whitney Chadwick, 'Leonora Car-
 rington: Evolution of a Feminist Consciousness', pp. 37-42.

125 'earliest form of social order': Chloe Aridjis, 'Leonora Carrington and
 the Secret of the Sacred Feminine', *frieze* online, 18 June 2019, https://
 frieze.com/article/leonora-carrington-and-secret-sacred-feminine

126 'in terms of explanation': TateShots, Interview with Leonora Car-
 rington, *Leonora Carrington: Britain's Lost Surrealist*.

126 'emerging from the murk': Chloe Aridjis, 'Tea and Creatures with
 Leonora Carrington', *frieze masters*, issue 6, 2017, accessed online,
 https://frieze.com/article/tea-and-creatures-leonora-carrington

126 most famous works: In the collection of The Metropolitan Museum
 of Art, New York.

127 *I myself was the white colt*: Leonora Carrington, 'Down Below', in *The
 House of Fear: Notes from Down Below*, p. 194.

127 'turn myself into a horse': Marina Warner, Introduction to Leonora
 Carrington, *The House of Fear: Notes from Down Below*, p. 2.

128 'around in the snow': All quotes from Leonora Carrington, 'The
 Oval Lady', in *The House of Fear: Notes from Down Below*, pp. 37-43.

128 'That's why we have art': Heidi Sopinka, 'An Interview with Leonora
 Carrington'.

129 'the great concealer': James Hall, *The Self-Portrait: A Cultural History*
 (London: Thames & Hudson, 2014), p. 249.

129 one of her feet was crushed: *The Diary of Frida Kahlo: An intimate
 Self-Portrait*, Essay and commentaries by Sarah M. Lowe (New York:
 Harry N. Abrams, 1995), p. 12.

129 'me, the universe': Ibid. p. 235.

130 'the subject I know best': Ibid. p. 14.

130 'a ribbon around a bomb': https://www.moma.org/collection/
 works/79374

130 'and told me I was': Anthony White, 'My Mother, Myself and the Universe', in exhibition catalogue, *Frida Kahlo, Diego Rivera and Mexican Modernism* (National Gallery of Australia, 2001), p. 25.

130 'I painted my own reality': *The Diary of Frida Kahlo: An Intimate Self-Portrait*, Essay and commentaries by Sarah M. Lowe, p. 287.

130 *Henry Ford Hospital*: In the collection of the Museo Dolores Olmedo.

131 birth or miscarriage before: Sarah M. Lowe is fascinating on this, in her essay in *The Diary of Frida Kahlo: An Intimate Self-Portrait*, p. 25.

132 Mexican love songs: Carlos Fuentes, *The Diary of Frida Kahlo: An Intimate Self-Portrait*, Essay and commentaries by Sarah M. Lowe, p. 22.

132 the Three Stooges: *The Diary of Frida Kahlo: An Intimate Self-Portrait*, Essay and commentaries by Sarah M. Lowe, p. 15.

132 'four-letter words': Carlos Fuentes, *The Diary of Frida Kahlo: An Intimate Self-Portrait*, Essay and commentaries by Sarah M. Lowe, p. 21.

132 *Self-Portrait with the Portrait of Doctor Farill*: In a private collection in Mexico City.

133 'quite often despair': *The Diary of Frida Kahlo: An Intimate Self-Portrait*, Essay and commentaries by Sarah M. Lowe, p. 252.

133 'serve the Party': Ibid. p. 252.

133 'poetry on canvas': Ibid. p. 13.

133 'pulmonary embolism': Ibid. p. 292.

134 'I hope never to return': Ibid. p. 285.

Chapter Five: Solitude

136 'make the greatest discoveries': Helene Schjerfbeck letter to Einar Reuter, 14 April 1920?, quoted in Leena Ahtola-Moorhouse, '"It is basically human life that most fascinates me." The Life and Work', in *Helene Schjerfbeck*, eds. Annabelle Görgen and Hubertus Gaßner, Hamburger Kunsthalle (Munich: Hirmer Verlag, 2007), p. 28.

136 you give her an entire world: Anna-Maria von Bonsdorff, 'Fine Things Alongside Fierce Things', in *Helene Schjerfbeck* (London: Royal Academy of Arts, 2019), p. 11.

136 accepted by the institution: Ibid. p. 12.

137 quoted it decades later: Ibid. p. 14.

137 in which his name appeared: Ibid. p. 15.

138 'something new for me': Ibid. p. 18.

138 used as teaching aids: Jeremy Lewison, 'The Mask and the Mirror', in *Helene Schjerfbeck*, p. 29.

138 Fra Angelico: Anna-Maria von Bonsdorff, 'Fine Things Alongside Fierce Things', in *Helene Schjerfbeck*, p. 16.

138 Futurism or Expressionism: Jeremy Lewison, 'The Mask and the Mirror', in *Helene Schjerfbeck*, p. 29.

138 silence in her classes: *Guide for Friends: Helene Schjerfbeck*.

138 struggled financially: Anna-Maria von Bonsdorff, 'Fine Things Alongside Fierce Things', in *Helene Schjerfbeck*, p. 18.

138 'our income depends': Jeremy Lewison, 'The Mask and the Mirror', in *Helene Schjerfbeck*, p. 30.

138 magazines such as *Chiffons*: Ibid. p. 33.

138 Van Gogh and Gauguin: Anna-Maria von Bonsdorff, 'Fine Things Alongside Fierce Things', in *Helene Schjerfbeck*, p. 19.

139 comparisons to Whistler: Sigurd Frosterus, 'Färgproblemet I måleriet' (The Colour Problem in Painting), Helsinki, 1920, pp. 9–10, quoted in Anna-Maria von Bonsdorff, 'Fine Things Alongside Fierce Things', in *Helene Schjerfbeck*, p. 20.

139 'painting in art': Helene Schjerfbeck letter to Einar Reuter, 3 May 1924, quoted in Anna-Maria von Bonsdorff, 'Fine Things Alongside Fierce Things', in *Helene Schjerfbeck*, p. 20.

139 the Dutch masters: Anna-Maria von Bonsdorff, 'Fine Things Alongside Fierce Things', in *Helene Schjerfbeck*, p. 20.

139 'raw and weak to me': Letter to Maria Wiik, 18 December 1927, quoted by Anna-Maria von Bonsdorff, 'Fine Things Alongside Fierce Things', in *Helene Schjerfbeck*, p. 24.

139 'on the artwork itself?': Helene Schjerfbeck letter to Einar Reuter 24 November 1943, quoted in Anna-Maria von Bonsdorff, 'Fine Things Alongside Fierce Things', in *Helene Schjerfbeck*, p. 21.

139 'a question of fairness': Helene Schjerfbeck letter to Marianna Westermarck, 2 August 1911, quoted in Anna-Maria von Bonsdorff, 'Fine Things Alongside Fierce Things', in *Helene Schjerfbeck*, p. 22.

139 159 works: Anna-Maria von Bonsdorff, 'Fine Things Alongside Fierce Things' in *Helene Schjerfbeck*, p. 23.

139 1,000 letters: Ibid. p. 23.

140 she became ill: Ibid. p. 25.

140 hid from well-wishers: Rebecca Bray, Chronology, *Helene Schjerfbeck*, p. 154.

142 made her very pleased: Ibid. p. 155.

144 he was lauded: Michael Holroyd, *Augustus John* (London: Penguin, 1976), p. 86.

144 'and his ardour': Undated letter from Edna Clarke to the artist Michel Salaman, quoted in Alison Thomas, *Portraits of Women: Gwen John and her Forgotten Contemporaries* (Cambridge: Polity Press, 1994), p. 66.

144 'the waif of Pimlico': Michael Holroyd, *Augustus John*, p. 132.

144 to amuse them: Alison Thomas, *Portraits of Women: Gwen John and her Forgotten Contemporaries*, p. 71.

144 Edwin was a solicitor: Sue Roe, *Gwen John, A Life*, Preface (London: Vintage Digital, 2010). Chapter 1 (accessed on a Kindle, n.p.).

144 gout and exhaustion: Ibid.

144 remote with grief: Alison Thomas, *Portraits of Women: Gwen John and her Forgotten Contemporaries*, p. 36.

144 music for the organ: Sue Roe, *Gwen John, A Life*, Preface. Chapter 1 (accessed on a Kindle, n.p.).

144 a chilly silence: Michael Holroyd, *Augustus John*, p. 28.

144 'Art and Beauty': Augustus John, *Chiaroscuro: Fragments of Autobiography* (London: Jonathan Cape, 1952), p. 17.

144 'Halleluja Chariot': Sue Roe, *Gwen John, A Life*, Preface. Chapter 1 (accessed on a Kindle, n.p.).

145 'everything was dead': Quoted in Virginia Ironside, 'I think if we are to do beautiful pictures, we ought to be free from family conventions and ties', *Tate Etc*, 1 September 2004, accessed online, https://tinyurl.com/sdvbwjg

145 'cheap and hygienic': Augustus John, *Chiaroscuro: Fragments of Autobiography*, p. 49.

145 from the naked model: Alison Thomas, *Portraits of Women: Gwen John and her Forgotten Contemporaries*, p. 2.

145 women students: Ibid. p. 3.

145 the school's corridor: Michael Holroyd, *Augustus John*, p. 58.

145 since the Renaissance: Ibid. p. 86.

146 her extreme reserve: Alison Thomas, *Portraits of Women: Gwen John and her Forgotten Contemporaries*, p. 35.

146 'quiet in her manners': Ibid. p. 64.

146 bloom in the wild: Ibid. p. 35.

146 'slums and underground cellars': Augustus John, *Finishing Touches*, quoted in Sue Roe, *Gwen John, A Life*, Preface. Chapter 2 (accessed on a Kindle, n.p.).

146 a passionate attachment: Michael Holroyd, *Augustus John*, p. 78.

146 and velvet bow: Mary Taubman, *Gwen John* (London: Scolar Press, 1985), p. 15.

146 'called "comfortable friends"': Quoted in Virginia Ironside, 'I think if we are to do beautiful pictures, we ought to be free from family conventions and ties'.

146 her need for solitude: Michael Holroyd, *Augustus John*, p. 78.

147 nocturnes and arrangements: The Metropolitan Museum of Art, New York, https://www.metmuseum.org/toah/hd/whis/hd_whis.htm

147 'paint and brushes': Mary Taubman, *Gwen John*, p. 16.

147 singing and talking: Michael Holroyd, *Augustus John*, p. 111.

147 'octave on a piano': Mary Taubman, *Gwen John*, p. 23.

147 'fine sense of tone': Augustus John, *Chiaroscuro: Fragments of Autobiography*, p. 66.

147 'for an "interior"': Mary Taubman, *Gwen John*, p. 16.

148 'has had its day': Michael Holroyd, *Augustus John*, p. 43.

148 Édouard Manet: Sue Roe, *Gwen John, A Life*, Preface. Chapter 3 (accessed on a Kindle, n.p.).

148 'capable of thinking so': Alison Thomas, *Portraits of Women: Gwen John and her Forgotten Contemporaries*, p. 65.

148 'could ever penetrate': Michael Holroyd, *Augustus John*, p. 191.

148 'an implacable will': Augustus John, *Chiaroscuro: Fragments of Autobiography*, p. 256.

148 'natural gaiety and humour': Michael Holroyd, *Augustus John*, p. 79.

148 a Goya painting: Mary Taubman, *Gwen John*, p. 108.

148 into her hair: Michael Holroyd, *Augustus John*, p. 113.

148 'I think of people': Sue Roe, *Gwen John, A Life*, Preface. Chapter 4 (accessed on a Kindle, n.p.).

148 she fell in love: Ibid.

149 'spent her time in tears': Augustus John, *Chiaroscuro: Fragments of Autobiography*, p. 57.

149 'as she did': Ibid. p. 248.

149 'pursued by Pan': Michael Holroyd, *Augustus John*, p. 166.

149 'are empty of it': Ibid. pp. 190-1.

149 money and cakes: Ibid. p. 192.

149 grapes and beer: Sue Roe, *Gwen John, A Life*, Preface. Chapter 5 (accessed on a Kindle, n.p.).

149 under the stars: Ibid.

149 farmers or gendarmes: Michael Holroyd, *Augustus John*, pp. 192-3.

149 'did in England': Alison Thomas, *Portraits of Women: Gwen John and her Forgotten Contemporaries*, p. 119.

150 'its effects, itself unseen': Sue Roe, *Gwen John, A Life*, Preface. Chapter 5 (accessed on a Kindle, n.p.).

150 NEAC show of 1909: Michael Holroyd, *Augustus John*, p. 194.

150 'known about before)': Mary Taubman, *Gwen John*, p. 30.

150 scores of times: Ibid. p. 18.

150 'burdens of domesticity': Alison Thomas, *Portraits of Women: Gwen John and her Forgotten Contemporaries*, p. 1.

151 moved to Paris: Sue Roe, *Gwen John, A Life*, Preface. Chapter 6 (accessed on a Kindle, n.p.).

151 'family convention and ties': Alison Thomas, *Portraits of Women: Gwen John and her Forgotten Contemporaries*, p. 235.

151 core of her existence: Ibid. p. 118.

151 'little copse of trees': Sue Roe, *Gwen John, A Life*, Preface. Chapter 6 (accessed on a Kindle, n.p.).

151 least bohemian of bohemians: Mary Taubman, *Gwen John*, p. 18.

151 for each painting: Ibid. p. 27.

152 she never dated them: Ibid. p. 31.

152 pose for women: Alison Thomas, *Portraits of Women: Gwen John and her Forgotten Contemporaries*, p. 119.

152 Arthur Symons, and others: Sue Roe, *Gwen John, A Life*, Preface. Chapter 6 (accessed on a Kindle, n.p.).

152 (my little sister): Ibid.

152 a *belle artiste*: Augustus John, *Chiaroscuro: Fragments of Autobiography*, p. 250.

152 who had died in 1903: He never completed the sculpture; the working model is in the collection of the Musée Rodin.

152 an admirable body: Augustus John, *Chiaroscuro: Fragments of Autobiography*, p. 250.

153 'drawings in mind': Sue Roe, *Gwen John, A Life*, Preface. Chapter 7 (accessed on a Kindle, n.p.).

153 often three a day: Alison Thomas, *Portraits of Women: Gwen John and her Forgotten Contemporaries*, p. 121.

153 'I'm not particularly amusing': Sue Roe, *Gwen John, A Life*, Preface. Chapter 6 (accessed on a Kindle, n.p.).

153 'I do love you': Ibid.

153 the book very beautiful: Ibid.

153 'artists living today': Rainer Maria Rilke, *Letters to a Young Poet*, trans. M.D. Herter Norton (New York and London: W.W. Norton & Company, 1993), p. 26.

153 a client of Rodin's: Rachel Corbett, *You Must Change Your Life: The Story of Rainer Maria Rilke and Auguste Rodin* (New York and London: W.W. Norton & Company, 2016), Kindle Edition, p. 152.

153 'like a thieving servant': Ibid.

154 'you are far away': Rainer Maria Rilke, 'Letter Four, Worpswede, near Bremen, July 16th 1903', in *Letters to a Young Poet*, trans. M.D. Herter Norton, p. 39.

154 organisation of his life: Rachel Corbett, *You Must Change Your Life: The Story of Rainer Maria Rilke and Auguste Rodin*, p. 148.

154 the world at large: Sue Roe, *Gwen John, A Life*, Preface. Chapter 7 (accessed on a Kindle, n.p.).

154 made her so unhappy: Ibid.

154 'Because I'm happy': Sue Roe, *Gwen John, A Life*, Preface. Chapter 6 (accessed on a Kindle, n.p.).

154 1905 and 1906: Sue Roe, *Gwen John, A Life*, Preface. Chapter 7 (accessed on a Kindle, n.p.).

154 his death in 1917: Sue Roe, *Gwen John, A Life*, Preface. Chapter 6 (accessed on a Kindle, n.p.).

154 Japanese drawings: Sue Roe, *Gwen John, A Life*, Preface. Chapter 10 (accessed on a Kindle, n.p.).

154 resumed the affair: Alison Thomas, *Portraits of Women: Gwen John and her Forgotten Contemporaries*, p. 122.

155 'except in my room': Mary Taubman, *Gwen John*, p. 18.

155 'sacrifice the Picasso': Alison Thomas, *Portraits of Women: Gwen John and her Forgotten Contemporaries*, p. 153.

155 'indeed I am, somewhat': Gwen John letter to Ursula Tyrwhitt, 4 February 1910, in Mary Taubman, *Gwen John*, p. 29.

155 'simplest rule by myself': Sue Roe, *Gwen John, A Life*, Chapter 11 (accessed on a Kindle, n.p.).

155 bought in 1895: Rachel Corbett, *You Must Change Your Life: The Story of Rainer Maria Rilke and Auguste Rodin*, p. 84.

155 bluebells and anemones: Sue Roe, *Gwen John, A Life*, Chapter 11 (accessed on a Kindle, n.p.).

155 oil painting on a Dürer: Ibid.

155 'the greatest painter of the century': Sue Roe, *Gwen John, A Life*, Chapter 12 (accessed on a Kindle, n.p.).

156 'groping in the dark': Augustus John, *Chiaroscuro: Fragments of Autobiography*, p. 255.

156 clippings from magazines: Mary Taubman, *Gwen John*, p. 20.

156 nuns – in churches: Sue Roe, *Gwen John, A Life*, Preface (accessed on a Kindle, n.p.).

156 'look in shop windows': Sue Roe, *Gwen John, A Life*, Chapter 12 (accessed on a Kindle, n.p.).

156 come back to England: Michael Holroyd, *Augustus John*, p. 517.

156 'each other's solitude': Alison Thomas, *Portraits of Women: Gwen John and her Forgotten Contemporaries*, p. 178.

156 'difficulties and obstacles come': Ibid. p. 179.

156 'and am getting better': Sue Roe, *Gwen John, A Life*, Chapter 14 (accessed on a Kindle, n.p.).

157 she moved in: Ibid.

157 'I like this life very much': Alison Thomas, *Portraits of Women: Gwen John and her Forgotten Contemporaries*, p. 182.

157 'be without fear': Augustus John, *Chiaroscuro: Fragments of Autobiography*, p. 255.

158 'the pink flower': Sue Roe, *Gwen John, A Life*, Chapter 16 (accessed on a Kindle, n.p.).

158 'the finding of the forms': Mary Taubman, *Gwen John*, p. 29.

158 Chicago and Boston: Now in the collection of the Museum of Modern Art, New York.

159 'but she is dreadful': Mary Taubman, *Gwen John*, p. 18.

159 and eighty drawings: Ibid. p. 8.

159 and twenty-four drawings: Sue Roe, *Gwen John, A Life*, Chapter 19 (accessed on a Kindle, n.p.).

159 'the point of art': Mary Taubman, *Gwen John*, p. 30.

159 'more than we dreamt of': Alison Thomas, *Portraits of Women: Gwen John and her Forgotten Contemporaries*, p. 181.

160 'very dark, dark, clothes': https://www.youtube.com/watch?v=Uhcq_4QutW8, *Augustus & Gwen John: The Fire and the Fountain*, BBC film, 1975.

160 'you must continue': Augustus John, *Chiaroscuro: Fragments of Autobiography*, p. 255.

160 and then in Toronto: Sue Roe, *Gwen John, A Life*, Chapter 20 (accessed on a Kindle, n.p.).

160 flowers and stones: Mary Taubman, *Gwen John*, p. 21.

160 'stalks of flowers': Augustus John, *Chiaroscuro: Fragments of Autobiography*, p. 255.

160 seated by a window: Cecily Langdale, *Gwen John*, p. 232, cited in Sue Roe, *Gwen John, A Life*, Chapter 21 (accessed on a Kindle, n.p.).

161 she never returned: Michael Holroyd, *Augustus John*, p. 675.

161 the Canon Piermé: Sue Roe, *Gwen John, A Life*, Chapter 21 (accessed on a Kindle, n.p.).

161 'nearer God, nearer reality': Alison Thomas, *Portraits of Women: Gwen John and her Forgotten Contemporaries*, p. 184.

161 blankets, a stove: Ibid.

161 stomach problems and bronchitis: Sue Roe, *Gwen John, A Life*, Chapter 21 (accessed on a Kindle, n.p.).

161 needed to see the sea: Augustus John, *Chiaroscuro: Fragments of Autobiography*, p. 256.

161 provisions for her cats: Ibid.

161 magnificent self-portrait: In the collection of London's National Portrait Gallery.

162 her most famous painting: In the Tate collection.

162 'Brown has brought already': Mary Taubman, *Gwen John*, p. 108.

162 his death in 1941: He bequeathed it to his niece, who sold it to the Tate Gallery in 1942.

162 'and I am a shadow': Michael Holroyd, *Augustus John*, p. 1.

163 'as I think, of any other': Ibid. p. 676.

163 'the brother of Gwen John': Ibid. p. 80.

163 'about another person': Anne-Louise Willoughby, *Nora Heysen: A Portrait* (Fremantle: Fremantle Press, 2019), p. 73.

164 'I don't push myself': Ibid. p. 17.

164 'comfortable obscurity': Lou Klepac, *Nora Heysen* (Sydney: The Beagle Press, 1989), p. 15.

164 National Portrait Gallery: Anne-Louise Willoughby, *Nora Heysen: A Portrait*, p. 77.

164 father in his studio: Ibid. p. 16.

164 than from anyone else: Jane Hylton, *Nora Heysen: Light and Life* (Kent Town: Wakefield Press, 2009), p. 12.

164 Heather Rusden: Nora Heysen interviewed by Heather Rusden, 1994, TRC 3121. National Library of Australia.

165 a cigarette being smoked: Unless otherwise stated, all quotes from Nora Heysen interviewed by Heather Rusden, 1994, TRC 3121. National Library of Australia.

166 and Ellis Rowan: Jane Hylton, *Nora Heysen: Light and Life*, p. 13.

166 Robert Menzies: Anne-Louise Willoughby, *Nora Heysen: A Portrait*, pp. 32, 52.

166 a large painting palette: Ibid. p. 52.

166 with her portraits: Ibid. p. 62.

166 'marking out its territory': Ibid.

166 'daughter of Hans Heysen': Ibid. p. 63.

167 brown velvet jacket: Lou Klepac, *Nora Heysen,* p. 9.

168 'because I never have since': Anne-Louise Willoughby, *Nora Heysen: A Portrait*, p. 77.

168 She was twenty-two: Ibid. p. 81.

168 'in love with it': Ibid. p. 85.

168 Fantin-Latour was their idol: Catherine Speck, *Selected Letters of Hans Heysen and Nora Heysen* (Canberra: National Library of Australia, 2011), p. 17.

168 'put my foot through all mine': Ibid. p. 23.

168 'Ridiculously high prices': Anne-Louise Willoughby, *Nora Heysen: A Portrait*, p. 86.

168 'views there are about': Ibid. p. 101.

168 'to say for themselves': Jane Hylton, *Nora Heysen: Light and Life*, p. 26.

168 'will be your protection': Anne-Louise Willoughby, *Nora Heysen: A Portrait*, p. 107.

169 winter horribly cold: Lou Klepac, *Nora Heysen,* p. 10.

169 they thought Evie was gay: Anne-Louise Willoughby, *Nora Heysen: A Portrait*, p. 110.

169 'in my surroundings': Ibid. p. 63.

169 'too low in tone': Jane Hylton, *Nora Heysen: Light and Life*, p. 27.

169 'vibration and light': Lou Klepac, *Nora Heysen,* p. 11.

170 'Meninsky drawings': Anne-Louise Willoughby, *Nora Heysen: A Portrait*, p. 136.

170 'and their merits': Ibid. p. 137.

170 'most used book': Lou Klepac, *Nora Heysen,* p. 12.

171 'Devastating': Anne-Louise Willoughby, *Nora Heysen: A Portrait*, p. 138.

171 'heart taken out of me': Lou Klepac, *Nora Heysen,* p. 13.

172 'work it out for myself': Ibid. p. 16.

172 the work of Botticelli: Jane Hylton, *Nora Heysen: Light and Life*, p. 10.

173 swimming in the harbour: Anne-Louise Willoughby, *Nora Heysen: A Portrait*, p. 169.

173 'impossible for a woman': 'Domestic Ties Downfall of Women Art Careerists', *The Sunday Mail*, Brisbane, 22 January 1939, https://trove.nla.gov.au/newspaper/article/98237346#

173 'had the best exhibit': Nora Heysen letter to her parents, 29 January 1939, in Catherine Speck, ed., *Selected Letters of Hans Heysen and Nora Heysen*, p. 29.

173 would return the prize: Lou Klepac, *Nora Heysen*, p. 14.

174 'they will grow tired of it': Nora Heysen letter to her parents, Sunday 1939, in Catherine Speck, ed., *Selected Letters of Hans Heysen and Nora Heysen*, p. 104.

174 'a Good Cook': 'Girl Painter Who Won Art Prize is Also a Good Cook', https://trove.nla.gov.au/newspaper/article/55464841

174 'in comfortable obscurity': Lou Klepac, *Nora Heysen*, p. 14.

174 'always interested in faces': Anne-Louise Willoughby, *Nora Heysen: A Portrait*, p. 52.

175 'twice as many exhibitions': Lou Klepac, *Nora Heysen*, p. 15.

175 'a wish of ten years standing': Ibid. p. 19.

175 her role as a wife: Anne-Louise Willoughby, *Nora Heysen: A Portrait*, p. 304.

176 another brother, David: Catherine Speck, *Selected Letters of Hans Heysen and Nora Heysen*, p. 29.

176 *The Age* newspaper: Nora Heysen, 'I Don't Know if I Exist in My Own Right', *The Age*, 6 October 1962.

177 'the old-fashioned way': Lou Klepac, *Nora Heysen*, p. 15.

177 'I'm quite happy': Ibid. p. 15.

177 'and due long ago!': Anne-Louise Willoughby, *Nora Heysen: A Portrait*, p. 309.

177 grief was immense: Ibid. pp. 304–10.

178 'it's still very nice': Nora Heysen to Catherine Speck, 15 September 1989, in Catherine Speck, ed., *Selected Letters of Hans Heysen and Nora Heysen*, p. 18.

178 'what women did': Nora Heysen interviewed by Michael Cathcart, 'Arts Today', ABC Radio National, 12 January 2001, cited in Anne-Louise Willoughby, *Nora Heysen: A Portrait*, p. 54.

Chapter Six: Translation

181 far outnumbered the men: https://www.ngv.vic.gov.au/exhibition/modern-australian-women

181 'emerged from that period': Margaret Preston, 'Why I Became a Convert to Modern Art', in *Selected Writings, Margaret Preston*, compiled by Elizabeth Butel (Sydney: Ett Imprint, 2015), pp. 25-6.

182 'used on the linoleum': Margaret Preston, 'From Eggs to Electrolux', in *Selected Writings, Margaret Preston*, compiled by Elizabeth Butel, p. 15.

182 'only through tradition': Margaret Preston, 'Why I Became a Convert to Modern Art', *Selected Writings, Margaret Preston*, compiled by Elizabeth Butel, p. 23.

182 'Australia has produced': Margaret Preston, 'From Eggs to Electrolux', in *Selected Writings, Margaret Preston*, compiled by Elizabeth Butel, p. 17.

182 'out of her mind': Margaret Preston, 'From Eggs to Electrolux', in *Selected Writings, Margaret Preston*, compiled by Elizabeth Butel, p. 18.

182 four years younger: Peter Di Sciascio, 'Australian Lesbian Artists of the Early Twentieth Century', in *Out Here, Gay and Lesbian Perspectives VI*, eds Yorick Smaal and Graham Willett (Melbourne: Monash University Publishing, 2011), sourced online, https://tinyurl.com/y7l84ho6

182 for almost a decade: Deborah Edwards, 'Genesis of a Still-Life Painter', in *Margaret Preston* (Sydney: Art Gallery of New South Wales, Thames & Hudson, 2005), p. 22.

182 take place in Australia: Rex Butler and A.D.S. Donaldson, 'French, Floral and Female: A History of UnAustralian Art, 1900–1930', Part 1, *emaj* issue 5, 2010, p. 20, https://emajartjournal.files.wordpress.com/2012/04/butlerdonaldson.pdf

182 'glorious beyond our expectations': Deborah Edwards, Biographical notes, *Margaret Preston*, p. 271.

182 'impresses the ignorant': Margaret Preston, 'From Eggs to Electrolux', in *Selected Writings, Margaret Preston*, compiled by Elizabeth Butel, p. 19.

183 'roused little enthusiasm': Ibid.

183 'Everything is for the men': Deborah Edwards, Biographical notes, *Margaret Preston*, p. 271.

183 'appreciate Australian art': Margaret Preston, 'From Eggs to Electrolux', in *Selected Writings, Margaret Preston*, compiled by Elizabeth Butel, p. 19.

183 'the lively moderns': Margaret Preston, 'Why I Became a Convert to Modern Art', in *Selected Writings, Margaret Preston*, compiled by Elizabeth Butel, p. 24.

183 'has something in it': Ibid.

183 'the pupil of his eye': Margaret Preston, 'From Eggs to Electrolux', in *Selected Writings, Margaret Preston*, compiled by Elizabeth Butel, p. 19.

183 included six of them: Rex Butler and A.D.S. Donaldson, 'French, Floral and Female: A History of UnAustralian Art, 1900–1930', p. 16.

183 in France at the time: Deborah Edwards, Biographical notes, *Margaret Preston*, p. 272.

183 Matisse's use of colour: Deborah Edwards, 'Genesis of a Still-Life Painter', in *Margaret Preston*, p. 27.

183 'more and more muddled': Leon Gellert quoting Margaret Preston in Deborah Edwards, 'Genesis of a Still-Life Painter', in *Margaret Preston*, p. 22.

183 'shrine of Velasquez': Margaret Preston, 'Why I Became a Convert to Modern Art', in *Selected Writings, Margaret Preston*, compiled by Elizabeth Butel, p. 25.

183 her flower paintings: Margaret Preston, 'From Eggs to Electrolux', in *Selected Writings, Margaret Preston*, compiled by Elizabeth Butel, p. 21.

183 (Marguerite Le Roy): Peter Di Sciascio, 'Australian Lesbian Artists of the Early Twentieth Century', sourced online, https://tinyurl.com/y7l84ho6

184 'one vision in art': Ibid. p. 20.

184 J.D. Fergusson: Deborah Edwards, 'The Decorative Vision', in *Margaret Preston*, p. 41.

184 'on colour principles': Deborah Edwards, Biographical notes, in *Margaret Preston*, p. 273.

184 'worth aiming for': Deborah Edwards, 'The Decorative Vision', in *Margaret Preston*, p. 35.

184 'Margaret McPherson': Deborah Edwards, Biographical notes, in *Margaret Preston*, p. 273.

184 'betraying the land of their birth': Quoted in Deborah Edwards, 'Genesis of a Still-Life Painter', in *Margaret Preston*, p. 22.

184 'broken up a twosome': Quoted in Peter Di Sciascio, 'Australian Lesbian Artists of the Early Twentieth Century'.

185 Middle East and Europe: Elizabeth Butel, Introduction to *Selected Writings, Margaret Preston*, p. 9.

185 'flat, not vertical': Margaret Preston, 'From Eggs to Electrolux', in *Selected Writings, Margaret Preston*, compiled by Elizabeth Butel, p. 22.

185 'think things out': Margaret Preston, 'Why I Became a Convert to Modern Art', in *Selected Writings, Margaret Preston*, compiled by Elizabeth Butel, p. 25.

185 'and unaesthetic one': Margaret Preston, 'From Eggs to Electrolux', in *Selected Writings, Margaret Preston*, compiled by Elizabeth Butel, p. 22.

185 'not following her mind': Ibid.

185 'the age it is painted in': Margaret Preston, 'Why I Became a Convert to Modern Art', in *Selected Writings, Margaret Preston*, compiled by Elizabeth Butel, p. 26.

185 'express her surroundings': Margaret Preston, 'From Eggs to Electrolux', in *Selected Writings, Margaret Preston*, compiled by Elizabeth Butel, pp. 19-22.

186 'the natural enemy of the dull': Deborah Edwards, in *Margaret Preston*, p. 9.

186 'into which they had fallen': Art Gallery of New South Wales, Sydney, Australia website, https://www.artgallery.nsw.gov.au/collection/works/7215

186 'disliking apron strings': Margaret Preston, 'Australian Artists Versus Art', *Selected Writings, Margaret Preston*, compiled by Elizabeth Butel, p. 28.

186 'problems can be isolated': Quoted in Deborah Edwards, 'A Modern Order Geometrically Defined', in *Margaret Preston*, p. 118.

187 'or a cushion cover': Margaret Preston, 'Art for Crafts', in *Selected Writings, Margaret Preston*, compiled by Elizabeth Butel, pp. 55-7, is particularly shocking.

187 'national art for Australia': Margaret Preston, 'New Development in Australian Art', in *Selected Writings, Margaret Preston*, compiled by Elizabeth Butel, p. 78.

187 'for this country': Margaret Preston, 'Aboriginal Art', in *Selected Writings, Margaret Preston*, compiled by Elizabeth Butel, p. 83.

187 depth and complexity: In 2005 the Indigenous Australian curator and writer Hetti Perkins wrote of Preston's work: 'To Aboriginal eyes it reads as a scrambled orthography of vaguely familiar words or a discordant symphony where the notes don't ring quite true. Preston's passionate attempts, while well intentioned, were doomed to fail ultimately because they are meaningless to Aboriginal people - not unlike the contemporaneous government policy of assimilation.' Deborah Edwards, *Margaret Preston*, p. 10.

187 'in the world can produce': Art Gallery of New South Wales, http://
www.artgallery.nsw.gov.au/sub/preston/artist_1950.html

188 part of the pantheon: Deborah Edwards, 'A Modern Order, Geomet-
rically Arrived', in *Margaret Preston*, p. 147.

189 'the general impression': Reported in 'Women's News, Women
Painters Exhibition at the Art Gallery', *Sydney Morning Herald*, 5
August 1946, quoted in Deborah Edwards, 'A Modern Order, Geo-
metrically Arrived', in *Margaret Preston*, p. 147.

189 'I am not a flower': Art Gallery of New South Wales, https://www.
artgallery.nsw.gov.au/collection/works/937

189 on board: In the collection of the Smithsonian American Art
Museum in Washington, DC.

190 efforts at drawing: Romare Bearden and Harry Henderson, *A History
of African American Artists from 1792 to the Present* (New York: Pan-
theon Books, 1993), p. 381.

190 eat in the kitchen: *The Black Women Oral History Project, 1976-1981*,
interview with Loïs Mailou Jones conducted by Theresa Danley, re-
corded 30 January and 6 August 1977, Schlesinger Library, Radcliffe
Institute, Harvard University, Cambridge, Massachusetts. Sequence
16, https://iiif.lib.harvard.edu/manifests/view/drs:45172384$3i

190 'make something beautiful': Romare Bearden and Harry Henderson,
A History of African American Artists from 1792 to the Present, p. 381.

191 Loïs's interest in art: Quoted in Donna Seaman, *Identity Unknown:
Rediscovering Seven American Women Artists* (London: Bloomsbury
Publishing, 2017), Kindle Edition, p. 99.

191 'art as a career': Ibid.

191 outdoor exhibitions: Ibid. p. 100.

191 she was talented: *The Black Women Oral History Project, 1976-1981*,
interview with Loïs Mailou Jones conducted by Theresa Danley,
Sequence 22.

191 Dvořák to spirituals: In an interview in 1893, Dvořák said that: 'In
the negro melodies of America I discover all that is needed for a great
and noble school of music.' James Creelman interview with Antonín
Dvořák, *New York Herald*, 21 May 1893.

191 'want to arrive': *The Black Women Oral History Project, 1976-1981*,
interview with Loïs Mailou Jones conducted by Theresa Danley,
Sequence 19.

192 never forgot it: Romare Bearden and Harry Henderson, *A History of
African American Artists from 1792 to the Present*, p. 383.

192 travel to France: *The Black Women Oral History Project, 1976–1981*, interview with Loïs Mailou Jones conducted by Theresa Danley, Sequence 19.

192 'I would go to Paris': Charles H. Rowell, 'An Interview with Lois Mailou Jones', *Callaloo*, no. 39, 1989, pp. 357–78. JSTOR, www.jstor.org/stable/2931576

192 'into her own art': Lisa E. Farrington, *Creating Their Own Image: The History of African-American Women Artists* (Oxford: Oxford University Press, 2005), p. 87, https://tinyurl.com/y3jlhbxa

193 'known by name': Ibid.

193 'help her people': Ibid.

193 'the artist of American life': Alain Locke in 'The Legacy of the Ancestral Arts', *The New Negro*, 1925, quoted in Mary Schmidt Campbell's introduction to *Harlem Renaissance Art of Black America* (The Studio Museum in Harlem, New York: Harry N. Abrams, 1980), p. 11.

194 '"Nordic Transcription"': Romare Bearden and Harry Henderson, *A History of African American Artists from 1792 to the Present*, p. 245.

194 *Ethiopia Awakening*: Charles H. Rowell, 'An Interview with Loïs Mailou Jones', *Callaloo*, p. 358.

194 a cosmic ray: In the collection of the Milwaukee Art Museum.

194 'to be shackle-free': *The Black Women Oral History Project, 1976–1981*, interview with Loïs Mailou Jones conducted by Theresa Danley, Sequence 25.

194 always dreamed of: Ibid. Sequence 26.

194 not her race: Ibid.

195 'that sort of mysticism': Ibid.

195 (The Fetishes): In the collection of the Smithsonian Museum.

195 'the right to use it': *The Black Women Oral History Project, 1976–1981*, interview with Loïs Mailou Jones conducted by Theresa Danley, Sequence 32.

196 'hasn't been easy': Charles H. Rowell, 'An Interview with Lois Mailou Jones', pp. 357–78.

196 '"We can't take you on"': Quoted in Donna Seaman, *Identity Unknown: Rediscovering Seven American Women Artists*, Kindle Edition, p. 94.

196 representation in New York: Romare Bearden and Harry Henderson, *A History of African American Artists from 1792 to the Present*, p. 241.

196 'may need to go': Baltimore Museum of Art, https://artbma.org/exhibitions/black-art-1939

196 'contribute as artists': *The Black Women Oral History Project, 1976-1981*, interview with Loïs Mailou Jones conducted by Theresa Danley, Sequence 32.

197 'do something about it': Charles H. Rowell, 'An Interview with Lois Mailou Jones', pp. 357-78.

197 'Little Paris': Romare Bearden and Harry Henderson, *A History of African American Artists from 1792 to the Present*, p. 385.

198 her faith in herself: Charles H. Rowell, 'An Interview with Lois Mailou Jones', pp. 357-78.

198 in the village: Romare Bearden and Harry Henderson, *A History of African American Artists from 1792 to the Present*, p. 386.

198 'in the very back': *The Black Women Oral History Project, 1976-1981*, interview with Loïs Mailou Jones conducted by Theresa Danley, Sequence 32.

198 and his wife: In 1955, Loïs was awarded the Diplôme Décoration de L'Ordre National, Honneur et Mérite au Grand Chevalier.

199 'now going through': *The Black Women Oral History Project, 1976-1981*, interview with Loïs Mailou Jones conducted by Theresa Danley, Sequence 35.

199 'to help her people': Romare Bearden and Harry Henderson, *A History of African American Artists from 1792 to the Present*, p. 381.

199 'sort of union of Africa': *The Black Women Oral History Project, 1976-1981*, interview with Loïs Mailou Jones conducted by Theresa Danley, Sequence 32.

200 'the best in the world': Ibid. Sequence 54, https://iiif.lib.harvard.edu/manifests/view/drs:45172384$54i

200 'forty-five years late': Lee Fleming, review of 'The World of Lois Mailou Jones' at the Corcoran Gallery, Washington, 7 October 1994, *The Washington Post*, accessed online, https://tinyurl.com/rq2fwy7

201 in her possession: Jill Trevelyan, Introduction to *Rita Angus, An Artist's Life* (Auckland: Te Papa Press, 2008), p. ix.

201 a different colour: Ibid. p. 7.

201 'and never stopped': Jean Jones quoted in ibid. p. 9.

201 'draw seeing every feather': Janet Paul, 'Biographical Essay', in *Rita Angus* (New Zealand: National Art Gallery, 1983), p. 13.

201 and buying of art: Jill Trevelyan, *Rita Angus, An Artist's Life*, p. 1.

202 'Vermeer portraits and Cézanne': Janet Paul, 'Biographical Essay', in *Rita Angus*, p. 14.

202 took to heart: Jill Trevelyan, *Rita Angus, An Artist's Life*, p. 24.

202 a whole group: Kenneth Clark, 'Provincialism', in *Moments of Vision* (London: John Murray, 1981), p. 61, quoted in Janet Paul, 'Biographical Essay', in *Rita Angus*, p. 14.

202 school years by decades: Jill Trevelyan, *Rita Angus, An Artist's Life*, p. 27.

202 'with interesting collars': Ibid. p. 28.

202 'the play of reflected lights': Ibid. p. 31.

202 was never consummated: Ibid. p. 39.

203 approximations intrigued her: Janet Paul, 'Biographical Essay', in *Rita Angus*, p. 16.

203 'the process of becoming': Jill Trevelyan, *Rita Angus, An Artist's Life*, p. 175.

203 in Grecian dancing: Ibid. p. 47.

204 'provide them for [themselves]': https://christchurchartgallery.org. nz/collection/l022017/rita-angus/gasworks

205 'That is what happened': Jill Trevelyan, *Rita Angus, An Artist's Life*, p. 55.

205 handouts from her mother: Janet Paul, 'Biographical Essay', in *Rita Angus*, p. 18.

205 she disliked it intensely: Ibid.

205 It didn't sell: Jill Trevelyan, *Rita Angus, An Artist's Life*, p. 68.

205 *Self-Portrait (in green jacket)*: In the collection of Te Papa, on loan from the Rita Angus Estate.

206 new and liberated woman: Claire Finlayson, *This Thing in the Mirror: Self-Portraits by New Zealand Artists* (Nelson: Craig Potton Publishing, 2004), p. 12.

206 ballet lessons herself: Jill Trevelyan, *Rita Angus, An Artist's Life*, p. 75.

206 dancers in rehearsal: Janet Paul, 'Biographical Essay', in *Rita Angus*, p. 20.

206 'unusual freedoms': Jill Trevelyan, *Rita Angus, An Artist's Life*, p. 83.

207 'mysticism unearthed': Rita Angus letter to Douglas Lilburn, 13 November 1944, cited in Jill Trevelyan, *Rita Angus, An Artist's Life*, p. 1.

207 again, sold nothing: Biographical details from the Museum of New Zealand/Te Papa Tongarewa Rita Angus timeline, https://collections. tepapa.govt.nz/topic/2702

207 end of her life: Jill Trevelyan, *Rita Angus, An Artist's Life*, p. 120.

207 'to serve the arts': https://collections.tepapa.govt.nz/topic/2702

207 'ill and near starvation': Janet Paul, 'Biographical Essay', in *Rita Angus*, p. 23.

207 slept for days: Ibid. pp. 23–4.

207 'live up to my history of women': Jill Trevelyan, *Rita Angus, An Artist's Life*, p. 150.

208 'international brotherhood': Ibid. p. 184.

208 'They may live in Heaven': Ibid. p. 163.

208 the Committee's order: https://collections.tepapa.govt.nz/topic/2702

208 any of her work: Jill Trevelyan, *Rita Angus, An Artist's Life*, p. 170.

208 Edna's house-coat: Ibid. p. 194.

209 'the living over the dead': Ibid. p. 191.

209 from her breakdown: In the collection of the Museum of New Zealand, Te Papa Tongarewa.

210 'and half Polynesian': Claire Finlayson, *This Thing in the Mirror: Self-Portraits by New Zealand Artists*, p. 16.

210 *Sun Goddess*: Jill Trevelyan, *Rita Angus, An Artist's Life*, p. 194.

210 'and infinitely beautiful': Janet Paul, 'Biographical Essay', in *Rita Angus*, p. 25.

212 place of immortality: Katalin Keserü, 'Amrita Sher-Gil: The Indian Painter and her French and Hungarian Connections', in *Amrita Sher-Gil: Art & Life. A Reader* (New Delhi: Oxford University Press, 2014), p. 67.

213 drawing a nude: Yashodhara Dalmia, *Amrita Sher-Gil: A Life* (Harmondsworth: Penguin, 2006, sourced from Kindle, 2016), p. 19.

213 criticising Catholic rituals: Ibid. p. 20.

213 the night sky: Ibid. p. 21.

213 with a dagger: Ibid. p. 20.

213 final years of her life: Mulk Raj Anand, Introduction to *Amrita Sher-Gil* (New Delhi: National Gallery of Modern Art, 1989), p. 2.

213 study art in Paris: Yashodhara Dalmia, *Amrita Sher-Gil: A Life*, p. 25.

213 'think for ourselves': Amrita Sher-Gil, 'Evolution of My Art', in *Amrita Sher-Gil: Art & Life. A Reader*, p. 3.

214 'find out things for myself': Ibid.

214 only twenty-eight: Mulk Raj Anand, Introduction to *Amrita Sher-Gil*, p. 4.

214 174 documented works: Sotheby's film on Amrita Sher-Gil self-portrait, https://www.youtube.com/watch?v=z2icBO5DmuY; ninety-five of Amrita Sher-Gil's works are in the Museum of Modern Art in Delhi.

214 'apart from beauty': Yashodhara Dalmia, *Amrita Sher-Gil: A Life*, p. 47.

215 the act of laughing: Amrita Sher-Gil, *Self-Portrait* [a], 1930, National Gallery of Modern Art, New Delhi.

215 fur coat and a beret: Amrita Sher-Gil, *Self-Portrait* [b], 1930, National Gallery of Modern Art, New Delhi.

215 towards her craft: Amrita Sher-Gil, *Self-Portrait with Easel*, 1930, National Gallery of Modern Art, New Delhi.

215 and fellow student: Katalin Keserü, 'Amrita Sher-Gil: The Indian Painter and Her French and Hungarian Connections', in *Amrita Sher-Gil: Art & Life. A Reader*, p. 74.

215 Marie-Louise Chassany: Amrita Sher-Gil, *Marie-Louise Chassany*, 1932, National Gallery of Modern Art, New Delhi.

216 *Young Girls*: Amrita Sher-Gil, *Young Girls*, 1932, National Gallery of Modern Art, New Delhi.

216 'generalizations or banalities': Katalin Keserü in the catalogue *Amrita Sher-Gil*, Ernst Museum, Budapest, 5 September–3 October 2001, p. 47. Cited in Yashodhara Dalmia, *Amrita Sher-Gil: A Life*, p. 33.

217 as well as men: Yashodhara Dalmia, *Amrita Sher-Gil: A Life*, pp. 33–5.

218 'marry him. Voilà!': Ibid. pp. 39–40.

218 'destiny as a painter': Amrita Sher-Gil, 'Evolution of My Art', in *Amrita Sher-Gil: Art & Life. A Reader*, p. 5.

218 'India belongs to me': Mulk Raj Anand, Introduction to *Amrita Sher-Gil*, p. 2.

218 'the whole Renaissance!': Amrita Sher-Gil in a letter dated September 1934 to her parents, Budapest. Cited in Yashodhara Dalmia, *Amrita Sher-Gil: A Life*, p. 43.

218 'expected to see': Amrita Sher-Gil, 'Evolution of My Art', in *Amrita Sher-Gil: Art & Life. A Reader*, p. 5.

218 dressed only in saris: Amrita Sher-Gil letter to her mother, Hungary, undated, 1933 or 1934, in *Amrita Sher-Gil* (Bombay: Tata Press Limited, undated), pp. 93–4.

218 villages of Punjab: Mulk Raj Anand, Introduction to *Amrita Sher-Gil*.

219 'underdeveloped mind': Amrita Sher-Gil, 'Evolution of My Art', in *Amrita Sher-Gil: Art & Life. A Reader*, p. 5.

219 'and that is right': Amrita Sher-Gil letter to Victor Egan, cited in Yashodhara Dalmia, *Amrita Sher-Gil: A Life*, p. 53.

219 'few can boast of': Amrita Sher-Gil letter to the committee of the Simla Fine Arts Society, 21 September 1935, in *Amrita Sher-Gil*, Tata Press Limited, p. 95.

219 'meaning of my subject': Amrita Sher-Gil, 'Evolution of My Art', in *Amrita Sher-Gil: Art & Life. A Reader*, p. 3.

219 the suffering she witnessed: Mulk Raj Anand, Introduction to *Amrita Sher-Gil*, pp. 18-19, explores the idea of the lamentation in her work.

220 'sad eyes created in me': Yashodhara Dalmia, *Amrita Sher-Gil: A Life*, p. 74.

220 Bombay Art Society: Ibid. pp. 76-7.

220 supposedly lacking innovation: Ibid. p. 170.

220 as poverty porn: See Geeta Kapur, 'The Evolution of Content in Amrita Sher-Gil's Paintings', in *Amrita Sher-Gil*, Tata Press Limited, pp. 39-53.

221 'belong to this country': Professor R.C. Tandon quoted in Sonal Khullar, 'An Art of the Soil: Amrita Sher-Gil (1913-41)', in *Worldly Affiliations, Artistic Practice, National Identity and Modernism in India, 1930-1990* (Berkeley: University of California Press, 2015), p. 52.

221 'as time goes on': Sonal Khullar, 'An Art of the Soil: Amrita Sher-Gil (1913-41)', in *Worldly Affiliations, Artistic Practice, National Identity and Modernism in India, 1930-1990*, p. 51.

221 had met in Simla: Yashodhara Dalmia, *Amrita Sher-Gil: A Life*, p. 109.

221 to reject monogamy: Ibid. p. 112.

221 *The Potato Peeler*: Amrita Sher-Gil, *The Potato Peeler*, 1938, National Gallery of Modern Art, New Delhi.

221 *Merry Cemetery*: Amrita Sher-Gil, *Merry Cemetery*, 1939, National Gallery of Modern Art, New Delhi.

222 'like tongues of flame': Sonal Khullar, 'An Art of the Soil: Amrita Sher-Gil (1913-41)', in *Worldly Affiliations, Artistic Practice, National Identity and Modernism in India, 1930-1990*, p. 80.

222 a failed abortion: Yashodhara Dalmia, *Amrita Sher-Gil: A Life*, pp. 179-81.

Chapter Seven: Naked

223 statues of; as virgin: Kenneth Clark, *The Nude: A Study in Ideal Form* (London: The Folio Society, first published 1956; 2010), p. 336.

224 *Self-Portrait on her Sixth Wedding Anniversary*: In the collection of the Paula Modersohn-Becker Museum in Bremen - the first museum devoted to a female artist.

225 daughter's artistic ambitions: *The Letters and Journals of Paula Modersohn-Becker*, translated and annotated by J. Diane Radycki (New Jersey and London: The Scarecrow Press, 1980), p. 3.

225 by ten to one: Diane Radycki, *Paula Modersohn-Becker: The First Modern Artist* (New Haven and London: Yale University Press, 2013), pp. 51-4.

225 'my drawing lessons': Paula Becker letter to her family, Berlin, 21 October 1892, in *The Letters and Journals of Paula Modersohn-Becker*, p. 5.

225 'the cloth keep its place': *The Letters and Journals of Paula Modersohn-Becker*, p. 4.

226 she stayed for two years: Diane Radycki, *Paula Modersohn-Becker: The First Modern Artist*, p. 55.

226 'try and develop it': Waldemar Becker to Paula Becker, 11 May 1896, quoted in Diane Radycki, *Paula Modersohn-Becker: The First Modern Artist*, p. 16.

226 'comfort every day': Paula Becker letter to her family, Berlin, 20 February 1897, in *The Letters and Journals of Paula Modersohn-Becker*, p. 18.

226 'she is constantly observing': Paula Becker letter to her family, Berlin, 5 March 1897, in *The Letters and Journals of Paula Modersohn-Becker*, p. 19.

226 'land of the gods': Paula Becker journal, Worpswede, Summer 1897, in *The Letters and Journals of Paula Modersohn-Becker*, p. 29.

227 'have a profound mood': Ibid. p. 31.

227 'We're both doing great!': Paula Becker letter to her family, Worpswede, July 1897, in *The Letters and Journals of Paula Modersohn-Becker*, p. 34.

227 'for your child': Ibid. p. 33.

227 'something fascinating for me': Paula Becker letter to her family, on the train to Berlin, 5 December 1897, in *The Letters and Journals of Paula Modersohn-Becker*, p. 42.

227 in her hair: Paula Becker letter to her family, Berlin, 19 February 1898, in *The Letters and Journals of Paula Modersohn-Becker*, p. 47.

227 'painting a landscape': Paula Modersohn-Becker letter to her parents, August 1897, quoted in Doris Hansmann, *The Worpswede Artists' Colony* (Munich, London and New York: Prestel Verlag, 2011), p. 62.

228 'My ass is all blind': Paula Becker journal, 4 October 1898, in *The Letters and Journals of Paula Modersohn-Becker*, p. 71.

228 'been quietly laid?': Paula Becker journal, 11 November 1898, in *The Letters and Journals of Paula Modersohn-Becker*, p. 75.

228 'I can become something!': Paula Becker journal, 15 November 1898, in *The Letters and Journals of Paula Modersohn-Becker*, p. 77.

228 'I accuse her': Paula Becker journal, 29 November 1898, in *The Letters and Journals of Paula Modersohn-Becker*, p. 79.

228 'I'm alive': Paula Becker journal, 19 January 1899, in *The Letters and Journals of Paula Modersohn-Becker*, p. 85.

228 who pleased her immensely: Paula Becker letter to her father, Worpswede, 9 March 1899, in *The Letters and Journals of Paula Modersohn-Becker*, p. 90.

229 'waterlilies in our hair': Paula Becker letter to her mother, Worpswede, June 1899, in *The Letters and Journals of Paula Modersohn-Becker*, p. 93.

229 'to disappear completely': Paula Becker letter to her family, Worpswede, June 1899, in *The Letters and Journals of Paula Modersohn-Becker*, p. 97.

229 talk of the town: Paula Becker letter to her mother, Worpswede, August 1899, in *The Letters and Journals of Paula Modersohn-Becker*, p. 97.

229 seasick and nauseous: Arthur Fitger review of Paula Modersohn, Clara Westhoff and Maria Bock in *Weser-Zeitung*, 20 December 1899, quoted in *The Letters and Journals of Paula Modersohn-Becker*, p. 105.

229 'into the ground': Paula Becker journal, December 1899, in *The Letters and Journals of Paula Modersohn-Becker*, p. 99.

230 'a period of one month': Eugene Muntz, 'The Ecole des Beaux-Arts', *The Architectural Record*, January 1901, cited in *The Letters and Journals of Paula Modersohn-Becker*, p. 106.

230 'a brutal strength': Paula Becker journal, January 1900, in *The Letters and Journals of Paula Modersohn-Becker*, p. 109.

230 boulevard Raspail: Diane Radycki, *Paula Modersohn-Becker: The First Modern Artist*, p. 63.

230 'alpha and omega': Paula Becker, letter to her family, 11 January 1900, in *The Letters and Journals of Paula Modersohn-Becker*, p. 111.

231 'like a thunderstorm': Paula Becker letter to Clara Rilke, Worpswede, 21 October 1907, in *The Letters and Journals of Paula Modersohn-Becker*, p. 311.

231 'and absinthe bars': Paula Becker letter to Otto Modersohn, Paris, 28

February 1900, in *The Letters and Journals of Paula Modersohn-Becker*, p. 134.

231 'about what matters': Ibid. pp. 134-5.

231 they drank champagne: Diane Radycki, *Paula Modersohn-Becker: The First Modern Artist*, p. 79.

231 'that comes her way': Paula Becker letter to her family, 13 April 1900, in *The Letters and Journals of Paula Modersohn-Becker*, p. 122.

231 on the moor: *The Letters and Journals of Paula Modersohn-Becker*, p. 149.

231 'you may be certain': Paula Becker letter to Otto Modersohn, Worpswede, Autumn 1900, in *The Letters and Journals of Paula Modersohn-Becker*, p. 153.

232 'the dark sculptor': *The Letters and Journals of Paula Modersohn-Becker*, p. 150.

232 'Sweet and pale': Paula Modersohn-Becker journal, Worpswede, 3 September 1900, in *The Letters and Journals of Paula Modersohn-Becker*, p. 152.

232 'in my hands and hair': Paula Modersohn-Becker journal, Worpswede, 26 July 1900, in *The Letters and Journals of Paula Modersohn-Becker*, pp. 151-2.

232 'on his violin': Paula Modersohn-Becker letter to her aunt Marie, Worpswede, October 1900, in *The Letters and Journals of Paula Modersohn-Becker*, pp. 151-2.

232 'not becoming something': Paula Modersohn-Becker letter to her mother, Worpswede, 3 November 1900, in *The Letters and Journals of Paula Modersohn-Becker*, p. 159.

232 'see a bit of heaven': Paula Modersohn-Becker letter to Otto Modersohn, Berlin, 13 January 1901, in *The Letters and Journals of Paula Modersohn-Becker*, pp. 170-1.

232 'Worpswede for me': Paula Becker letter to Otto Modersohn, Berlin, 15 January 1901, in *The Letters and Journals of Paula Modersohn-Becker*, p. 171.

233 'beautiful with her': Paula Modersohn-Becker journal, Worpswede, 20 December 1901, in *The Letters and Journals of Paula Modersohn-Becker*, p. 201.

233 'thousand languages of love': Paula Modersohn-Becker letter to Clara Westhoff-Rilke, December 1901, in *The Letters and Journals of Paula Modersohn-Becker*, p. 202.

233 'heavy and anxious cares?': Rainer Maria Rilke letter to Paula Modersohn-Becker, 12 February 1902, in *Letters of Rainer Maria Rilke*

(1892–1910), trans. Jane Bannard Greene and M.D. Herter Norton (New York: W.W. Norton & Company, 1972), p. 65.

234 'this serious stillness': Paula Modersohn-Becker journal, Worpswede, Easterweek, March 1902, in *The Letters and Journals of Paula Modersohn-Becker*, p. 206.

234 'companion for one's soul': Paula Modersohn-Becker journal, Worpswede, 31 March 1902, in *The Letters and Journals of Paula Modersohn-Becker*, p. 206.

234 'she is monumental': Otto Modersohn journal, 11 March 1902, in *The Letters and Journals of Paula Modersohn-Becker*, p. 220.

234 in the countryside: Rachel Corbett, *You Must Change Your Life: The Story of Rainer Maria Rilke and Auguste Rodin* (New York: W.W. Norton & Company, Kindle Edition, 2016), pp. 104–5.

234 'can be quite contagious': Paula Modersohn-Becker letter to Otto Modersohn, Paris, 12 February 1903, in *The Letters and Journals of Paula Modersohn-Becker*, p. 202.

235 'in harmony, too': Paula Modersohn-Becker letter to Otto Modersohn, Paris, 14 February 1903, in *The Letters and Journals of Paula Modersohn-Becker*, p. 202.

235 the Dutch masters: Paula Modersohn-Becker letter to Otto Modersohn, Paris, 17 February 1903, in *The Letters and Journals of Paula Modersohn-Becker*, pp. 228–9.

235 greatest living French artist: Paula Modersohn-Becker letter to Otto Modersohn, Paris, 26 February 1903, in *The Letters and Journals of Paula Modersohn-Becker*, p. 234.

235 'distinguished German painter': Rainer Maria Rilke letter to Auguste Rodin, quoted in *The Letters and Journals of Paula Modersohn-Becker*, p. 244.

235 'friendly and charming': Paula Modersohn-Becker letter to Otto Modersohn, Paris, 2 March 1903, in *The Letters and Journals of Paula Modersohn-Becker*, p. 236.

235 five artists, including Otto: Rainer Maria Rilke, *Worpswede* (Berlin: Velhagen & Klasing, 1903).

235 'more Rilke in it than Worpswede': Paula Modersohn-Becker letter to Martha Hauptmann, quoted in Doris Hansmann, *The Worpswede Artists' Colony*, p. 61.

235 'preoccupied with themselves': Paula Modersohn-Becker letter to Otto Modersohn, Paris, 3 March 1903, in *The Letters and Journals of Paula Modersohn-Becker*, p. 237.

235 'over each other': Paula Modersohn-Becker journal, 25 February 1903, in *The Letters and Journals of Paula Modersohn-Becker*, p. 233.

235 danced in the garden: Paula Modersohn-Becker letter to her aunt Marie, Worpswede, 30 April 1904, in *The Letters and Journals of Paula Modersohn-Becker*, p. 237.

235 'dreadful Englishwomen': Paula Modersohn-Becker letter to Otto Modersohn, Paris, 19 February 1905, in *The Letters and Journals of Paula Modersohn-Becker*, p. 258.

235 'as into another life': Paula Modersohn-Becker letter to Otto Modersohn, Paris, 19 February 1905, in *The Letters and Journals of Paula Modersohn-Becker*, p. 257.

236 'life-size heads': Otto Modersohn quoted in Diane Radycki, *Paula Modersohn-Becker: The First Modern Artist*, p. 132.

236 wrong end of her brush: *The Letters and Journals of Paula Modersohn-Becker*, p. 268.

236 a dark background: Paula Modersohn-Becker, *Clara Rilke-Westhoff*, November 1905, Hamburger Kunsthalle.

236 'to go back to Paris': Clara Westhoff-Rilke quoted in *The Letters and Journals of Paula Modersohn-Becker*, p. 277.

236 'married is rather hard': Paula Modersohn-Becker letter to her mother, Worpswede, 26 November 1905, in *The Letters and Journals of Paula Modersohn-Becker*, p. 270.

236 'art very difficult': Paula Modersohn-Becker letter to her sister Milly, Worpswede, 6 December 1905, in *The Letters and Journals of Paula Modersohn-Becker*, p. 270.

236 'and his direction': Rainer Maria Rilke, letter to Karl von der Heydt, 16 January 1906, cited in *The Letters and Journals of Paula Modersohn-Becker*, p. 270.

236 'not to be married': Diane Radycki, *Paula Modersohn-Becker: The First Modern Artist*, pp. 133-4.

237 he wanted to see: *The Letters and Journals of Paula Modersohn-Becker*, p. 279.

237 'about to happen': Paula Modersohn-Becker journal, Paris, 24 February 1906, in *The Letters and Journals of Paula Modersohn-Becker*, p. 280.

237 'more and more': Diane Radycki, *Paula Modersohn-Becker: The First Modern Artist*, p. 152.

237 'without each other': Paula Modersohn-Becker letter to Otto Modersohn, Paris, 22 February 1906, in *The Letters and Journals of Paula Modersohn-Becker*, p. 281.

237 'all sorts of things to learn': Paula Modersohn-Becker letter to Otto Modersohn, Paris, 19 March 1906, in *The Letters and Journals of Paula Modersohn-Becker*, p. 282.

237 send her money: Paula Modersohn-Becker letter to Otto Modersohn, Paris, 9 April 1906, in *The Letters and Journals of Paula Modersohn-Becker*, p. 283.

237 like something sacred: Paula Modersohn-Becker, *Herma Becker Holding a Flower*, 1906, Private Collection.

237 she painted him, too: Paula Modersohn-Becker, *Werner Sombart*, 1906, Kunsthalle Bremen.

237 'a little lonely': Paula Modersohn-Becker letter to Bernhard Hoetger, Paris, May 1906, in *The Letters and Journals of Paula Modersohn-Becker*, p. 285.

238 blank as a mask: Paula Modersohn-Becker, *Lee Hoetger Holding a Flower*, August 1906, Paula Modersohn-Becker Museum, Bremen.

238 flowers that surround her: Paula Modersohn-Becker, *Lee Hoetger in a Garden*, 1906, Paula Modersohn-Becker Museum, Bremen.

238 for an artist's model: Paula Modersohn-Becker letter to her sister, Paris, May 1906, in *The Letters and Journals of Paula Modersohn-Becker*, p. 286.

238 'living in ecstasy': Paula Modersohn-Becker letter to her mother, Paris, 8 May 1906, in *The Letters and Journals of Paula Modersohn-Becker*, p. 286.

238 portrait of Rilke: Paula Modersohn-Becker, *Rainer Maria Rilke*, May–June 1906, Private Collection.

238 eyes are weary: Paula Modersohn-Becker, *Self-Portrait with Lemon*, 1906–7, Private Collection.

238 seven of which are nudes: Diane Radycki, *Paula Modersohn-Becker: The First Modern Artist*, p. 148.

238 as if to smell it: Paula Modersohn-Becker, *Self-Portrait Nude with Amber Necklace*, Half-length II, 1906, Kunstmuseum Basel.

238 orange like talismans: Paula Modersohn-Becker, *Standing Self-Portrait Nude with Hat*, 1906, Private Collection.

238 easily recognisable: Paula Modersohn-Becker, *Large Standing Self-Portrait Nude*, 1906, Galerie Neue Meister, Dresden.

239 a shining goldfish bowl: Paula Modersohn-Becker, *Child with Goldfish Bowl*, 1906, Neue Pinakothek, Munich.

240 'function of painting': Diane Radycki, *Paula Modersohn-Becker: The First Modern Artist*, pp. 34–5.

240 ignored by critics: Diane Radycki, *Paula Modersohn-Becker: The First Modern Artist*, p. 35.

240 'at Otto Modersohn's side': Paula Modersohn-Becker letter to Clara Westhoff-Rilke, 17 November 1906, in Diane Radycki, *Paula Modersohn-Becker: The First Modern Artist*, p. 213.

240 *Garden Ornament and Poppies*: Paula Modersohn-Becker, *Old Poorhouse Woman in a Garden with Garden Ornament and Poppies*, 1907, Paula Modersohn-Becker Museum, Bremen.

241 by a pregnant woman: Paula Modersohn-Becker, *Self-Portrait with Two Flowers in Her Raised Left Hand*, 1907, Museum of Modern Art, New York.

241 her last letter to Clara: Paula Modersohn-Becker letter to Clara Westhoff-Rilke, Worpswede, 21 October 1907, in *The Letters and Journals of Paula Modersohn-Becker*, p. 311.

241 'Cézannes on exhibit': Paula Modersohn-Becker letter to her mother, Worpswede, 22 October 1907, in *The Letters and Journals of Paula Modersohn-Becker*, p. 312.

241 She was thirty-one: Clara Westhoff-Rilke description, *The Letters and Journals of Paula Modersohn-Becker*, p. 313.

241 'I accuse: all men': Rainer Maria Rilke, *Requiem for a Friend*, 1908.

243 'somersaults and cartwheels': June Rose, *Mistress of Montmartre: A Life of Suzanne Valadon* (London: Richard Cohen Books, 1998), p. 33.

243 'I was a boy': Ibid.

243 her focus turned to art: Catherine Hewitt, *Renoir's Dancer: The Secret Life of Suzanne Valadon* (London: Icon Books, 2017), pp. 61-9.

243 *The Grove Sacred to the Arts and Muses*: Pierre Puvis de Chavannes, *The Sacred Grove, Beloved of the Arts and Muses*, 1884-9, The Art Institute of Chicago.

243 *The Large Bathers*: Pierre-Auguste Renoir, *Les Grandes Baigneuses*, 1884-7, The Philadelphia Museum of Art.

243 *Dance at Bougival*: Pierre-Auguste Renoir, *La Danse à Bougival*, 1883, Museum of Fine Arts, Boston.

243 *Girl Braiding her Hair*: Pierre-Auguste Renoir, *La Natte*, 1886-7, Museum Langmatt, Baden.

243 *The Hangover*: Henri de Toulouse-Lautrec, *Gueule de Bois/La Buveuse*, 1887-9, Harvard Art Museums, Cambridge, Massachusetts.

244 Maria followed him, laughing: June Rose, *Mistress of Montmartre: A Life of Suzanne Valadon*, p. 51.

244 charcoal and pastel: Suzanne Valadon, *Self-Portrait*, 1883, Musée

National d'Art Moderne/Centre de Création Industrielle - Centre Pompidou, Paris.

245 300 years earlier: Saskia Ooms, 'The Female Avant-Garde Artist', in *Valadon, Utrillo and Utter in the rue Cortot Studio: 1912–1926* (Paris: Somogy éditions d'Art, 2015), p. 21.

245 and Baudelaire's poems: June Rose, *Mistress of Montmartre: A Life of Suzanne Valadon*, p. 71.

245 'achievement as an artist': Ibid. p. 1.

245 the Paris Salon: Catherine Hewitt, *Renoir's Dancer: The Secret Life of Suzanne Valadon*, p. 73.

245 from the 1860s: For more on Impressionism and gender equality: Griselda Pollock, *frieze masters*, issue 6, 2018, https://frieze.com/article/overlooked-radicalism-impressionist-mary-cassatt

246 'that enchanted me': June Rose, *Mistress of Montmartre: A Life of Suzanne Valadon*, p. 29.

246 'just as ridiculous': Renoir letter to Philippe Burty, quoted in June Rose, *Mistress of Montmartre: A Life of Suzanne Valadon*, p. 60.

246 'That day I had wings': Catherine Hewitt, *Renoir's Dancer: The Secret Life of Suzanne Valadon*, p. 149.

246 the end of his life: June Rose, *Mistress of Montmartre: A Life of Suzanne Valadon*, p. 2.

247 a bohemian vicar: Suzanne Valadon, *Portrait of Erik Satie*, 1909, Musée National d'Art Moderne/Centre de Création Industrielle - Centre Pompidou, Paris.

247 'I dance very rarely': Description of Satie from June Rose, *Mistress of Montmartre: A Life of Suzanne Valadon*, pp. 100–4.

247 'smells of the world': Catherine Hewitt, *Renoir's Dancer: The Secret Life of Suzanne Valadon*, p. 168.

247 'Tuesday 20th June': June Rose, *Mistress of Montmartre: A Life of Suzanne Valadon*, p. 105.

248 made her own furniture: Catherine Hewitt, *Renoir's Dancer: The Secret Life of Suzanne Valadon*, pp. 191–2.

248 by his mental health: Ibid. p. 196.

248 'excellent artist?': June Rose, *Mistress of Montmartre: A Life of Suzanne Valadon*, p. 124.

248 'I am nearing 67': Catherine Hewitt, *Renoir's Dancer: The Secret Life of Suzanne Valadon*, p. 206.

248 cried for a week: June Rose, *Mistress of Montmartre: A Life of Suzanne Valadon*, p. 127.

249 *Adam and Eve*: Suzanne Valadon, *Adam and Eve*, 1909, Musée National d'Art Moderne/Centre de Création Industrielle - Centre Pompidou, Paris.

249 censorious gallery-goers: June Rose, *Mistress of Montmartre: A Life of Suzanne Valadon*, p. 134.

249 *Joy of Life*: Suzanne Valadon, *La Joie de vivre* (Joy of Life), 1911, The Metropolitan Museum of Art, New York.

249 laid out before her: Suzanne Valadon, *The Future Unveiled, or The Fortune Teller*, 1912, Association des Amis du Musée du Petit Palais de Genève.

250 about Suzanne's work: June Rose, *Mistress of Montmartre: A Life of Suzanne Valadon*, p. 146.

250 (Family Portrait): Suzanne Valadon, *Portrait de Famille*, 1912, Musée d'Orsay, Paris.

250 'public scorn and ridicule': Maurice Utrillo, *The Story of my Youth*, quoted in June Rose, *Mistress of Montmartre: A Life of Suzanne Valadon*, pp. 160-1.

251 'the breath that animates it': Robert Rey in *L'Opinion*; Tabarant in *L'Oeuvre*; André Warnod in *L'Avenir*, quoted in June Rose, *Mistress of Montmartre: A Life of Suzanne Valadon*, p. 184.

251 *The Blue Room*: Suzanne Valadon, *La Chambre bleu*, 1923, in the collection of Musée National d'Art Moderne/Centre de Création Industrielle - Centre Pompidou, Paris.

251 ate caviar on Fridays: June Rose, *Mistress of Montmartre: A Life of Suzanne Valadon*, p. 196.

251 she tipped a train driver: Ibid. p. 221.

251 to the Riviera: Ibid. p. 196.

252 the following year: Ibid. pp. 203-4.

252 'the Unholy Trinity': Catherine Hewitt, *Renoir's Dancer: The Secret Life of Suzanne Valadon*, p. 232.

252 'or her spite?': *Beaux-Arts* review, January/July 1929, quoted in June Rose, *Mistress of Montmartre: A Life of Suzanne Valadon*, p. 220.

253 frank self-portrait: Suzanne Valadon, *Self-Portrait with Naked Breasts*, 1931, Collection Bernardeau, Paris.

253 'the most personal': Catherine Hewitt, *Renoir's Dancer: The Secret Life of Suzanne Valadon*, p. 376.

253 three years earlier: June Rose, *Mistress of Montmartre: A Life of Suzanne Valadon*, p. 247.

253 thirty-one etchings: Catherine Hewitt, *Renoir's Dancer: The Secret Life of Suzanne Valadon*, p. 388.

254 'to do me justice': Suzanne Valadon to Francis Carco, quoted in Catherine Hewitt, *Renoir's Dancer: The Secret Life of Suzanne Valadon*, p. 376.

254 'painting and the painter': Alice Neel, c. 1930, untitled and undated typescript, Neel Archives, quoted by Ann Temkin, 'Alice Neel: Self and Others' in *Alice Neel*, ed. Ann Temkin (New York: Harry N. Abrams, in association with Philadelphia Museum of Art on the occasion of the exhibition 'Alice Neel', 2000), p. 13.

255 'You lose all your escapes': Alice Neel to Eleanor Munro, quoted in Jeremy Lewison, 'Showing the Barbarity of Life: Alice Neel's Grotesques', in *Alice Neel: Painted Truths* (Houston: The Museum of Fine Arts, Distributed by Yale University Press, 2010), p. 51.

255 'against everything decent': Alice Neel to Frederick Castle, 'Alice Neel', *Artforum* 22, no. 2, October 1983, quoted in Jeremy Lewison, 'Showing the Barbarity of Life: Alice Neel's Grotesques', in *Alice Neel: Painted Truths*, p. 56.

255 'everyone needed money': Alice Neel interviewed in *Alice Neel, A Documentary* directed by Andrew Neel, 2007.

255 'to be a lion': Ibid.

256 sanatorium in Philadelphia: Ann Temkin, 'Alice Neel: Self and Others', in *Alice Neel*, ed. Ann Temkin, p. 15.

256 'fascinated and terrified me': Alice Neel, A Statement, quoted in Jeremy Lewison, 'Showing the Barbarity of Life: Alice Neel's Grotesques', in *Alice Neel: Painted Truths*, p. 34.

256 the year before: Alice Neel, *Kenneth Doolittle*, 1931, The Estate of Alice Neel.

256 sexual invitation: Alice Neel, *Kenneth Doolittle*, 1931, Hirshhorn Museum and Sculpture Gardens, Smithsonian Institution, Washington.

257 naked, urinating, alienated: Alice Neel, *Untitled (Alice Neel and John Rothschild in the Bathroom)*, and *Alienation*, 1935, The Estate of Alice Neel.

257 José Santiago: Alice Neel, *Alice and José*, 1938, The Estate of Alice Neel.

257 often abusive: Alice Neel interviewed in *Alice Neel, A Documentary* directed by Andrew Neel, 2007.

257 her children's wellbeing: According to her two sons in ibid.

257 'interest in humanity': Alice Neel interview in ibid.

258 'an untenanted house': Ibid.

258 left-wing galleries: Jeremy Lewison and Barry Walker, Curators' statement, *Alice Neel: Painted Truths*, p. 12.

258 'not being art at all': Cited in Ann Temkin, 'Alice Neel: Self and Others', in *Alice Neel*, ed. Ann Temkin, p. 26.

258 'central casting': Peter C. Marzio, Preface, *Alice Neel: Painted Truths*, p. 10.

259 'the right to paint': Alice Neel interview in *Alice Neel, A Documentary* directed by Andrew Neel, 2007.

259 'get rid of it': Ibid.

260 'purely psychological': Ibid.

Acknowledgements

I am indebted to Jenny Lord of Weidenfeld & Nicolson for not only suggesting I pitch her an idea but then supporting my proposal and improving the final product with her insightful editing. A massive thank you to my agent, David Godwin, for his boundless support and enthusiasm. I would also like to thank my Project Editor Clarissa Sutherland, my copyeditor Richard Mason, and the designer Steve Marking.

I could not have written this book without the boundless support of family and friends, near and far. I thank you all, but in particular, Alice Higgie-Crosbie, Andrew Higgie and Suzie Higgie; Polly Braden, Tommaso Corvi-Mora, Dominic Eichler, Cornelia Grassi, Donna Huddleston, Shelley Klein, Luke Milne, Martine Murray, David Noonan, Kirsty Argyle, Chloe Aridjis, Negar Azimi, Michael Bracewell, Lisa Brice, Daniel Cataldi, Adam Chodzko, Judith Clark, Eric and Wendy van Cuylenberg, Adam Davies, Bayard Ficht, Jack Finsterer, Toby Follett, Dan Fox, Kira Freije, Peter Graham, Sarah Greentree, Garrick Jones, Roland Kapferer, Janice Kerbel, Paul Kildea, Maria Kontis, Sylvia Kouvali, Rannva Kunnoy, Garth McLean, Rafael Ortega, Duro Olowu, Felicity Packard, Amalia Pica, Michael Raedecker, Chris Rickwood, Paul Schütze, Renee So, Polly Staple, Annika Ström and Sam Thorne.

I am grateful to *frieze* magazine for granting me a three-month sabbatical that allowed me the rare luxury of full-time writing. I have learned so much from *frieze* friends and colleagues, past and present, and I thank them all.

I bow down to all of the artists who appear in this book for their bravery and brilliance: their legacy continues to enrich the world.

Without the many books and articles that I have cited, I would not have been able to write this one. I am indebted to the brilliant authors and publishers who have kept - and continue to keep - the conversation about women in art history alive.

I wrote much of this book in the National Library, Canberra, the library of the National Gallery of Australia and the British Library in London: oases of sanity. Thank you to each and every librarian!

I dedicate *The Mirror and the Palette* to my mother, Jean Higgie. She - and my beloved and much-missed father, William Higgie - instilled in me a love of art, books and history, people and places, that I can never repay.

Illustration Credits

Museum of Modern Art (MoMA). © 2020. Digital image, The Museum of Modern Art, New York/Scala, Florence.

17. Helene Schjerfbeck, *Self-portrait*, 1912. Alamy.
18. Suzanne Valadon, *Family Portrait*, 1912. Alamy.
19. Margaret Preston, *Self-portrait*, 1930. Art Gallery of New South Wales, Gift of the artist at the request of the Trustees 1930 © AGNSW.
20. Nora Heysen, *Self-portrait*, 1932. Gift of Howard Hinton 1932 / Bridgeman Images.
21. Amrita Sher-Gil, *Self-portrait as Tahitian*, 1934. Collection of Navina and Vivan Sundaram.
22. Leonora Carrington, *Self-portrait*, 1937-8. New York, Metropolitan Museum of Art © Image copyright The Metropolitan Museum of Art / Art Resource / Scala, Florence.
23. Loïs Maillou Jones, *Self-portrait*, 1940. Washington DC Smithsonian American Art Museum © Photo Smithsonian American Art Museum / Art Resource / Scala, Florence.
24. Helene Schjerfbeck, *Self-portrait with Red Spot*, 1944. Alamy.
25. Rita Angus, *Rutu*, 1951. Museum of New Zealand Te Papa Tongarewa, purchased 1992 with New Zealand Lottery Grants Board funds © Reproduced courtesy of the Estate of Rita Angus.
26. Frida Kahlo, *Self-portrait with the Portrait of Doctor Farill*, 1951. Alamy.
27. Alice Neel, *Self Portrait*, 1980. NPG Washington.

Index